GREAT STORE DESIGN

Edited by Natalie Häntze

teNeues

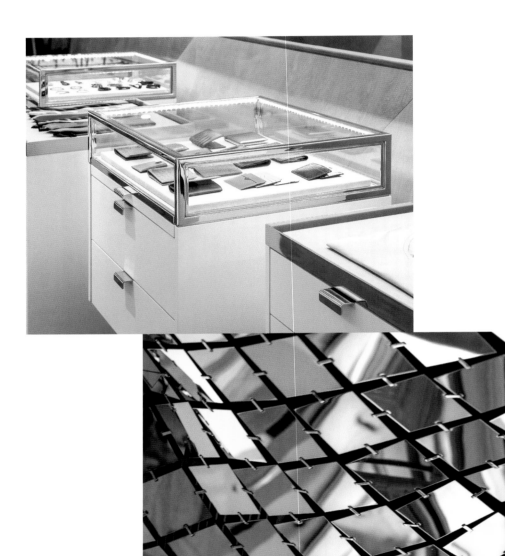

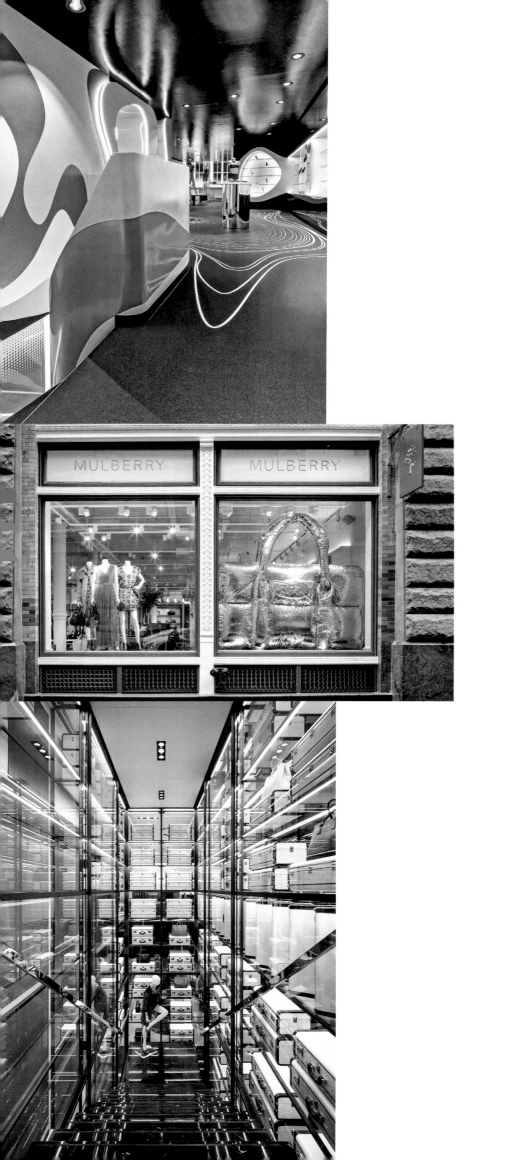

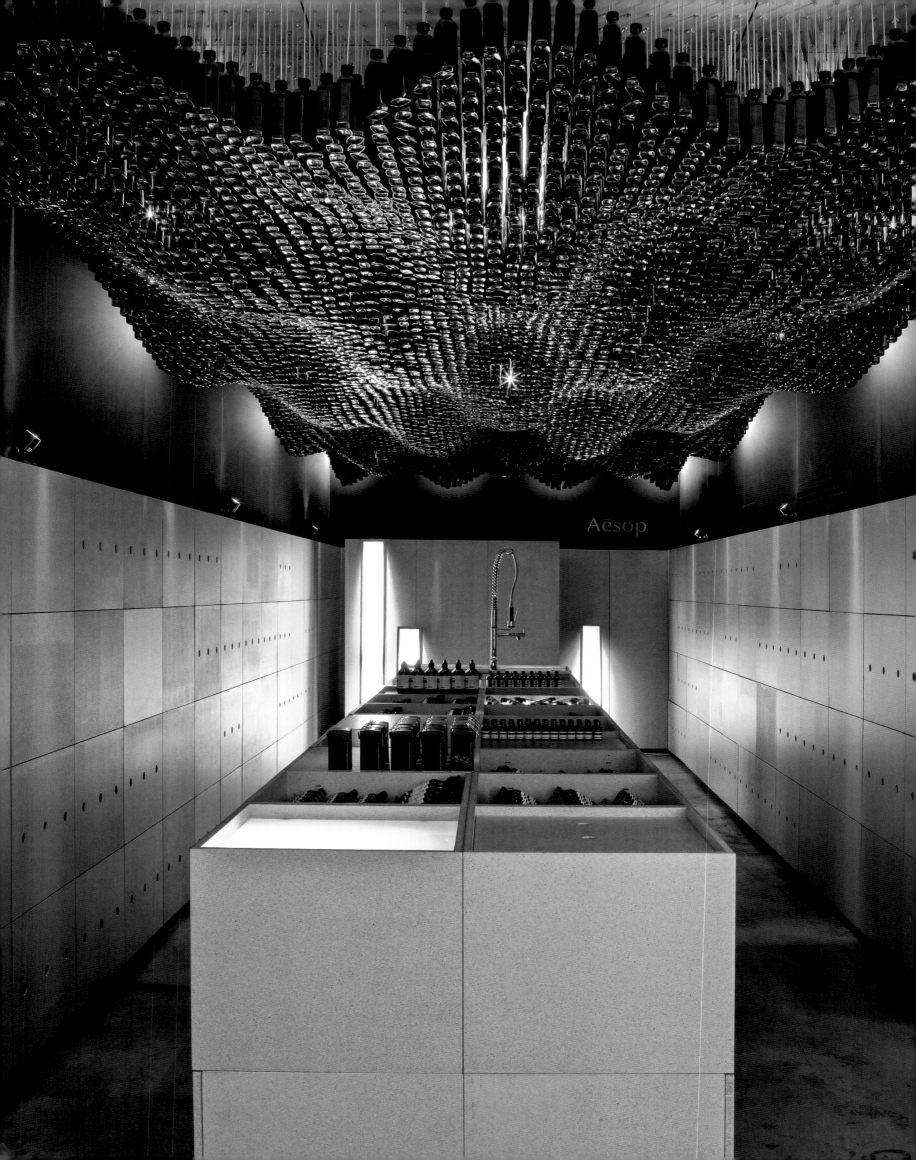

Preface

Stepping into another world is a magical moment: everything around you seems to create a mood that touches you and literally invites you to stroll around the entire space. Your hand brushes over the clothes as you pass, and perhaps you smell a lovely fresh scent. Your eyes enjoy some exotic colors, and a decorative detail brings a smile to your lips. You are inspired. A single fantastically composed store can do all that and more. It gives you the feeling of suddenly being part of a story, of playing a role. Just like that, a simple pleasure. Take, for example, Replay in Milan, where design duo Roman & Williams, who honed their skills as successful Hollywood movie set designers, combined nature scenes with a warehouse vibe to create a whole new retail experience. Or consider the purist formal language of Australian cosmetics brand Aesop, who turns each store into a unique oasis of well-being. At Christian Dior, elegance is all about subtlety, while Versace turns it into something loud and opulent, and at Prada, it takes on an intellectual and linear quality.

Great Store Design shows the latest hot spots selling the hottest brands alongside unique, undiscovered shops: signature stores for Davidoff or Mercedes, lovingly curated jeans and streetwear stores, the elegant champagne store around the corner, and the minimalist bakery. How is this book different? For the first time, you can read the exciting stories behind the designs as brand builders and creative workers share their wisdom. For many years now, stores have been more than places to buy things—they spread a message and make brands into tangible experiences. Retail design has become its own separate discipline. With big design stars like Peter Marino, Matteo Thun, and Karim Rashid, there is a rich international retail design and architecture scene. Interviews with designers and brand managers feed both your head and your heart.

The book is organized like a stroll through a downtown shopping area: you'll pass glamorous flagship stores, discover surprising little gems, and get charming insider tips—all with tons of useful information in a snappy package. As you stroll through the shops, you'll meet lots of new people on every page. *Great Store Design* will delight you with a totally new take on retail: in-depth research and fascinating information with the quality of an opulent coffee-table book. It's a must-have for design aficionados who want to know more about brands and markets, and also for people who simply love to shop! It's good required reading for professionals looking for fresh inspiration and new international partners.

Vorwort

Der Schritt in eine andere Welt – ein magischer Moment. Alles um einen herum scheint irgendwie stimmig, berührt und fordert förmlich dazu auf, sich durch die Räume treiben zu lassen. Man streicht mit der Hand im Vorbeigehen über Stoffe, riecht vielleicht eine duftige Frische, erfreut sich an ausgefallenen Farben, lächelt über ein dekoratives Detail. Ist inspiriert. Ein einziger fantastisch komponierter Laden kann das erreichen. Dieses Gefühl, plötzlich Teil einer Story zu sein. Mittendrin. Einfach so, einfach gut. Ob bei Replay in Mailand, wo das auf erfolgreiche Hollywood-Kulissen abonnierte Designer-Duo Roman & Williams kurzerhand Naturszenen und Lagerhaus-Stimmung zu einem Raumerlebnis verdichtet hat. Oder die puristische Formsprache der australischen Kosmetikmarke Aesop, die aus jedem Store eine individuelle Wohlfühl-Oase macht. Die subtile Eleganz bei Christian Dior, die sich bei Versace plötzlich laut und opulent zeigt, um schließlich bei Prada intellektuell und gradlinig zu werden.

Great Store Design zeigt die neuesten Hotspots großer Marken genauso wie originelle, bisher unentdeckte Läden – Signature Stores von Davidoff oder Mercedes, liebevoll kuratierte Jeans- und Streetwearläden, das elegante Champagner-Geschäft um die Ecke oder den minimalistischen Brotladen. Neu dabei ist, dass erstmals die spannenden Geschichten dahinter erzählt werden. Markenmacher und Kreative kommen zu Wort. Stores sind längst nicht mehr nur Shopping-Destinationen – sie verkünden eine Botschaft, wollen Marken erlebbar machen. Die Gestaltung von Läden ist eine eigene Disziplin geworden. Neben den großen Stars wie Peter Marino, Matteo Thun oder Karim Rashid gibt es eine vielfältige internationale Design- und Architekturszene. Emotional und informativ: Interviews mit Designern und Markenverantwortlichen.

Aufgebaut ist das Buch wie ein Shoppingbummel: Man passiert glamouröse Flagships, macht überraschende Entdeckungen, erhält charmante Geheimtipps. Dazu gibt es Wissenswertes knackig verpackt. Beim Flanieren durch die Geschäfte lernt man Seite für Seite jede Menge neuer Leute kennen. *Great Store Design* überrascht mit einem völlig neuen Mix: Fundierte Recherche und spannende Informationen in der Qualität eines opulenten Bildbandes. Ein Must-have für Menschen, die sich für Design interessieren, die mehr wissen wollen über Marken und Märkte, aber auch für solche, die einfach gerne shoppen. Und eine Pflichtlektüre für Profis auf der Suche nach frischen Impulsen und internationalen Partnern.

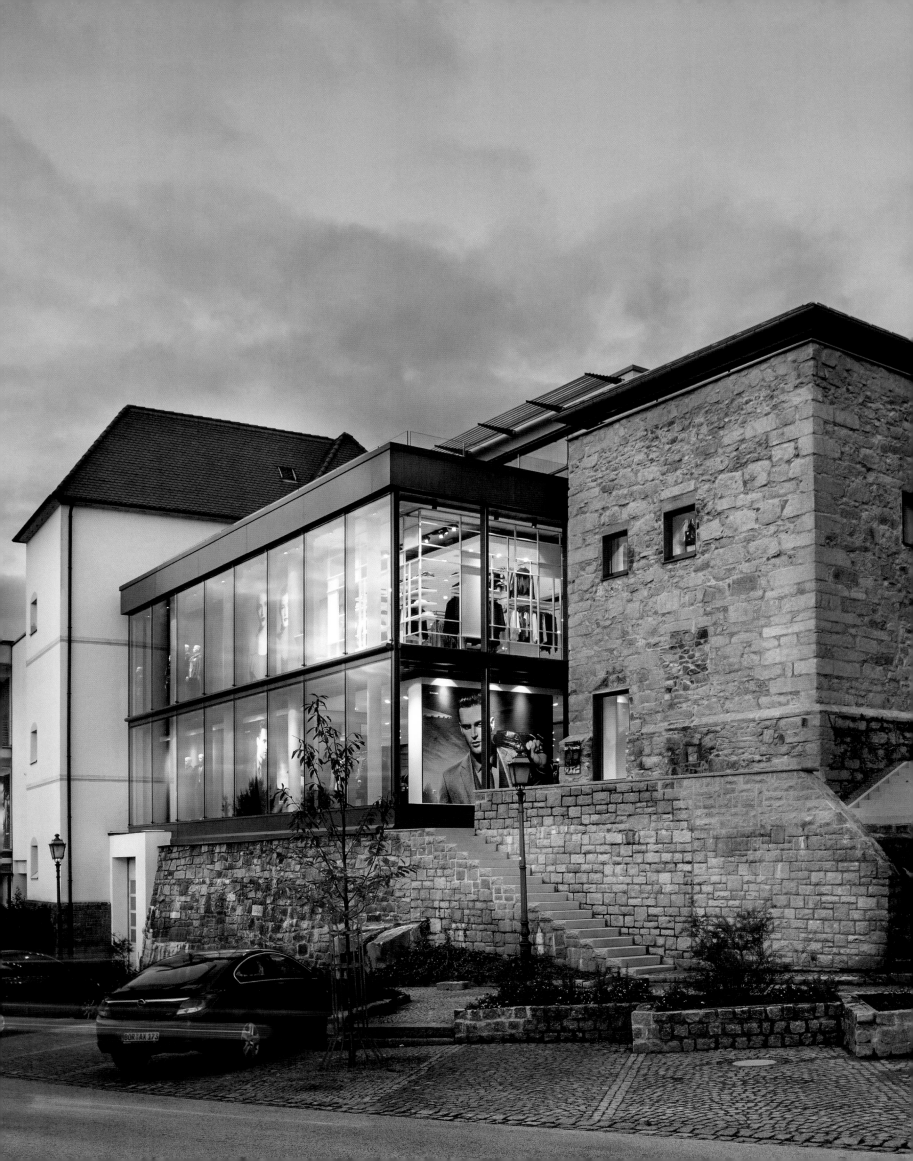

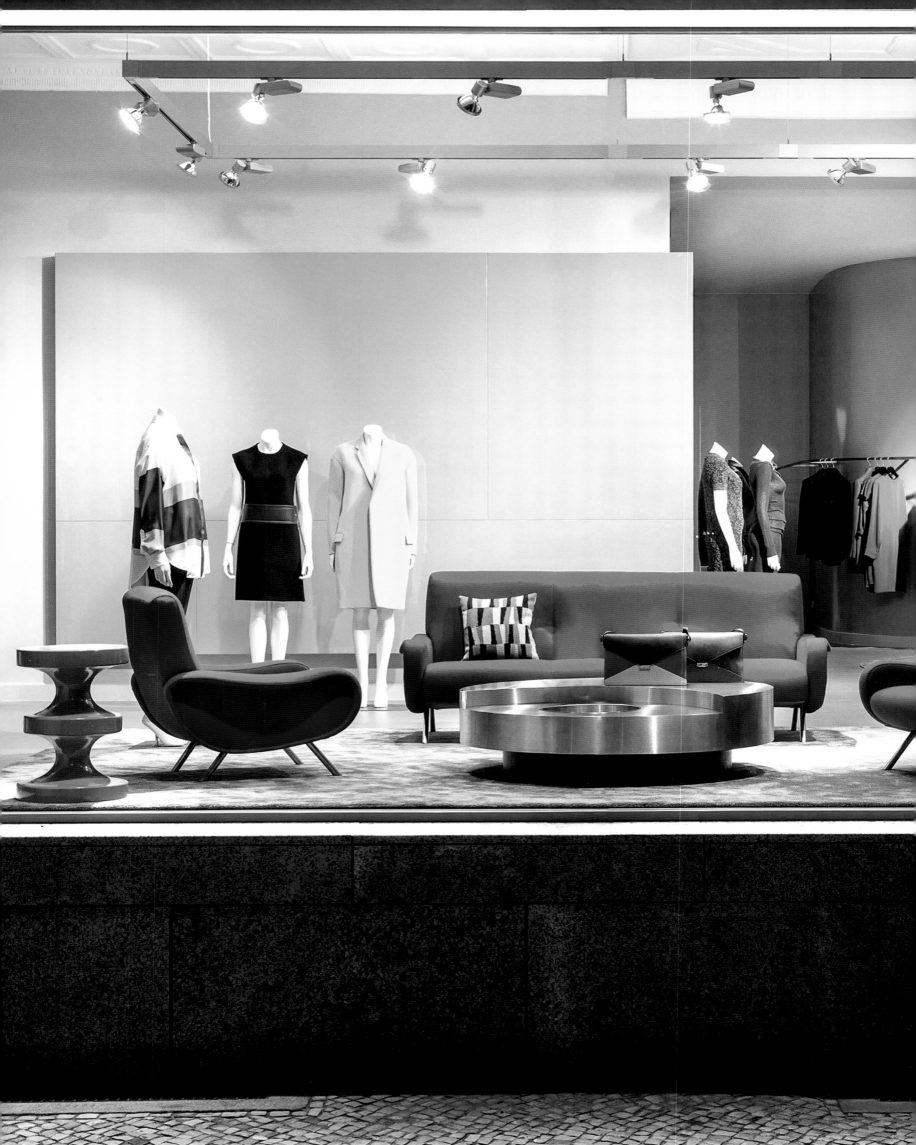

Préface

L'immersion dans un autre monde : un moment magique. Tout autour de soi semble en harmonie, débordant d'émotions, et incite à se laisser porter à travers les pièces. En passant, on caresse les étoffes du bout des doigts, une fraîcheur parfumée s'échappe çà et là, on se délecte des surprenantes couleurs, on sourit d'un détail décoratif. L'inspiration magique monte. Une simple boutique à l'agencement fantastique peut produire tous ces effets-là. Ce sentiment de faire subitement partie d'une histoire. D'y être en plein dedans. Simplement comme cela, simplement bien. Que ce soit chez Replay Milan, où le duo de designers Roman & Williams, habitué des grandes coulisses hollywoodiennes, a mis en place en un clin d'œil des scènes de nature et une ambiance d'entrepôt de manière à en faire une expérience unique de l'espace. Ou le langage visuel puriste de la marque de cosmétiques Aesop, qui transforme chaque boutique en une oasis unique de bien-être. L'élégance subtile de chez Christian Dior, qui se présente subitement tambours battants et en grandes pompes chez Versace, pour finir rectiligne et intellectuelle chez Prada.

Great Store Design présente les nouveaux éléments phares des grandes marques, ainsi que des boutiques originales et encore inconnues du grand public : Des boutiques signature de Davidoff ou Mercedes, des magasins de jeans ou de streetwear décorés avec amour, l'élégant caviste du coin ou la boulangerie minimaliste. Ce qui est nouveau, c'est que pour la première fois, leurs histoires sont racontées au public. Les créateurs et les créatifs ont la parole. Voici longtemps que les magasins ne sont plus uniquement des destinations shopping : ils véhiculent un message ayant pour objectif de rendre les marques tangibles, palpables. L'aménagement des boutiques est devenu une discipline à part entière. Outre les grandes stars telles que Peter Marino, Matteo Thun ou Karim Rashid, il existe également une scène riche et variée dans le design et l'architecture internationale. Émotionnels et informatifs : Interviews avec les designers et les responsables des marques.

Le livre est structuré comme une virée shopping : On passe devant des boutiques glamour, on fait des découvertes surprenantes, et on décèle de véritables petits trésors. Tout un tas de choses bonnes à savoir, astucieusement présentées. En flânant dans les boutiques, on apprend à connaître de nombreuses personnes, page après page. *Great Store Design* surprend avec son nouveau mélange : De la recherche et des informations passionnantes, avec la qualité d'un album illustré. Un must-have pour tous ceux qui s'intéressent au design, qui souhaitent en savoir plus sur les marques et les marchés, mais aussi pour ceux qui aiment simplement faire du shopping. Et un incontournable pour les professionnels à la recherche d'idées nouvelles et de partenaires internationaux.

„Mein Pool ist dein Pool!" Diese Redewendung, mit der in Kalifornien gerne freundschaftliches Wohlwollen zum Ausdruck gebracht wird, ist der Plot für die Gestaltung von The Row in Los Angeles. Häufig als oberflächlich missverstanden, darf sie auch einfach als ein freundliches Willkommen interpretiert werden. Wer vorbeischaut, wird inspiriert, erlebt ein paar Wohlfühl-Momente und kann gehen, wann er will. Eigentlich ganz schön viel für eine unverbindliche Freundschaftsgeste. Das Szenario ziele darauf ab, Kunden zum Kauf zu animieren, mag manch einer kritisieren. Stimmt – aber was ist falsch daran? Freundschaft im ursprünglichsten Sinne bedeutet, durch Sympathie und Vertrauen verbunden zu sein. Keine schlechte Idee, wenn eine Marke langfristig Kunden binden möchte. Der Store ist als ein großzügiges Loft gestaltet: urban, edgy und etwas avantgardistisch. Mid-Century-Möbel, Vintage-Teppiche und Old-School-Zimmerpflanzen schaffen eine sehr private Atmosphäre. Der eklektische Mix aus Designklassikern von Prouvé und Hans Hansen, roh belassenem Holz, origineller Dekoration, Designer-Leuchten und eben diesen 900 Pool-Quadratmetern verdichten Möbel und Kollektion zu einer entspannten Wohnstory und laden zum Entdecken ein. Hinter The Row stehen die Schwestern Ashley und Mary-Kate Olsen. Als Kinderstars in Hollywood gestartet, haben sie sich irgendwann aus der Schauspielerei verabschiedet und nach neuen Wegen gesucht. Heraus kam ihr eigenes Label – benannt nach der Londoner Savile Row. Es hätte eine dieser gängigen Trend-trifft-Merchandising-Kollektionen werden können. Wurde es aber nicht. Die Olsen-Zwillinge fanden tatsächlich ihren eigenen Stil, setzten auf Qualität, feinste Materialien und hohe Schneiderkunst, holten den Layering-Style aus der Grunge-Ecke und stehen heute für Understatement-Chic. Genau das strahlt auch der Store aus. Sympathisch und unaufgeregt zeigt die Marke, was sie zu bieten hat. Das schafft Vertrauen. Eine schöne Basis für Freundschaften und gute Geschäfte.

"My pool is your pool!"

THE ROW

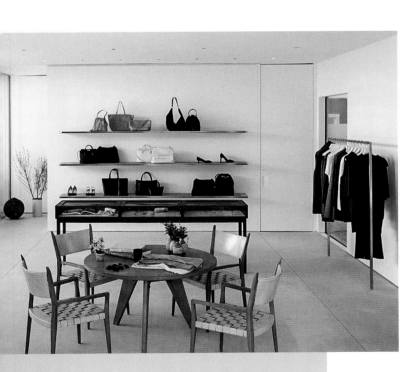

"My pool is your pool!" This common California expression of friendly goodwill is the plot line for the design of The Row in Los Angeles. Often misunderstood as a superficial throwaway line, it can also be interpreted as a simple friendly welcome. Anyone can drop in, get some inspiration, enjoy a few relaxing moments, and leave whenever he likes. It's pretty great for a no-obligation offer of hospitality. Some might criticize and say that the scenario is designed to get customers to buy. True enough, but what's wrong with that? Friendship in its original sense means to develop a connection built on affection and trust. Not a bad idea if a brand wants to inspire long-term loyalty in its customers. The store is designed like a roomy loft: urban, edgy, and somewhat avant-garde. Mid-century furniture, vintage rugs, and old-school houseplants create a very private atmosphere. The eclectic mix of design classics from Prouvé and Hans Hansen, unfinished wood, original decorations, designer lighting, and the aforementioned 900 square meters of pool space unify the furniture and collections to create a relaxed residential feel that invites customers to explore and discover. The Row is the brainchild of sisters Ashley and Mary-Kate Olsen, former child TV stars who eventually left Hollywood to look for a different life. The result was their own label, named after London's Savile Row. It could have been one of these trend-meets-merchandising collections, but it wasn't. The Olsen twins truly found their own style, emphasizing quality, the finest materials, and excellent tailoring. They pulled layered styles out of the grunge world and now stand for understated chic, which is exactly what the store exudes. The brand shows what it has to offer in a friendly, low-key way. And that creates trust, a great foundation for friendships as well as brisk sales.

« Ma piscine est ta piscine ! » : cette expression, fréquemment utilisée en Californie pour exprimer une bienveillance amicale, est le thème mis en scène pour l'agencement de The Row à Los Angeles. Souvent mal comprise et interprétée comme de la superficialité, elle peut également être interprétée comme de l'hospitalité. Ceux qui passent devant se sentent inspirés, connaissent des instants de bien-être et sont libres de partir lorsqu'ils le souhaitent. Ce qui est déjà beaucoup pour un geste amical n'exigeant rien en retour. Certains peuvent évoquer comme critique le fait que le scénario a pour objectif de pousser les clients à l'achat. C'est vrai, mais en quoi est-ce blâmable ? L'amitié au sens premier signifie être lié par de la sympathie et de la confiance. Ce qui n'est donc pas une mauvaise idée lorsqu'une marque souhaite fidéliser durablement ses clients. La boutique est conçue comme un loft spacieux : style urbain, novateur et un tantinet avant-gardiste. Des meubles du milieu du siècle dernier, des tapis vintage et des plantes d'intérieur de style ancien créent une atmosphère très intime. Le mélange éclectique entre des classiques de design signés Prouvé et Hans Hansen, du bois laissé à l'état brut, la décoration d'origine, des lampes de créateurs et ces fameux 900 mètres carrés de piscine condense meubles et collection en une véritable histoire d'habitation invitant le client à venir la découvrir. Ce sont les sœurs Ashley et Mary-Kate Olsen qui sont à l'origine de The Row. Ayant fait leurs débuts en tant qu'enfants stars à Hollywood, elles ont fait leurs adieux à la comédie pour explorer de nouveaux horizons. Le résultat fut la naissance de leur propre label, qui doit son nom à la rue londonienne Savile Row. Cela aurait pu devenir une de ces communes collections où le merchandising répond à la tendance du moment. Mais il en a été autrement. Les jumelles Olsen ont découvert leur propre style, misé sur la qualité, sur les matériaux les plus raffinés et sur la couture très haut de gamme, puis sont allées chercher le style des superpositions de la tendance grunge pour en faire aujourd'hui le synonyme de chic sobre et épuré. C'est précisément l'ambiance de la boutique. La marque présente ses créations dans une atmosphère sympathique et sereine qui inspire confiance. Une jolie base pour les amitiés comme pour les affaires.

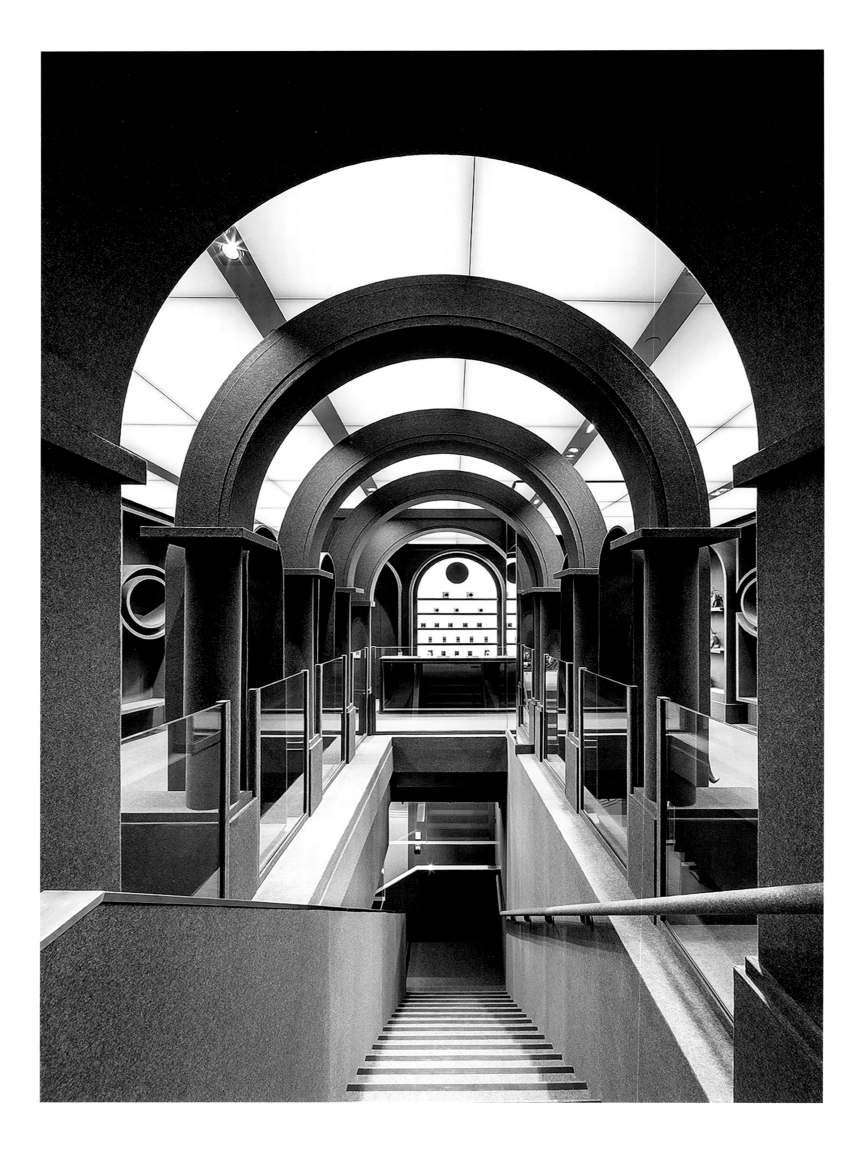

VIKTOR & ROLF PARIS

Ghost architecture: Amsterdam avant-garde label Viktor & Rolf's Paris flagship store is done entirely in gray felt. This interior by architecture firm Architecture & Associés highlights a modern interpretation of neoclassicism. Glamorous and rebellious— like the handwriting of designers Viktor Horsting and Rolf Snoeren—are the best adjectives to describe the materials chosen for the interior design. Launched as an independent creative venture in the early '90s, the duo is now an established presence at Paris prêt-à-porter shows.

Ghost Architecture: Das Amsterdamer Avantgarde-Label Viktor & Rolf präsentiert sich im Pariser Flagship Store vollständig in grauem Filz. Das Interieur des Architekturbüros Architecture & Associés setzt auf modern interpretierten Neoklassizismus. Glamourös und rebellisch – wie die Handschrift der beiden Designer Viktor Horsting und Rolf Snoeren – fiel die Materialwahl für das gesamte Interieurdesign aus. Als Independent-Kreative Anfang der 90er-Jahre gestartet, ist das Duo heute eine feste Größe auf den Pariser Prêt-à-porter-Schauen.

Architecture fantasmagorique : Dans sa boutique vedette de Paris, la marque avant-gardiste d'Amsterdam Viktor & Rolf se présente entièrement habillée de feutre gris. L'intérieur, conçu par le cabinet d'architectes Architecture & Associés, mise sur une interprétation moderne du néo-classicisme. Glamour et rebelles comme le style propre aux designers Viktor Horsting et Rolf Snoeren : telles sont les caractéristiques des matériaux qui ont été choisis pour l'agencement intérieur. Ce duo de designers, qui s'est lancé au début des années 1990 sous l'égide de l'indépendance et de la créativité, est aujourd'hui une valeur sûre des défilés de prêt-à-porter parisiens.

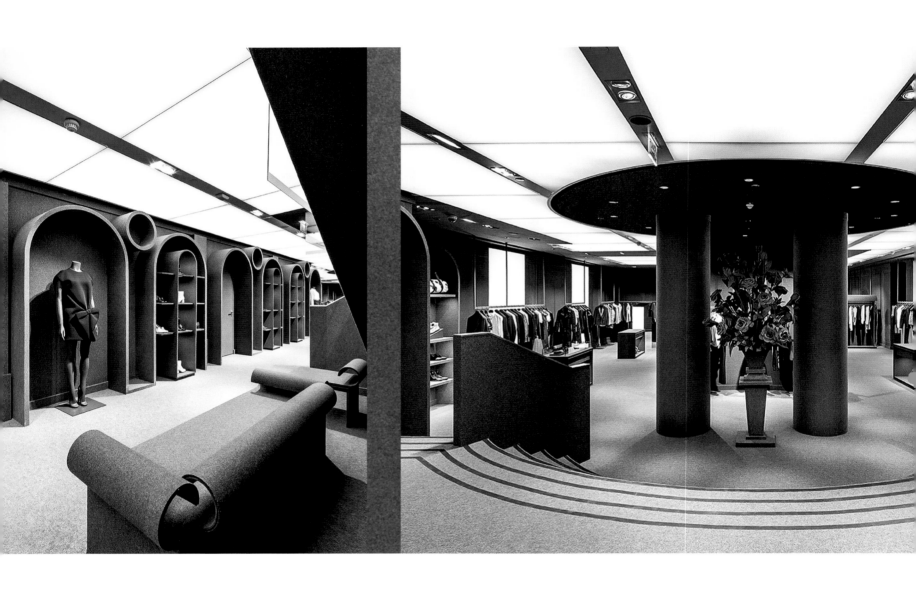

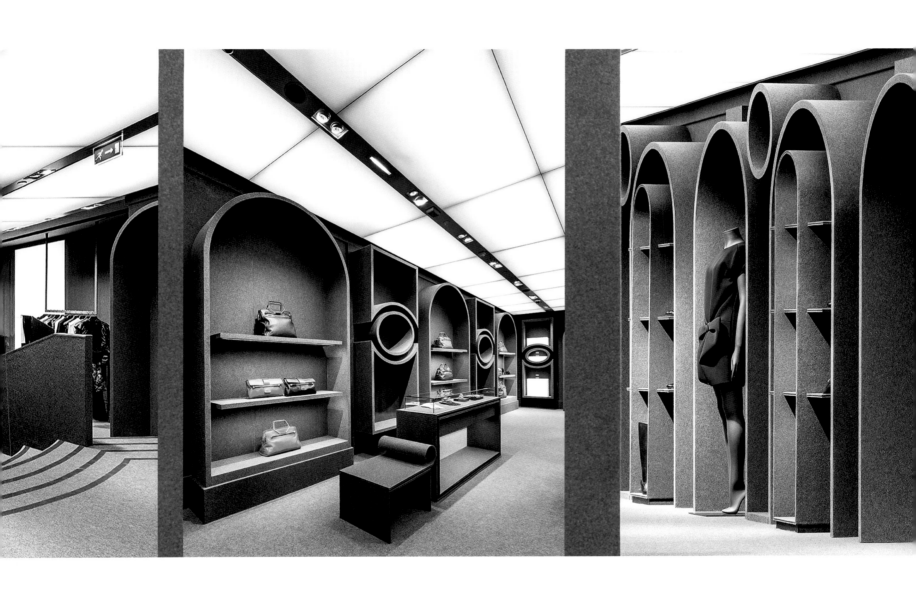

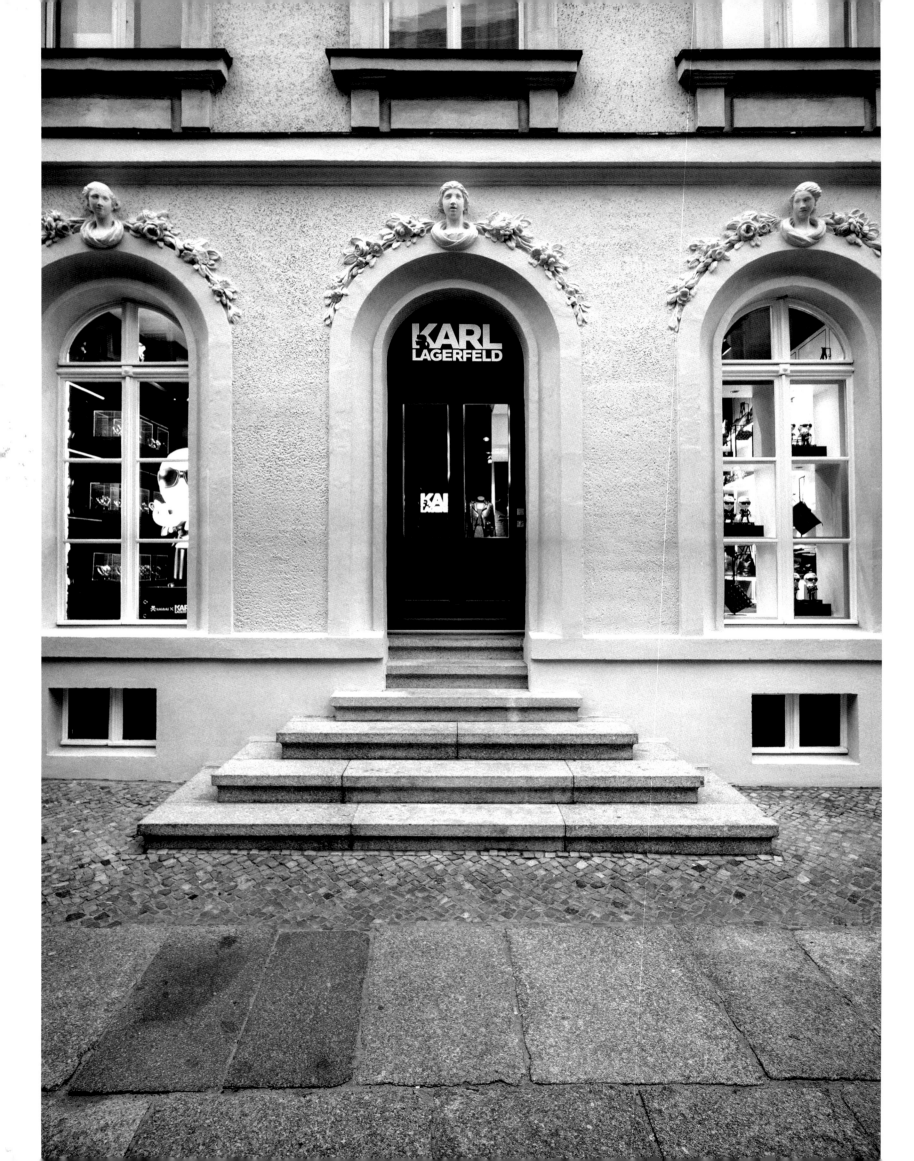

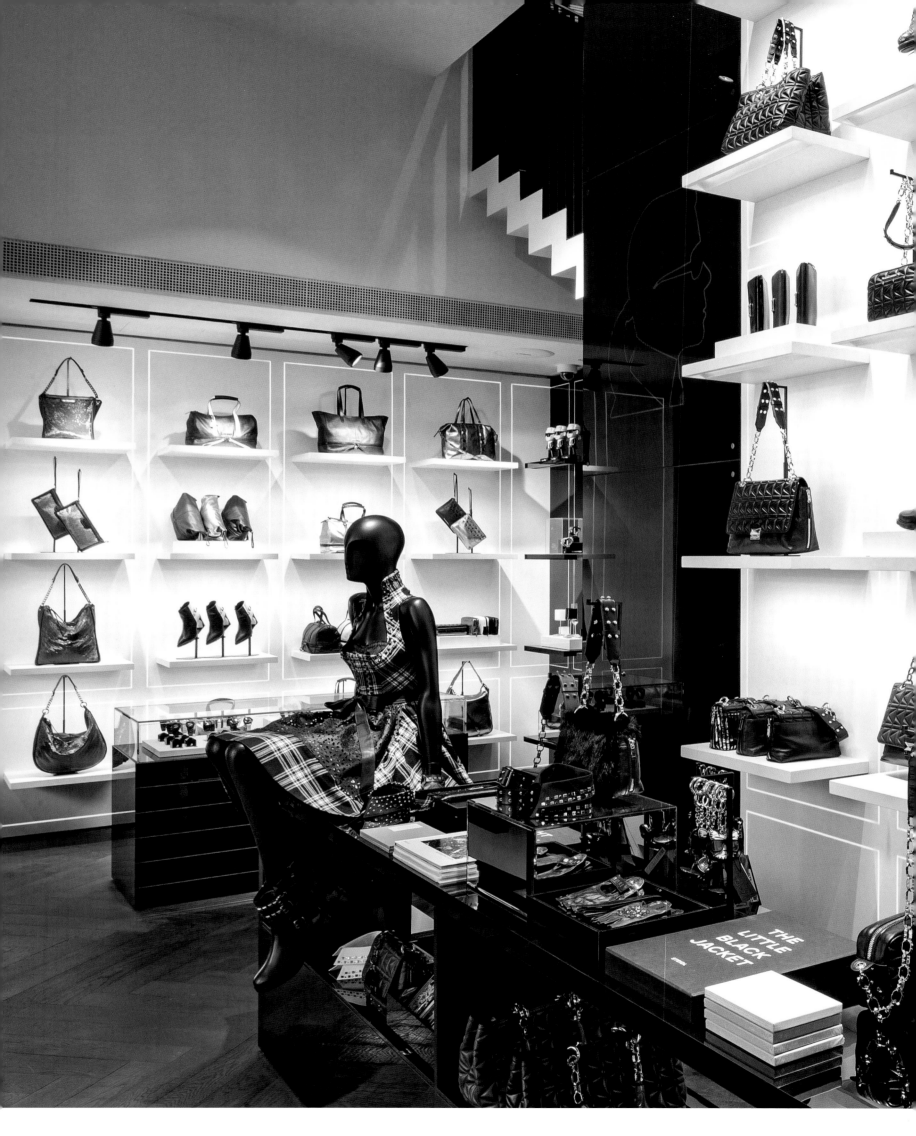

"You can't get any more Karl than we already have here," says CEO Pier Paolo Righi, and he means more than the typical black-and-white Lagerfeld design. The profile of the fashion legend is practically omnipresent: as a large wall graphic, a wallpaper pattern, and even as a posable tokidoki figure. Approaching the Karl Lagerfeld myth and translating it into a store concept was the challenge facing Berlin design firm Plajer & Franz Studio. The basic concept, a fusion of contrasts in materials, colors, and textures faithful to the Karl Lagerfeld DNA, is riddled with subtle local touches. The Berlin store only hints at the bourgeois wooden coffering on the wall and presents whitewashed faux Berlin masonry instead. Lagerfeld was involved in the entire development process. "He's not hard to understand. You just have to get his key attributes: iconic, ironic, creative, artistic," says Righi, assuring that Lagerfeld is easy to deal with after that. Plajer & Franz Studio seems to have succeeded: "It's like a puzzle: you have to figure out from the briefing what you can use to create a store. This gentle self-mockery, the contrasts Karl Lagerfeld presents as a person—he's a very modern man who also stands for tradition. Black-and-white, old and new, translated into a store concept."

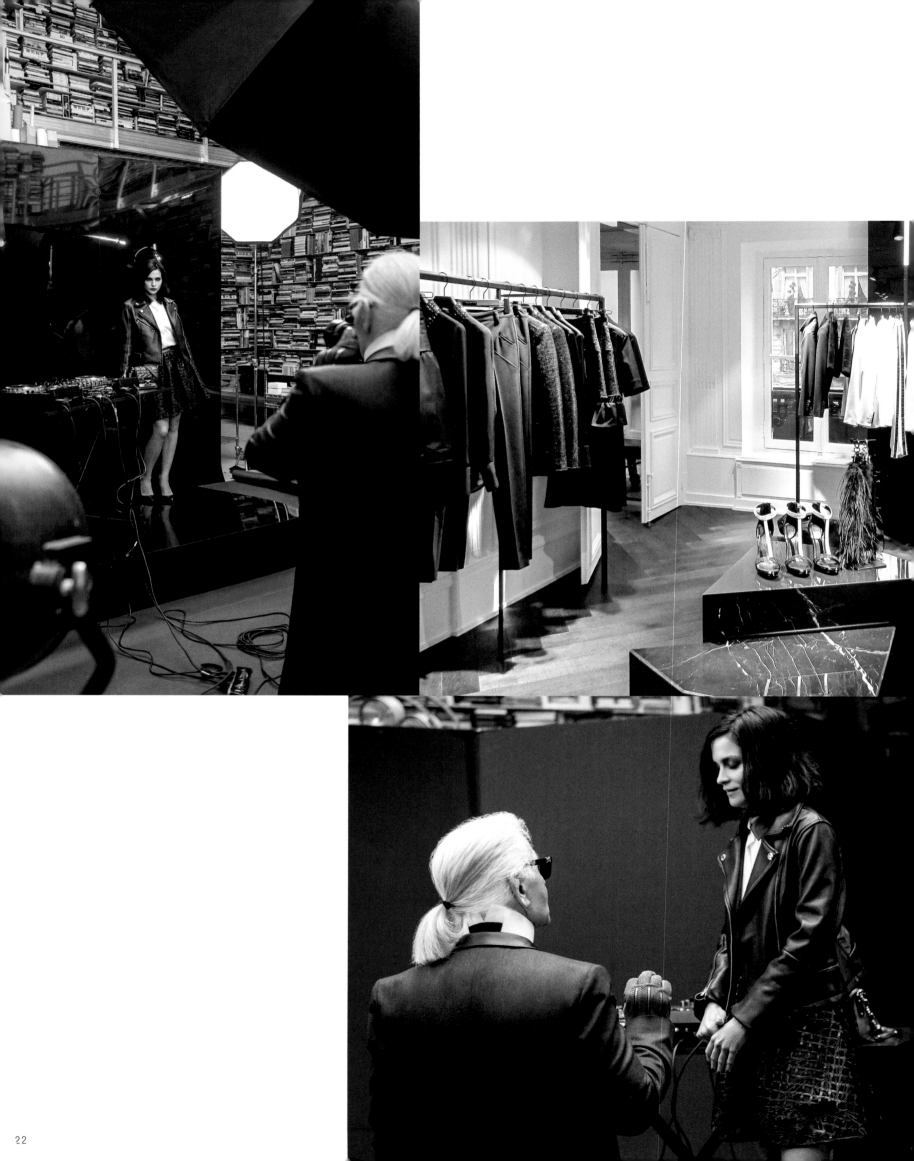

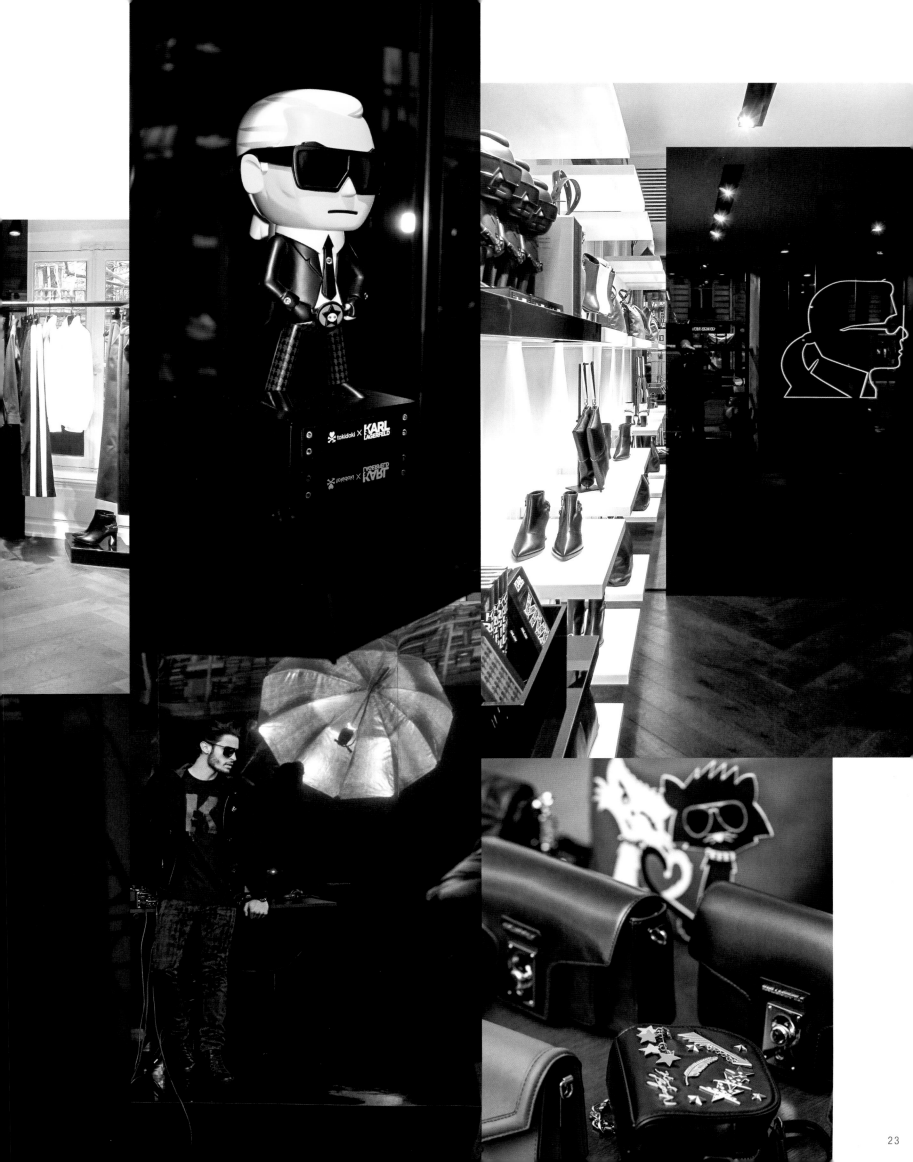

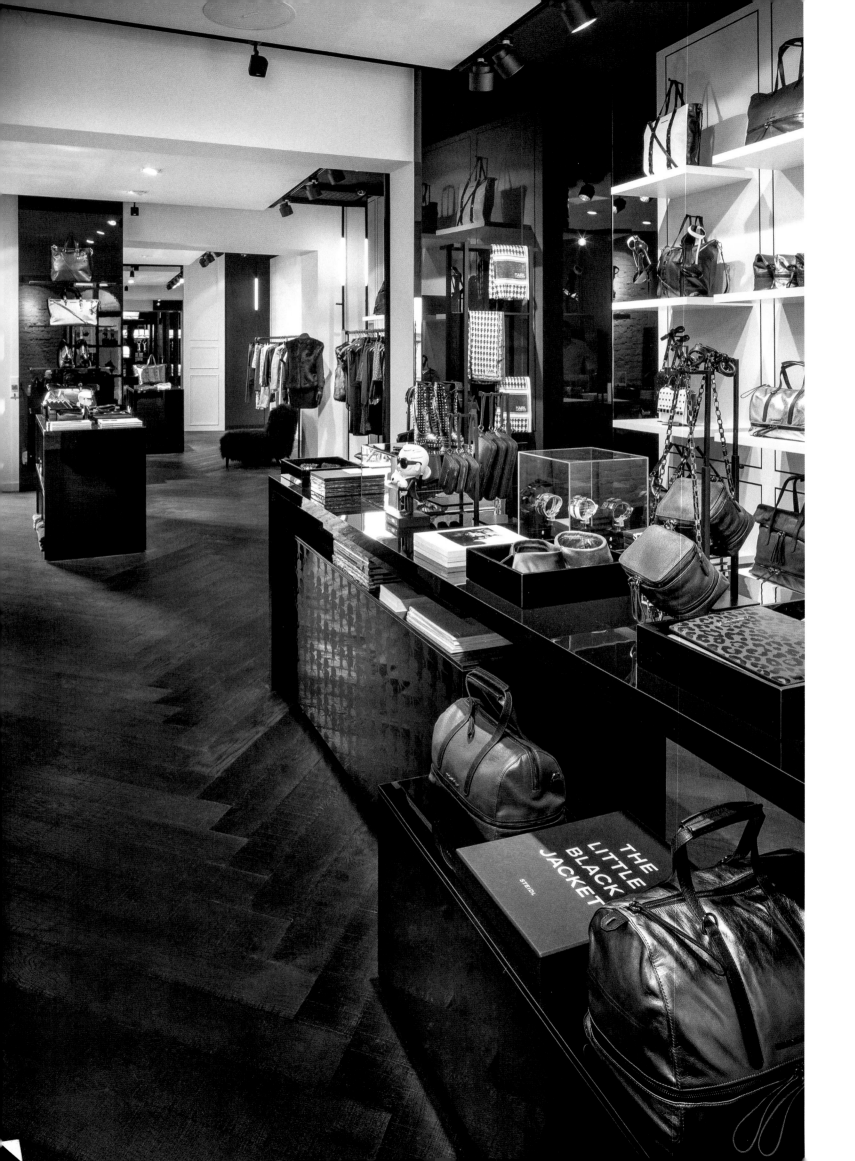

„Mehr Karl, als hier inszeniert wird, geht nicht", sagt CEO Pier Paolo Righi und meint damit nicht nur die Gestaltung in Lagerfeld-typischem Schwarz-Weiß. Das Profil des Modemeisters ist nahezu omnipräsent: als große Wandgrafik, als Tapetendruck, gar als possierliche Tokidoki-Figur. Sich dem Mythos Karl Lagerfeld zu nähern und in ein Storekonzept zu übersetzen war die Herausforderung des Berliner Designbüros Plajer & Franz Studio. Die Grundidee, Kontraste in Materialien, Farben und Haptik im Sinne der KL-DNA zu verschmelzen, ist von feinen lokalen Anleihen durchzogen. So deutet der Berliner Store die großbürgerlichen Holzkassetten an der Wand lediglich an und lässt stattdessen geweißeltes Berliner Mauerwerk stehen. Lagerfeld war am gesamten Entwicklungsprozess beteiligt. „Es ist nicht schwer, ihn zu verstehen, man muss nur seine Key-Attribute begreifen: iconic, ironic, creative, artistic", sagt Righi und versichert, dann sei er easy. Plajer & Franz Studio scheint das gelungen zu sein: „Es ist wie ein Rätsel: Aus dem Briefing muss man herauslösen, woraus ein Laden entstehen kann. Diese leichte Selbstironie, die Kontraste in der Person Karl Lagerfeld – ein sehr moderner Mensch, der auch für Tradition steht. Schwarz und Weiß, alt und neu in ein Storekonzept übersetzt."

« Difficile de faire mieux en matière de mise en scène de Karl », déclare le PDG Pier Paolo Righi, en faisant allusion à bien plus qu'au seul agencement en noir et blanc caractéristique de Karl Lagerfeld. Le profil du ponte de la mode est ici omniprésent : sous forme de grand graphique mural, d'imprimé des tapisseries, et même de figurine Tokidoki. S'imprégner du mythe Karl Lagerfeld et le transposer en concept de boutique : tel fut le défi du bureau d'architectes berlinois Plajer & Franz Studio. L'idée de base consistant à fusionner les contrastes dans des matériaux, des couleurs dans la haptique, au sens de l'ADN de KL, est complétée par les inspirations locales. Ainsi, la boutique de Berlin se contente de faire une allusion discrète aux cassettes en bois de la haute bourgeoisie décorant les murs pour laisser la place à de la maçonnerie berlinoise blanchie à la chaux. Lagerfeld a participé à toute la procédure de conception. « Ce n'est pas difficile de le comprendre. Il faut juste saisir ses attributs clés : iconique, ironique, créatif, artistique », déclare Righi, assurant que la collaboration serait alors simple. Plajer & Franz Studio semble y être parvenu : « C'est comme une énigme : Il faut décortiquer ce qui s'est dit au briefing pour ensuite définir les composantes de la boutique. Cette autodérision, les contrastes du personnage Karl Lagerfeld, quelqu'un de très moderne et à la fois un défenseur des traditions. Noir et blanc, ancien et nouveau, transposés dans un concept de boutique ».

"There's nothing worse than good taste and perfection. There must be flaws, or you won't reach people anymore."

Emmanuel de Bayser, The Corner Berlin

THE
CORNER
BERLIN

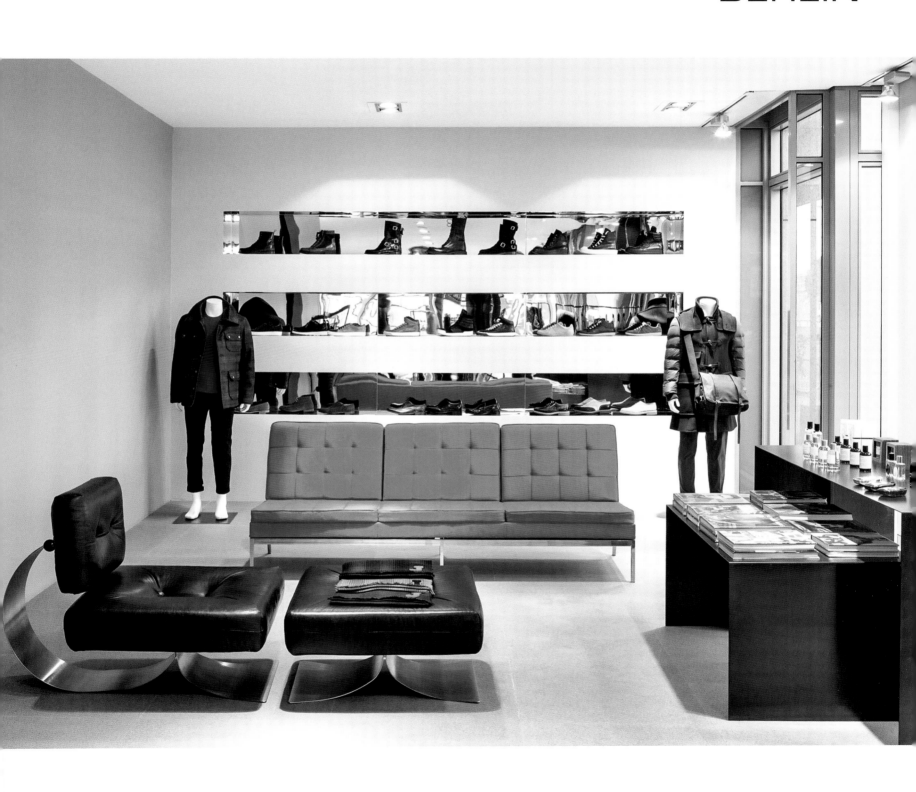

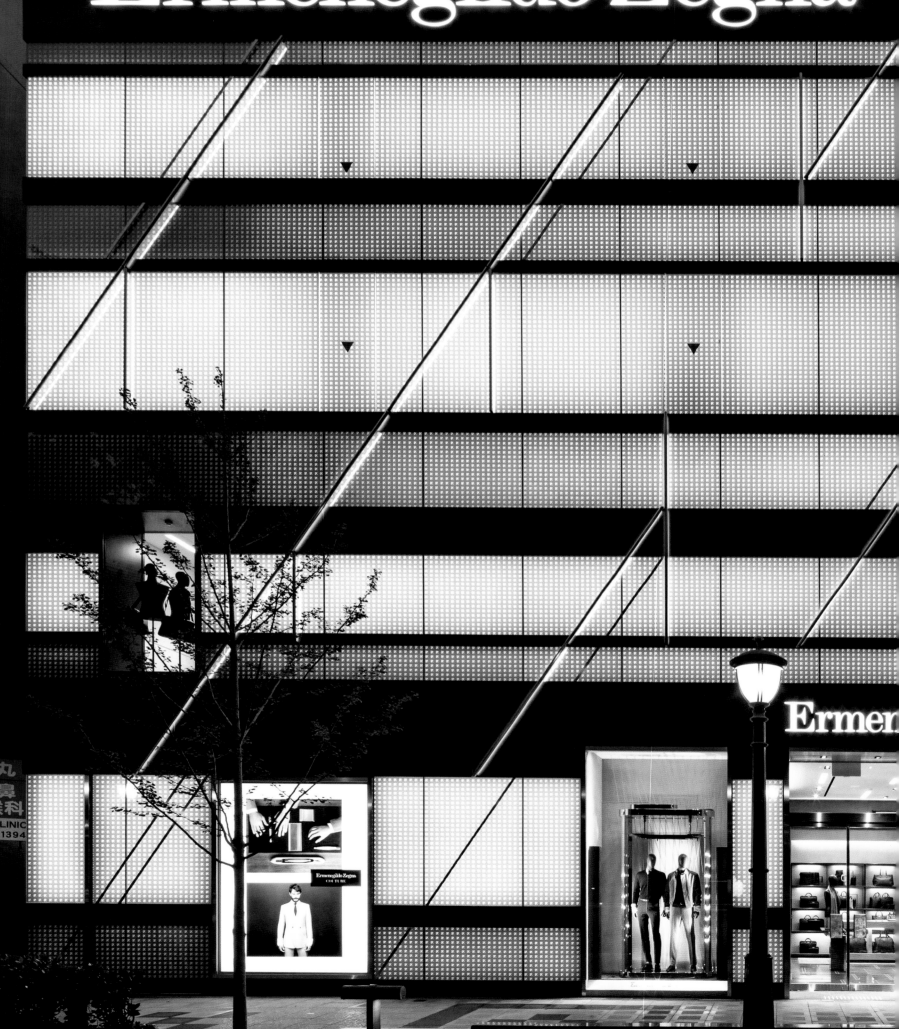

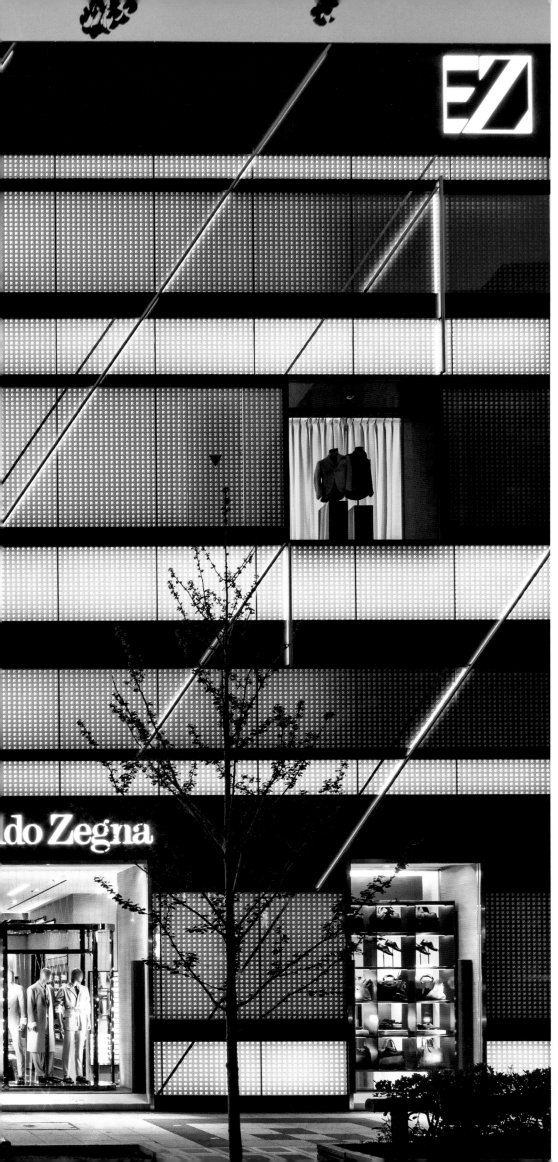

ZEGNA
OSAKA & MIAMI

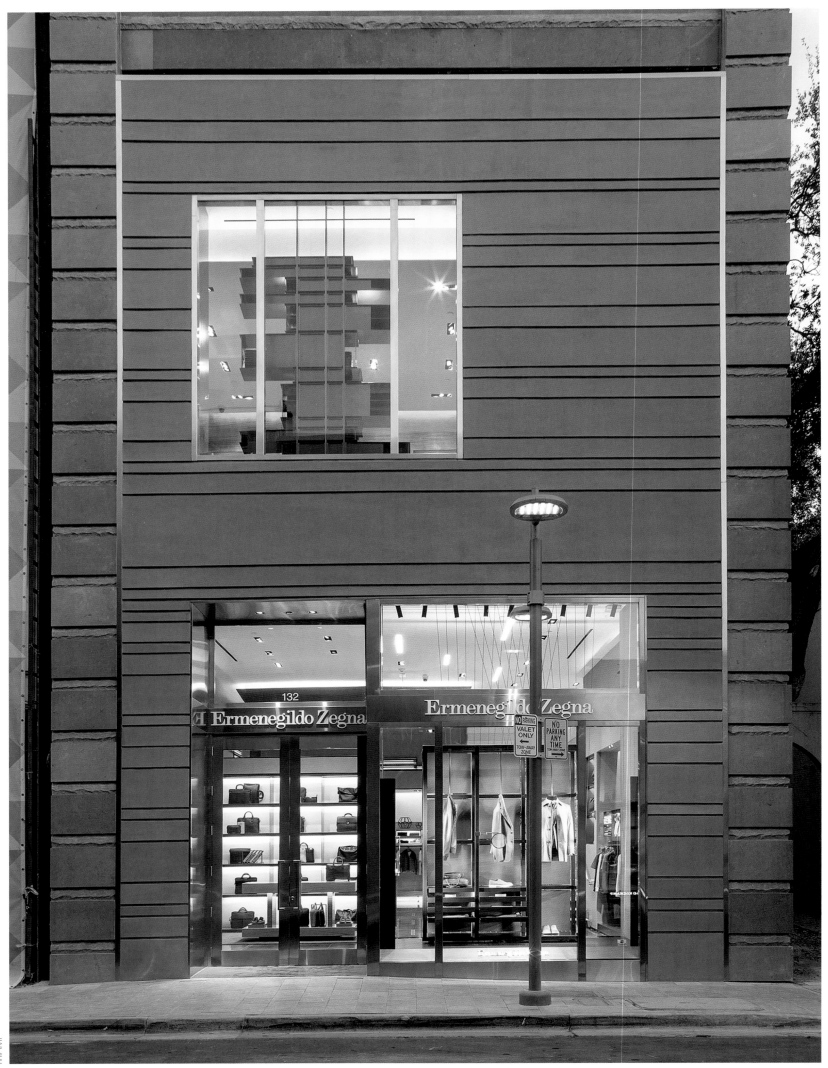

It could easily be the setting for a Grisham thriller. When even the façade branding makes a statement, you can say with confidence that the brand was consistently implemented throughout the architecture of the space. Peter Marino is the genius responsible for Ermenegildo Zegna's new store concept, and he translated the core values of the Italian luxury tailor into a clear interior language. A backlit monogram is the highlight of the Osaka store's façade. Inside, the elegance continues: satin finishes, polished woods, dark metallic tones and antique bronze create a luxurious and intimate atmosphere.

The Zegna store in the Miami Design District is also based on Marino's proposals. Zegna's roots lie in a woolen mill founded in 1910 in the Italian city of Trivero. Wires suspended in metal frames, rosewood, and mahogany hint at the industrial look of the weaving factory and give the store an artificial industrial charm. The company's ZegnArt initiative promotes artists by displaying their work in the many stores around the world. Again and again, the Italian luxury brand's ad campaigns connect understatement with urban city life. The focus is always on the product in its rawest form: the very finest textiles.

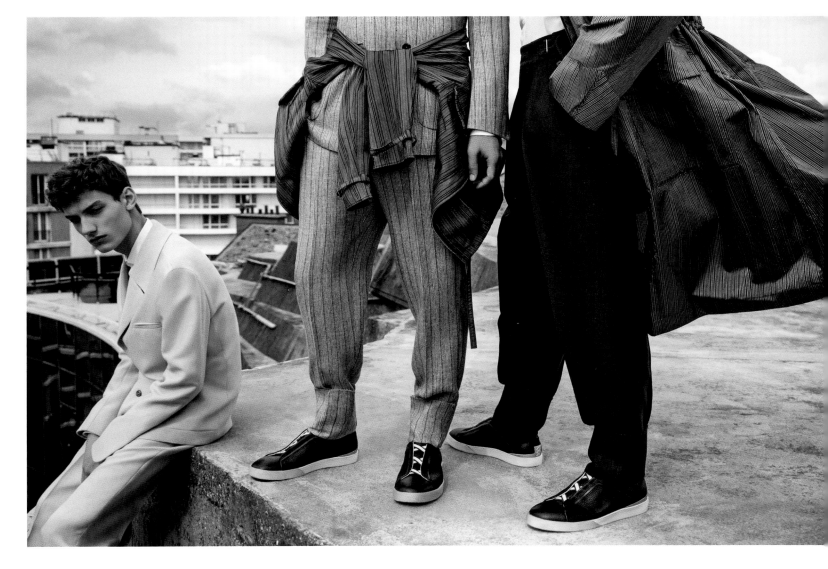

Es könnte auch das Setting für einen Wirt-schaftskrimi à la Grisham sein. Wenn bereits das Fassaden-Branding ein Statement ist, wurde Marke konsequent architektonisch umgesetzt. Peter Marino zeichnet für das neue Storekonzept von Ermenegildo Zegna verantwortlich und hat die Kernwerte des italienischen Luxusschneiders in eine klare Interieursprache übersetzt. Die Fassade des in Osaka eröffneten Stores kennzeichnet das hinterleuchtete Monogramm. Dahinter geht es edel weiter: satinierte Oberflächen, po-lierte Hölzer, dunkle Metalltöne und Antique-bronze kreieren eine luxuriöse und intime Atmosphäre.

Auch der Store im Miami Design District basiert auf den Entwürfen Marinos. Zegnas Wurzeln liegen in der 1910 gegründeten Wollfabrik im italienischen Trivero. In Metall-rahmen gespannte Drahtseile, Rosenholz und Mahagoni sind Reminiszenzen an den Industrielook der Weberei und geben dem Store einen artifiziellen Industriecharme. Mit der Initiative ZegnArt fördert die Marke Künst-ler, deren Werke weltweit in den Global Stores ausgestellt werden. Auch die Kampagnen der italienischen Luxusbrand verbinden im-mer wieder Understatement mit urbanem Stadtleben. Im Mittelpunkt steht das Produkt in seiner Urform: feinstes Tuch.

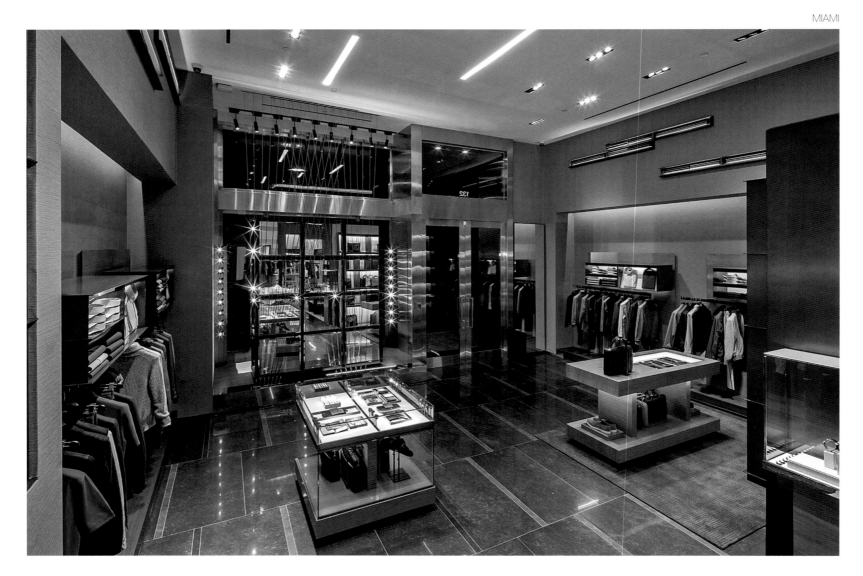

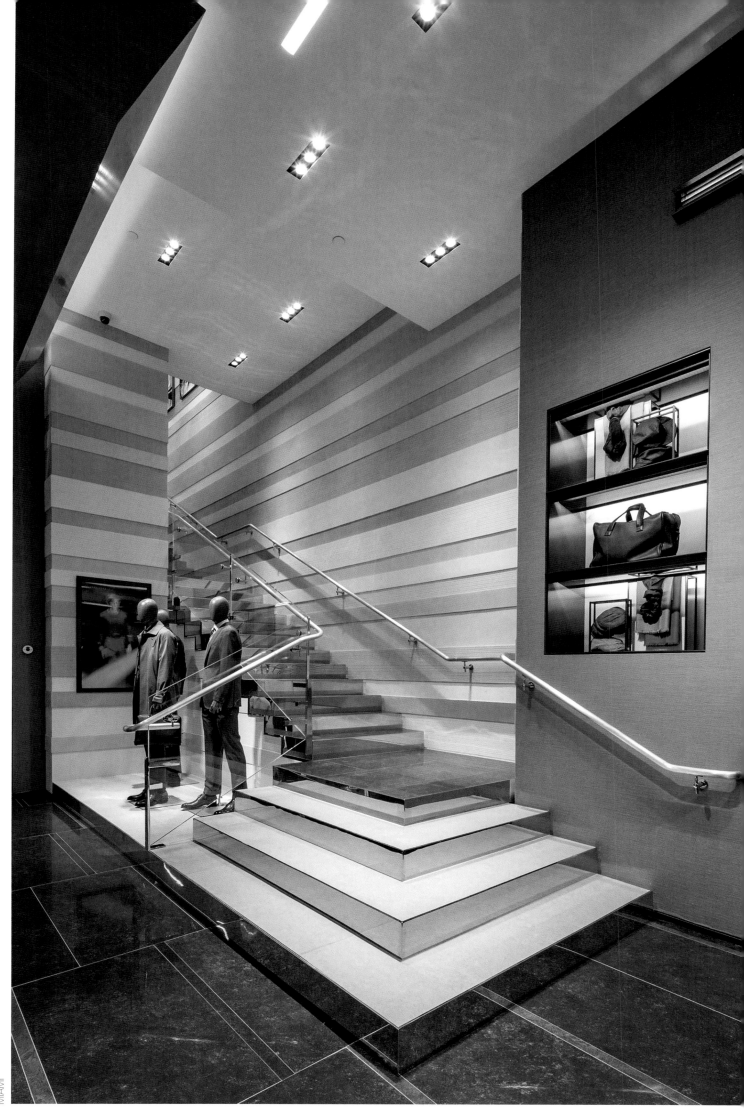

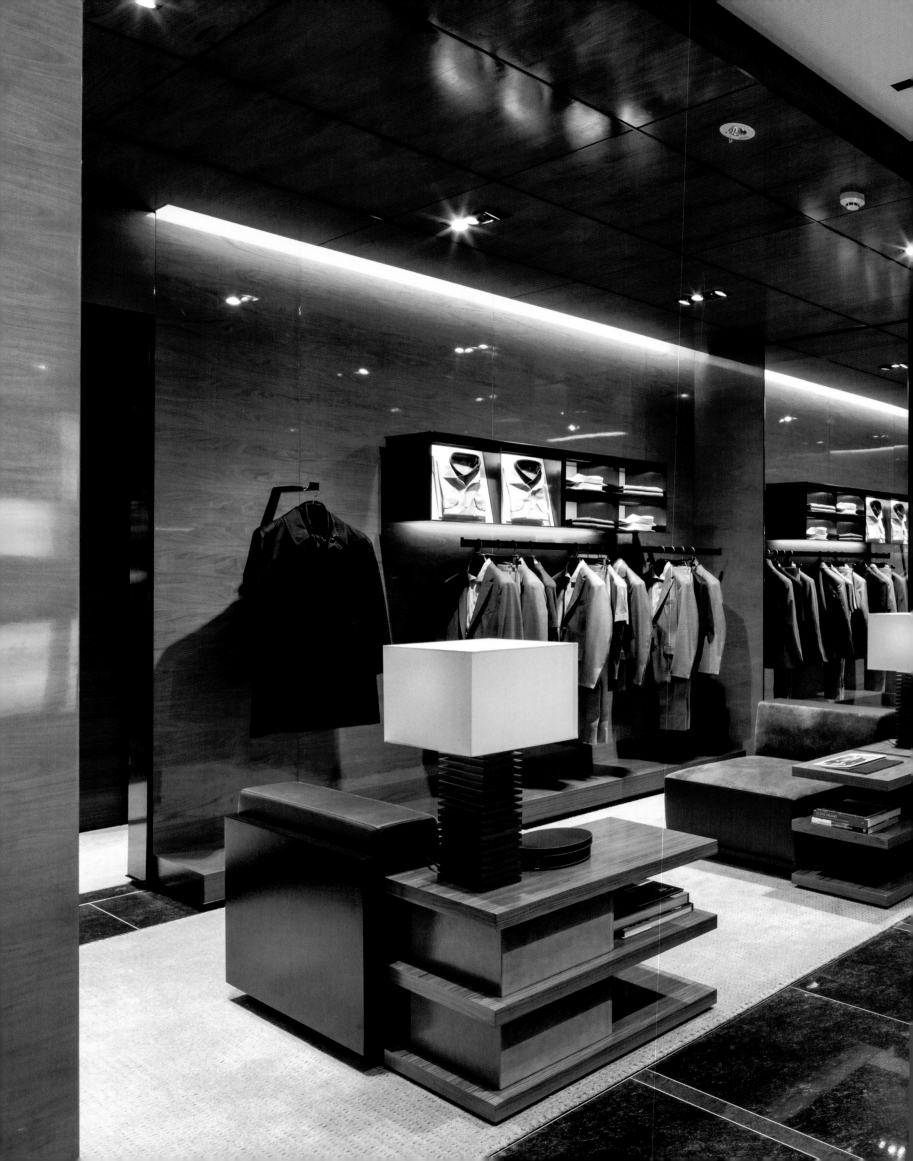

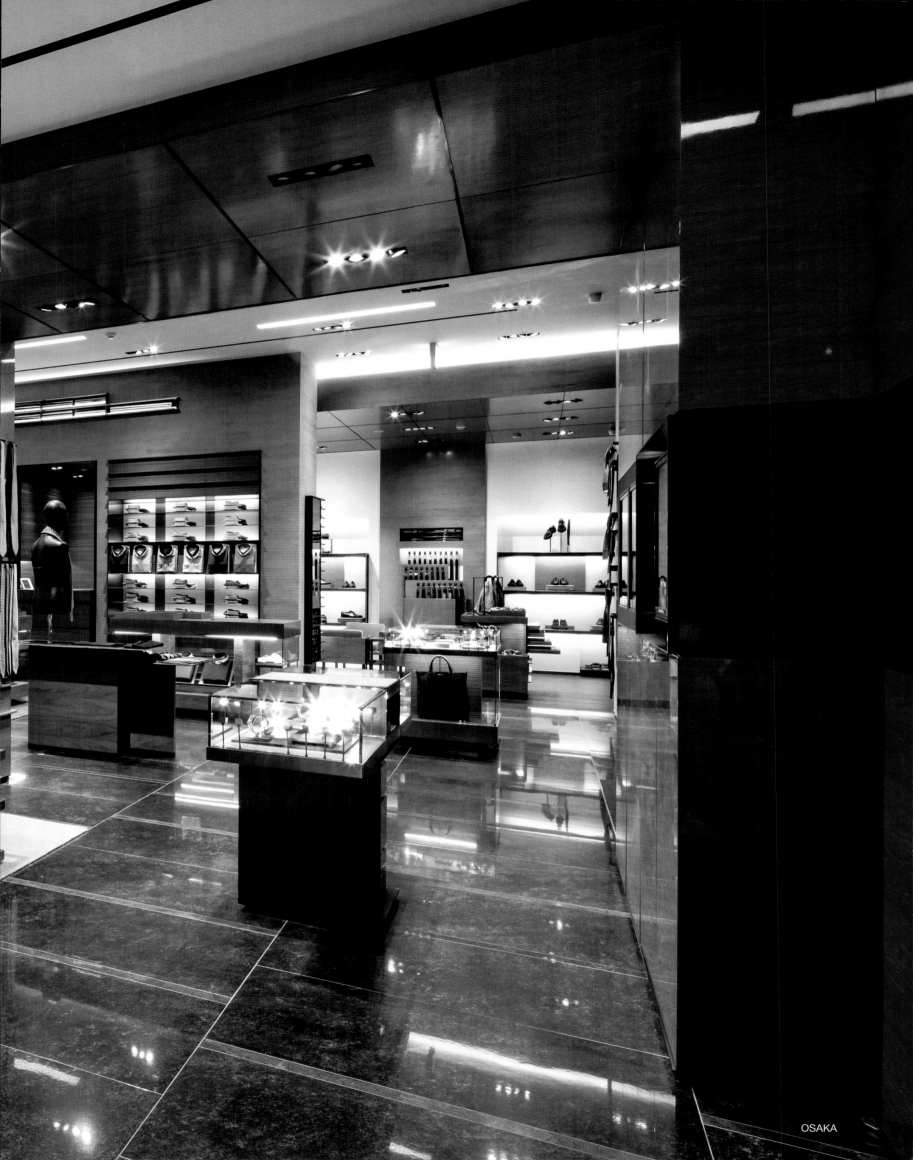

OSAKA

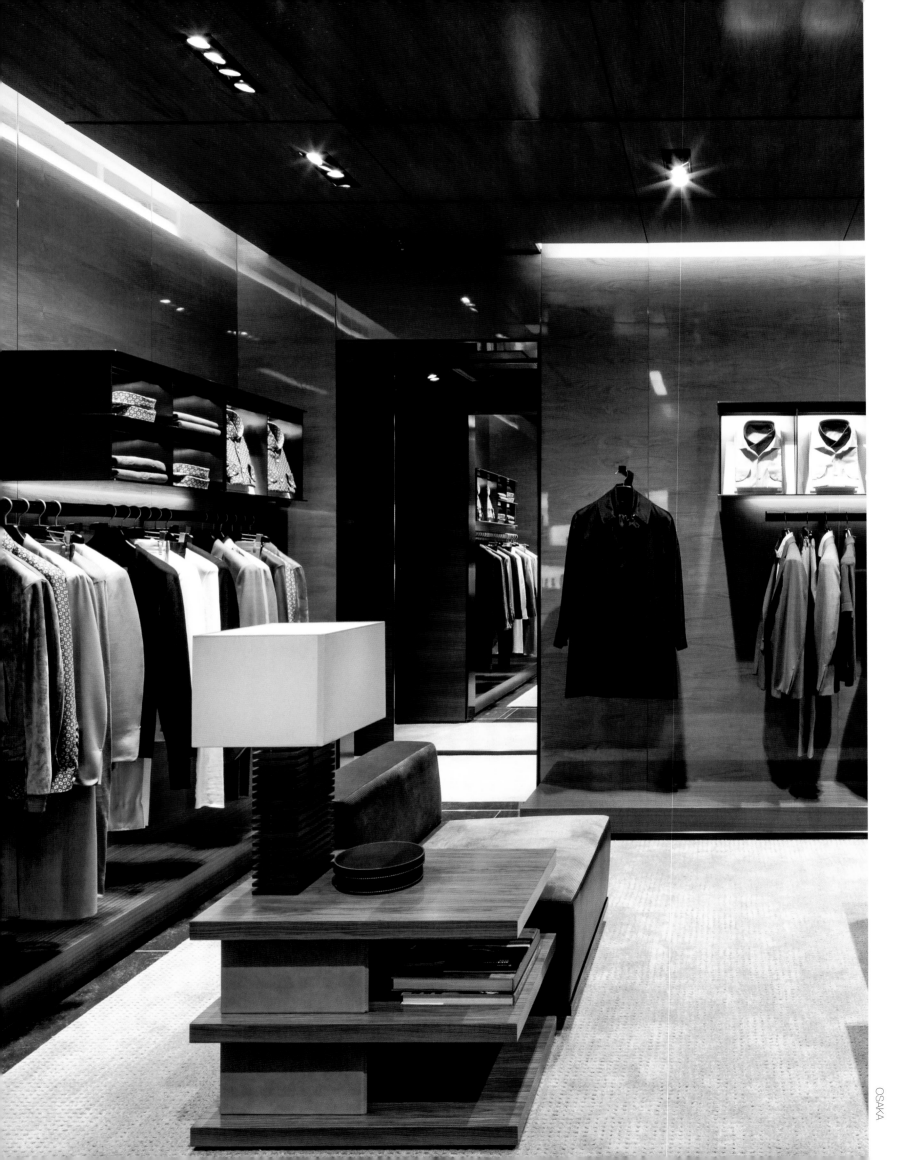

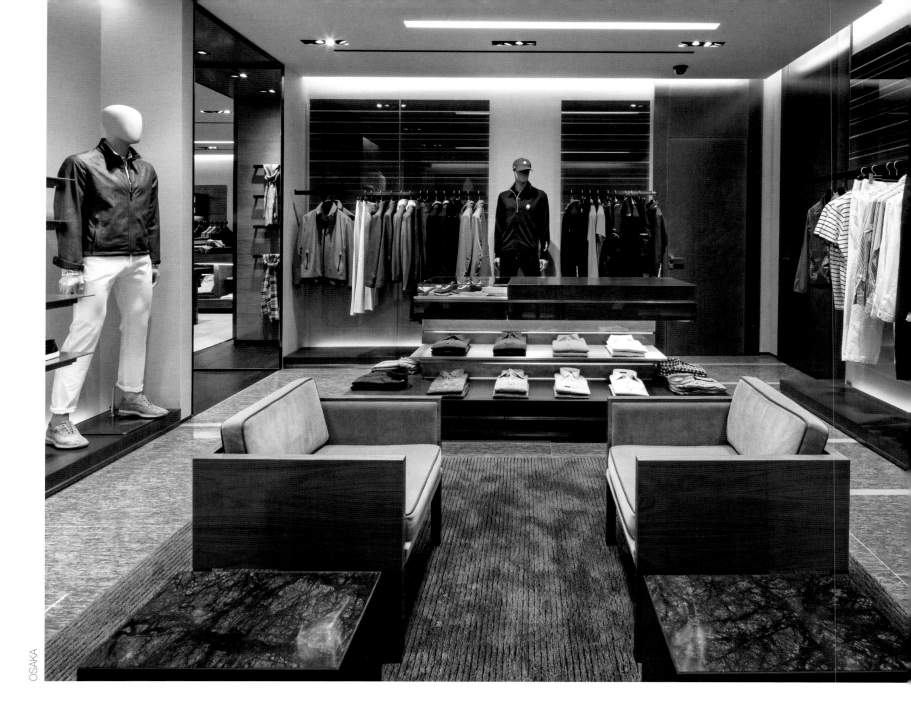

Cela pourrait également servir de cadre à un polar économique à la Grisham. Si le branding de la façade est déjà éloquent, l'architecture correspondante a bien été réalisée pour la marque. On doit le concept des boutiques d'Ermenegildo Zegna à Peter Marino qui a transposé les valeurs clés du couturier italien de luxe en un langage d'intérieur clair. La façade de la boutique qui a ouvert ses portes à Osaka se caractérise par le monogramme rétroéclairé. Ce qu'il y a derrière poursuit le raffinement : surfaces satinées, bois poli, tons métalliques foncés et bronzes antiques créent une atmosphère à la fois luxueuse et intime.

La boutique du District Design de Miami se base sur les conceptions de Marino. Les racines de Zegna remontent à la fabrique de laine créée en 1910 à Trivero, en Italie. Des fils de fer tendus dans un cadre métallique, du bois de rose et de l'acajou sont des réminiscences du style industriel des ateliers de tissage, et confèrent à la boutique son charme industriel artificiel. Avec l'initiative ZegnArt, la marque promeut des artistes dont les œuvres sont exposées dans les Global Stores du monde entier. Les campagnes menées par la marque de luxe italienne allient sobriété et style de vie urbaine. Au centre de l'attention : le produit dans sa forme originelle : le tissu le plus fin.

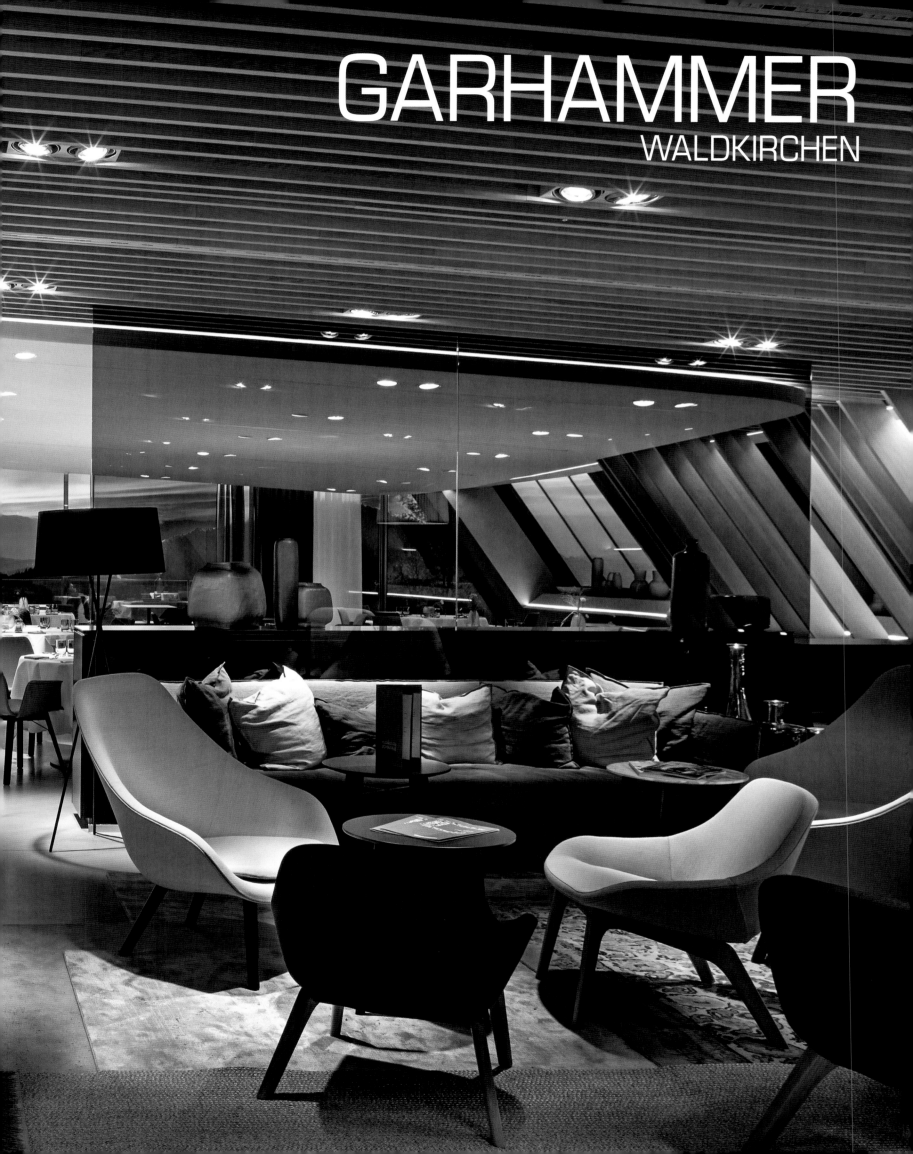

GARHAMMER

WALDKIRCHEN

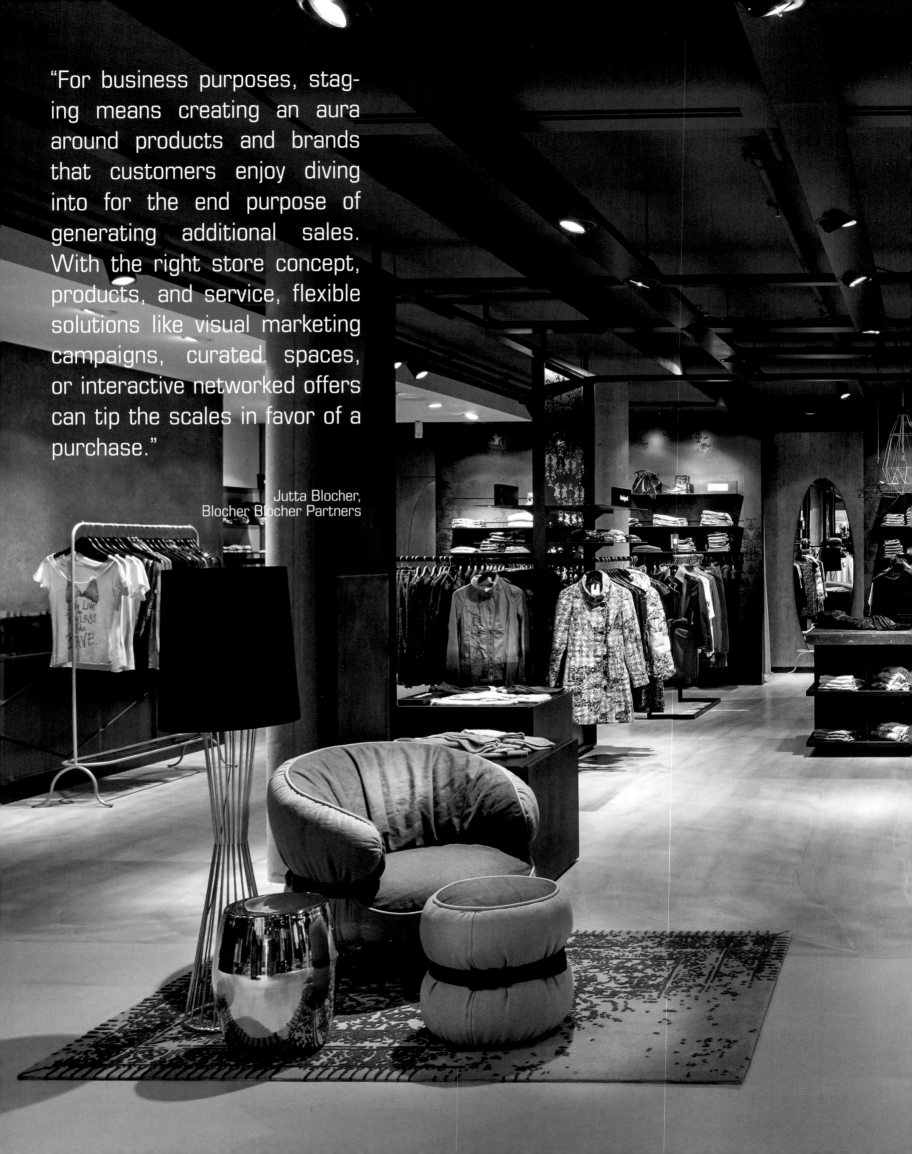

"For business purposes, staging means creating an aura around products and brands that customers enjoy diving into for the end purpose of generating additional sales. With the right store concept, products, and service, flexible solutions like visual marketing campaigns, curated spaces, or interactive networked offers can tip the scales in favor of a purchase."

Jutta Blocher,
Blocher Blocher Partners

DAVIDOFF

GENEVA

AND

BASEL

Davidoff CEO Hans-Kristian Hoejsgaard calls his branding strategy "democratic luxury," which essentially means that he wants to create an innovative brand that integrates traditional customer habits in new ways. It's not easy, but absolutely necessary to prevent a brand from sinking into the dust of its glorious past. Under the aegis of Hoejsgaard, the Swiss company has consistently followed a carefully balanced brand and product concept since 2011. The challenge: exciting long-term aficionados just as much as a younger and primarily female clientele while remaining credible as a brand—for cab drivers and businessmen, connoisseurs and Sunday smokers alike.

Tradition is the impetus for this transformation. It all began with tobacco dealer Zino Davidoff from Geneva. In 1970, Davidoff sold his shop, which flourished thanks to his enormous knowledge and great passion, to Max Oettinger AG in Basel. Zino stayed on as a brand ambassador, giving the brand identity and authenticity. After multiple international mergers and acquisitions, today's Oettinger Davidoff AG was formed. The latest coup for the cigar maker is the Churchill brand. The company spent two years refining Churchill's blend, aroma, and flavor as well as tweaking its market positioning and target demographic "to put a surprise on the family brand menu." Buoyed by the spirit of statesman and aristocrat Winston Churchill, his great-great-grandson Randolph now fills the role of the brand ambassador with verve.

The stores are inspiring hot spots where heritage and vision come together in a classic-modern ambiance, reflecting an openness that allays any nervousness people might have about coming inside. It is a high-end concept, Hoejsgaard emphasizes, but it is also about creating a comfortable and welcoming atmosphere. The large pictures on the walls are the result of a major art initiative the company has implemented to promote artists from the Caribbean. This elegantly bridges the gap between the product's origin and a luxurious self-image. Naturally, the Swiss company is also a sponsor of Art Basel—an excellent opportunity to win new customers.

The retail design, developed by Paris agency Stories, conveys luxury you can touch: high-end wood, warm natural colors and finely nuanced copper tones come together to make a reserved and elegant statement. Original details like the Ontwerpduo Light Forest lighting, which runs across the ceiling panel like a system of pipes, provide accents. The walk-in humidor in the Geneva flagship store has a canopy of tobacco leaves which are kept moist, allowing customers to experience the product in its raw form. The store at company headquarters in Basel is in a historic building with a view of the Rhine, where elegant club chic meets historical flair: original 20th century Lounge Chairs are paired with the classic Dezza Chair from Poltrona Frau. Albero shelving designed by Frattini for Poltrona Frau provides functional decoration, and glass lighting from Dechem Studio rounds out the interior. The message is working: the customer base has gotten much younger, Hoejsgaard notes, and for the 30 and up generation, the cigar is becoming an increasingly common lifestyle choice.

Davidoff-CEO Hans-Kristian Hoejsgaard bezeichnet seine Branding-Strategie als „demokratischen Luxus" und meint damit vor allem, dass eine innovative Marke geschaffen werden soll, die auf neuen Wegen tradierte Kundengewohnheiten integriert. Nicht ganz einfach, jedoch unbedingt notwendig, will eine Marke nicht im Staub der glanzvollen Vergangenheit versinken. Unter der Ägide von Hoejsgaard setzt das Schweizer Unternehmen seit 2011 konsequent ein sensibel austariertes Marken- und Produktkonzept um. Die Herausforderung: angestammte Aficionados ebenso zu begeistern wie ein jüngeres, vor allem auch weibliches Klientel und dabei als Marke glaubwürdig zu bleiben – für den Taxifahrer genauso wie für den Unternehmer, den Connaisseur, den Bieder- oder den Lebemann.

Taktgeber für den Wandel ist die Tradition. Alles begann mit dem Tabakhändler Zino Davidoff aus Genf, der 1970 sein etabliertes, durch seine enorme Kenntnis und große Passion geprägtes Fachgeschäft für Tabakwaren an die Max Oettinger AG in Basel verkaufte. Zino blieb dem Unternehmen als Markenbotschafter erhalten und schuf so Identität und Glaubwürdigkeit. Diverse internationale Fusionen und Unternehmenszukäufe später formierte sich die heutige Oettinger Davidoff AG. Neuester Coup des Zigarrenhauses ist die Marke Churchill. Zwei Jahre habe man an Blend, Aroma und Flavour gearbeitet. Ebenso lang an der Markt- und Zielgruppenpositionierung, „um daraus eine Überraschung in der Menükarte der Markenfamilie zu machen". Getragen vom Geist des Staatsmanns und Aristokraten Winston Churchill füllt nun dessen Ururenkel Randolph mit Verve die Rolle des Markenbotschafters aus.

Die Stores sind inspirative Hotspots – hier verbinden sich Heritage und Vision in klassisch-modernem Ambiente, spiegeln Offenheit, wollen Schwellenangst nehmen. Es gehe dabei schon um High End, betont Hoejsgaard. Aber eben auch um die Schaffung einer Wohlfühl- und Willkommensatmosphäre. Die großflächigen Bilder an den Wänden sind Ausdruck einer breit angelegten Kunstinitiative des Unternehmens, mit der Künstler karibischer Herkunft gefördert werden. So wird elegant der Bogen zwischen Produktursprung und luxuriösem Selbstverständnis geschlagen. Natürlich sind die Schweizer auch Sponsor der Art Basel – eine große Chance, viele Kunden abzuholen.

Das Retaildesign soll Luxus zum Anfassen transportieren. Entwickelt hat es die Pariser Agentur Stories: Edle Hölzer, warme Naturfarben sowie fein nuancierte Kupfertöne fügen sich zu einer zurückhaltenden und dabei eleganten Formensprache. Originelle Details wie die Leuchten Light Forest von Ontwerpduo, die gleich einem Rohrsystem über das Deckensegel laufen, setzen Akzente. Der begehbare Humidor im Genfer Flagship Store hat einen Himmel aus stets befeuchteten Tabakblättern, die das Produkt in seiner Urform erlebbar machen. Der Store am Stammsitz in Basel befindet sich in einem historischen Gebäude mit Blick über den Rhein. Hier herrscht edler Club-Chic mit historischem Flair: Original Lounge Chairs aus den 20. Jahrhundert werden mit dem Klassiker Dezza Chair von Poltrona Frau kombiniert. Funktionale Dekoration bietet das Regal Albero von Frattini. Die gläsernen Leuchtelemente von Dechem Studio krönen das Interieur. Die Botschaft kommt an: Die Kundschaft habe sich deutlich verjüngt, bemerkt Hoejsgaard, für die Generation 30 plus gehöre die Zigarre immer mehr zum Lifestyle-Repertoire.

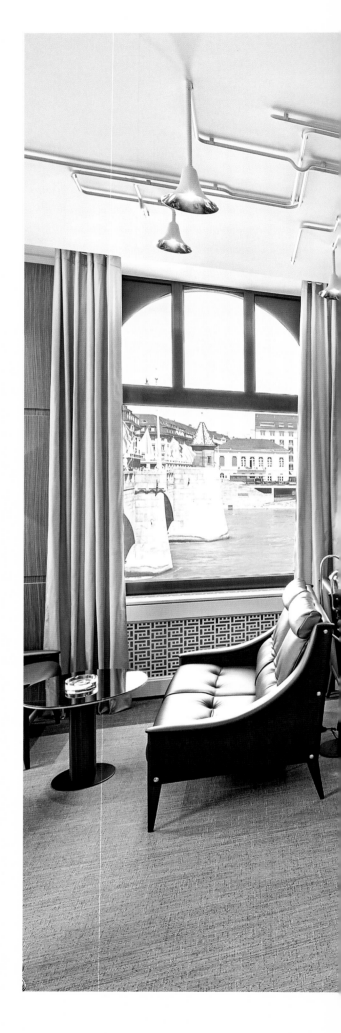

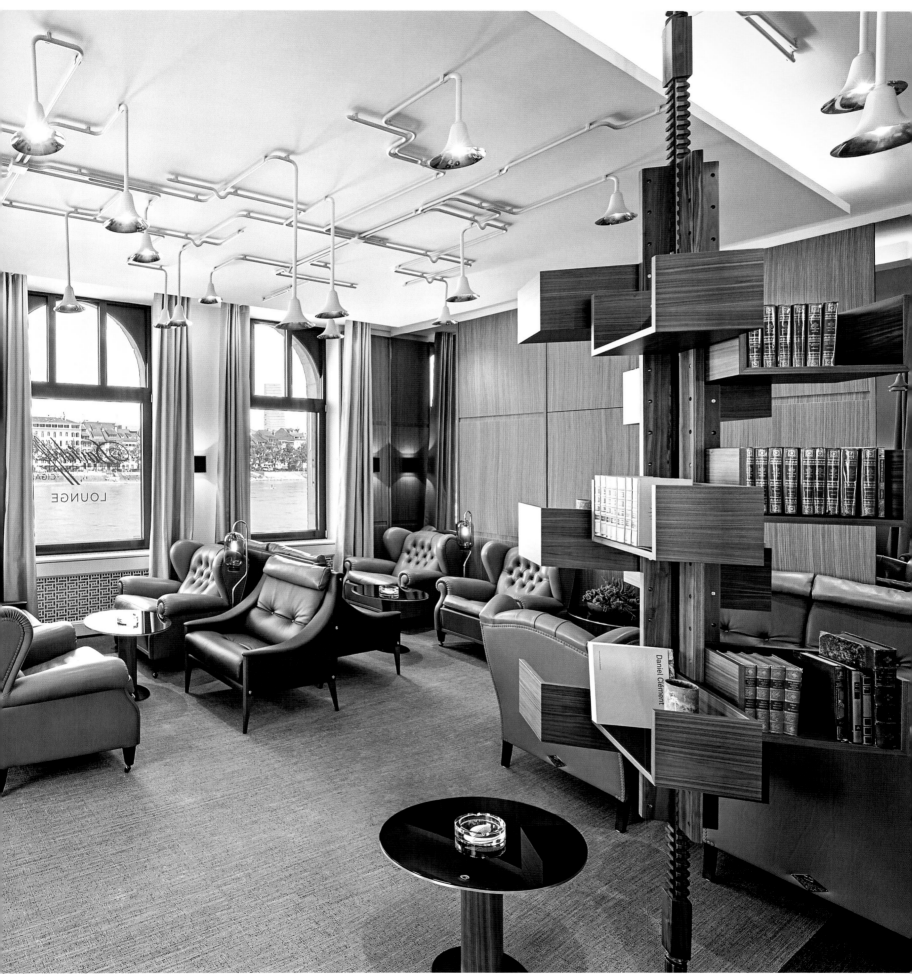

Hans-Kristian Hoejsgaard, le PDG de Davidoff, qualifie sa stratégie de branding de « luxe démocratique », exprimant par là le fait qu'il souhaite créer une marque innovante intégrant au moyen de nouvelles méthodes les habitudes des clients qui se sont imposées avec le temps. Pas si simple, et pourtant absolument indispensable si une marque ne souhaite pas s'embourber dans la poussière d'un passé brillant mais révolu. Sous l'égide d'Hoejsgaard, l'entreprise suisse applique depuis 2011 un concept de produits et de marque à l'équilibre parfait. Le défi : séduire aussi bien les aficionados de longue date qu'une clientèle plus jeune et principalement féminine tout en conservant sa crédibilité en tant que marque ; c'est-à-dire cibler le chauffeur de taxi tout comme l'entrepreneur, le connaisseur, Monsieur tout-le-monde ou le bon vivant.

Le moteur du changement, c'est la tradition. Tout a commencé avec Zino Davidoff, négociant en tabac à Genève, qui, en 1970, vendit à la société Max Oettinger AG de Bâle son commerce de tabac, qui se caractérisait par ses immenses connaissances dans le domaine ainsi que par la passion qu'il véhiculait. Zino resta dans l'entreprise en tant qu'ambassadeur de la marque, créant ainsi l'identité et la crédibilité de cette dernière. Après diverses fusions internationales et rachats d'entreprises, l'entreprise reçut son nom actuel, Oettinger Davidoff AG. Le dernier coup de cette maison de cigares est la marque Churchill. L'élaboration du mélange, de l'arôme et du goût a pris deux ans, tout comme celle du positionnement sur le marché et par rapport au groupe cible, « afin de créer l'effet de surprise dans la carte des menus de la famille de marques ». S'appuyant sur l'esprit de l'homme d'État et aristocrate Winston Churchill, c'est désormais son arrière-petit-fils Randolf qui joue avec brio le rôle de l'ambassadeur de la marque. Les boutiques sont des points névralgiques très inspirants : c'est là que s'allient héritage et vision en une ambiance classico-moderne visant à refléter

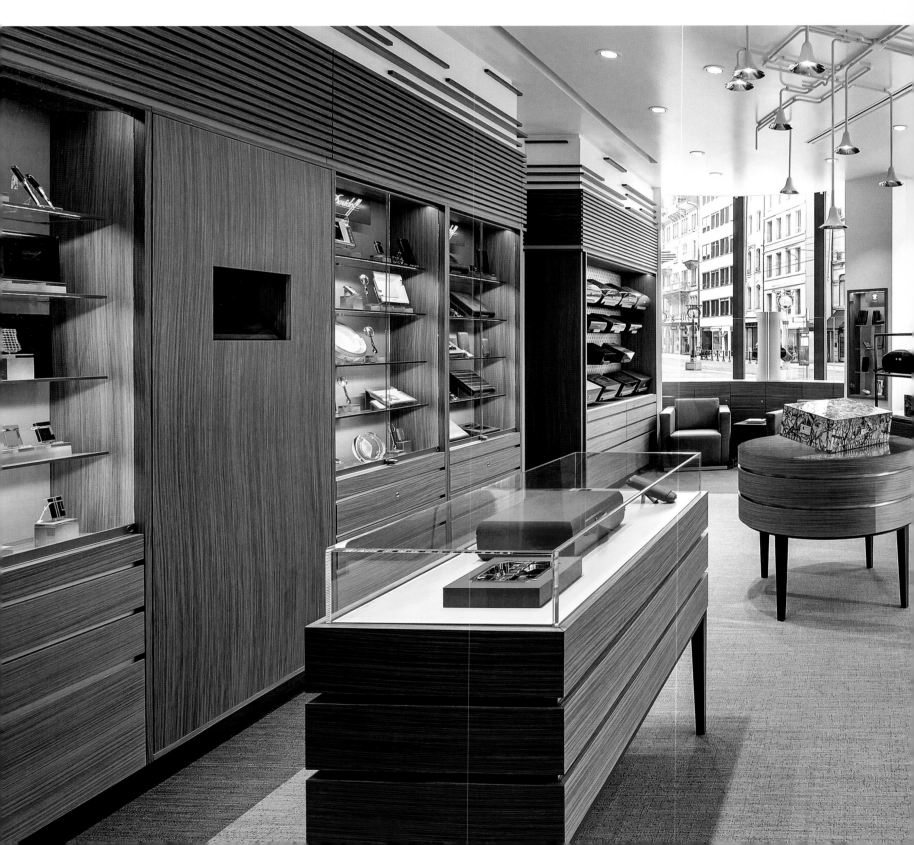

l'ouverture aux autres et à aider à surmonter les réticences. Hoejsgaard souligne qu'il s'agit d'un segment haut de gamme. Mais également de la création d'une atmosphère de bien-être et d'hospitalité. Les grands tableaux affichés aux murs sont l'expression d'une initiative artistique de grande envergure lancée par l'entrepreneur et ayant pour objet la promotion d'artistes d'origine caribéenne. C'est donc avec élégance que la marque allie l'origine des produits à un luxe évident. Bien entendu, les Suisses sont également sponsors d'Art Basel : une opportunité permettant de conquérir de nombreux clients. Conçu par l'agence parisienne Stories, le design des boutiques a pour objectif de rendre le luxe saisissable : bois raffinés, couleurs naturelles chaudes et dégradés de tons cuivrés se marient pour délivrer un langage visuel à la fois discret et élégant. Des détails originaux tels que les lampes Light Forest d'Ontwerpduo, qui parcourent le plafond suspendu telles un système de tuyauterie, donnent le ton. L'humidor praticable du magasin vedette, installé à Genève, est doté d'un ciel de feuilles de tabac toujours humidifiées, qui permettent de faire l'expérience du produit sous sa forme d'origine. Le magasin du siège, à Bâle, est installé dans un bâtiment d'époque avec vue sur le Rhin. Il y règne une ambiance de club chic au cachet historique. Des fauteuils Lounge Chair d'origine, datant du XXe siècle, sont combinés au produit classique Dezza Chair de Poltrona Frau. La décoration fonctionnelle est assurée par l'étagère Albero de Frattini. Les luminaires en verre, de Dechem Studio, décorent l'intérieur. Le message est délivré : la clientèle se serait considérablement rajeunie, note Hoejsgaard, et le cigare ferait de plus en plus partie du style de vie de la génération des 30 ans et plus.

GENEVA

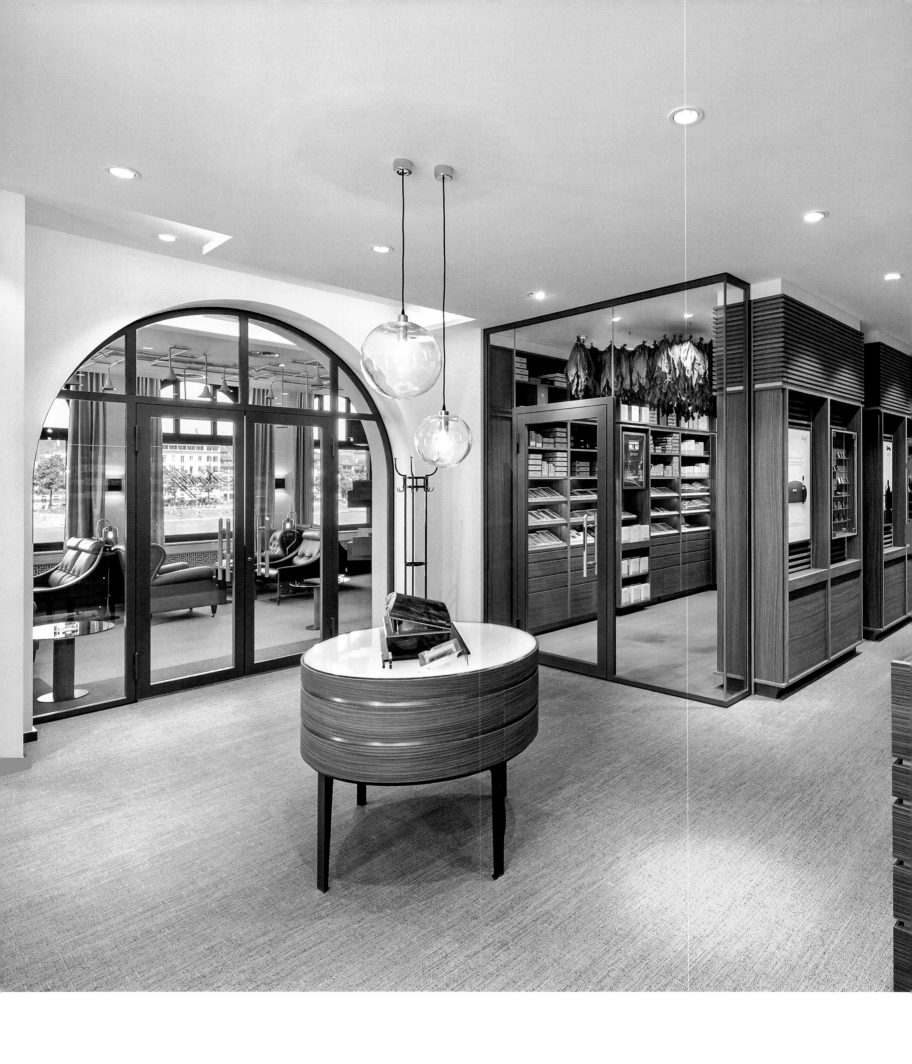

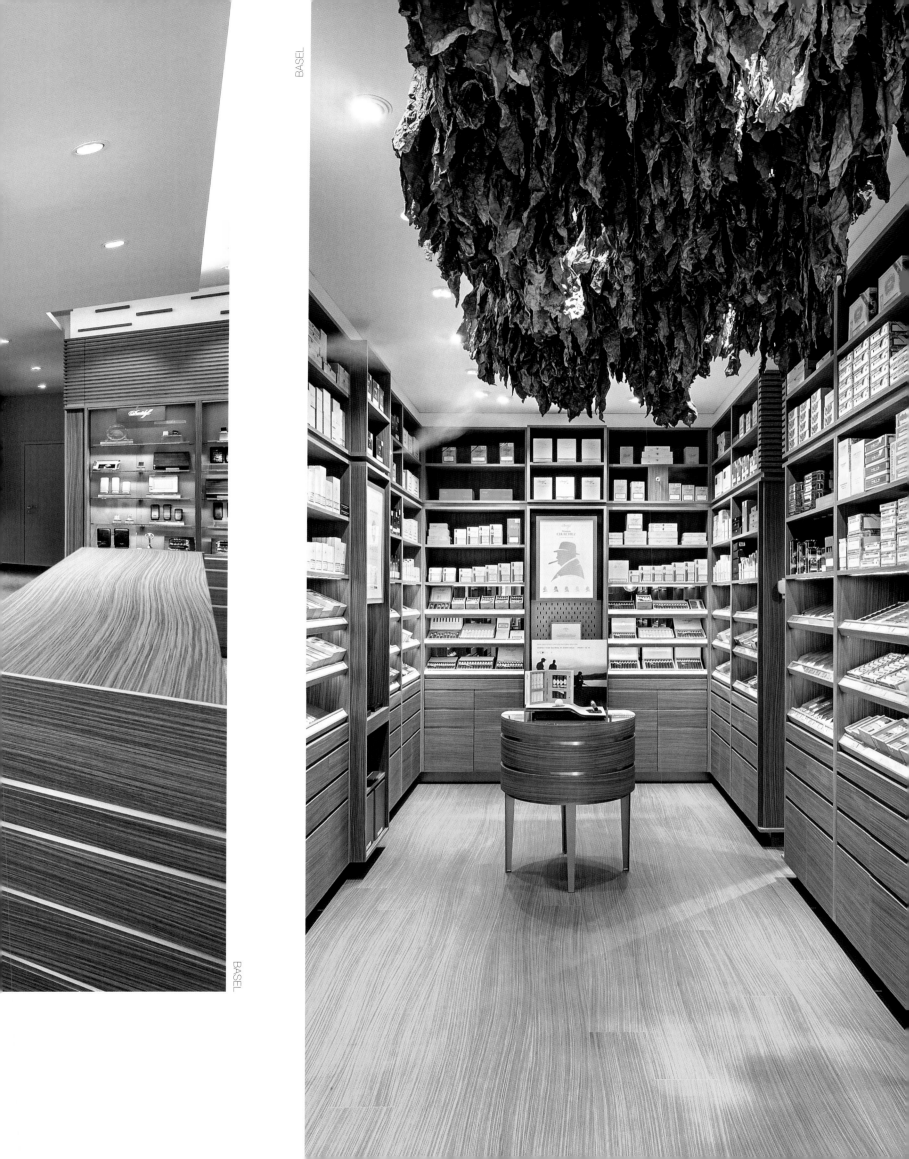

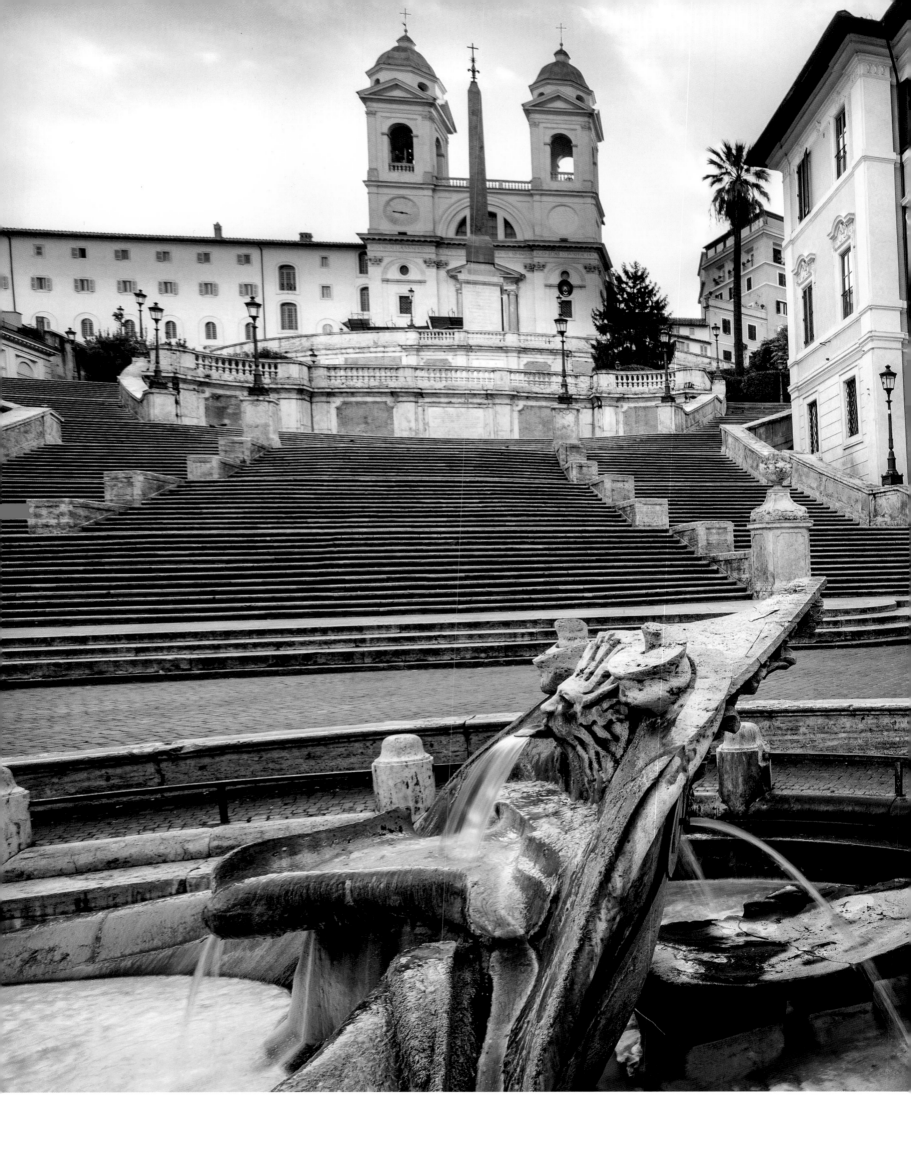

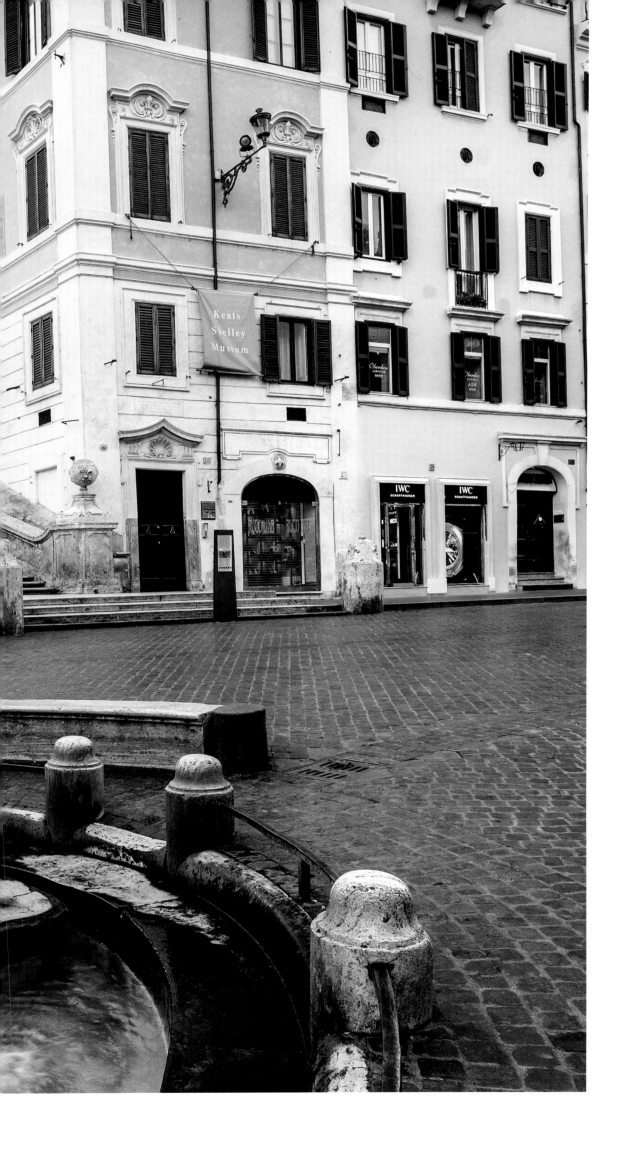

IWC

SCHAFFHAUSEN
ROME

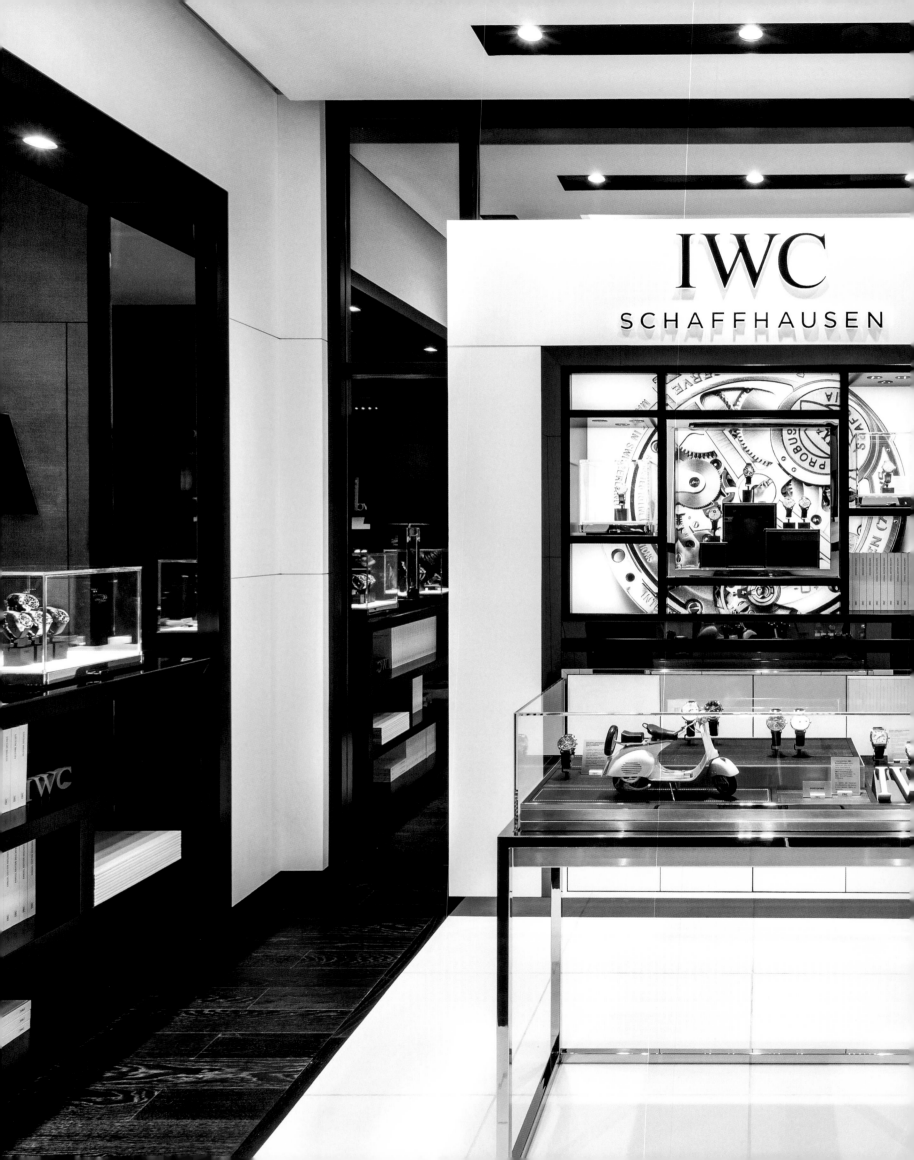

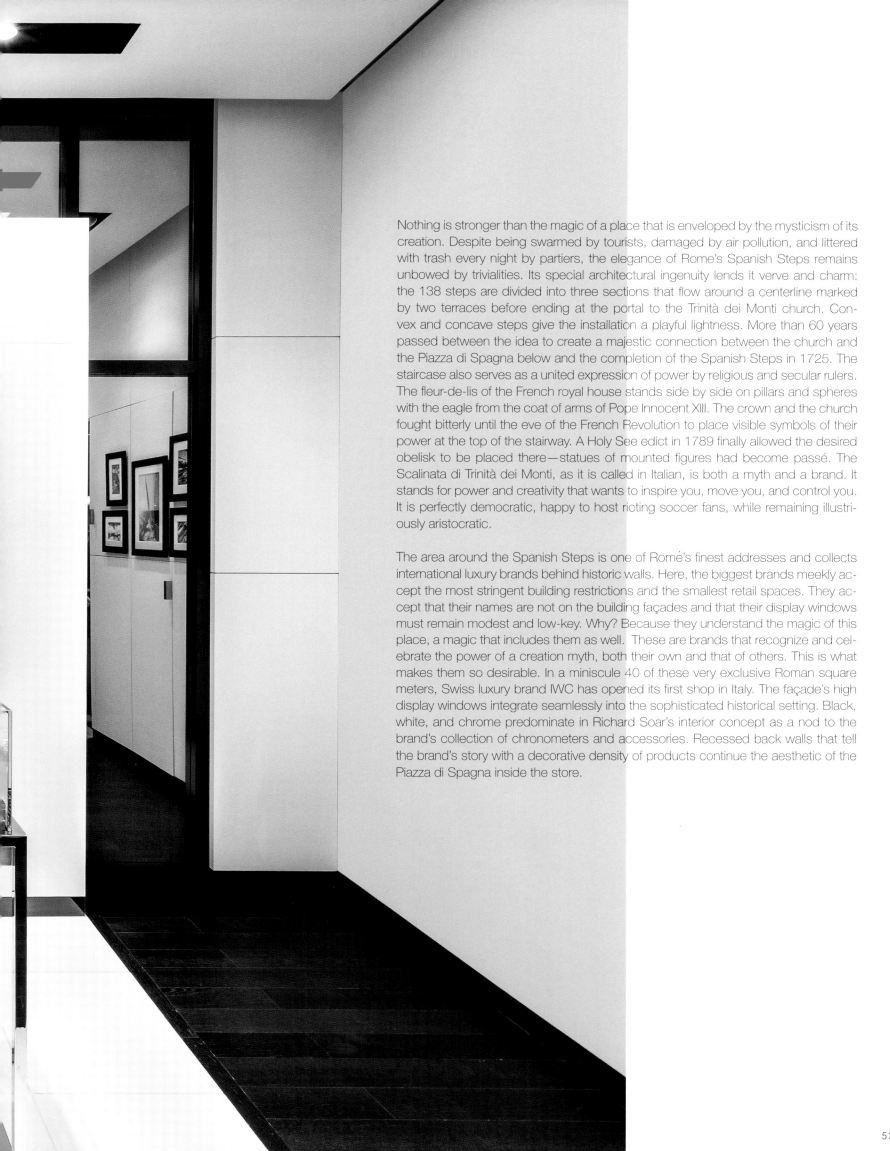

Nothing is stronger than the magic of a place that is enveloped by the mysticism of its creation. Despite being swarmed by tourists, damaged by air pollution, and littered with trash every night by partiers, the elegance of Rome's Spanish Steps remains unbowed by trivialities. Its special architectural ingenuity lends it verve and charm: the 138 steps are divided into three sections that flow around a centerline marked by two terraces before ending at the portal to the Trinità dei Monti church. Convex and concave steps give the installation a playful lightness. More than 60 years passed between the idea to create a majestic connection between the church and the Piazza di Spagna below and the completion of the Spanish Steps in 1725. The staircase also serves as a united expression of power by religious and secular rulers. The fleur-de-lis of the French royal house stands side by side on pillars and spheres with the eagle from the coat of arms of Pope Innocent XIII. The crown and the church fought bitterly until the eve of the French Revolution to place visible symbols of their power at the top of the stairway. A Holy See edict in 1789 finally allowed the desired obelisk to be placed there—statues of mounted figures had become passé. The Scalinata di Trinità dei Monti, as it is called in Italian, is both a myth and a brand. It stands for power and creativity that wants to inspire you, move you, and control you. It is perfectly democratic, happy to host rioting soccer fans, while remaining illustriously aristocratic.

The area around the Spanish Steps is one of Rome's finest addresses and collects international luxury brands behind historic walls. Here, the biggest brands meekly accept the most stringent building restrictions and the smallest retail spaces. They accept that their names are not on the building façades and that their display windows must remain modest and low-key. Why? Because they understand the magic of this place, a magic that includes them as well. These are brands that recognize and celebrate the power of a creation myth, both their own and that of others. This is what makes them so desirable. In a miniscule 40 of these very exclusive Roman square meters, Swiss luxury brand IWC has opened its first shop in Italy. The façade's high display windows integrate seamlessly into the sophisticated historical setting. Black, white, and chrome predominate in Richard Soar's interior concept as a nod to the brand's collection of chronometers and accessories. Recessed back walls that tell the brand's story with a decorative density of products continue the aesthetic of the Piazza di Spagna inside the store.

Nichts ist stärker als die Magie eines Ortes, den die Mystik seiner Entstehung umhüllt. Touristenbevölkert, luftverschmutzt und allabendlich mit den Resten der Spaßgesellschaft übersät, trotzt die Eleganz der Spanischen Treppe in Rom jeder Trivialität. Es ist die besondere architektonische Raffinesse, die ihr Schwung und Charme verleiht: Die 138 Stufen der dreigeteilten Treppe fließen um eine Mittelachse, die durch zwei Terrassen markiert ist, um schließlich vor dem Portal der Kirche Trinità dei Monti zu enden. Konvex oder konkav angelegte Stufen geben dem Bauwerk verspielte Leichtigkeit. Über 60 Jahre dauerte es von der Idee, den unbefestigten Abhang zwischen der Kirche und der tiefer liegenden Piazza di Spagna majestätisch zu verbinden, bis zur Fertigstellung 1725. Die Treppe vereint zudem den Machtgestus klerikaler und weltlicher Herrscher: Die Lilien des französischen Königshauses finden sich neben dem Adler als Wappentier von Papst Innozenz XIII. auf Pfeilern und Kugeln. Erbittert stritten Krone und Kirche bis zum Vorabend der Französischen Revolution um sichtbare Insignien der Macht am Abschluss der Treppe. Erst 1789 konnte dort auf Geheiß des Heiligen Stuhls endlich der ersehnte Obelisk platziert werden – die Zeit der Reiterdenkmäler war passé. Die Scalinata di Trinità dei Monti (so der italienische Name) ist Mythos und Marke zugleich. Sie steht für Macht und Kreativität, will begeistern, berühren und herrschen. Sie zeigt sich demokratisch – lässt gelassen randalierende Fußballfans zu – und bleibt dabei erhaben aristokratisch.

Die Umgebung der Spanischen Treppe zählt zu den feinsten Adressen Roms und versammelt internationale Luxus-Brands hinter historischen Mauern. Hier lassen sich die ganz großen Marken strengste Bauauflagen bei kleinster Verkaufsfläche gefallen. Nehmen hin, dass ihr Name nicht auf Fassaden erscheint und Schaufenster nur sehr dezent gestaltet werden dürfen. Weil sie um den Zauber des Standorts wissen, der auch auf sie abstrahlt. Es sind Marken, die die Kraft eines Gründungsmythos erkennen und ihn zelebrieren. Ihren eigenen genauso wie den der anderen. Das macht sie so begehrt. Auf gerade mal 40 dieser exklusiven römischen Quadratmeter befindet sich der erste Store der Schweizer Luxusmarke IWC in Italien. Elegant fügt sich die Fassade mit ihren hohen Schaufenstern in das mondäne historische Setting. In dem von Richard Soar verantworteten Interieur-Konzept dominieren Schwarz, Weiß und Chrom in Anlehnung an die Chronometer und Accessoires-Kollektion. Eingelassene Rückwände, in denen die Markengeschichte in dekorativer Produktdichte erzählt wird, setzen die Ästhetik der Piazza di Spagna im Inneren fort.

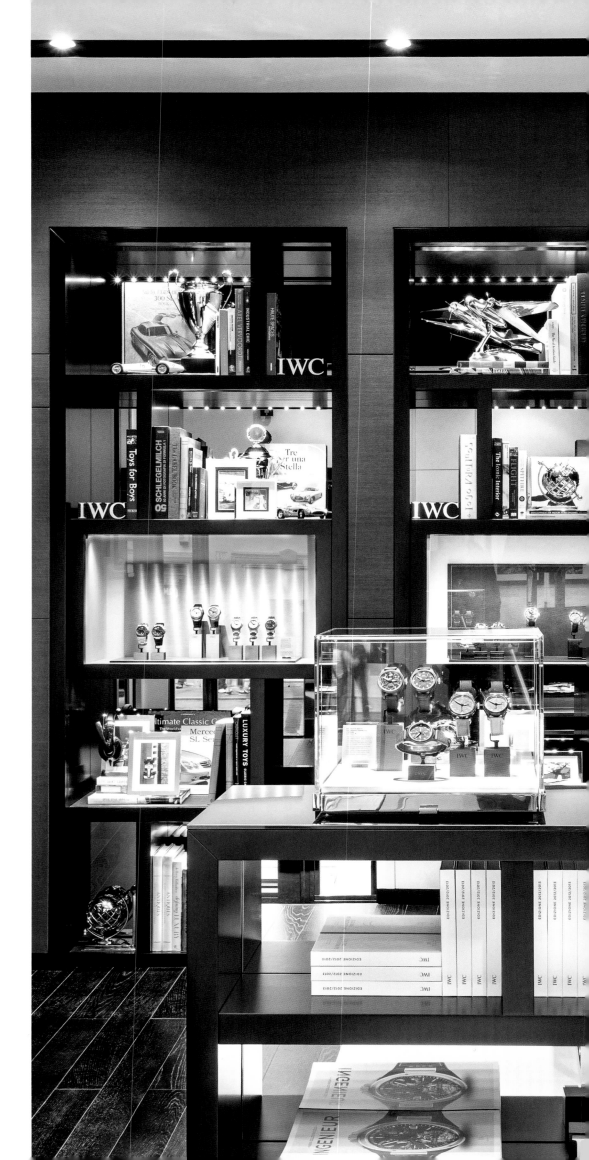

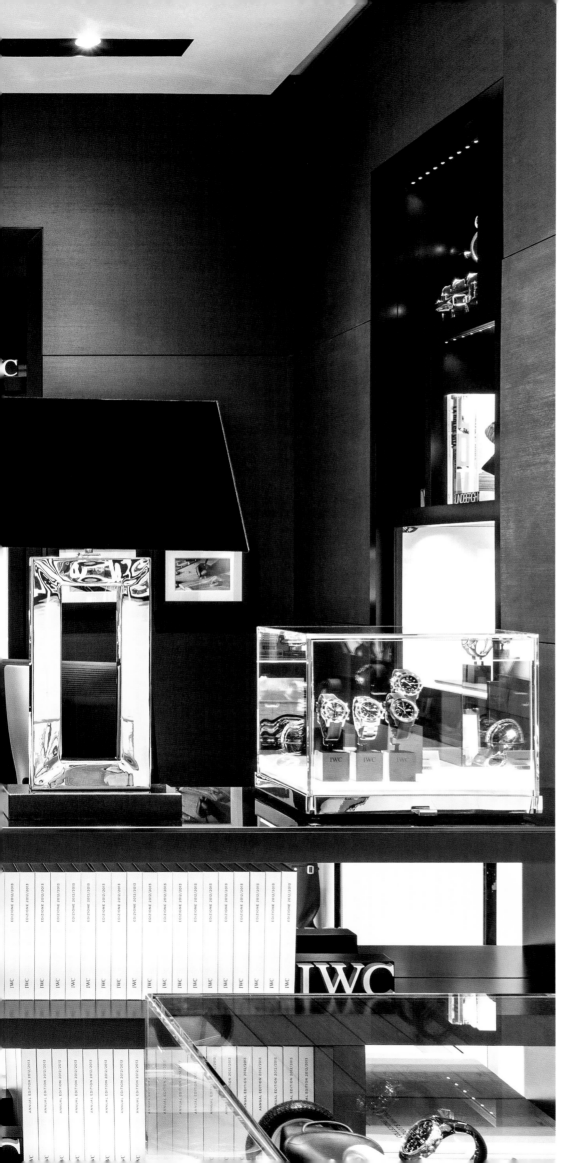

Rien n'est plus fort que la magie d'un lieu enveloppé par le côté mystique de sa naissance. Envahi de touristes, pollué et recouvert tous les soirs des restes laissés par les badauds, l'élégant et monumental escalier de la Trinité-des-Monts résiste à toutes les trivialités. C'est son raffinement architectural si particulier qui lui confère son élan et son charme : Les 138 marches de l'escalier, réparties en trois paliers, s'écoulent autour d'un axe central marqué par deux terrasses, pour enfin se terminer face à la porte de l'Église Trinité-des-Monts. Les marches, convexes ou concaves, confèrent à l'ouvrage une légèreté enjouée. Il fallut plus de 60 ans entre le moment où fut formulée l'idée de relier la pente située entre l'église et la Place d'Espagne, en contrebas, et le moment où cela fut réalisé, en 1725. Par ailleurs, les escaliers réunissent les symboles de puissance des souverains cléricaux et des souverains séculaires. Les lys de la famille royale française décorent, aux côtés de l'aigle qui est l'emblème du Pape Innocent XIII, les flèches et les sphères. La Couronne et l'Église se livrèrent une querelle acharnée jusqu'à la veille de la Révolution Française au sujet de l'ajout de symboles de puissance à l'extrémité des escaliers. Ce ne fut qu'en 1789 que l'obélisque put être installé, sur l'ordre du Saint Siège : l'époque des monuments à la gloire des chevaliers était révolue. La Scalinata di Trinità dei Monti, comme l'appellent les Italiens, est à la fois un mythe et une marque. Elle représente la puissance et la créativité, et a pour objet de passionner, d'émouvoir et de dominer. Elle se montre démocratique, laisse, tranquille, agir les hooligans, et reste pourtant tout autant aristocratique.

Les abords de l'escalier monumental comptent parmi les adresses les plus raffinées de Rome, réunissant derrière des murs d'époque nombre de marques de luxe à la renommée internationale. Ici, les marques les plus célèbres se soumettent aux règles de construction les plus strictes, pour des surfaces de vente des plus limitées. Elles acceptent que leur nom n'apparaisse pas sur leurs façades ; leurs vitrines ne peuvent être agencées que dans la plus grande sobriété. Car elles respectent la magie des lieux, qui rayonne jusqu'à elles. Il s'agit de marques qui reconnaissent la force du mythe fondateur et qui le célèbrent. Le leur aussi bien que celui des autres. Ainsi, la puissance est désirable. C'est sur tout juste 40 mètres carrés de cet espace romain si exclusif que se trouve la première boutique italienne de la marque de luxe suisse IWC. Avec ses hautes vitrines, la façade s'intègre en toute élégance dans le cadre mondain d'époque. L'agencement intérieur conçu par Richard Soar est dominé par le noir, le blanc et le chrome, et fait une allusion à la collection de chronomètres et aux accessoires. Des panneaux arrières intégrés, sur lesquels est racontée l'histoire de la marque, poursuivent l'esthétique de la Place d'Espagne.

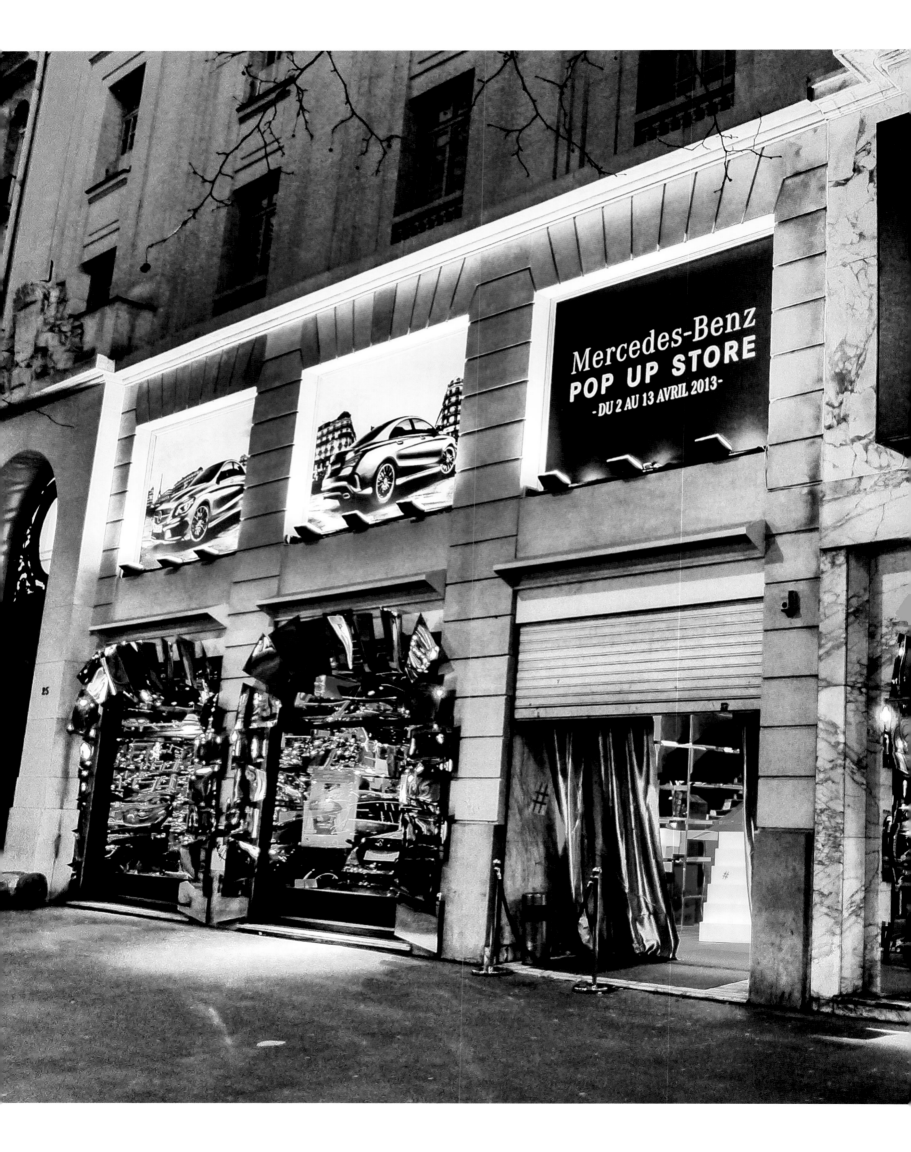

MERCEDES

"How do you bring opposites to-gether? Mercedes is a progres-sive company that remains true to tradition. I find that thrilling. We want to make the customer jour-ney more exciting."

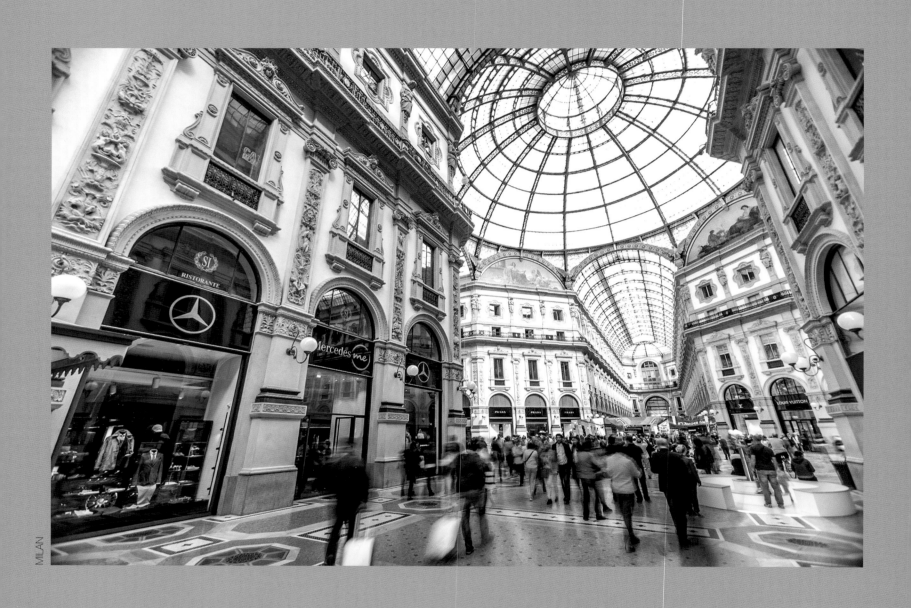

MILAN

What makes car dealerships sexy?
Was macht das Autohaus sexy?

"Our Mercedes me stores are a highly evolved version of our classic downtown showrooms: approachable and exclusive. The focus is more on the comprehensive brand—the whole world of Mercedes—than on the product itself. However, pop-up stores, pavilion concepts, and roadshows can also fill this role. It's about a different way of leading the customer to the brand and what Mercedes-Benz has to offer. In a much more relaxed way than in a traditional showroom and with less focus on closing a deal, people can come into contact with Mercedes Benz in their day-to-day lives. Food plays a special role here, as do events like art show openings and fashion shows. For example, we've already done a few events related to the FIFA World Cup at our Mercedes me store in Hamburg. The store can incorporate whatever is going on in the city at any given time. We want people to enjoy spending time in our Mercedes me stores and have a cup of coffee with only incidental references to Mercedes products. But of course at the end, everything leads back to the traditional dealership environment, because our dealerships and contract partners are full-service locations that are an important component of our automotive business. But of course, at the end, everything leads back to the traditional dealership environment, because our dealerships and contract partners are full-service locations that are an important component of our automotive business.

We speak to people's needs in a wide range of situations where they wouldn't consciously choose to visit a showroom. We find that addressing people in a completely different context—at an event, while they're shopping or going out for the evening—is very effective. Within this expanded context, we can present the brand in a completely different way and start a different kind of dialogue that represents the Mercedes-Benz attitude toward life. We can indirectly link the brand via content like material goods, architecture, and fine cuisine, which works very well. We have gained a lot of experience from our many stores in large cities, especially in Tokyo and Osaka, Japan. At midday, we have a business lunch for executives. In the afternoon, we offer food appropriate for mothers with children, and then we have after-work parties in the evening. None of that is directly related to selling cars, but it makes our brand a presence in people's lives."

Jens Thiemer,
Vice President Brand Communications Mercedes-Benz

„Bei unseren Mercedes me Stores geht es um den klassischen Innenstadt-Showroom in deutlich weiterentwickelter Form, nahbar und exklusiv. Der Fokus liegt dabei eher auf der ganzheitlichen Markenwelt – der Lebenswelt von Mercedes – als auf dem Produkt an sich. Diese Rolle können aber auch Pop-up-Stores, Pavillon-Konzepte oder Roadshows leisten. Es geht um eine andere Heranführung der Kunden an die Marke und die Angebote von Mercedes-Benz. Deutlich lässiger als im klassischen Autohaus und weniger abschlussorientiert sollen die Menschen im Alltag mit Mercedes-Benz in Berührung kommen. Gastronomie spielt dabei eine besondere Rolle, ebenso Veranstaltungen wie Vernissagen oder Fashionshows. Wir hatten beispielsweise in unserem Mercedes me Store in Hamburg schon einige Veranstaltungen im Rahmen der Fußball-WM. Je nachdem, was gerade in einer Stadt los ist, kann man den Store kontextbezogen einbinden. Es geht uns also primär darum, dass die Menschen gerne Zeit in unseren Mercedes me Stores verbringen, einen Kaffee trinken und nur nebenbei auf Mercedes-Produkte verwiesen werden. Aber natürlich leitet am Ende alles ins klassische Autohaus über, denn unsere Niederlassungen und Vertragspartner sind vollumfänglicher und wichtiger Bestandteil unseres Automobilgeschäfts.

Wir sprechen die Menschen bedürfnisorientierter an, in ganz unterschiedlichen Lebenssituationen, in denen sie eigentlich gar nicht bewusst den Weg in ein Autohaus wählen würden. Ansprachen in einem völlig anderen Kontext – bei einer Veranstaltung, beim Einkaufen oder beim Ausgehen – halten wir für sehr wirkungsvoll. Bei so einer erweiterten Kontextansprache können wir die Marke ganz anders präsentieren, können andere Dialoge führen, die das Lebensgefühl von Mercedes-Benz repräsentieren, und über Inhalte wie Materialität, Architektur und Gastronomie die Marke indirekt verknüpfen. Das funktioniert gut. Wir haben über die vielen Stores in den Metropolen dieser Welt eine Menge Erfahrung gesammelt. Vor allem in den japanischen Städten Tokio und Osaka. Tagsüber gibt es ein Business-Lunch für Geschäftsleute, nachmittags ist das Gastro-Angebot auf Mütter mit Kindern ausgerichtet, abends finden Afterwork-Partys statt. Das alles hat ja nicht in erster Linie etwas mit dem Verkauf von Autos zu tun, aber wir klinken uns als Marke ins Leben der Kunden ein."

Jens Thiemer,
Vice President Brand Communications Mercedes-Benz

« Nos concessions ‹ Mercedes me › sont une forme considérablement évoluée des salles d'exposition citadines, accessibles et exclusives à la fois. Elles mettent l'accent sur l'univers de la marque dans son ensemble, c'est-à-dire l'univers dans lequel évolue Mercedes, plutôt que sur le produit à proprement parler. Ce rôle peut également être rempli par les boutiques pop-up, les concepts de pavillons, ainsi que les road-shows. Il s'agit d'une autre manière d'amener le client à la marque et aux produits proposés par Mercedes-Benz. C'est de façon beaucoup plus désinvolte que dans une concession automobile classique, et moins orientée vers la vente, que le grand public doit, au quotidien, entrer en contact avec Mercedes-Benz. La gastronomie joue ici un rôle tout particulier, au même titre que des évènements tels que vernissages ou défilés de mode. Par exemple, dans notre boutique ‹ Mercedes me › de Hambourg, nous avons organisé plusieurs évènements dans le cadre de la Coupe du monde de football. Selon ce qui se passe dans une ville donnée, il est possible d'adapter la boutique au contexte. Notre objectif est que les gens viennent et apprécient passer du temps dans nos boutiques ‹ Mercedes me ›, y boivent un café, et que leur attention ne soit attirée sur les produits que de manière secondaire. Mais bien entendu, au final, tout incite à se rendre dans la concession automobile classique, car nos concessions et nos franchisés sont des composantes à part entière et d'une grande importance pour notre activité de vente automobile.

Nous nous adressons aux consommateurs en nous orientant vers leurs besoins, dans des situations de vie très différentes les unes des autres, et dans lesquelles ils ne penseraient pas à se rendre dans une concession automobile. Nous estimons qu'il est très efficace de s'adresser aux consommateurs dans un contexte totalement différent, par ex. lors d'un évènement, pendant une journée shopping ou lors d'une sortie. Le fait d'interpeller les consommateurs dans de si vastes contextes nous permet de présenter différentes facettes de la marque, d'avoir des dialogues différents quant au style de vie Mercedes-Benz, et de susciter des associations mentales indirectes avec la marque via des contenus tels que l'aspect matériel, l'architecture et la gastronomie. Cela fonctionne bien. Avec les nombreuses boutiques installées à travers les métropoles de ce monde, nous avons acquis une très grande expérience. Surtout à Tokyo et Osaka, au Japon. La journée, elles proposent un déjeuner business pour les hommes d'affaires, l'après-midi, l'offre de restauration s'adresse plus précisément aux mères et à leurs enfants, et le soir y sont organisées des soirées afterwork. Tout cela n'a aucun lien direct avec la vente de voitures, mais c'est notre manière de nous ancrer dans la vie des clients.»

Jens Thiemer,
Vice-président de la Brand Communications
chez Mercedes-Benz

Qu'est ce qui rend la concession automobile sexy ?

HAMBURG

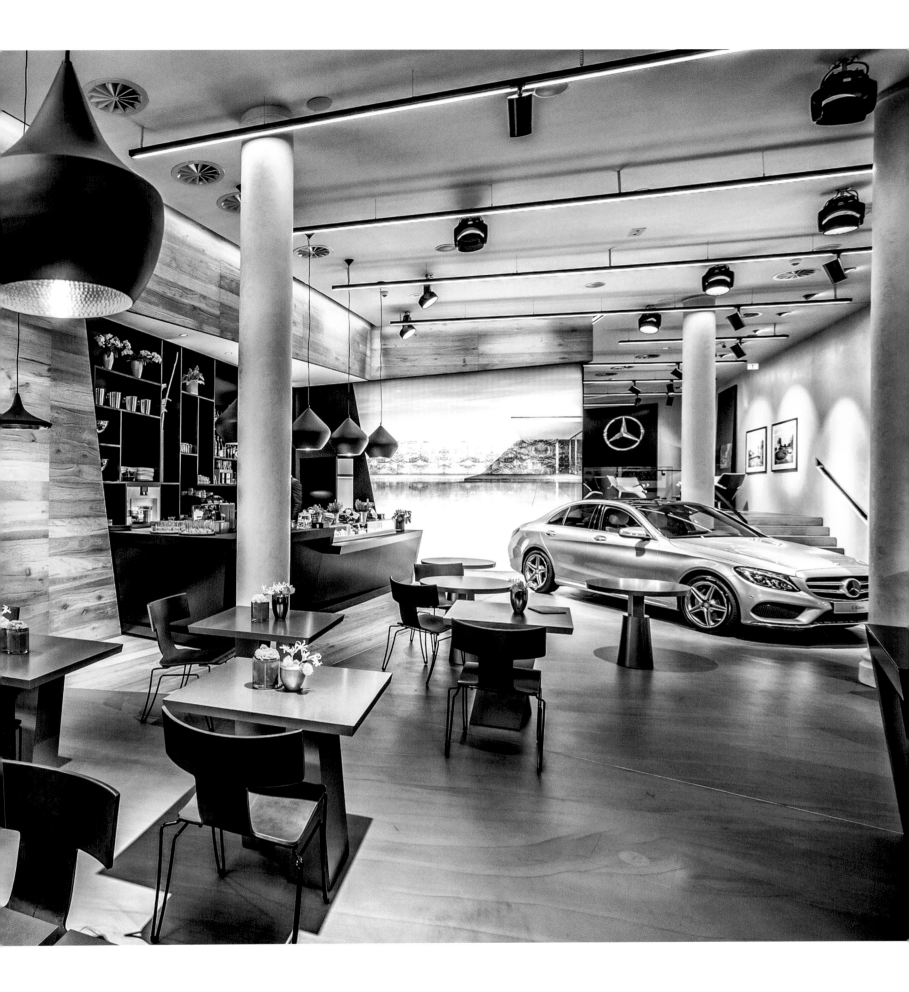

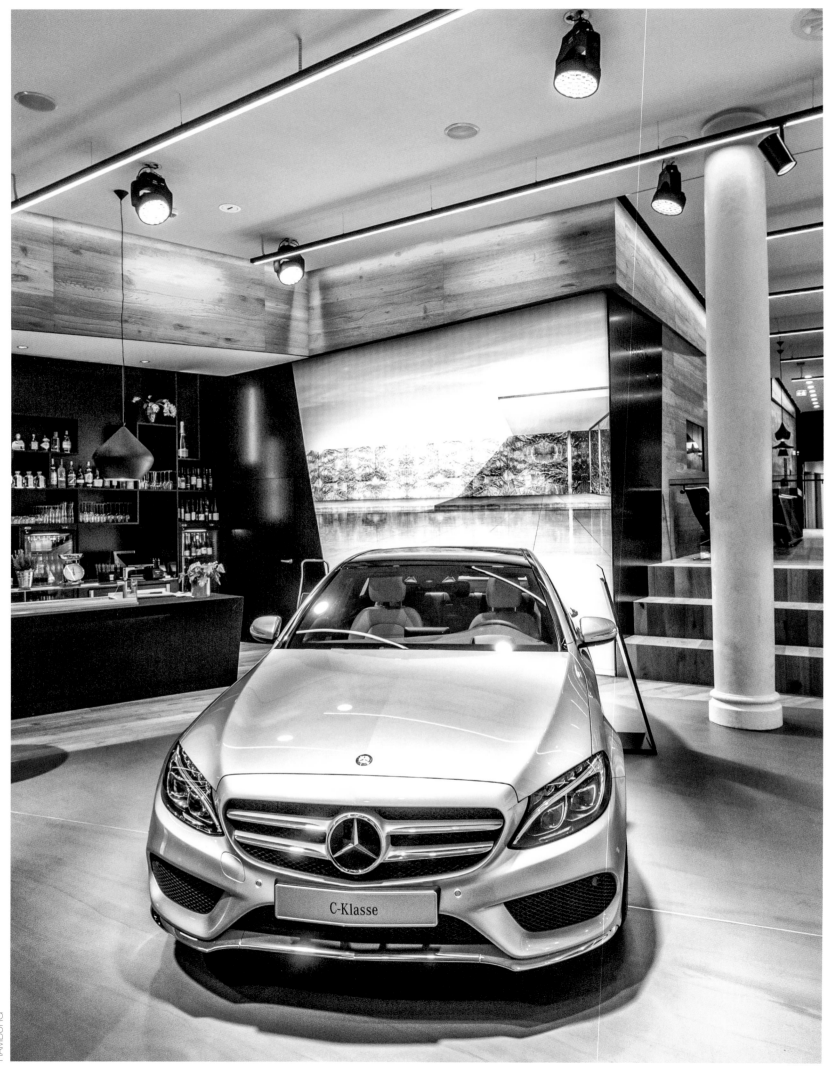

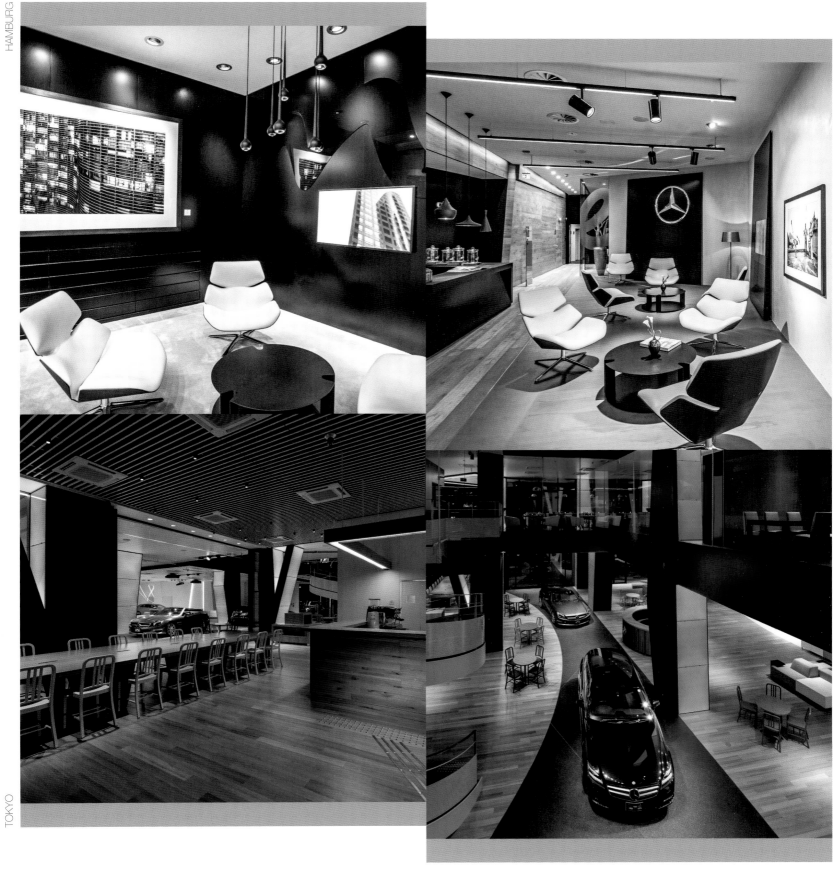

CONSULENZA 360° Capiamo insieme le tue esigenze.
Investimenti, prestiti, mutui, previdenza, servizi e non solo
...come possiamo aiutarti oggi?

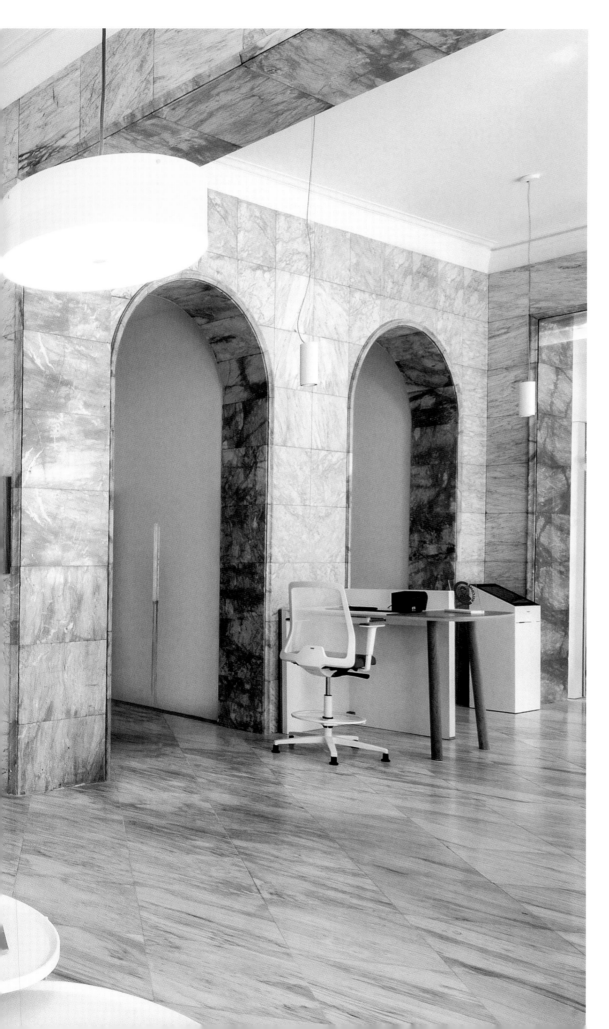

UNICREDIT
MILAN

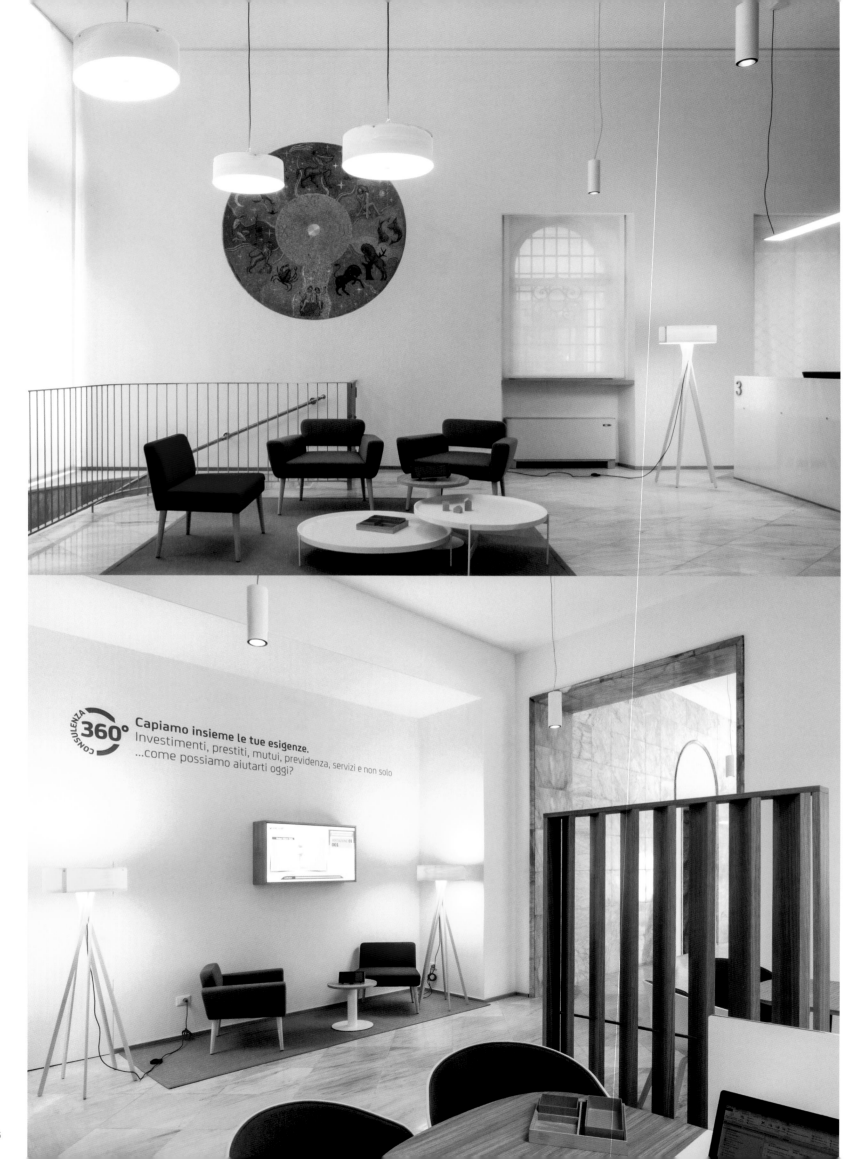

Transparency and flowing transitions are the basic elements of the newly redesigned UniCredit concept store in Milan. Architecture firm Matteo Thun & Partners has created a quiet, informal atmosphere where office furniture has been reduced to its key functions and combined with residential furniture. An atrium covered in evergreens connects the first and second floors. A lot of white and wood on ceilings, floors, and separators creates an exciting contrast to the classical severity of the marble entry hall. Seating is by La Cividina, and the Arba floor lamp is a design by Matteo Thun and Antonio Rodriguez for Belux.

Transparenz und fließende Übergänge sind die Grundidee des neu gestalteten UniCredit-Conceptstores in Mailand. Das Architekturbüro Matteo Thun & Partners hat eine ruhige, informelle Atmosphäre geschaffen, in dem Büromöbel auf ihre wesentliche Funktion reduziert und mit Wohnmöbeln kombiniert wurden. Ein mit Immergrün bewachsenes Atrium verbindet die zwei Etagen. Viel Weiß und Holz für Decken, Böden und Trennelemente bilden einen spannenden Dialog zur klassischen Strenge der Eingangshalle aus Marmor. Die Sitzmöbel stammen von La Cividina, die Stehlampe Arba ist ein Entwurf von Matteo Thun und Antonio Rodriguez für Belux.

"Reduce to the max!"

La transparence et les transitions continues constituent l'idée de base de la nouvelle agence concept d'UniCredit de Milan. Le bureau d'architectes Matteo Thun & Partners a créé une atmosphère calme et informelle dans laquelle le mobilier de bureau est réduit à sa fonction principale et combiné à des meubles d'habitation. Un atrium décoré de plantes à feuillage persistant relie les deux étages. L'importante quantité de bois et de blanc utilisée pour les plafonds, les sols et les éléments de séparation instaure un dialogue passionnant avec la sévérité classique du hall d'entrée en marbre. Les sièges proviennent de La Cividina, le lampadaire Arba est une création de Matteo Thun et Antonio Rodriguez pour Belux.

What are the special challenges associated with retail design?

It creates a bridge to product design and challenges you to create economies of scale. Ideally, you want to trigger multiplication—that's what generates success, not one-offs. What that means is that it costs less to make many objects than it does to make just one. Mass production creates a different pricing structure, and we in the retail business are really price engineers.

And that means ...?

We work on the budget every day—but creativity plays the biggest role at both ends of things. The customer gives us a square-foot price, and the challenge is to get the most out of this specified budget while delivering first-class quality.

What implications does that have for your design and development process?

One of the reasons the customer hires us is that our concepts are very price-sensitive. We don't say, oh, that's a pretty chandelier, so we'll put in ten of them. We might use two and hang objects between them that are equally appealing.

How do you adapt to the changing requirements of the retail business?

Reduce to the max! Reduce components, use the logic of interchangeable parts, and be really, really involved in the sample procurement phase. It's about subtraction, not addition. Anyone can add things. Subtracting them is harder. Today's retail business is about the art of subtraction.

So the essence of retail is the art of leaving things out?

It's about subtraction, as opposed to minimalism. Minimalism is lifeless and has no emotional charge. Everything that has to do with retail is high-voltage. Minimalism was more popular on the product end, although there were different interpretations of less-is-more. It's only now that we're being released from that tunnel of anemia.

So how much design do you need?

I can't answer that question because the term "design" has really been beaten to death. It's about the soul of the brand, about understanding the brand. When the little red thread, the core of the brand, remains intact throughout the process, then it works. In architecture, it's called the genius loci, the soul of the place, and in retail it is the soul of the brand.

Was ist die besondere Herausforderung im Retaildesign?

Es ist der Brückenschlag zum Produktdesign und die reizvolle Aufgabe der Scale of Economy. Im Idealfall auch die Multiplikation – sie generiert den Erfolg, nicht das Einzelstück. Das heißt, dass es weniger kostet, wenn man anstatt nur einem, viele Objekte herstellt. Die Serienproduktion generiert eine andere Preisstruktur und wir sind im Retailgeschäft eigentlich Preisingenieure.

Das bedeutet ...?

Wir arbeiten täglich am Budget – am Anfang und am Ende spielt die Kreativität die größte Rolle. Der Kunde gibt uns einen Quadratmeter-Preis vor und die Herausforderung besteht darin, das Beste aus diesem vorgegebenen Budget herauszuholen und trotzdem erstklassige Qualität zu realisieren.

Welche Konsequenzen ergeben sich daraus für die Designentwicklung?

Der Kunde engagiert uns, weil wir unter anderem unsere Entwicklungen sehr preissensibel machen. Wir sagen nicht, nur weil wir den Lüster schön finden, planen wir zehn davon ein. Wir verwenden vielleicht zwei und hängen dazwischen Objekte, die den gleichen Reiz ausstrahlen.

Wie begegnen Sie den veränderten Anforderungen im Retailgeschäft?

Reduce to the max! Also: Komponentenreduzierung, Gleichteillogik und sehr viel Engagement in der Bemusterungsphase. Subtraktion, nicht Addition. Addieren kann jeder, Subtrahieren ist schwieriger. Das moderne Retailgeschäft ist die Kunst der Subtraktion.

Die Essenz des Retails ist also die Kunst des Weglassens?

Subtraktion als Gegenteil von Minimalismus. Minimalismus ist blutleer und nicht emotional aufgeladen. Alles, was mit Retail zu tun hat, ist Hochvolt. Der Minimalismus war vor allem im Produkt populär, auch wenn es verschiedene Ausrichtungen im Less-is-more gab. Erst jetzt ist man dabei, uns aus dem Tunnel der Blutleere zu entlassen.

Wie viel Design muss sein?

Die Frage kann ich nicht beantworten, weil Design ein zu abgedroschener Begriff geworden ist. Es geht um die Seele der Marke, um das Markenverständnis. Wenn der rote Faden, das heißt der Markenkern, im Prozess aufrechterhalten bleibt, dann klappt es. In der Architektur nennt man es den Genius Loci, die Seele des Ortes, und im Retail ist es die Seele der Marke.

MATTEO THUN

Quel est le défi particulier auquel se trouve confronté le design dans le secteur de la vente au détail ?

C'est un pont entre le design de produit et la mission stimulante de l'économie d'échelle. Idéalement, c'est aussi la multiplication (celle-ci menant à la réussite), et non la pièce unique. Cela signifie qu'il revient moins cher de fabriquer beaucoup d'objets plutôt qu'un seul. La production en série génère une autre structure de prix, et nous sommes, à vrai dire, de véritables ingénieurs des prix de la vente au détail

C'est-à-dire ?

Nous travaillons quotidiennement sur le budget, mais au début et à la fin, c'est la créativité qui joue le rôle le plus important. Le client nous donne un prix au mètre carré, et le défi est de tirer le meilleur de ce budget imposé tout en fournissant une qualité maximale.

Quelles en sont les conséquences pour la conception du design ?

Le client nous engage notamment car nos conceptions sont particulièrement adaptées au budget. Nous ne sommes pas en train de dire que parce que nous avons trouvé le lustre nous allons forcément en prévoir dix identiques. Nous en utiliserons plutôt deux et suspendrons entre eux des objets dégageant le même charme.

Comment abordez vous le changement au niveau des exigences du commerce de détail ?

Réduire au maximum ! En d'autres termes, réduire les composantes, appliquer une logique consistant à employer plusieurs pièces identiques, et s'impliquer au plus haut point dans la phase de configuration. La soustraction, et non l'addition. Tout le monde peut faire une addition. Une soustraction est plus difficile. Le commerce de détail moderne, c'est l'art de la soustraction.

L'essence de la vente au détail, c'est donc l'art de l'omission ?

La soustraction, par opposition au minimalisme. Le minimalisme est vide de personnalité et d'émotions. Tout ce qui se rapporte à la vente au détail est survolté. Le minimalisme était surtout populaire au niveau du produit, et ce même s'il existait différentes directions dans l'approche du « moins, c'est plus ». On commence à peine à quitter le tunnel du vide de personnalité.

Le design oui, mais jusqu'à quel point ?

Je ne peux pas répondre à cette question, car le terme de « design » est devenu un terme bien trop banal. Il s'agit de l'âme de la marque, de la compréhension de la marque. Ce qui compte, c'est de conserver le fil conducteur, c'est-à-dire le noyau de la marque, tout au long du processus. En architecture, on appelle cela le « genius loci », l'âme du lieu, et dans le commerce de détail cela s'appelle « l'âme de la marque ».

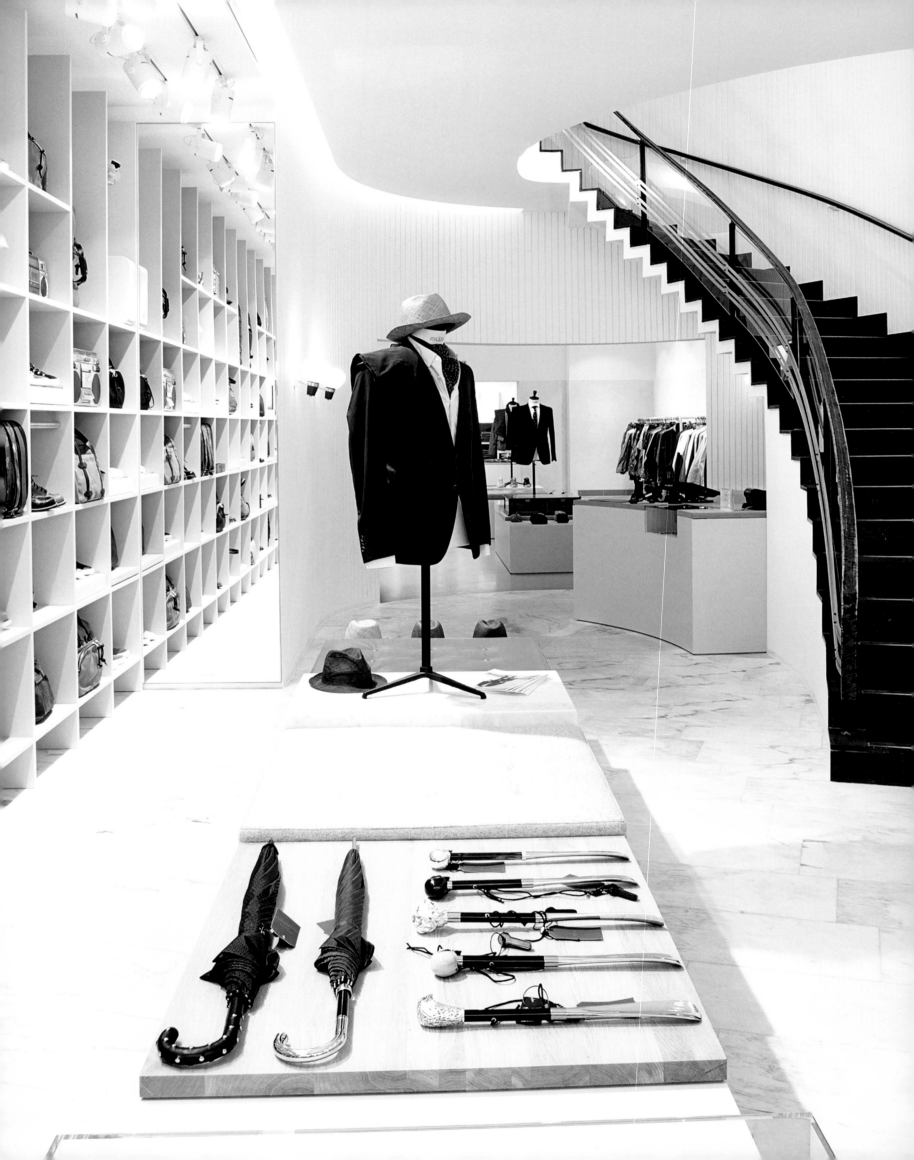

STEREO/MUC
MUNICH

Opened in March 2014, the store with its attached café on Residenzstraße has already become an established part of downtown Munich. The café was the previous longtime home of the Confiserie Rottenhöfer confectioner's shop and was carefully renovated for the new concept. The 1950s design elements were all preserved: the curved marble staircase, the slatted walls, wall tiles, and the enormous wall mural on the second floor.

Up there is where you will now find the STEREO/ Café, run by Arnold Jaeger Werner and his gastro-team, and a menu full of special surprises. There is apple champagne and steamed roast beef, house-made *pastéis*, and homemade apricot-tonka bean lemonade. Even the coffee is a house blend and is sold in the store.

The store is equally selective in its product offerings. Along with selected accessories, STEREO/ MUC sells authentic sportswear for men—outside the mainstream, but always at the center of fashion. "You have to experience and touch these things for yourself. There are no standard products here," says owner Florian Ranft. STEREO/MUC presents a lovingly selected brand world in its 300 square meters. Denim enthusiasts love the earthy American jeans from Gilded Age and AG as well as classic jeans from Levi's Vintage, Japanese denim from Edwin, and New York flair from BLK Denim. Sportswear from names like Baracuta, Hartford, Barena or Todd Snyder for Champion is part of the portfolio alongside high-end threads from Mauro Grifoni and leather jackets from Giorgio Brato. Knitwear lovers have Avant Toi, and brands like Paltò and Harris Wharf will compete to be your new favorite coat.

"Putting together the brands is really important to us—we only want to include styles that have the potential to be your new favorite thing to wear, things that we personally think are terrific," Henrik Soller emphasizes. This philosophy echoes throughout the entire portfolio: footwear choices include Red Wing, Tricker's, Church's and Adidas as well as New Balance, Officine Creative, and Diemme. The store has a generous selection of accessories—customers can choose from Atelier de l'Armée, Mismo, Felisi, or Filson bags, hand-embroidered bowties from Jupe by Jackie, and jewelry from M. Cohen, and Miansai to complete their look.

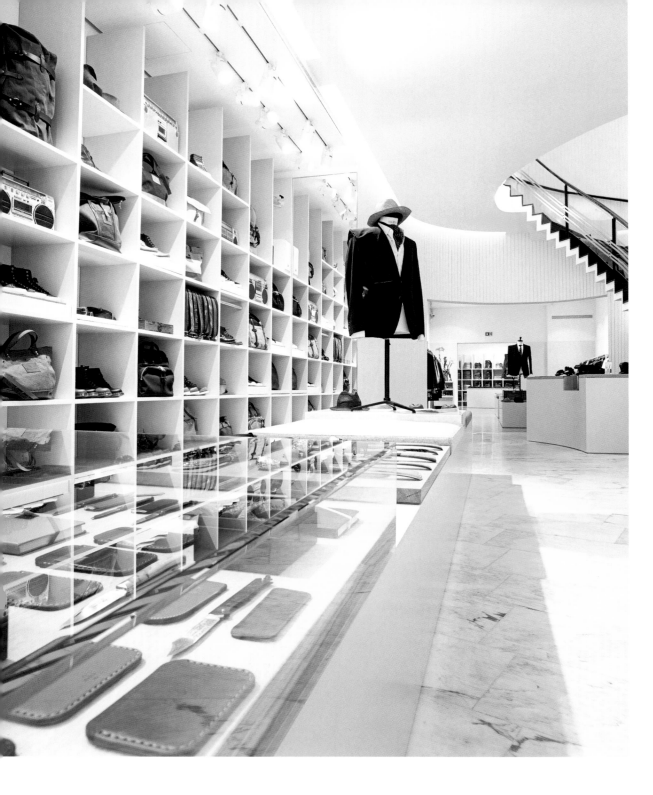

Im März 2014 eröffnet, gehört der Store mit angeschlossenem Café in der Residenzstraße bereits zum festen Bestandteil der Münchner Innenstadt. Das Ladenlokal beherbergte vorher die alteingesessene Confiserie Rottenhöfer und wurde für das neue Konzept behutsam renoviert. So wurden die Designelemente aus den 50er-Jahren erhalten: die geschwungene Marmortreppe etwa, die Lamellenwände, Wandkacheln, der Speiseaufzug oder auch das enorme Wandgemälde im ersten Obergeschoss.

Dort oben findet man heute das STEREO/Café, das vom Gastro-Team Arnold Jaeger Werner betrieben wird und Ausgesuchtes auf der Karte hat. Es gibt Apfelchampagner und dampfgegartes Roastbeef, hausgebackene Pastéis und selbstgemachte Aprikosen-Tonkabohnen-Limonade, aber auch der Kaffee ist Hausmarke und wird im Store verkauft.

Der Store ist ebenso erlesen in seinen Produkten. Neben ausgesuchten Accessoires bietet STEREO/MUC authentische Sportswear für Männer – abseits des Mainstreams, aber immer am Puls der Zeit. „Die Sachen muss man erleben, sie anfassen, hier gibt es keine Standardprodukte", so Inhaber Florian Ranft. Auf insgesamt 300 Quadratmetern

präsentiert STEREO/MUC eine liebevoll ausgewählte Markenwelt. Denim-Enthusiasten freuen sich über kernige US-amerikanische Jeans von Gilded Age und AG ebenso wie über Klassiker von Levi's Vintage, japanischen Denim von Edwin und New Yorker Flair von BLK Denim. Sportswear, etwa von Baracuta, Hartford, Barena oder Todd Snyder for Champion, gehört ebenso zum Portfolio wie feiner Zwirn von Mauro Grifoni oder Lederjacken von Giorgio Brato. Wer Strick liebt, wird bei Avant Toi fündig, und ins Rennen um den zukünftigen Mantel-Favoriten gehen Marken wie Paltò und Harris Wharf.

„Die Zusammenstellung der Marken liegt uns besonders am Herzen – wir wollen ausschließlich Styles zeigen, die das Potenzial zum Lieblingsteil haben und die wir selbst als gut empfinden", betont Henrik Soller. Dieses Herzblut zieht sich durch das gesamte Portfolio: In Sachen Footwear setzt man neben Red Wing, Tricker's, Church's und Adidas auf New Balance, Officine Creative und Diemme. Die Auswahl an Accessoires ist großzügig – bei Taschen können die Kunden zwischen Atelier de l'Armée, Mismo, Felisi oder Filson wählen, handbestickte Fliegen von Jupe by Jackie sowie Schmuck von M. Cohen und Miansai komplettieren den Look.

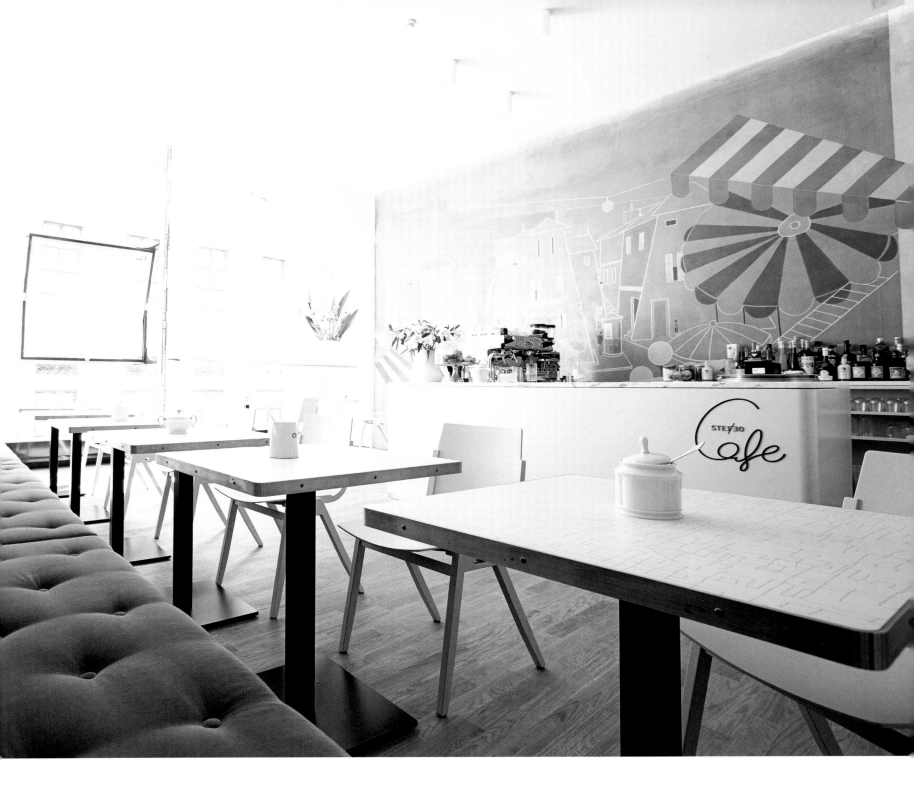

Ouverts en mars 2014 et situés sur la Residenzstraße, la boutique et le café qui y est rattaché, font déjà partie intégrante du centre ville de Munich. Auparavant, le local commercial abritait la traditionnelle confiserie Rottenhöfer, puis elle a été rénovée tout en douceur pour mettre en place le nouveau design. Cela permet de conserver les éléments de design des années 1950 : L'escalier en marbre, les murs à lamelles, le carrelage mural, le monte-plats ou la gigantesque pe inture murale du premier étage. On y trouve aujourd'hui le café, géré par l'équipe du Arnold Jaeger Werner et dont la carte propose des plats soigneusement sélectionnés. On peut y commander du cidre, du roastbeef cuit à la vapeur, du pastel de nata maison et de la limonade abricot-fève tonka faite maison, ainsi que du café torréfié maison.

La boutique est aussi raffinée que les produits qu'elle propose. Outre les accessoires triés sur le volet, STEREO/MUC propose une ligne sportswear authentique pour les hommes, différente du mainstream, mais parfaitement dans l'air du temps. « Il faut vivre les produits, les toucher. Nous n'avons pas de produits standards », déclare Florian Ranft, le propriétaire. Sur une surface totale de 300 mètres carrés, STEREO/MUC présente un univers de marque choisi avec amour. Les fans de denim sont ravis d'y trouver de véritables jeans US de Gildet Age et AG aussi bien que des grands classiques tels que Levi's Vintage, du denim japonais d'Edwin, ainsi que l'esprit new-yorkais de BLK Denim. Les sportswears de Baracuta, Hartford, Barena ou Todd Snyder for Champion, font aussi bien partie du portefeuille que les vêtements raffinés de Mauro Grifoni ou les vestes en cuir de Giorgio Brato. Les amateurs de maille trouveront leur bonheur avec Avant Toi, et le prochain chouchou parmi les manteaux est présenté par des marques telles que Paltò et Harris Wharf.

« Nous accordons une grande importance au choix des marques : nous voulons présenter uniquement des marques capables de fournir ‹ le vêtement préféré ›, et que nous considérons nous-mêmes comme dignes de cette fonction », souligne Henrik Soller. Cette passion se retrouve dans l'ensemble du portefeuille de produits : Pour ce qui est des chaussures, l'on mise sur Red Wing, Tricker's, Church's et Adidas, mais également surf New Balance, Officine Creative et Diemme. La sélection des accessoires est généreuse : les clients peuvent choisir leurs sacs parmi les marques Atelier de l'Armée, Mismo, Felisi ou Filson ; les nœuds papillon faits main parmi Jupe by Jackie, et compléter leur look avec des bijoux de M. Cohen ou de Miansai.

AESOP

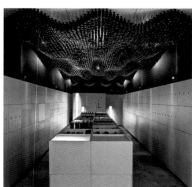

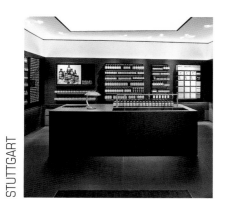

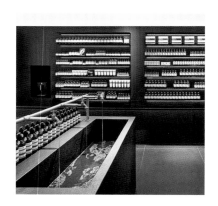

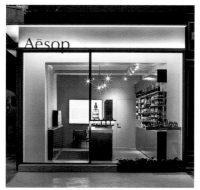

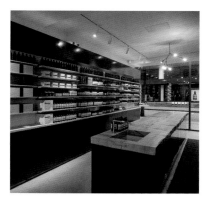

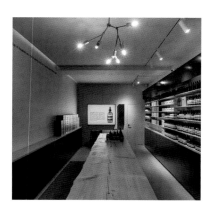

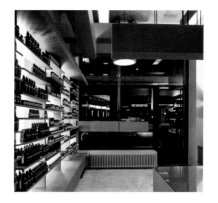

NEW YORK

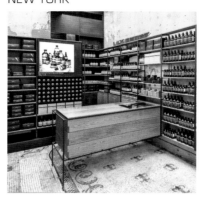

BERLIN MITTE

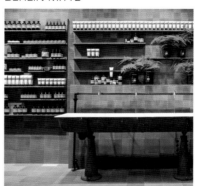

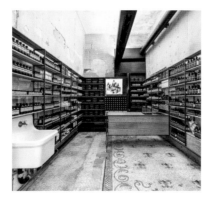

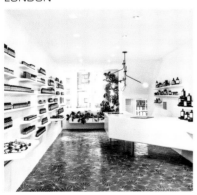

LONDON

TOKYO

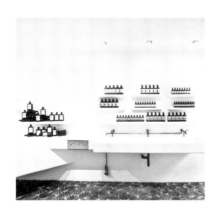

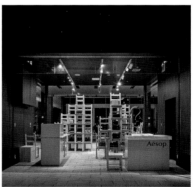

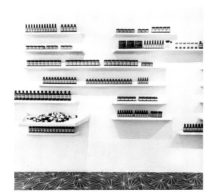

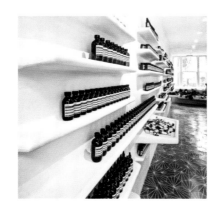

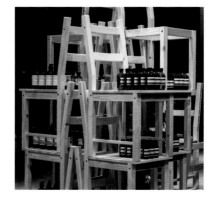

COLOGNE

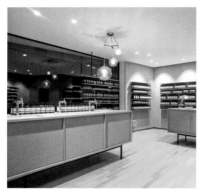

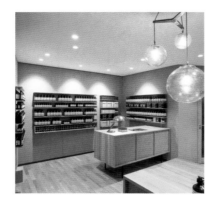

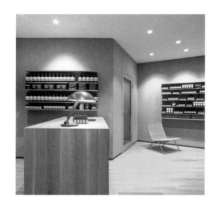

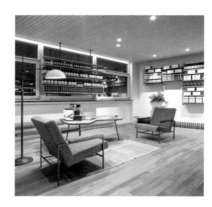

OSLO

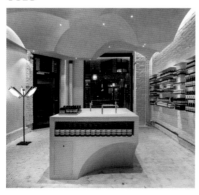

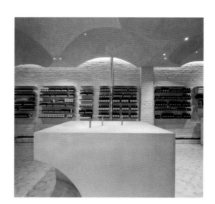

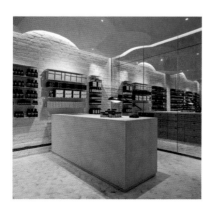

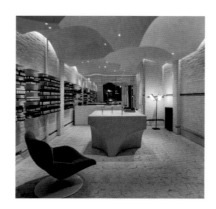

What do Virginia Woolf, Gerhard Richter's color charts, a shoemaker, and the theater all have in common? These widely disparate cultural reference points provide Australian cosmetics company Aesop with inspiration for their store designs. To Aesop, local anchoring goes beyond echoing the architectural features of the neighborhood to incorporating cultural context. The company's signature stores want to create emotional ties to the area and be considered part of the local identity while building their own unique vibe. "No two stores alike," is the guiding principle of founder Dennis Paphitis. Still, they have certain details in common: checkout counters, sinks, and narrow display cases provide a foundation for virtuoso designers to expand on, following the motto, "Smart design for a better quality of life."

Aesop partnered with Cigüe in Paris to design their store in London's Covent Garden section. The white fittings, wooden plank floors, and floral-green tiles reflect the dynamic modernism of the Roaring Twenties: sophisticated, yet pragmatic, with a touch of Virginia Woolf. Many of Aesop's spaces have a long and storied history. The Manhattan store, for example, was once a shoemaker's workshop. The old mosaic floor and the exposed plaster walls with a beautiful patina acquired over the years, speak for themselves. Design firm Architecture Outfit consciously chose this design to contrast with the elegance of Madison Avenue. In Berlin's Mitte district, 12,000 shimmering matte green cement tiles give a run-down former dairy store the enchanting feel of a forest meadow in the jungle of the big city. Before local firm Weiss-Heiten submitted their proposal, there was a discussion of culture ranging from Bauhaus to the abstract monochromatic works of Gerhard Richter. Another Aesop store in Berlin on Fasanenstraße becomes a dramatic place at night, when the open display cases are closed to create a pillared walkway lit from below. Norwegian design firm Snøhetta was inspired to create this dramatically scripted interior by the many theaters and fine arts institutions in the immediate vicinity.

Aesop has consistently worked to make its retail design part of how its brand speaks to customers around the world. In terms of packaging and advertising, the brand's CI is always understated and matter-of-fact, while the stores have a strong voice: exciting, versatile, and surprising—and never too loud.

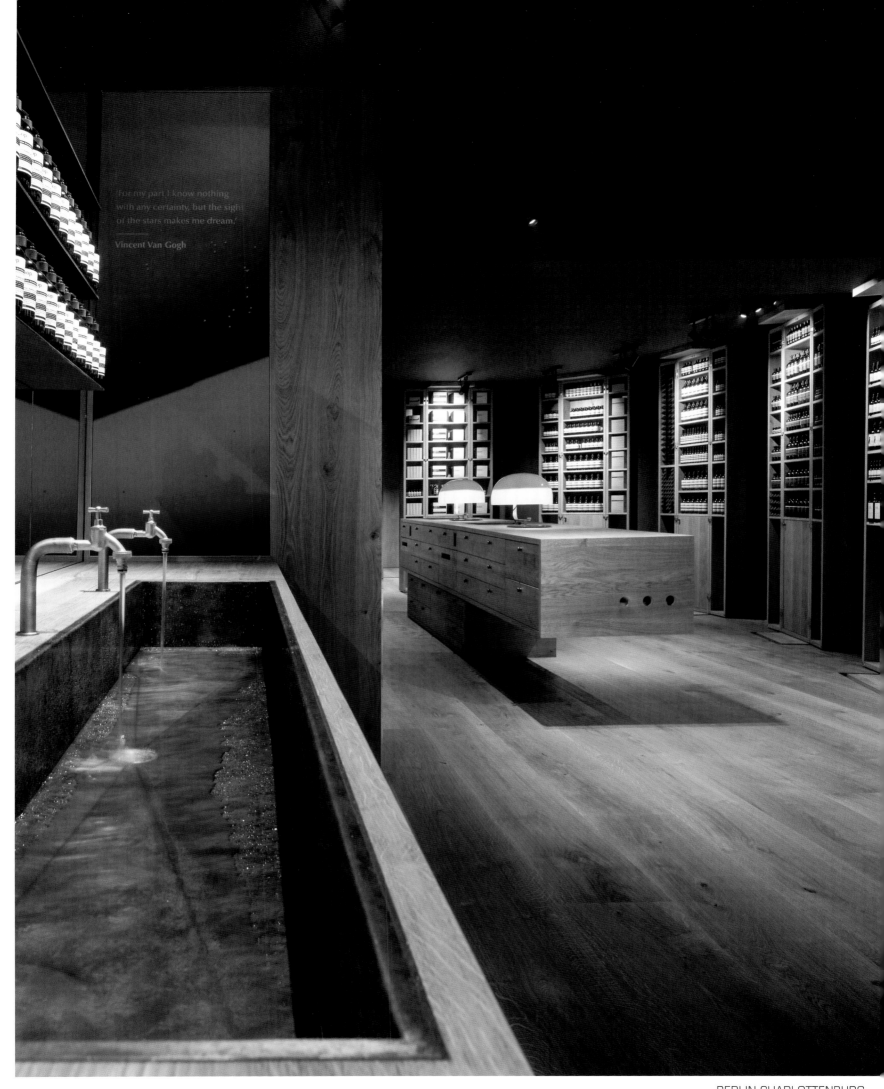

'For my part I know nothing with any certainty, but the sight of the stars makes me dream.'

Vincent Van Gogh

Was haben Virginia Woolf, die Farbtafeln eines Gerhard Richter, ein Schuster und das Theater gemeinsam? All diese so unterschiedlichen kulturellen Referenzpunkte dienen der australischen Kosmetikmarke Aesop als Inspirationsquelle für ihre Storekonzepte. Lokale Verankerung versteht die Kosmetikmarke nicht nur als Zitieren architektonischer Merkmale der Nachbarschaft, sondern als ein Eintauchen in kulturelle Zusammenhänge. Die Signature Stores von Aesop wollen sich emotional mit ihrer Umgebung verbinden, als Teil der lokalen Identität wahrgenommen werden. Und dabei einzigartig bleiben. „Kein Store gleicht dem anderen", lautet das Prinzip des Gründers Dennis Paphitis. Dennoch sind sie wiedererkennbar: Kassentresen, Waschbecken sowie schmale Regale bilden die Grundlinie, auf der virtuos gespielt wird: „Kluges Design verbessert die Lebensqualität."

So entstand mit dem Pariser Büro Ciguë das Geschäft in London, Covent Garden. Die weißen Objekte, Holzdielen und floralgrünen Fliesen spiegeln die dynamische Moderne der 20er-Jahre wider. Mondän und doch pragmatisch – mit einem Touch Virginia Woolf. Häufig haben die Läden eine Vorgeschichte; der in Manhattan war früher eine Schusterwerkstatt. Die Historie bleibt an dem alten Mosaikfußboden und den mit Patina überzogenen, offen verputzen Wänden ablesbar. Das Büro Architecture Outfit hat damit einen bewussten Gegenpol zum eleganten Umfeld der Madison Avenue entwickelt. 12 000 mattgrün schimmernde Zementfliesen geben einem heruntergekommenen ehemaligen Milchgeschäft in Berlin-Mitte den Zauber einer Waldlichtung im Großstadtdschungel. Dem Entwurf des lokalen Büros Weiss-Heiten ging eine kulturelle Diskussion vom Bauhaus bis zu den abstrakten, monochromen Werken Gerhard Richters voraus. Nachts wird es im Laden auf der Berliner Fasanenstraße dramatisch: Dann nämlich werden die offenen Schränke geschlossen und bilden einen von unten beleuchteten Säulengang. Zu dieser Interieur-Dramaturgie ließ sich das norwegische Architekturbüro Snøhetta von den verschiedenen Institutionen der darstellenden Künste aus der unmittelbaren Nachbarschaft inspirieren.

Konsequent hat Aesop sein Retaildesign international zur Markensprache entwickelt. Bleibt das CI der Marke bei Verpackung und Werbung immer reduziert und sachlich, bekommt der Store eine starke Stimme. Spannend, vielfältig, überraschend. Nie zu laut.

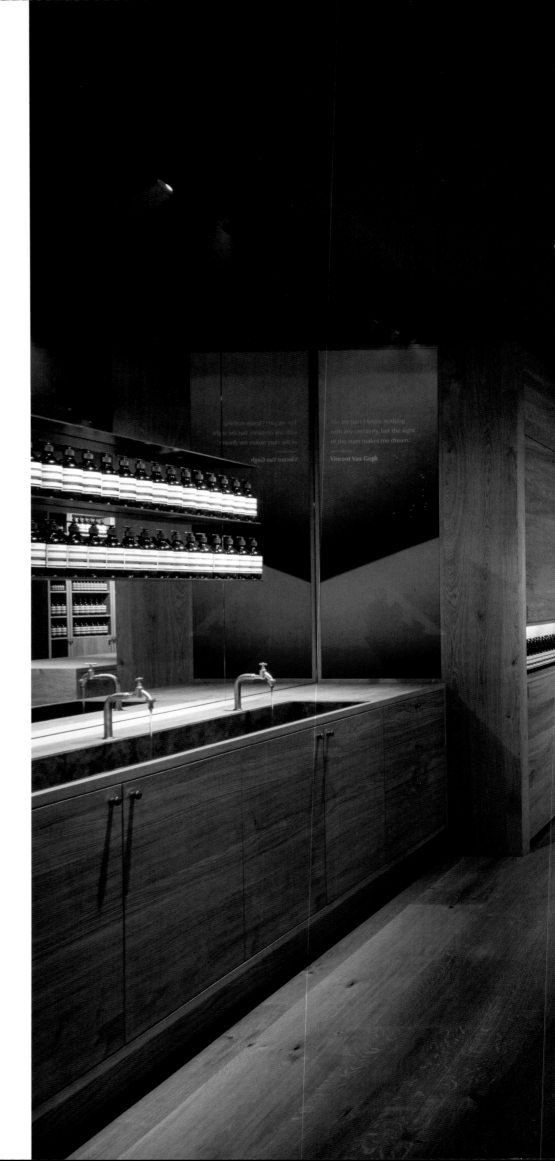

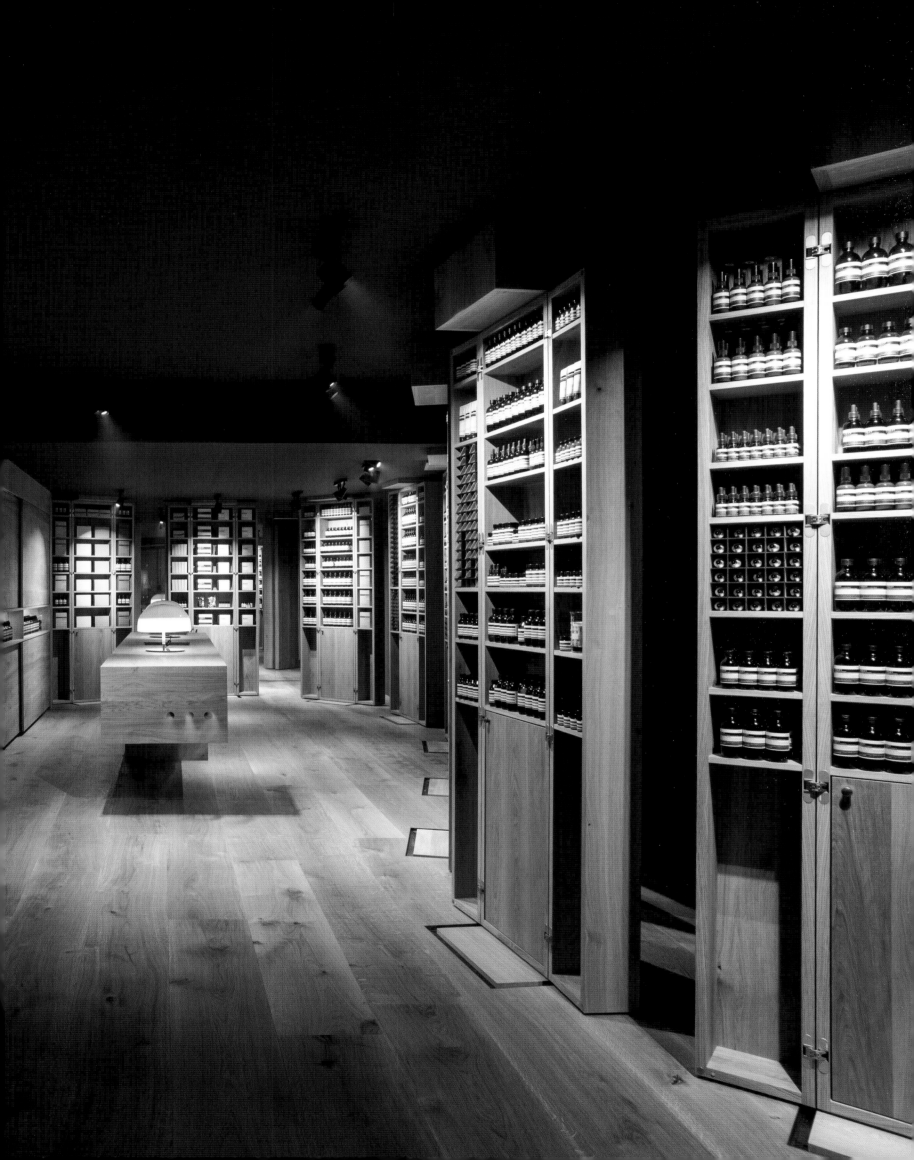

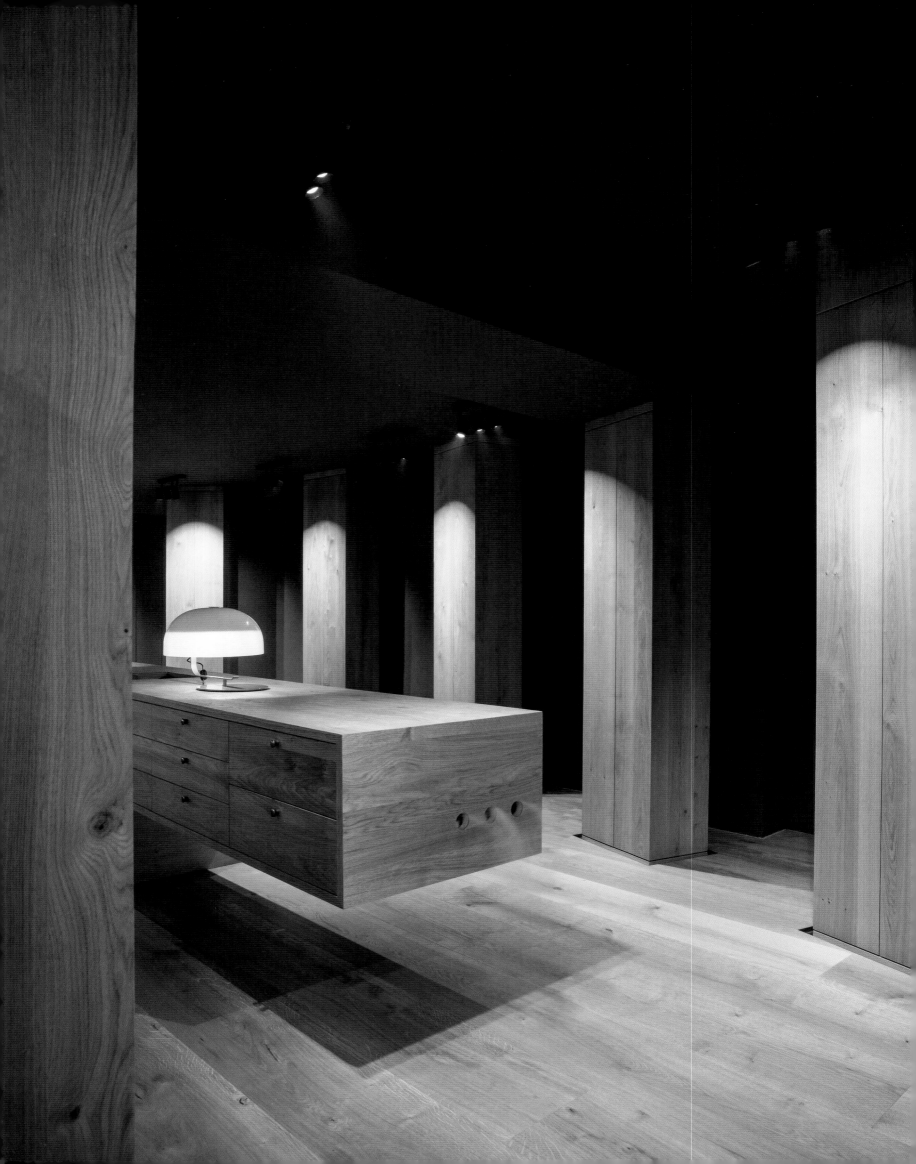

Quel est le point commun entre Virginia Woolf, les nuanciers de Gerhard Richter, un cordonnier et le théâtre ? Ces points de référence culturels, tous si différents les uns des autres, servent de source d'inspiration à la marque de produits cosmétiques australienne Aesop pour la conception de ses boutiques. Pour Aesop, s'intégrer localement signifie non seulement reprendre les caractéristiques architecturales du voisinage, mais également s'immerger dans les différents contextes culturels. Les boutiques Signature d'Aesop ont vocation à s'associer sur le plan émotionnel avec leur environnement et à être perçues comme une composante de l'identité locale. Tout en restant uniques. « Il n'existe pas deux boutiques identiques » : tel est le principe du fondateur Dennis Paphitis. Mais elles restent pourtant reconnaissables : les caisses, les lavabos et les petites étagères constituent les éléments servant de base à l'élaboration individuelle de chaque boutique, selon la devise « un design malin améliore la qualité de vie ».

C'est en collaboration avec l'agence parisienne Ciguë qu'a vu le jour la boutique de Londres Covent Garden. Les objets blancs, les planches en bois et les carrelages floraux aux tons verts restituent le dynamisme des années 1920. Mondain et pragmatique à la fois, avec une touche de Virginia Woolf. Souvent, les boutiques sont porteuses d'une histoire ancienne : par exemple, celle de Manhattan fut jadis l'atelier d'un cordonnier. Son histoire se reflète sur le vieux sol en mosaïque et sur les murs crépis entièrement patinés. Ainsi, l'agence Architecture Oufit a créé une opposition à l'environnement élégant de la Madison Avenue. Dans le quartier de Berlin Mitte, 12 000 carreaux en ciment mat vert confèrent à l'ancienne crèmerie délabrée le charme d'une clairière au milieu de la jungle qu'est cette métropole. La conception, réalisée par l'agence locale Weiss-Heiten a devancé la discussion culturelle, qui allait du style Bauhaus aux travaux abstraits et monochromes de Gerhard Richter. Dans une autre boutique Aesop berlinoise, située rue Fasanenstraße, l'accent est mis sur un décor nocturne dramatique. Les armoires, ouvertes, sont alors fermées, formant une allée de colonnes éclairées par le bas. Pour cette dramaturgie d'intérieur, le bureau d'architectes norvégien Snøhetta s'est inspiré des différentes institutions d'arts du spectacle situées à proximité.

Aesop a élevé le concept de design international de ses boutiques au statut de langage de la marque. Alors que l'identité de la marque est toujours réduite et fonctionnelle au niveau des emballages, ce sont les boutiques qui sont chargées d'exprimer cette identité. Passionnante, riche, surprenante. Jamais trop forte.

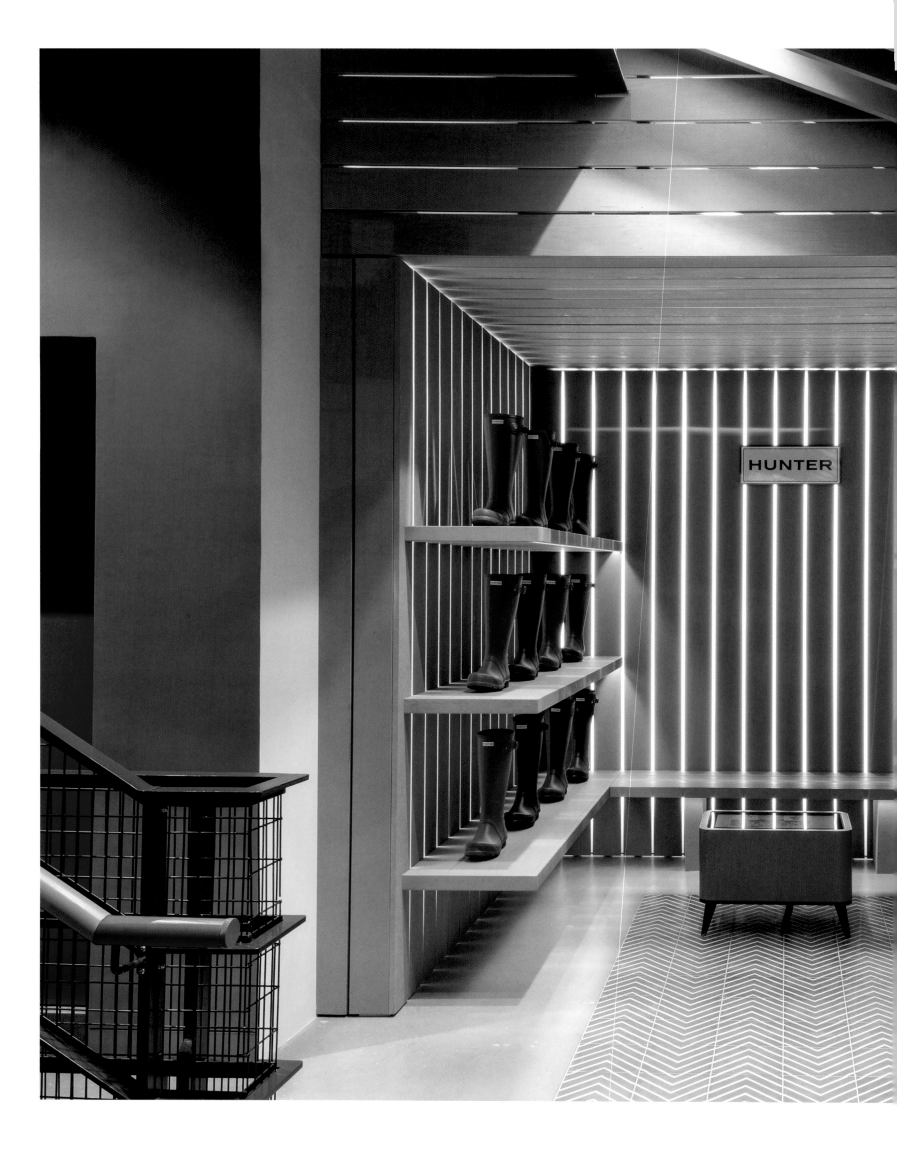

HUNTER
LONDON

Certainly by the time Kate Moss wore them with hot pants at the Glastonbury Festival, they became a cult hit: Hunter wellies, the stylish answer to constant rain showers and giant puddles. The official rubber boot supplier to the British royal family has now designed a full collection and even the right store to go with it on London's Regent Street—countryside meets urban attitude. Artificial box hedges, painted red displays, and green floor tile—imitating an English lawn–salute the British passion for gardening. A 16-foot LED wall provides live coverage of local weather conditions, and a recording of forest and meadow sounds plays in the elevator. Artificial sunlight streams through the slats of the ground-floor boot room, and a brick mirror separates the floor from the store's exposed concrete. It was important to creative director Alasdhair Willis to translate the brand's values into modern, strong architectural language. The flagship store was designed in cooperation with English design firm Checkland Kindleysides.

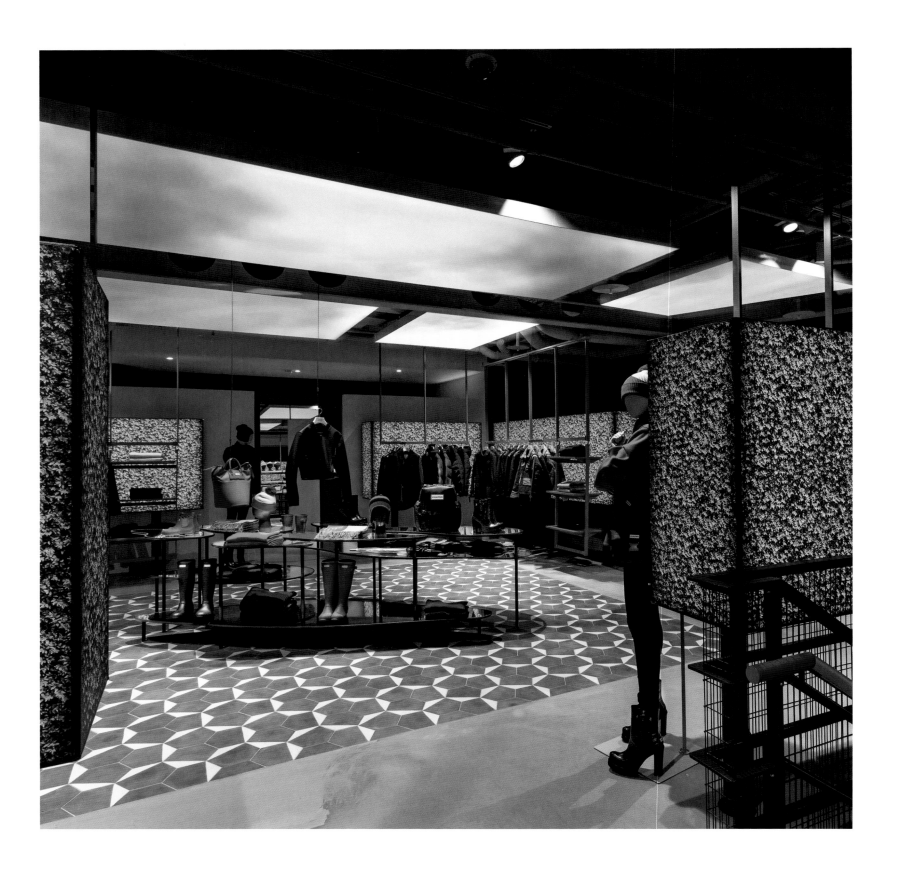

Spätestens seit Kate Moss sie beim Glaston-bury-Festival zu Hotpants trug, sind sie Kult: die Wellies von Hunter. Sie sind die stylishe Antwort auf Dauerregen und Riesenpfützen. Nun hat der Gummistiefel-Lieferant für das britische Königshaus eine vollständige Kollektion entworfen und den passenden Store gleich dazu. In der Londoner Regent Street trifft Countryside auf urbanes Lebensgefühl. Künstlich inszenierte Buchshecken, rot lackierte Warenträger und grüne – englischen Rasen imitierende – Bodenfliesen kokettieren mit britischer Gartenleidenschaft. Über eine fünf Meter hohe LED-Wand wird die Wetterlage der Insel topaktuell in den Laden geschaltet, und aus dem Fahrstuhl erklingt Wald- und Wiesenrauschen. Durch die Latten des Bootrooms im Erdgeschoss strahlt künstliches Sonnenlicht, der Boden grenzt sich durch einen Ziegelspiegel vom Sicht-beton des Stores ab. Kreativ-Chef Alasdhair Willis war es wichtig, die Markenwerte in eine moderne und starke Architektursprache zu übersetzen. Der Flagship Store entstand in Zusammenarbeit mit dem englischen Design-büro Checkland Kindleysides.

C'est au moins depuis que Kate Moss les a portées avec un mini-short au Festival de Glastonbury qu'elles sont devenues cultes : les Wellies de Hunter. Elles sont la réponse stylée à la pluie permanente et aux flaques géantes. Le fournisseur de bottes en caout-chouc de la famille royale britannique a dé-sormais créé une collection complète, et dans la foulée, la boutique qui va avec. Dans la rue londonienne de Regent Street, le style Countryside se mélange à un mode de vie urbain. Des haies de buis artificielles, des portants en vernis rouge et un carrelage vert, rappelant les fameuses pelouses anglaises, flirtent avec la passion anglaise pour les jar-dins. Dans la boutique, sur un mur de cinq mètres de haut éclairé par LED, la météo de l'île est présentée en continu, et de l'ascen-seur s'échappent des sons et ambiances de forêts et de prairies. Les stores de la Bootroom émettent des rayons solaires artifi-ciels, et le sol se distingue du béton apparent de la boutique grâce à un miroir de briques. Alasdhair Willis, le directeur artistique, voulait transposer les valeurs de la marque en un langage architectural moderne et puissant. Cette boutique vedette a vu le jour dans le cadre d'une collaboration avec le cabinet de designers Checkland Kindleysides.

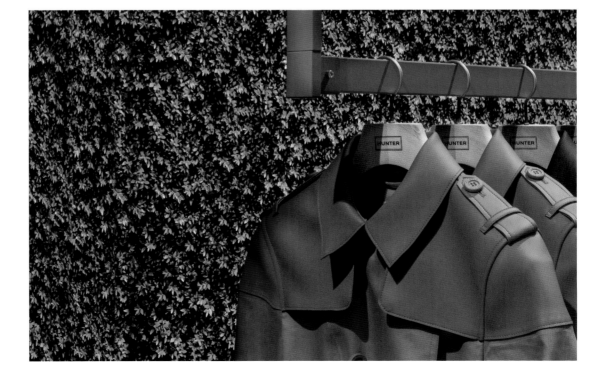

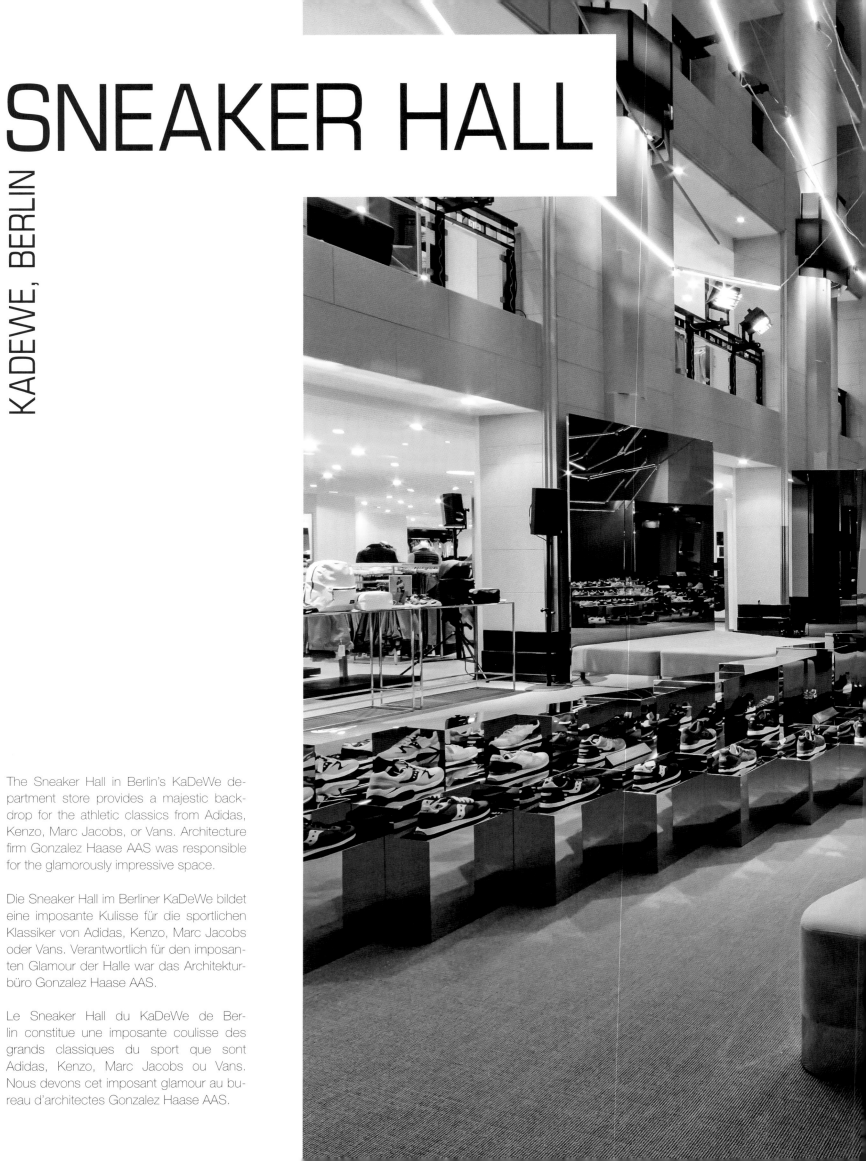

SNEAKER HALL

KADEWE, BERLIN

The Sneaker Hall in Berlin's KaDeWe department store provides a majestic backdrop for the athletic classics from Adidas, Kenzo, Marc Jacobs, or Vans. Architecture firm Gonzalez Haase AAS was responsible for the glamorously impressive space.

Die Sneaker Hall im Berliner KaDeWe bildet eine imposante Kulisse für die sportlichen Klassiker von Adidas, Kenzo, Marc Jacobs oder Vans. Verantwortlich für den imposanten Glamour der Halle war das Architekturbüro Gonzalez Haase AAS.

Le Sneaker Hall du KaDeWe de Berlin constitue une imposante coulisse des grands classiques du sport que sont Adidas, Kenzo, Marc Jacobs ou Vans. Nous devons cet imposant glamour au bureau d'architectes Gonzalez Haase AAS.

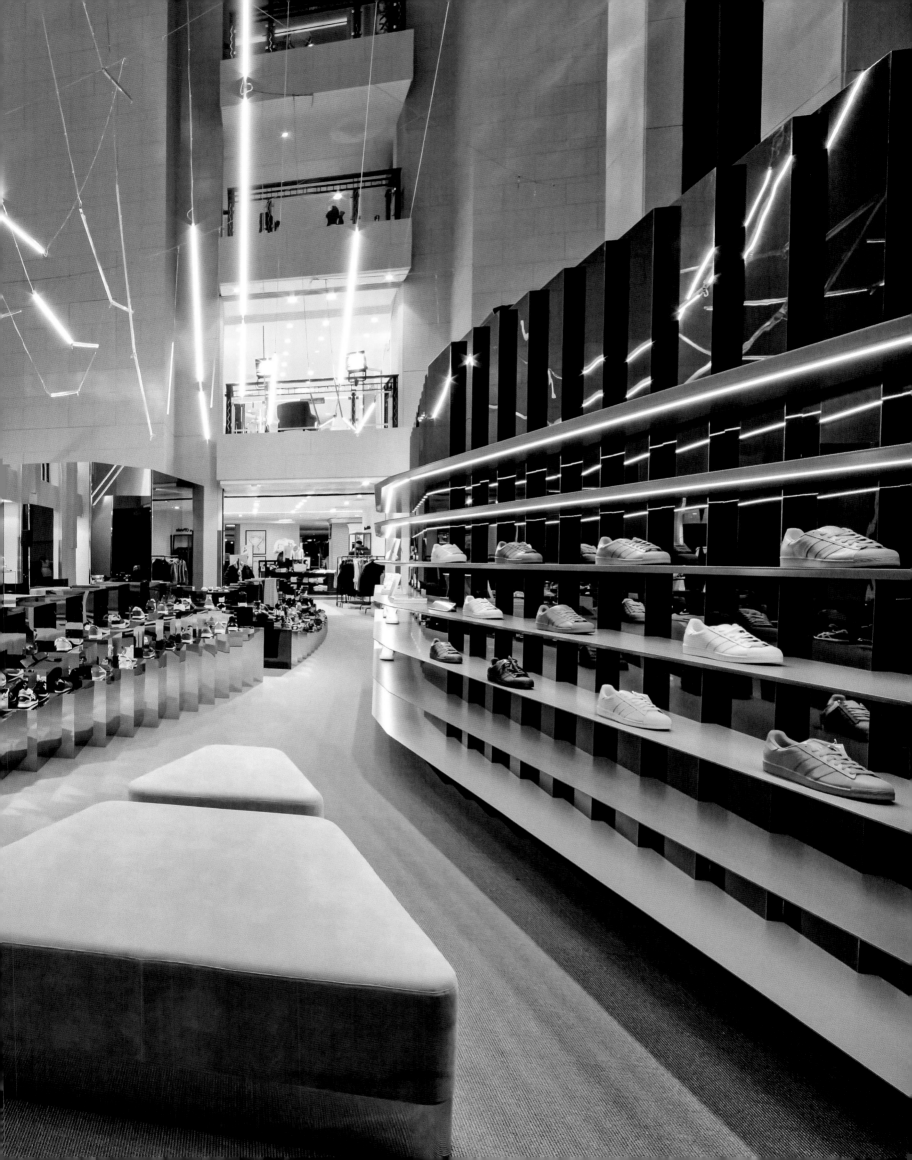

MILAN

Stephan Alesch and Robin Standefer are the creative duo behind the New York architecture firm Roman & Williams.

They are considered masters of the carefully orchestrated heritage look; their motto is that everything obeys the principles of a stage. What began as stage design at Hollywood film studios is now revolutionizing the accepted rules for store architecture. And their latest coup is the store for Italian denim brand Replay in the hip and trendy Porta Nuova section of Milan.

Hinter dem New Yorker Architekturbüro Roman & Williams steht das Kreativ-Duo Stephen Alesch und Robin Standefer.

Sie gelten als Meister des bewusst inszenierten Heritage-Looks. Alles gehorche den Prinzipien einer Kulisse, lautet ihr Credo. Was als Stage-Design in den Filmstudios Hollywoods begann, revolutioniert gerade gängige Regeln der Ladenarchitektur. Ihr neuester Coup: der Store für die italienische Denim-Marke Replay im Mailänder Szenestadtteil Porta Nuova.

Le duo formé par les créateurs Stephen Alesch et Robin Standefer est à l'origine du cabinet d'architectes new-yorkais Roman & Williams.

Ces deux créateurs sont considérés comme maîtres dans l'art de la mise en scène du style « Heritage ». Leur credo est que tout répond aux principes des coulisses. Ce qui a commencé en tant que design de scène des studios de cinéma hollywoodiens est en train de révolutionner les règles courantes de l'architecture des boutiques. Leur dernier coup : la boutique de la marque italienne Replay, dans le quartier branché de Porta Nuova à Milan.

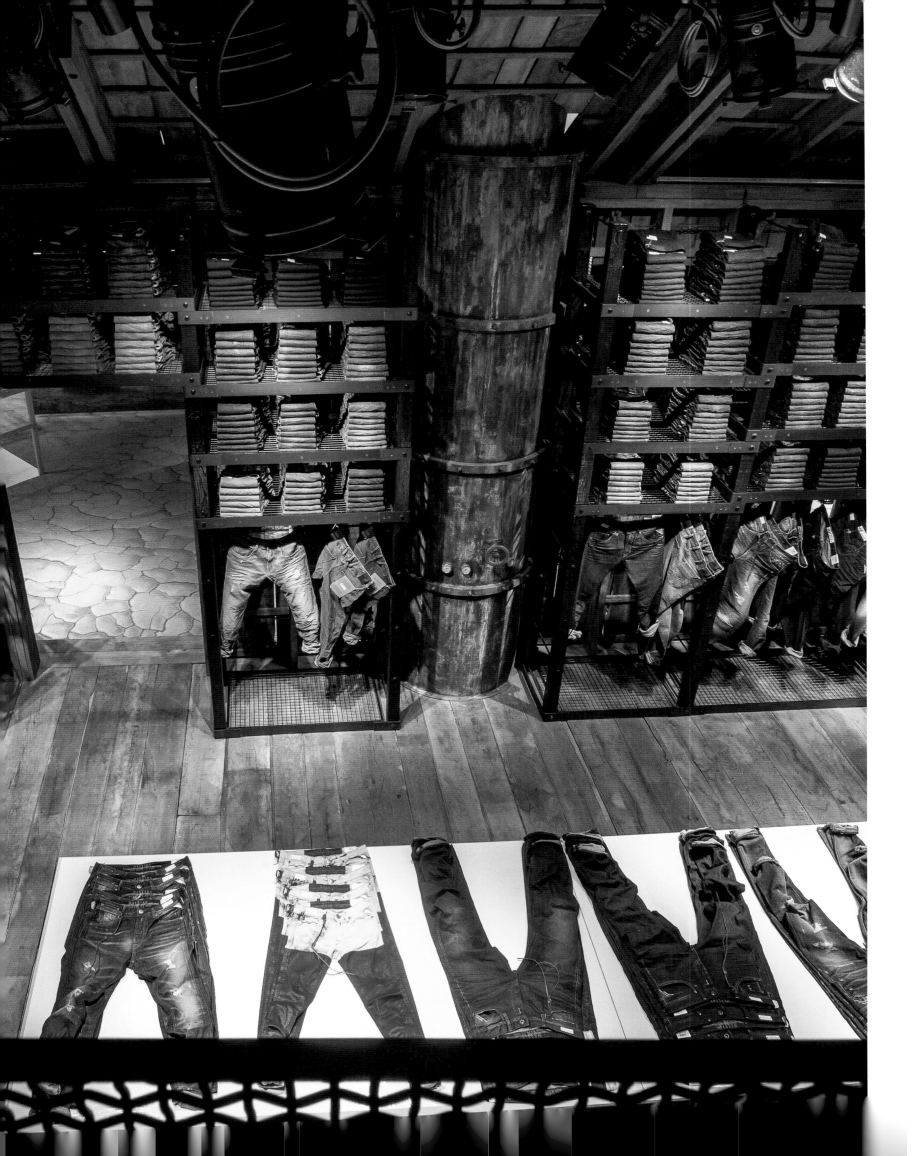

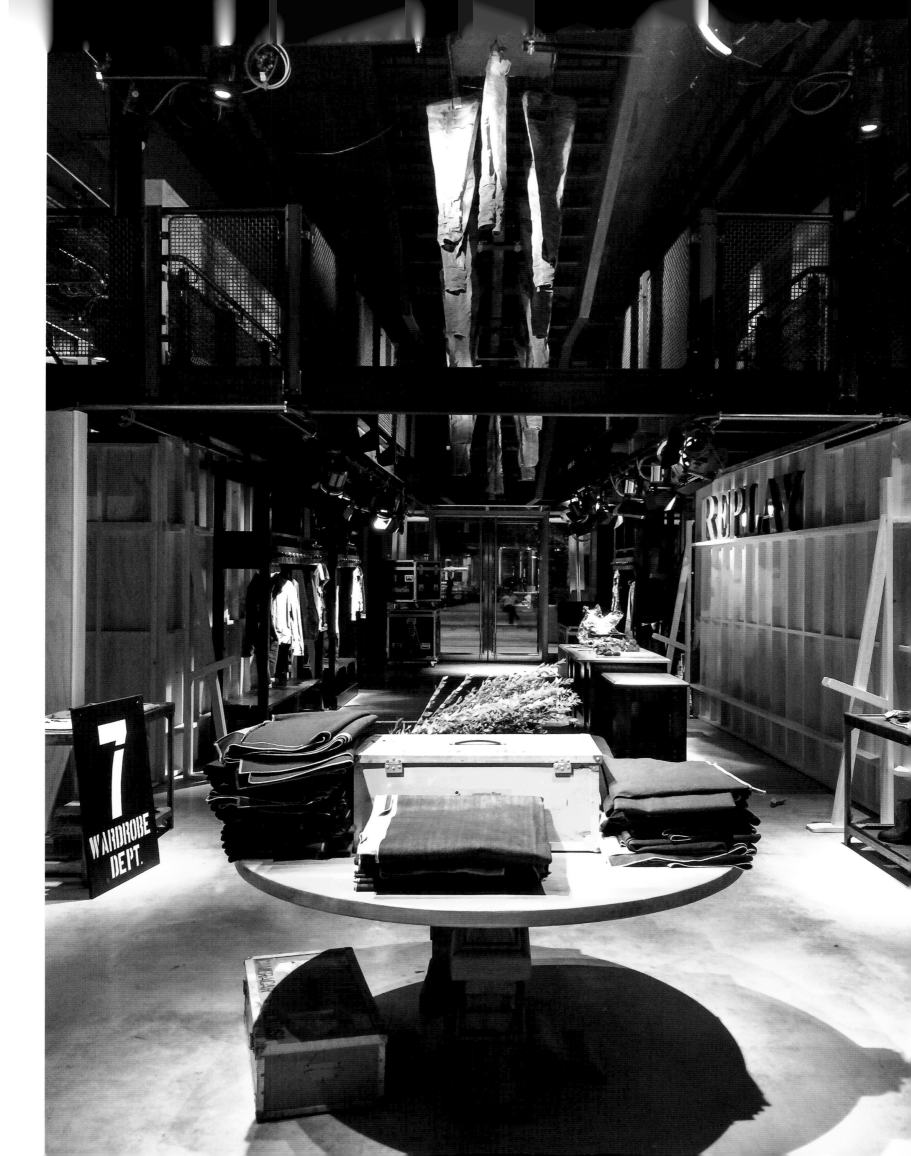

What was the set concept underlying the Milan Replay store design?

We spent ten years designing movie sets. The idea of a stage backdrop can be applied to retail settings as well: a store has to be able to adapt and re-invent itself to effectively showcase different collections and varying merchandising concepts. We think it's exciting that there are different sets for the store that are just waiting to make an appearance.

What approaches and ideas did you come up with to make that happen?

The design concept for the store is based on our set design experience. On the one hand, we went with a very theatrical design that shows the power of nature. For example, there's a tornado of brass butterflies concealing a typical Midwestern house, as well as a collapsed barn in a dried-up desert landscape. But we were equally intrigued with the idea of backstage elements of a movie set, which gives customers the feeling of going behind the scenes. The key concept behind the store is that we offer an exciting look at things both onstage and offstage. It surprises people and shows the best of both worlds.

Are there differences in designing for stores versus restaurants or homes?

Conceptually speaking, the process for retail design is very similar. You have to create a certain atmosphere and make it a place where people want to spend their time. A place where they feel comfortable, but willing to try something new and interact with their environment. We love places that have a life of their own and inspire guests with their story.

How do you develop a concept for a new project?

We want to create an atmosphere that draws people inside, regardless of how the space will ultimately be used. That is the primary focus for everything we design. We want to give places meaning, and sometimes create a history or strengthen an existing history. People want to experience places with depth and feel a connection to them. You can't do that with decoration alone. You need to tell a richer story.

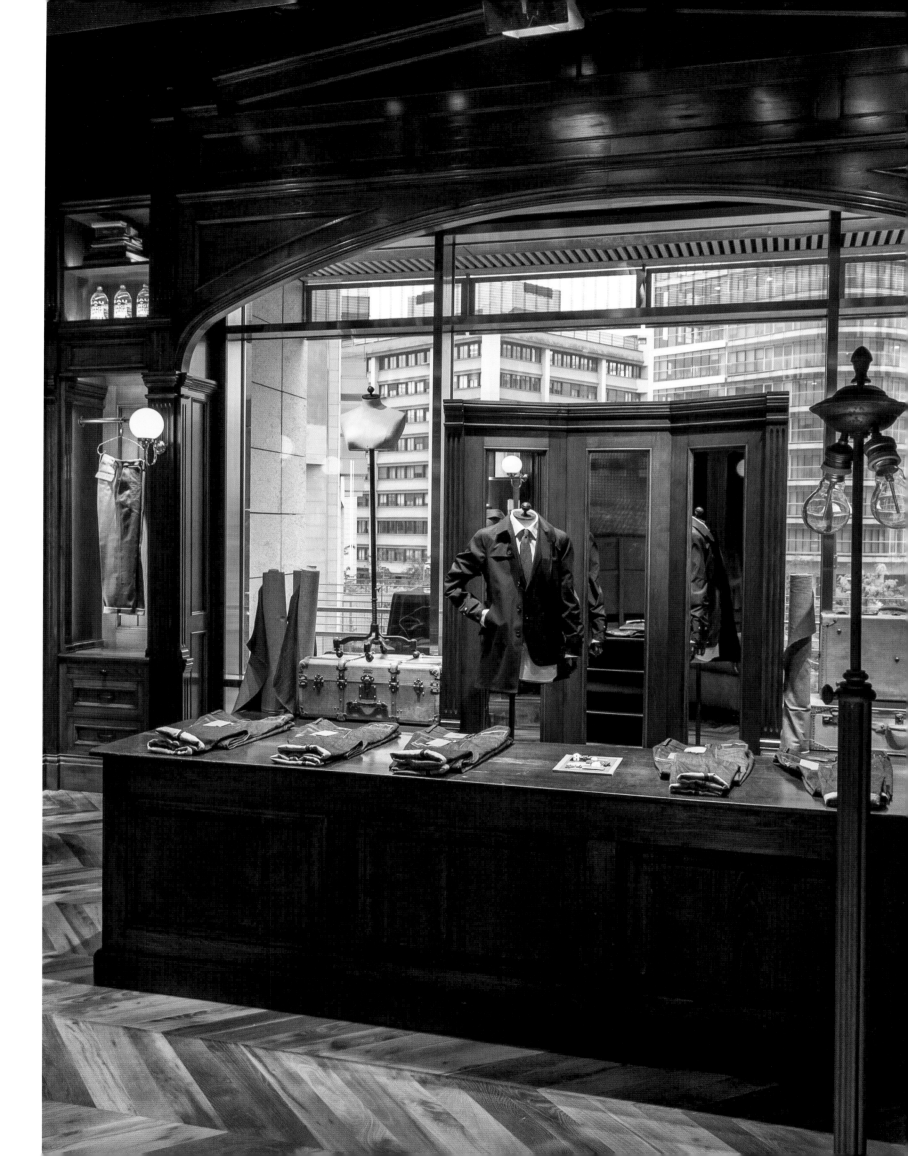

Was war die Setting-Idee für das Design des Replay Stores in Mailand?

Wir haben zehn Jahre lang Filmsets entworfen. Die Idee einer Bühnenkulisse lässt sich auf Retail übertragen: Ein Store muss in der Lage sein, sich den verschiedenen Kollektionen und dem wechselnden Merchandising anzupassen und sich entsprechend zu verändern. Wir finden es spannend, dass es verschiedene Sets für den Store gibt, die darauf warten, in Erscheinung zu treten.

Welche Ideen und Ansätze wurden entwickelt, um das zu realisieren?

Das Designkonzept des Stores basiert auf unseren Set-Erfahrungen. Wir haben uns einerseits für eine sehr theatralische Gestaltung entschieden und uns an Naturschauspielen orientiert. Da gibt es beispielsweise einen Tornado aus Messing-Schmetterlingen, der ein typisches Midwest-Haus verhüllt, oder eine verfallene Scheune in einer verdorrten Wüstenlandschaft. Aber genauso interessant erschien uns die Verwendung von Backstage-Elementen eines Filmsets. Das gibt den Besuchern das Gefühl, hinter die Kulissen schauen zu können. Leitende Idee des Stores ist es, spannende Blickwechsel sowohl vor als auch hinter die Kulissen zuzulassen. Das überrascht und zeigt das Beste aus beiden Welten.

Gibt es Unterschiede bei der Gestaltung von Stores, Restaurants oder Häusern?

Eine Retail-Location, ein Restaurant oder privaten Wohnraum zu designen ist eigentlich ein konzeptionell ähnlicher Prozess. Es muss eine bestimmte Atmosphäre geschaffen werden, um die Location in einen Ort zu verwandeln, an dem Menschen gerne ihre Zeit verbringen. An dem sie sich wohl fühlen, sich aber auch ausprobieren und mit ihrer Umgebung interagieren können. Wir lieben Orte, die lebendig sind und durch ihre Story inspirieren.

Wie nähert man sich konzeptionell einem neuen Projekt?

Indem man eine Atmosphäre erschafft, die in den Bann zieht – unabhängig von der finalen Verwendung. Das ist der primäre Fokus für alles, was wir entwerfen. Wir wollen Orten eine Bedeutung, manchmal auch eine Historie geben. Oder eine bereits existierende Geschichte verstärken. Menschen möchten Orte mit Tiefe erleben, um Verbundenheit zu fühlen. Das erreicht man nicht mit bloßer Dekoration. Dazu braucht es eine andere Erzähltiefe.

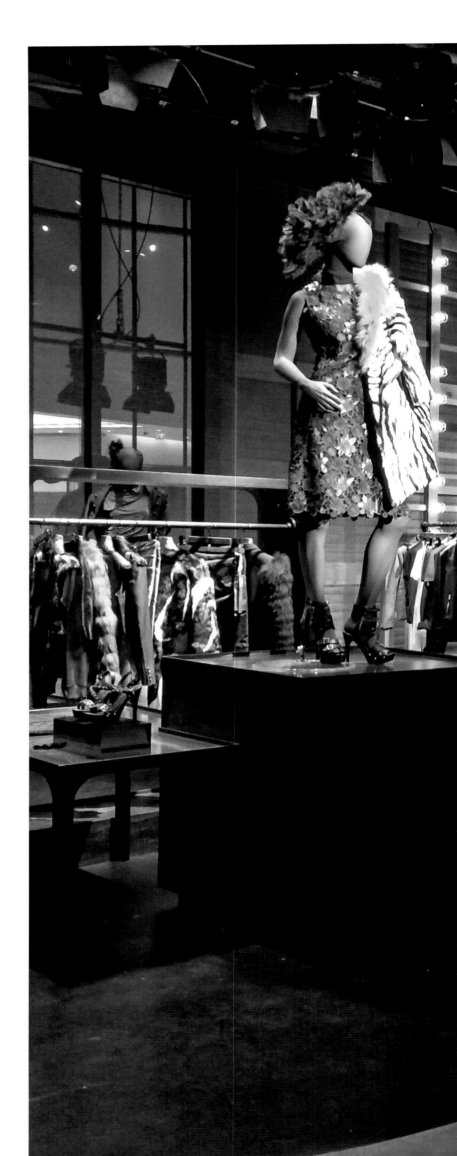

Quelle était l'idée de décor pour la conception de la boutique milanaise Replay ?

Nous avons conçu des plateaux de tournage de cinéma pendant dix ans. L'idée de coulisses de scène est transposable au commerce de détail : une boutique doit être en mesure de s'adapter aux différentes collections et aux changements de merchandising, et de changer en conséquence. Nous trouvons passionnant le fait qu'il existe plusieurs plateaux pour la boutique, qui attendent d'entrer en scène.

Quelles sont les idées et les approches ont été développées, à la réaliser ?

Le concept de design de boutiques se base sur notre expérience des plateaux de tournage. Nous avons d'une part opté pour un agencement très théâtral, tout en nous inspirant des spectacles de la nature. On trouve par exemple une tornade de papillons en laiton enveloppant une maison de style typique Midwest, ou encore une grange en ruines au milieu d'un paysage désertique et asséché. Mais nous avons trouvé tout aussi intéressant d'utiliser des éléments évoquant les coulisses d'un plateau de tournage de cinéma. Cela donne aux visiteurs l'impression de pouvoir deviner les coulisses. L'idée directrice de la boutique est de permettre des coups d'œil passionnants aussi bien devant que derrière les coulisses. L'effet est surprenant, et permet de découvrir le meilleur de ces deux univers.

Existe-t-il des différences au niveau de la conception de boutiques, de restaurants et de maisons ?

Concevoir une boutique, un restaurant ou une habitation privée est un processus de concept similaire. On crée une certaine atmosphère afin de transformer le lieu en un espace où les gens aiment passer leur temps. Un espace où ils se sentent bien, et qui donne envie de découvrir et d'interagir avec leur environnement. Nous aimons les endroits pleins de vie et qui inspirent par leur histoire.

Au niveau conceptionnel, comment se rapproche-t-on d'un nouveau projet ?

En créant une atmosphère envoûtante, quelle que soit son utilisation finale. C'est l'objectif premier, quoi que nous créions. Notre volonté est de conférer aux lieux une signification, parfois même une histoire. Ou renforcer un passé déjà existant. Les gens souhaitent faire l'expérience de lieux ayant de la profondeur, afin de s'y sentir liés. Cela n'est pas possible par le seul moyen de la décoration. Pour y parvenir, il faut une autre profondeur de narration.

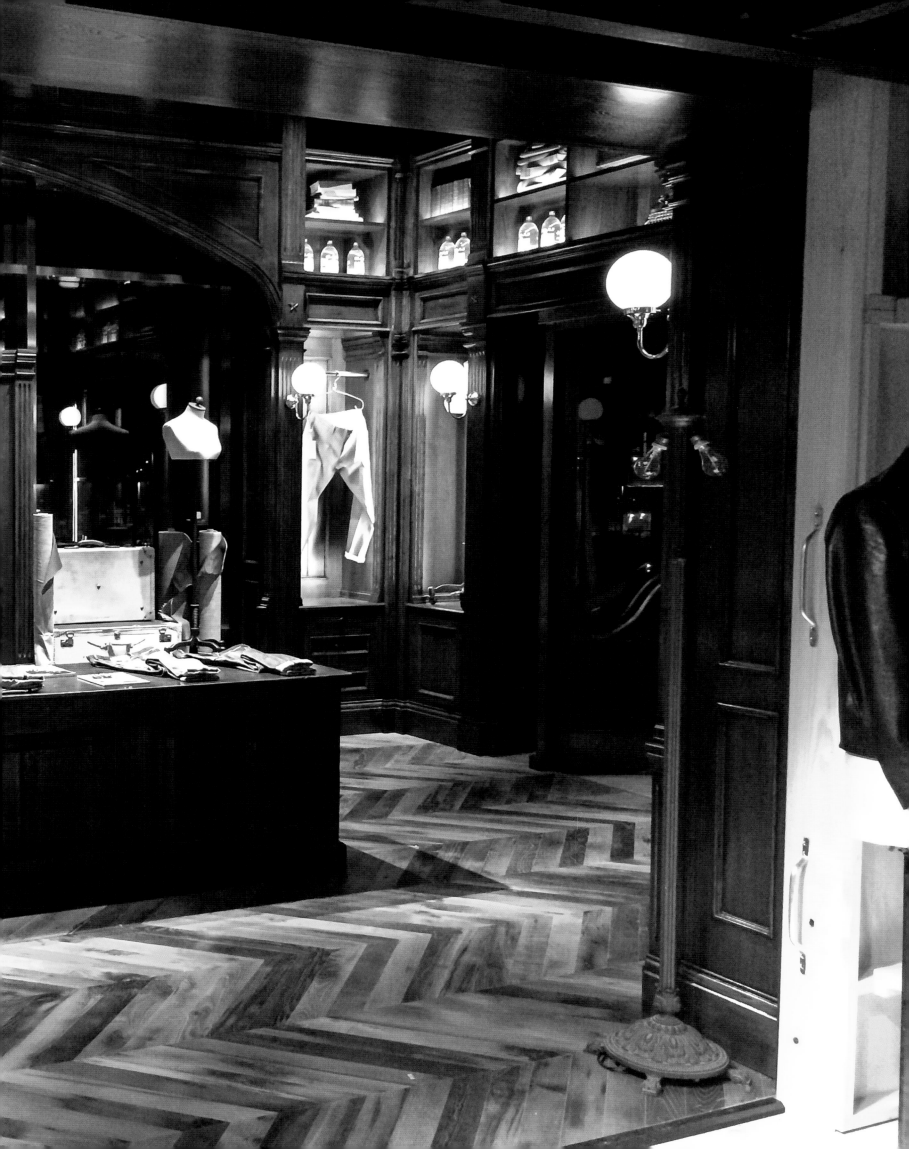

"Every concept must first be established and lived in the marketplace."

Dirk Moysig, Moysig Retail Design

BUGATTI

GÜTERSLOH

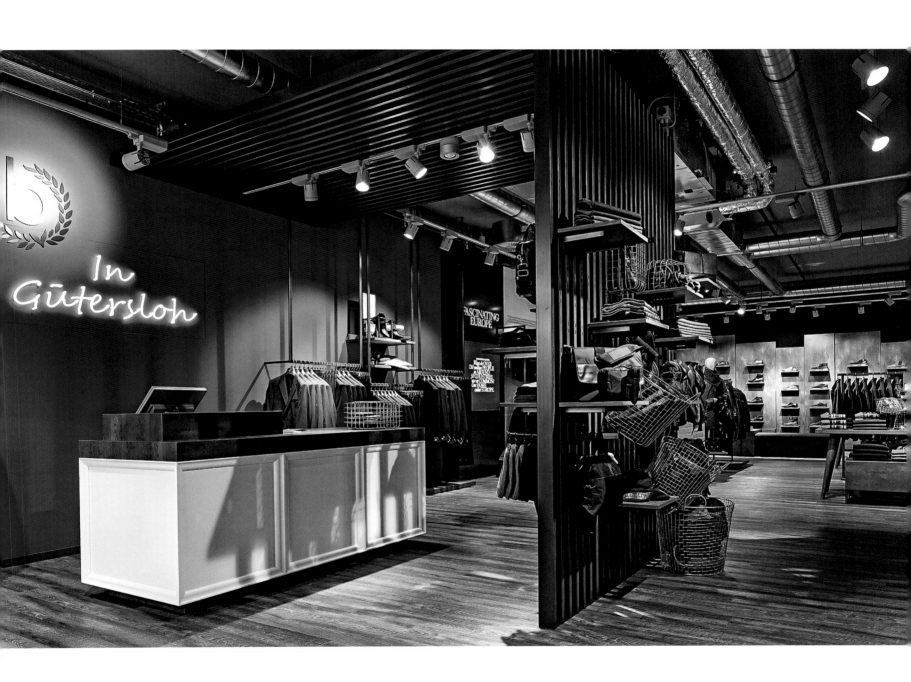

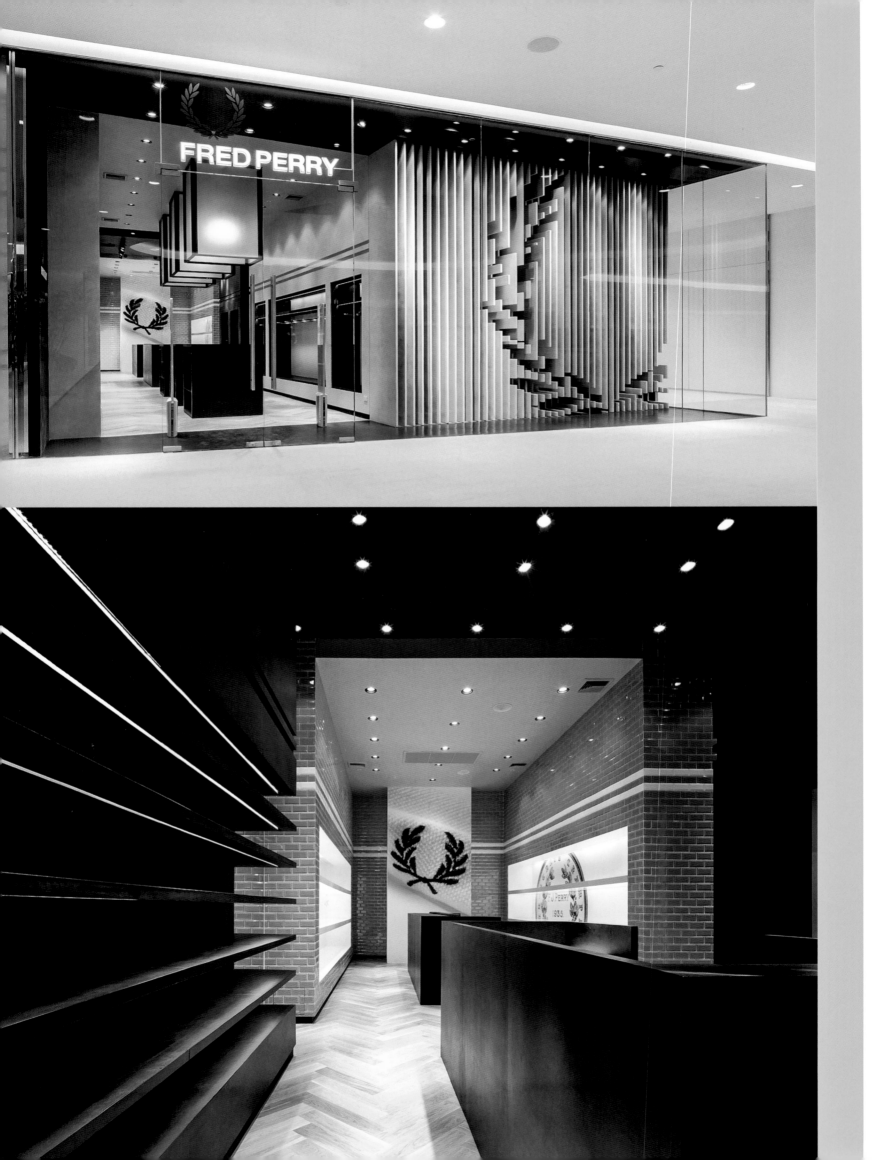

FRED PERRY

BANGKOK

"We want to bring some Britishness to Bangkok without slapping the Union Jack all over the walls. The store design subtly fuses the coolness of British culture with the sporty, tradition-filled history of the Fred Perry brand," explains Paul White of architecture firm Buckley Gray Yeoman. This is the principle behind the idea to render the brand logo, a laurel wreath, as a wooden relief carving. The store's black steel, yellow tile, and polished wood are reminiscent of London Tube stations. The logo can also be seen stitched on the walls, emulating the classic Fred Perry polo shirt.

„Wir wollten etwas Britishness nach Bangkok bringen, ohne die Wände mit dem Union Jack zu bekleben. Das Storedesign vereint nun subtil die Coolness britischer Kultur mit der sportlichen und traditionsreichen Geschichte der Marke Fred Perry", erklärt Paul White vom Architekturbüro Buckley Gray Yeoman die Idee, das Markenlogo – den Lorbeerkranz – als Relief aus Holz zu inszenieren. Schwarzer Stahl, gelbe Fliesen und poliertes Holz erinnern an die Bahnhöfe der Londoner Tube. Das Logo findet sich auch als Stitching an den Wänden und imitiert damit den Klassiker von Fred Perry: das Poloshirt.

« Nous voulions apporter l'esprit britannique à Bangkok sans pour autant placarder les murs avec l'Union Jack. Le design de la boutique associe avec subtilité la sobriété de la culture britannique avec l'histoire sportive et riche en traditions de la marque Fred Perry », déclare Paul White du bureau d'architectes Buckley Gray Yeoman pour expliquer l'idée de mettre en scène le logo de la marque (la couronne de lauriers) sous forme de relief en bois. L'acier noir, les carreaux jaunes et le bois poli rappellent les gares du métro londonien. Le logo se retrouve également sur les murs sous forme de broderie, imitant ainsi le grand classique de Fred Perry : le polo.

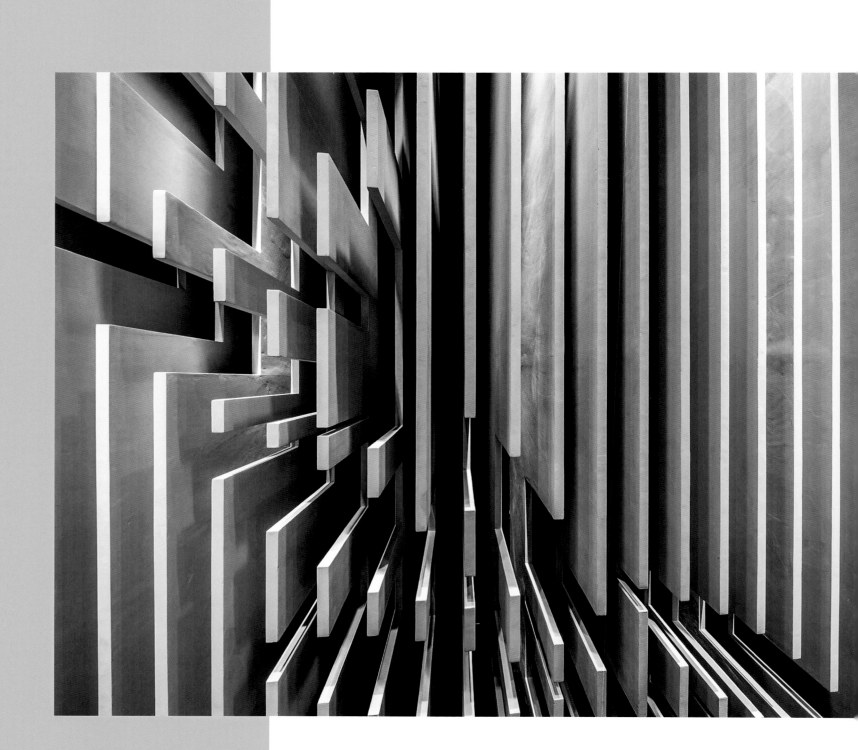

"We want to bring some British-ness to Bangkok without slapping the Union Jack all over the walls."

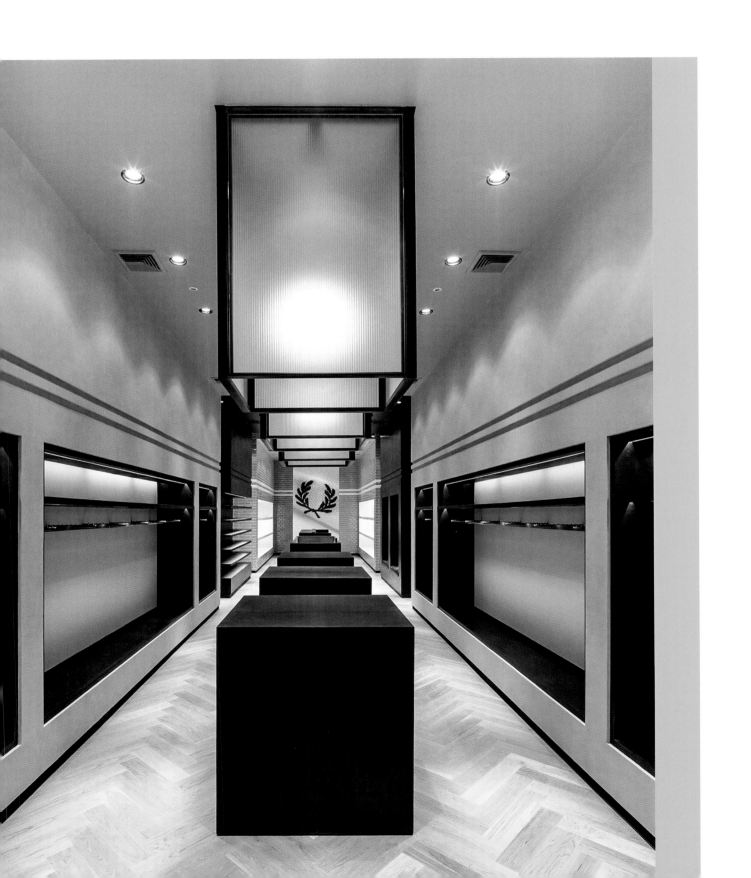

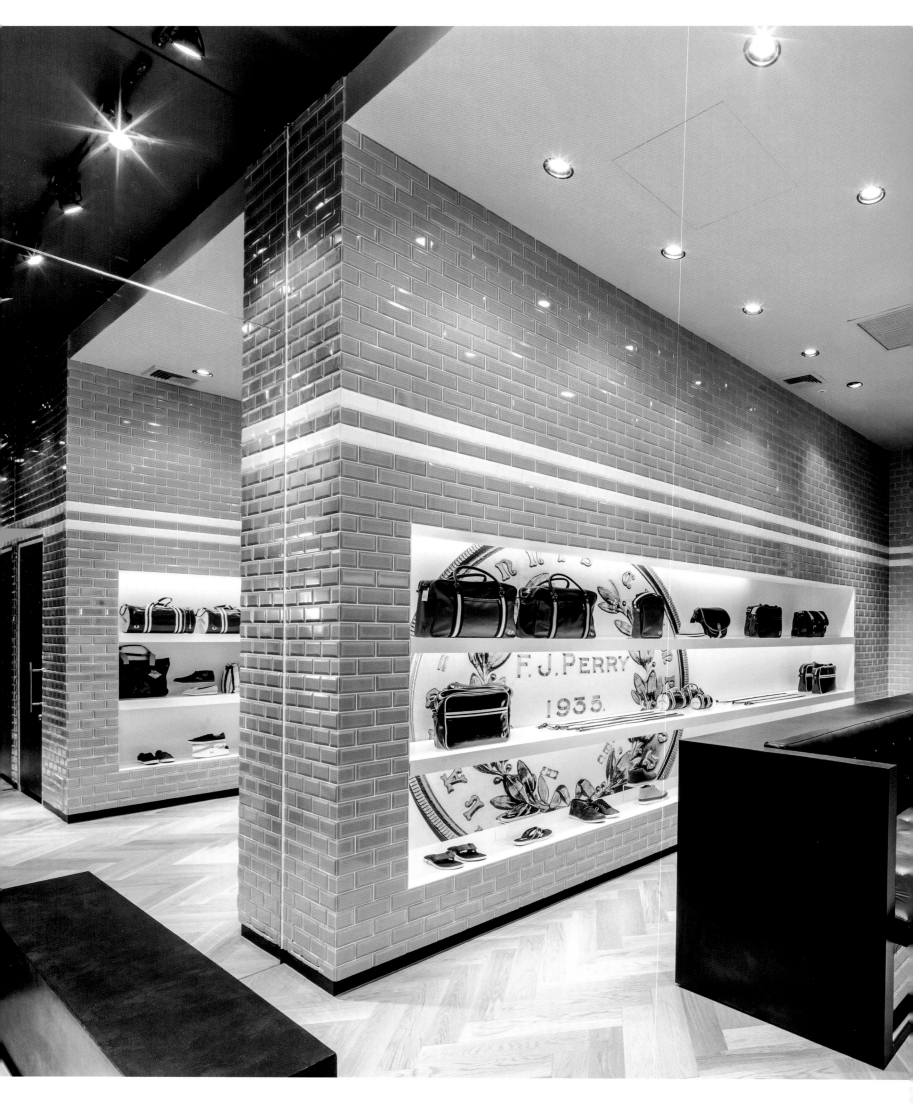

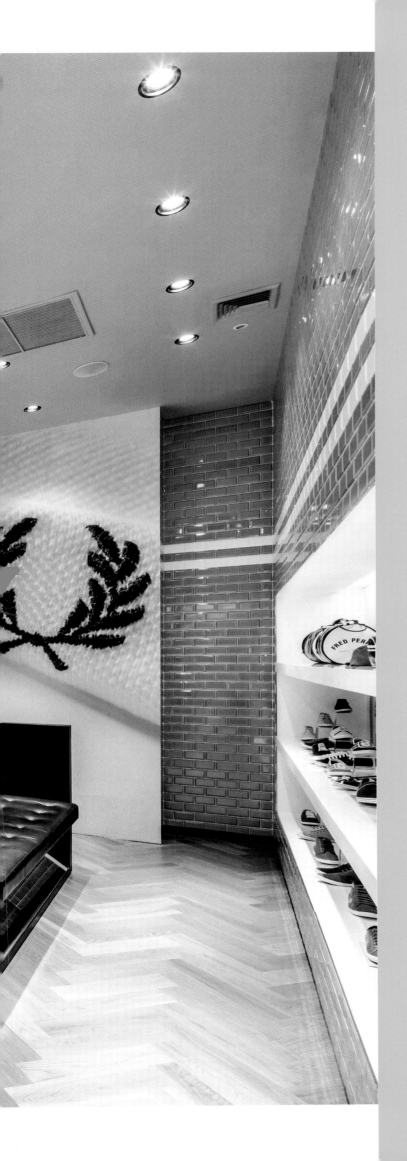

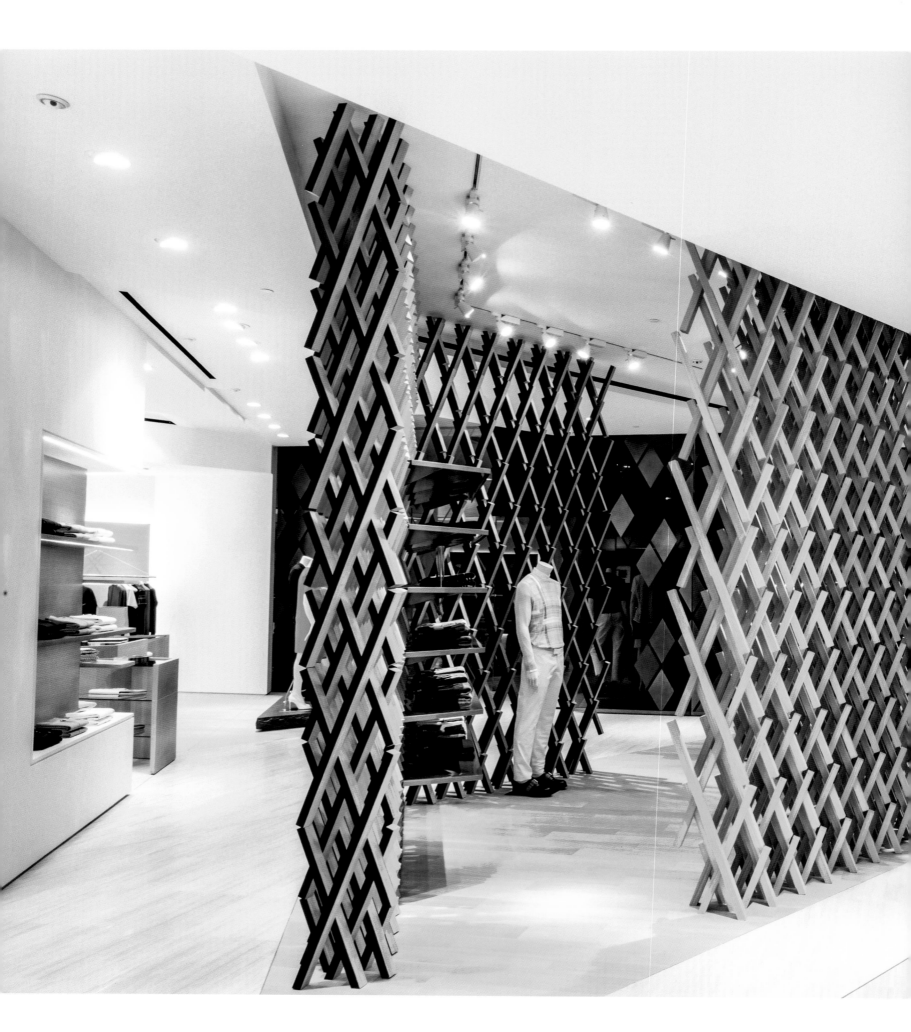

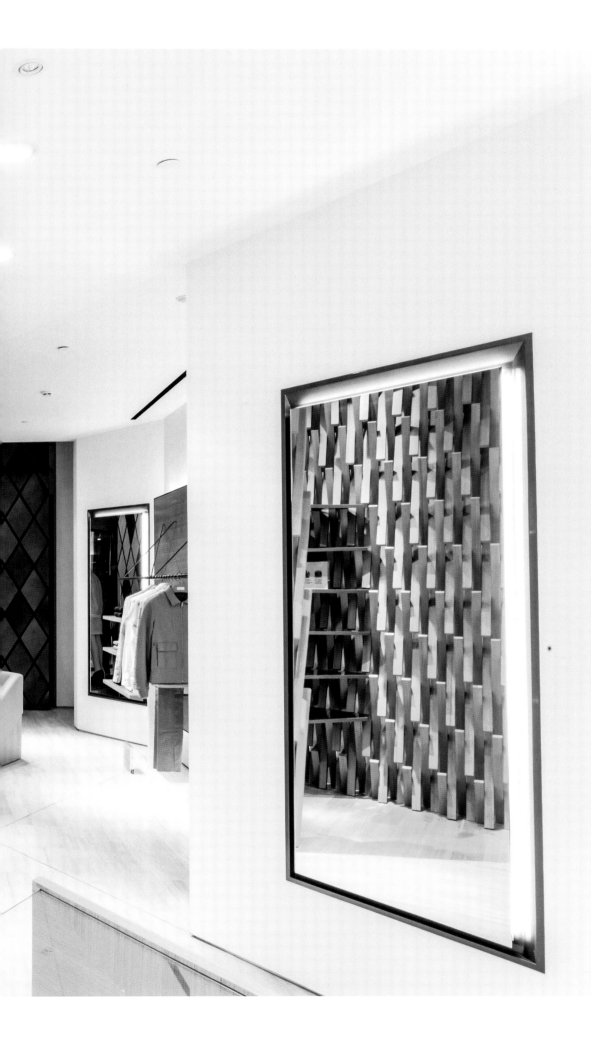

PRINGLE OF SCOTLAND

CHENGDU

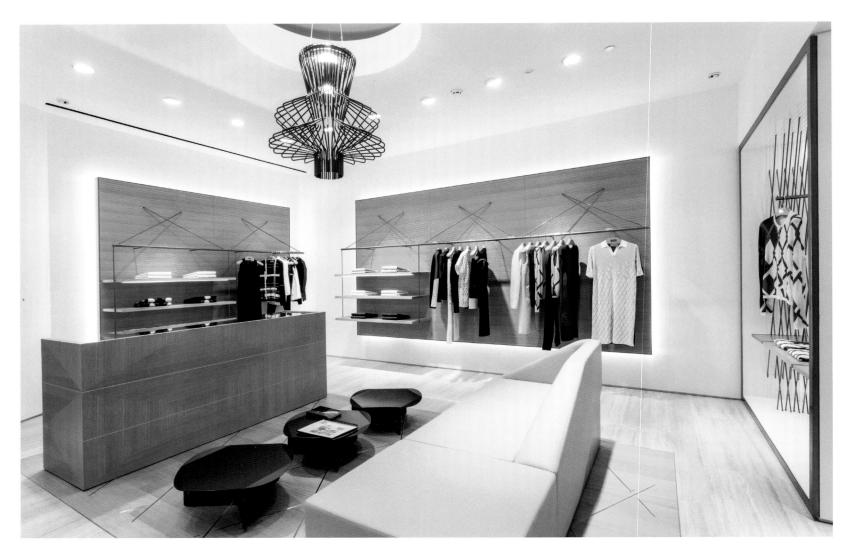

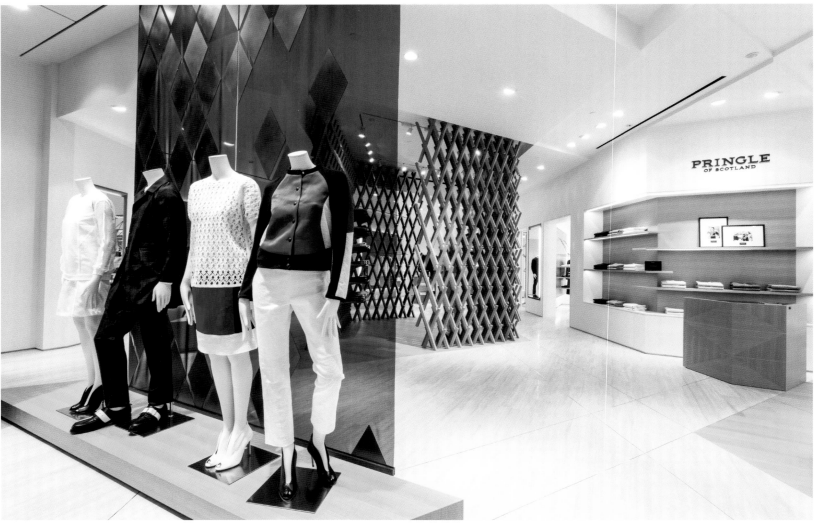

Swiss design firm Atelier oï turned a brand's heritage into a store concept: the argyle pattern, a diagonal Scottish diamond that is the hallmark of Pringle of Scotland, echoes through every aspect of the design. At the entrance, it dominates the front display windows as a metal element, and inside, it is a focal point, this time in wood. The materials used for the store design are also references to the brand's roots: wood and stone embody the typical landscapes of Scotland.

Das Schweizer Atelier oï setzte die Markenheritage in ein Storekonzept um: Das Argyle-Muster, ein schräg stehendes Schottenkaro und das Markenzeichen von Pringle of Scotland, zieht sich durch das gesamte Design. Im Eingang dominiert es die Schaufensterfront als Konstruktion aus Metall, und im Inneren ist es als Holzkonstruktion zentrales Element. Auch die verwendeten Materialien sind Anspielungen auf die Wurzeln der Marke: Holz und Stein sollen die typische Landschaft Schottlands verkörpern.

L'atelier suisse oï a transposé l'héritage de la marque dans son concept de boutique : Le jacquard argyle, un tissu écossais en biais et le logo de la marque Pringle of Scotland, se retrouvent dans tout le design. À l'entrée, le logo domine la vitrine sous forme de construction en métal, et à l'intérieur, sous forme de construction en bois, il constitue l'élément central. Les matériaux utilisés font allusion aux racines de la marque : Le bois et la pierre ont pour fonction de rappeler les paysages typiquement écossais.

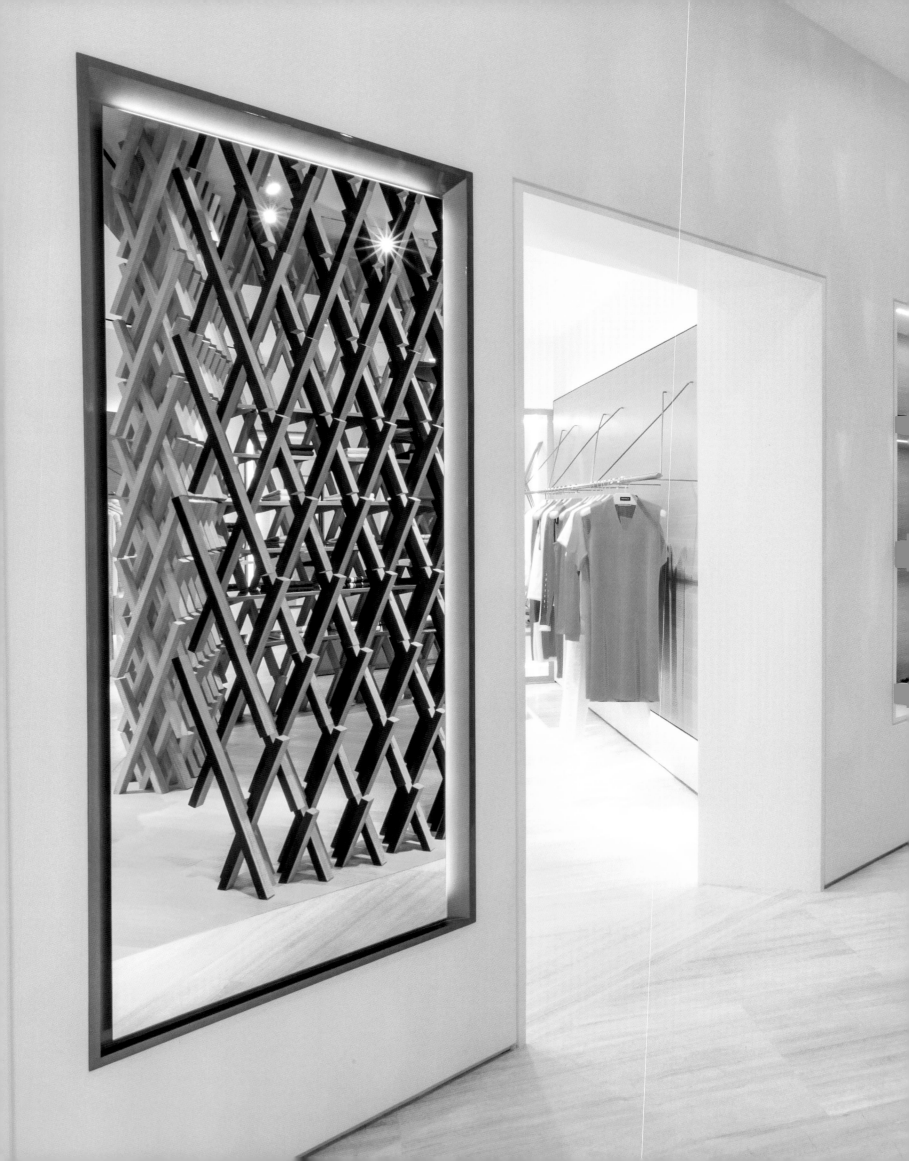

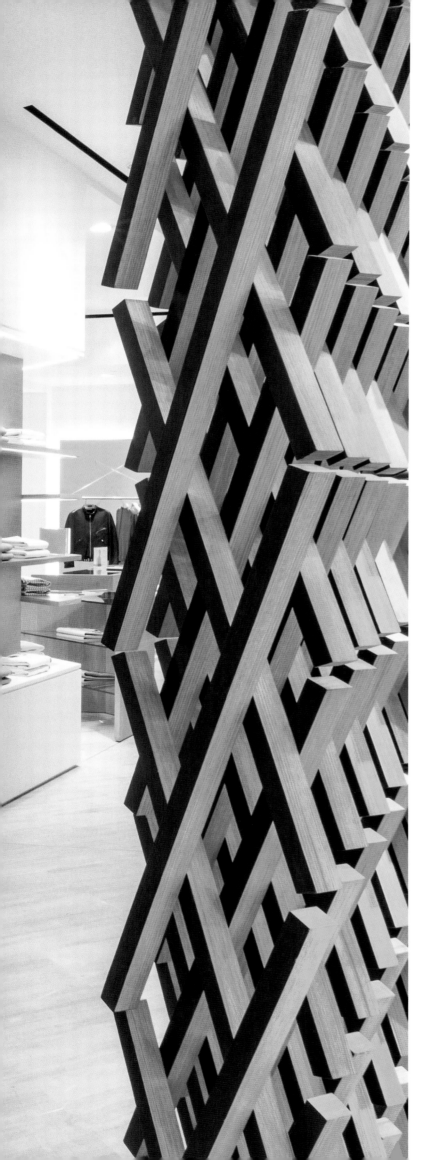

"For the Store I was determined to create a retail Environment filled with desire, emotion and passion."

Karim Rashid, Designer

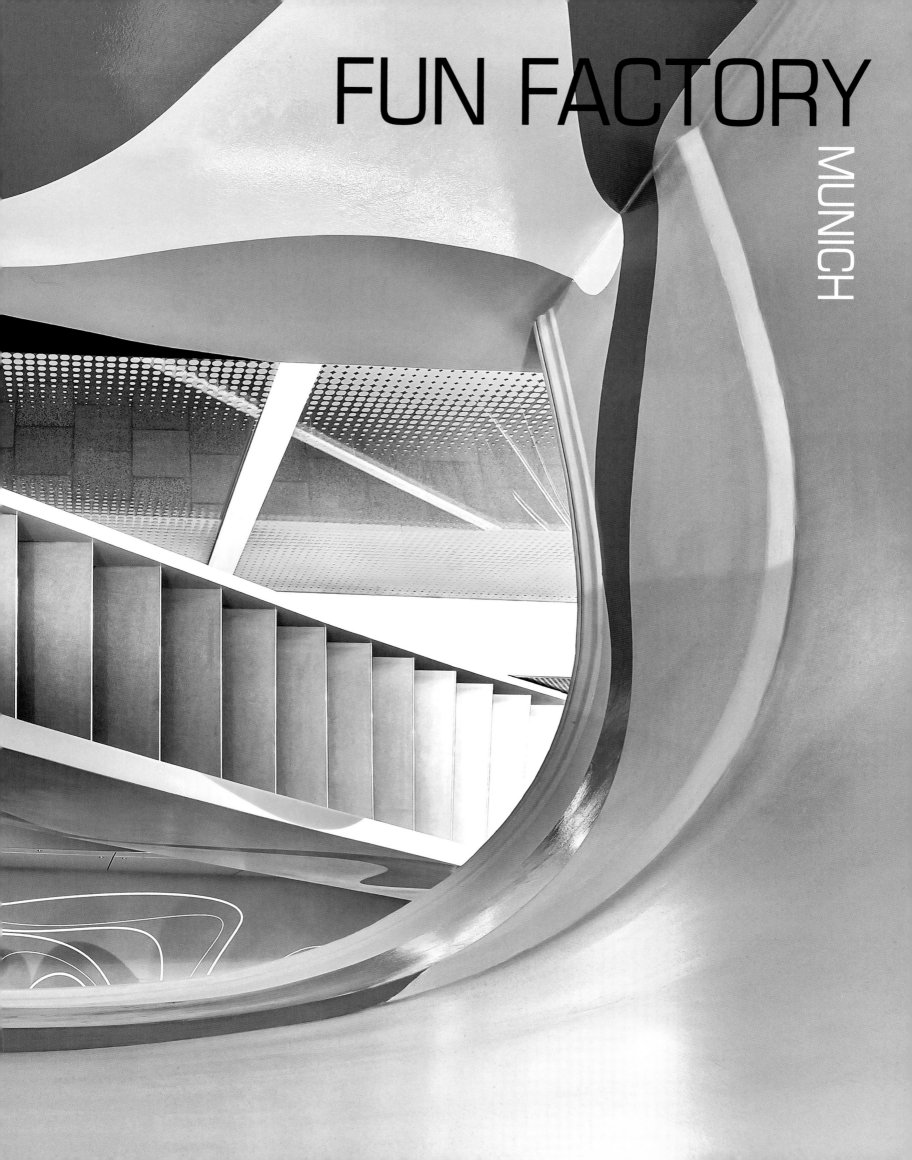

FUN FACTORY

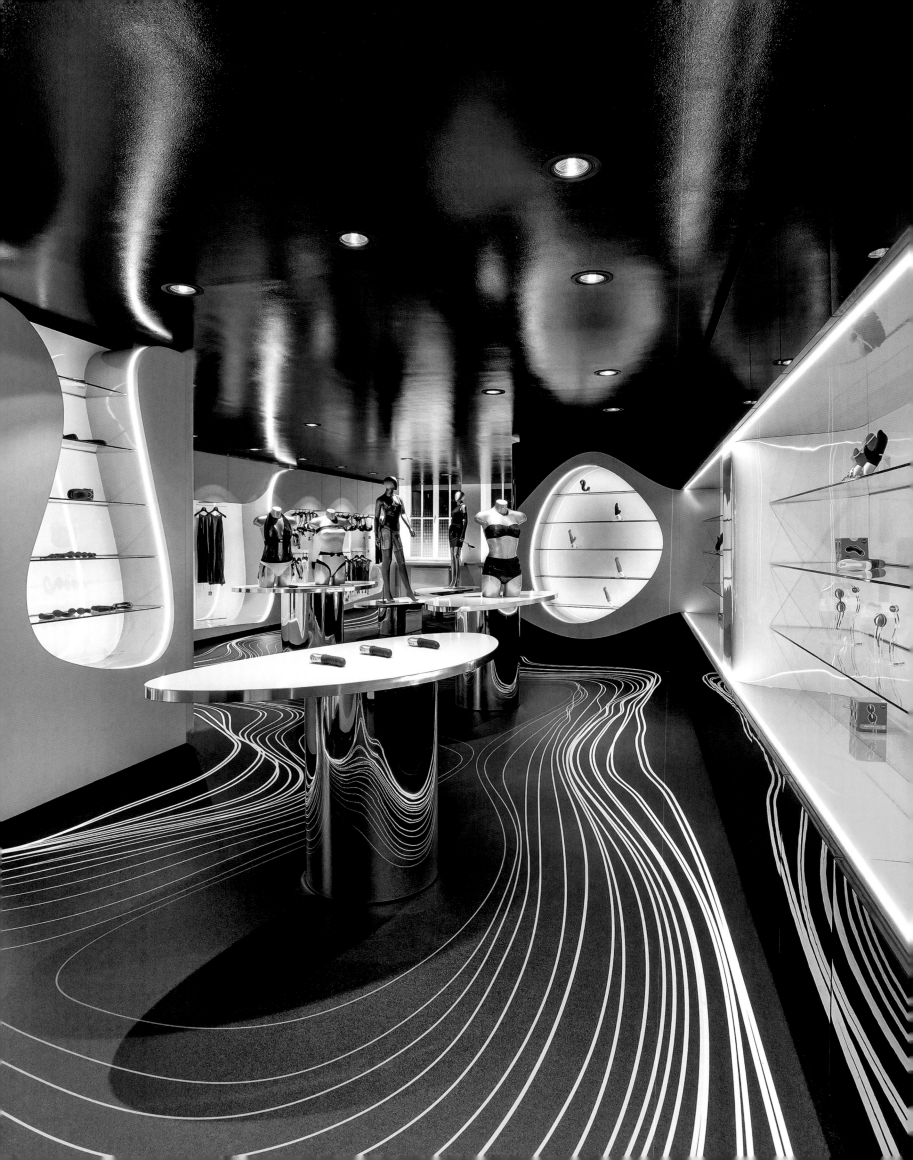

A red-light district transformed into the center of design : Fun Factory CEO Dirk Bauer combined desire with style, engaging star designer Karim Rashid to create avant-garde product and retail designs that turned sex shops into luxurious hot spots.

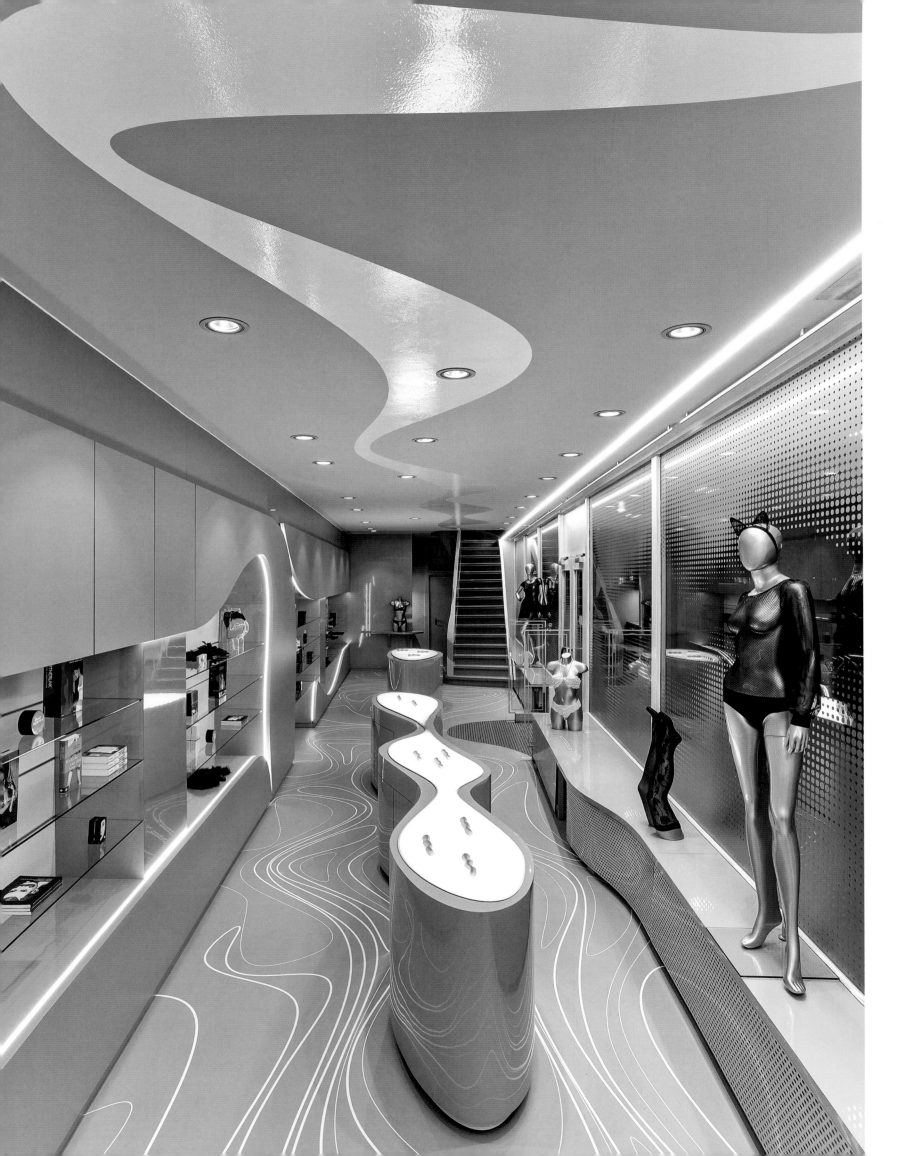

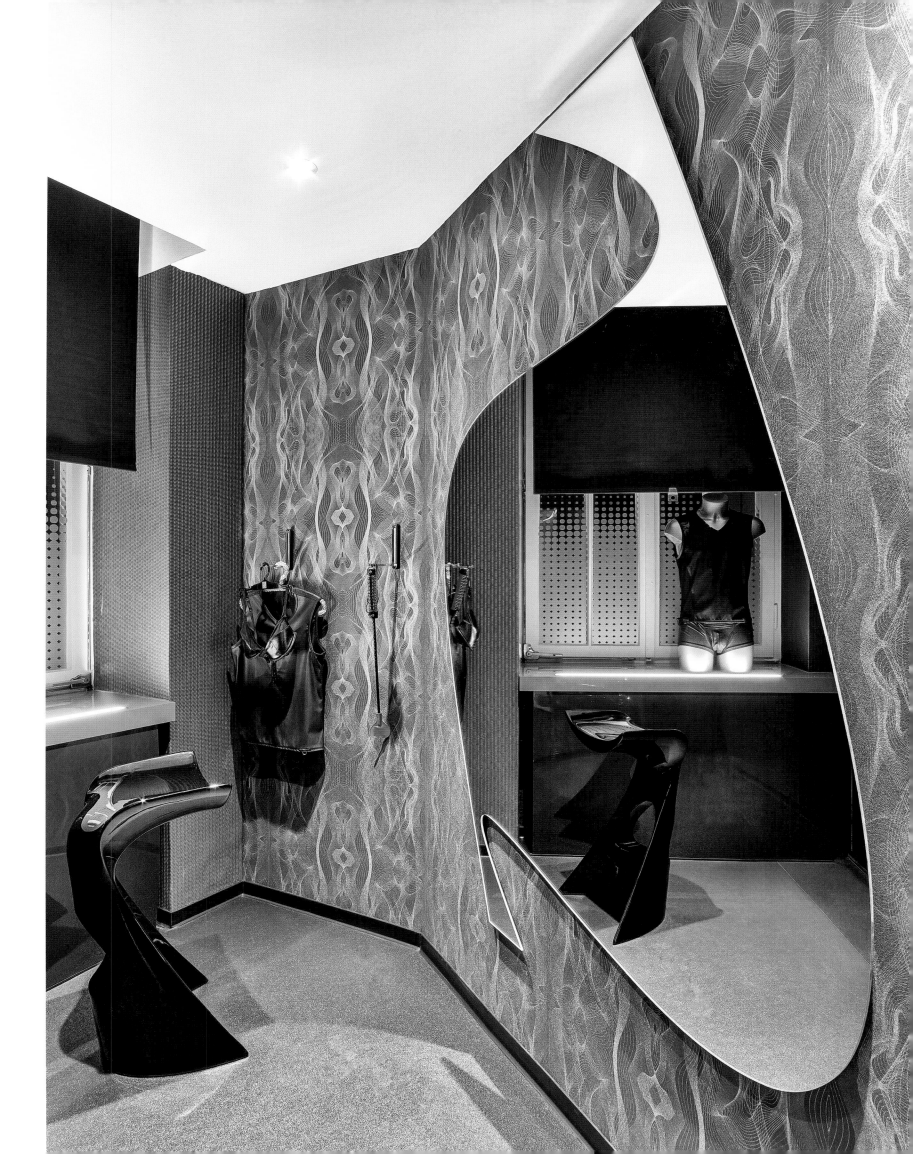

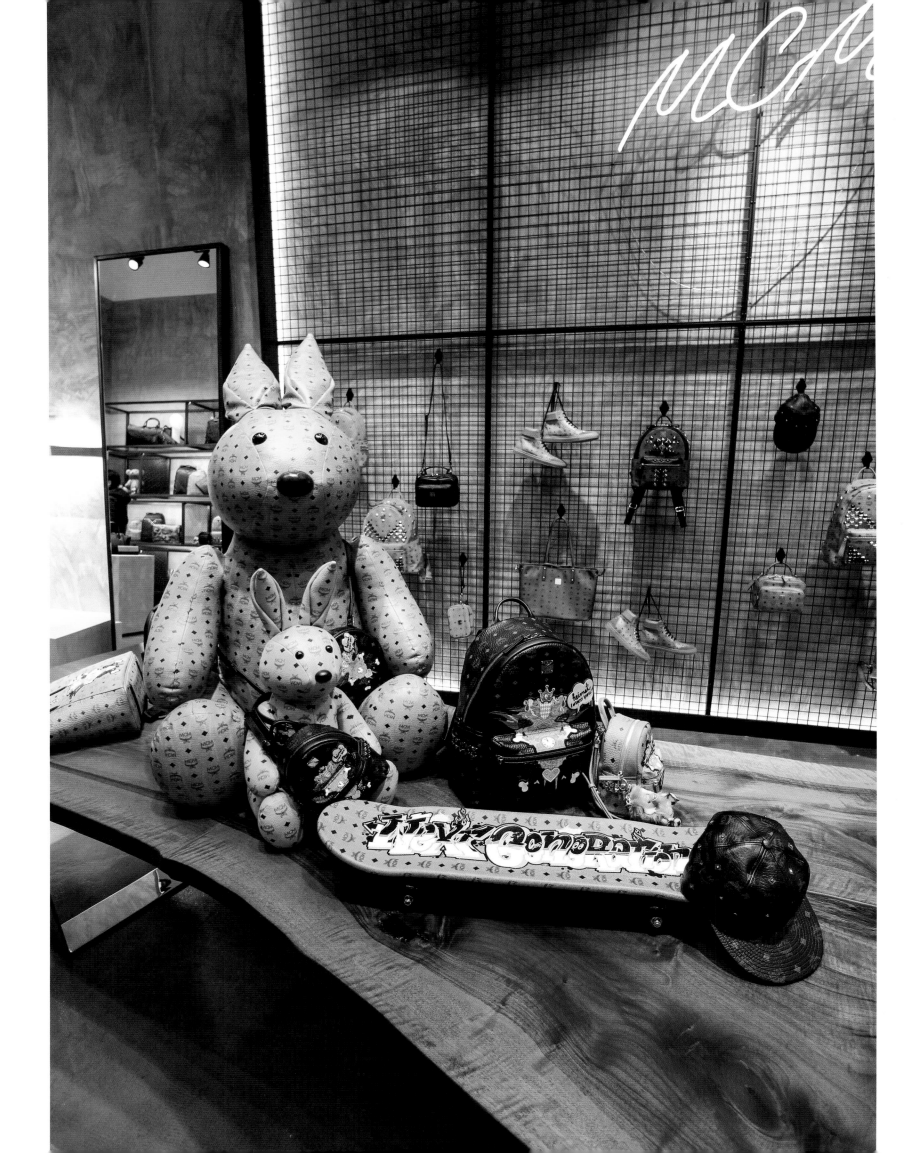

MCM Berlin

A successful label comeback: in 1976, Munich native Michael Cromer struck a fashion nerve. His MCM brand cognac-colored bags were high society's "it piece." The laurel wreath-adorned logo stands both for the founder's initials and the Roman numeral 1900 — the beginning of an era where traveling and mobility became the sign of a modern society. After years of ups and downs, the brand has a new signature and is once again on the road to success. It deliberately evokes the legendary Munich glamour of the '70s to create a mood. The Berlin store combines street life with luxury elements: untreated wood tables stand side by side with showy neon lights. The seating is also completely consistent with the brand's corporate identity.

Gelungenes Label-Comeback: 1976 traf der Münchner Michael Cromer den Nerv der Zeit. Die cognacfarbenen Taschen seiner Marke MCM wurden zum It-Piece der High Society. Dabei steht das mit Lorbeerblättern verzierte Logo sowohl für die Initialen des Gründers als auch für die römische Zahl 1900 – dem Beginn einer Epoche, in der Reisen und Mobilität das Zeichen einer modernen Gesellschaft wurden. Nach wechselvollen Jahren befindet sich die Marke nun mit neuer Handschrift wieder auf Erfolgskurs. Atmosphärisch wird an den legendären Münchner Glamour der 70er-Jahre angeknüpft. Der Berliner Store verbindet Streetlife mit luxuriösen Elementen: Naturbelassene Holztische stehen neben auffälligen Neonleuchten. Die Sitzelemente sind ganz in der CI der Marke gehalten.

Un retour réussi : en 1976, le Munichois Michael Cromer connut un grand succès, et les sacs couleur cognac de sa marque MCM devinrent les objets cultes de la Jet Set. Le logo, orné de feuilles de laurier, représente d'une part les initiales de son créateur, et d'autre part le chiffre romain 1900 : le début d'une époque où le voyage et la mobilité devinrent les symboles d'une société moderne. Après plusieurs années riches en évènements et une nouvelle griffe, la marque se trouve désormais à nouveau sur la voie du succès. Son ambiance vise à rappeler le légendaire glamour munichois des années 1970. La boutique berlinoise combine streetlife et éléments de luxe : Des tables en bois laissées à l'état naturel jouxtent d'ostentatoires néons. Les assises correspondent parfaitement à la corporate identity de la marque.

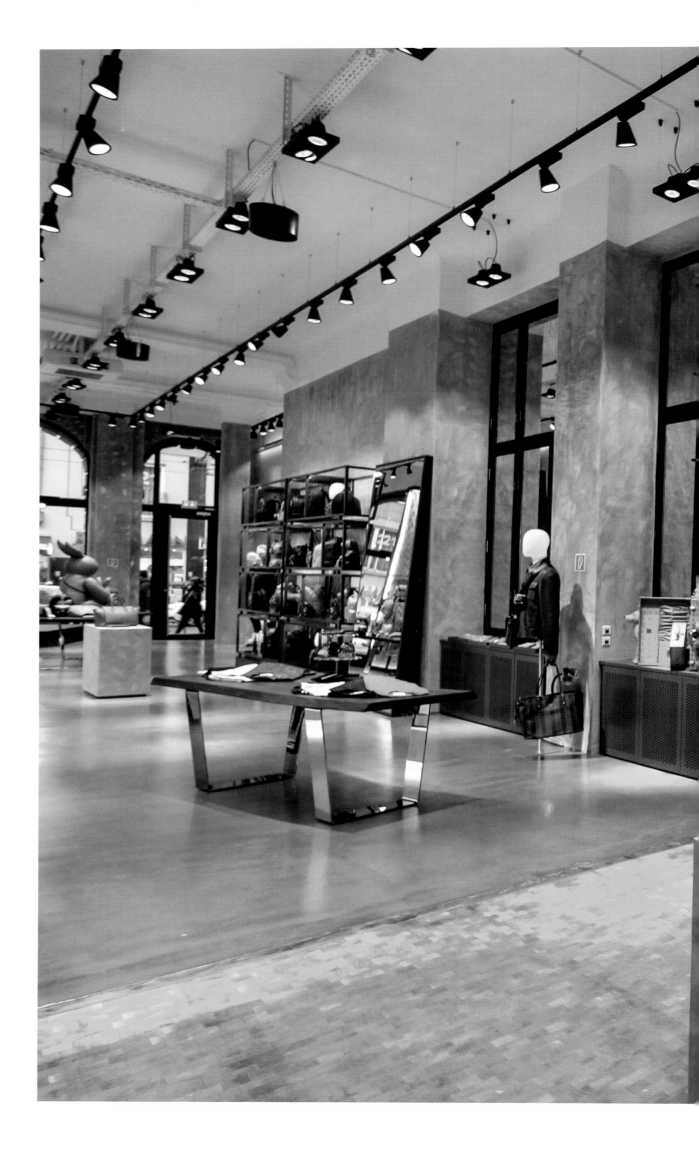

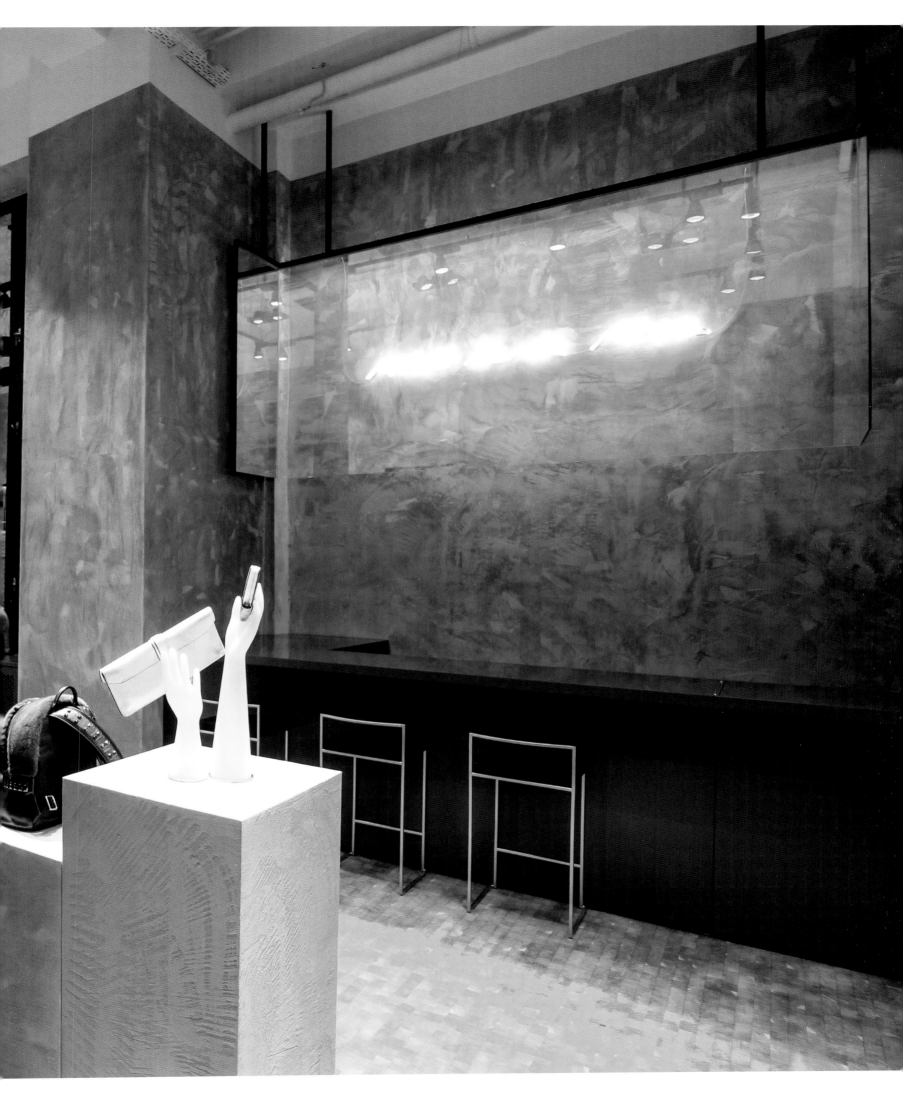

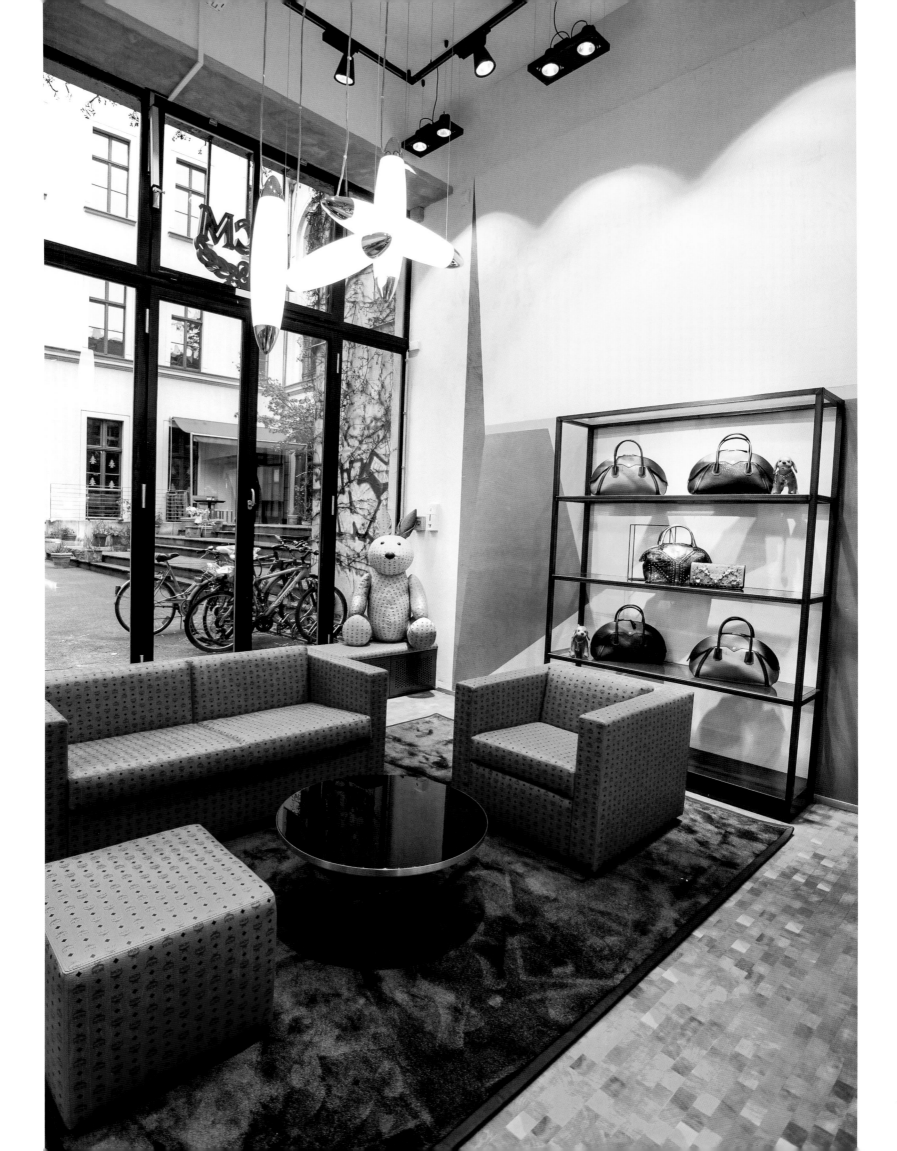

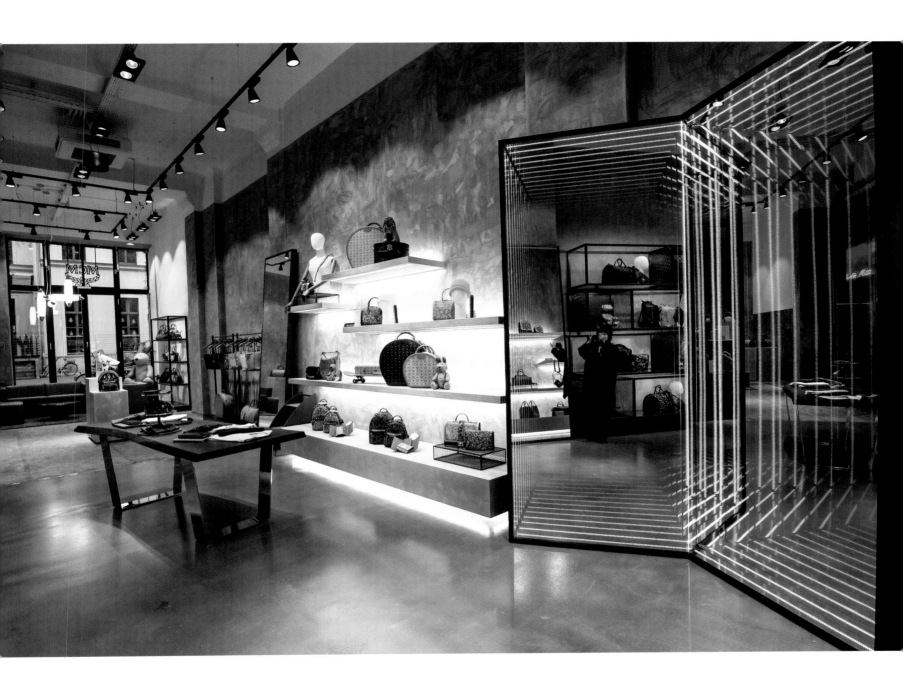

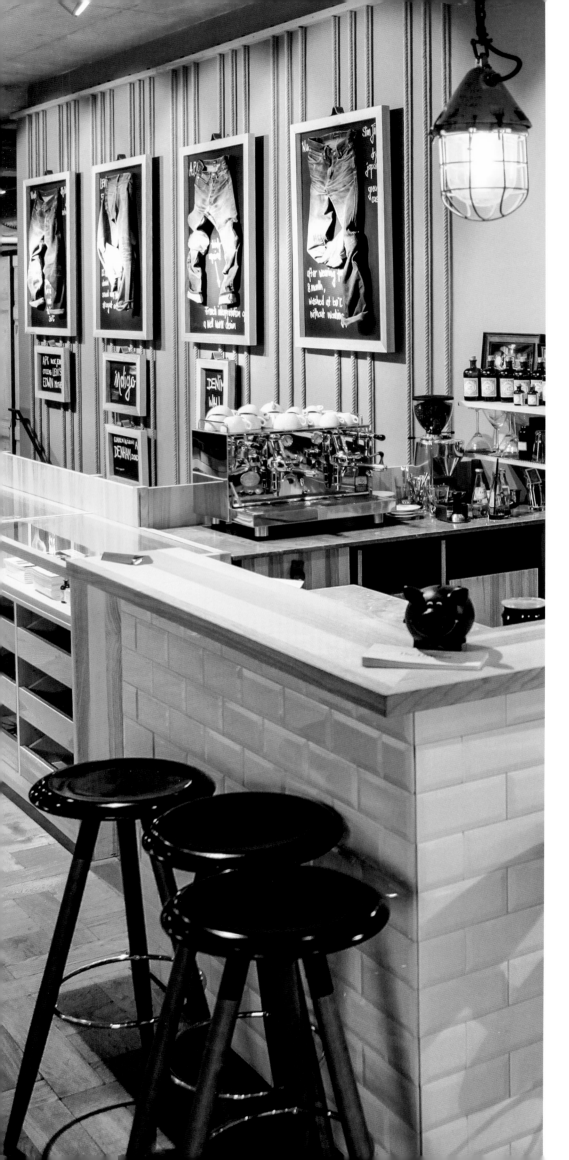

Nomen est omen—the old saying is certainly true of The Listener. As the business name says, those who run the store have made it a top priority to listen to their customers and adjust to their individual styles and needs. In the highly competitive world of fashion, individuality is the new key to success—anyone can do mainstream. Ardi Goldman and Hakan Temür, the minds behind The Listener, succeed brilliantly at this task. Located in Frankfurt's new trendy scene area in MA, The Listener offers trends and unusual brands in one store. In 520 square meters of space, customers can choose from traditional brands and new, young brands that are all standouts for their high quality and excellence in design. This devotion to design is also reflected in the interiors: brightly colored cement tiles, steel accents, wood, and shelving systems suspended by ropes create wonderful contrasts while simultaneously creating a cozy, homey atmosphere.

Nomen est omen – bei The Listener stimmt dieses Sprichwort auf jeden Fall. Denn die Macher hinter dem Store haben es sich, wie der Firmenname schon sagt, zur Aufgabe gemacht, dem Kunden zuzuhören und sich auf dessen individuellen Style und Wünsche einzustellen. In der hart umkämpften Modebranche ist Individualität der neue Leitfaden zum Erfolg – Mainstream kann schließlich jeder. Dies umzusetzen gelingt den Machern hinter The Listener, Ardi Goldman und Hakan Temür, mit Bravour. In Frankfurts neuem Szenequartier MA gelegen, bietet The Listener Trends und außergewöhnliche Marken in einem. Auf 520 Quadratmetern können Kunden zwischen Traditionsmarken und neuen, jungen Brands wählen, die sich alle durch Qualität und einen hohen Designanspruch auszeichnen. Diesen Designanspruch spiegelt auch das Interieur: Bunt gemusterte Zementfliesen, Stahlelemente, Holz und an Seilen hängende Regalsysteme bilden wunderbare Kontraste und verströmen gleichzeitig Gemütlichkeit.

Nomen est omen – chez The Listener, ce proverbe devient réalité. En effet, comme l'énonce le nom de l'entreprise, les créateurs de cette boutique se sont donnés pour mission d'être à l'écoute du client et de s'adapter à son style et à ses souhaits personnels. Dans le secteur de la mode, âprement disputé, l'individualité est le nouveau fil conducteur menant à la réussite : donner dans le mainstream, tout le monde en est capable. C'est ce que sont parvenus à mettre en application avec bravoure les créateurs de The Listener, Ardi Goldman et Hakan Temür. Situé dans le quartier branché MA de Francfort, The Listener propose des tendances et des marques originales. Sur 520 mètres carrés, les clients ont le choix entre marques traditionnelles et jeunes labels, se distinguant tous par leur qualité et leurs exigences sévères en termes de design. Ces exigences en matière de design se reflètent également dans la décoration intérieure : Des carreaux en ciment aux motifs colorés, des éléments en acier, du bois et des systèmes d'étagères suspendus à des cordes constituent de magnifiques contrastes tout en dégageant une ambiance très cosy.

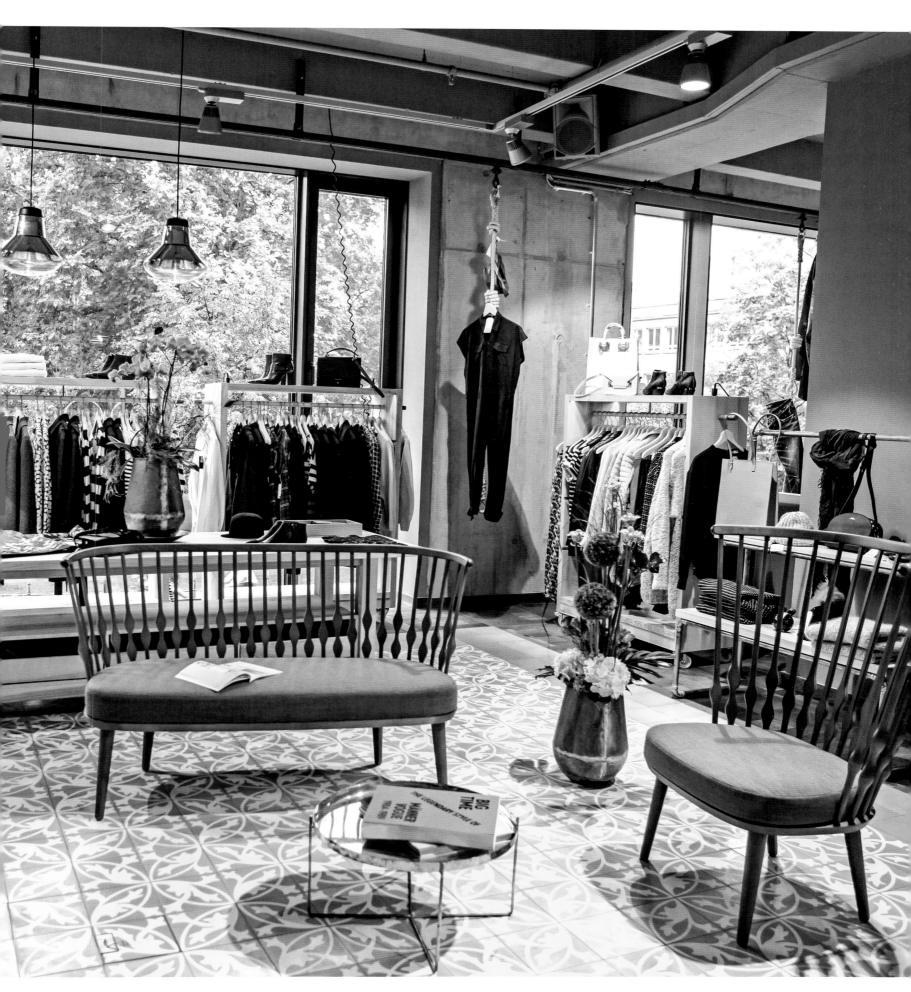

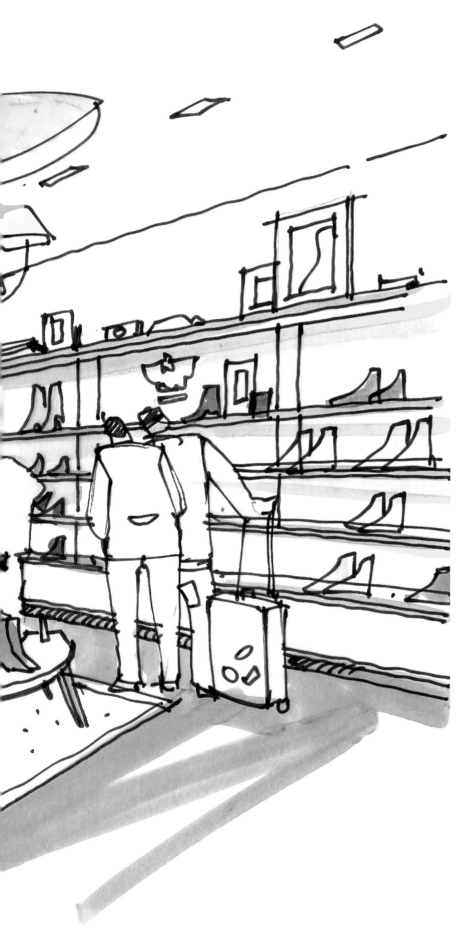

MAKING DESIGN WORK

OR HOW A STORE BECOMES A FAVORITE HANGOUT

Design does not function according to any specified rules. Design has to do with attitude, with the desire to change something preferably for the better. That requires an understanding of the brand and its customers. If you possess that, design can be something spectacular—a plea for boldness and daring.

Design funktioniert nicht nach vorgegebenen Regeln. Design hat was mit Haltung zu tun. Mit dem Wunsch, etwas zu verändern, bestenfalls es zu verbessern. Das setzt Verständnis voraus. Für die Marke. Und für deren Kunden. Dann kann die Wirkung von Design sogar bemerkenswert sein. Ein Plädoyer für mehr Kühnheit.

Le design ne fonctionne pas selon des règles prédéfinies. Le design se rapporte à la position. Avec le souhait de changer quelque chose, voire, idéalement, de l'améliorer. Cela exige de la compréhension. Pour la marque. Et pour ses clients. Alors l'effet du design peut même être visible. Un plaidoyer pour plus d'audace.

Sketches: Stanley Reich, Düsseldorf
www.reichundwamser.de

Musty nylon curtains on fitting room stalls gave way to swinging saloon doors, and every slap of the wood promised that life in a tight-fitting pair of jeans would be vastly more exciting. The jeans stores of the late '60s anchored themselves in the collective memory of entire generations. They had shelves and tables made of rustic wood and checkout counters that reminded you of bars from the classic TV show *Gunsmoke*.

And they were crammed to the ceiling with jeans, a density of merchandise that sprung not from some ingenious marketing strategy, but rather from the sheer necessity of presenting the huge number of sizes, fits, and fabrics in some reasonably orderly way. These stores became a synonym for freedom, the subversive counterculture to the conventional clothing shops of the day. Later, the rising hippie movement gave jeans stores an almost anarchist vibe. And they determined the visual theme song underlying store design for every denim brand for decades to come. In a nearly archetypical way, they stood for a new societal sound with a beat of freedom and autonomy.

Even today, rustic elements cling doggedly to the design of jeans stores. This store design became the blueprint for a story that followed its own internal logic, which enabled it to retain its authenticity—because a longing for freedom never goes out of style. ▶

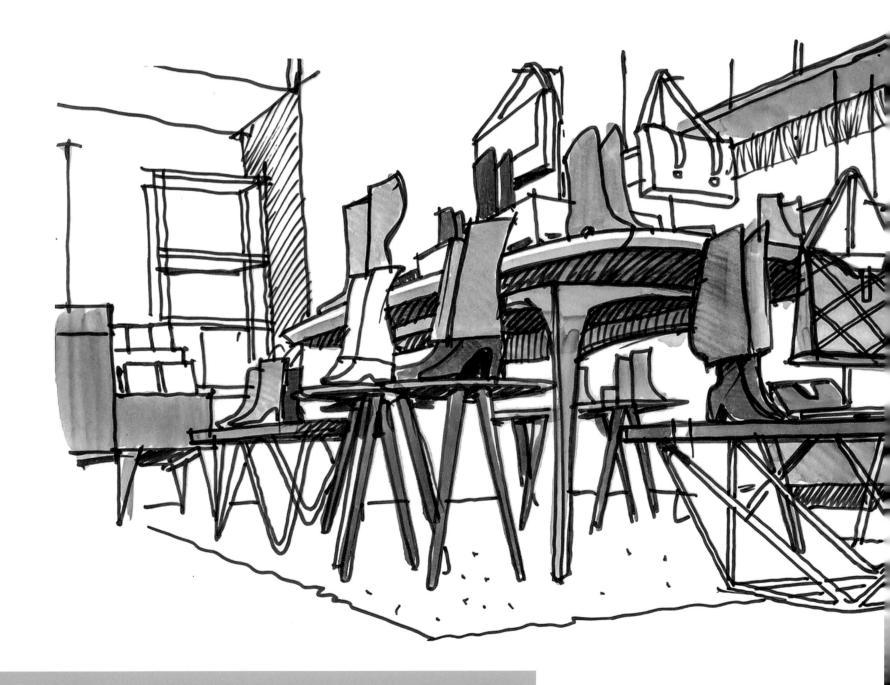

Eccentric equals meaningless

Good store design creates originals and avoids stereotypes. It turns browsers into buyers, customers into fans, and the previously uninformed into an interested audience. Successful design crescendos to a peak, is convincing down to the smallest detail, and creates an emotional bond between the product and the customer. Design demands an act of creation, not a mere copying process. Store design must be original and substantial. Effects for effects' sake and eccentricity rob the design of meaning. The design's job is to translate the biography of a brand into a three-dimensional experience, to utilize facts that want to be visually employed in the service of a good story. The brand's DNA will determine whether the story is a road movie, a drama, satire, or a daily soap. If you can tease out a well-done (but not overdone!) story, even from trivial material, you win. The creative process starts with exclusion, because the beating heart of the brand can only be uncovered via reduction. Only then can you feel the brand's essence and hear its message. This step is often overlooked, and a pile of colorful design proposals prevent people from discussing the brand, something that should start as a quiet and utterly unspectacular dialogue. As a result, people jump to copy things they've seen before to fill an empty space, and substance degenerates into a decorative gesture. Interior design is not an end in itself. It cannot work without an understanding of the customer and the brand. The better you tell the story, and the more details you include, the more customers notice and absorb it. Every design element, architectural detail, and expensive material you want to include must be carefully weighed against its relevance. Does it add to the desired brand experience? The risk of overwhelming people lurks in every detail. This only irritates people and rapidly turns curious customers into annoyed walkouts. In a world flooded with brands, utter fascination can quickly veer into directionless wheel-spinning. This is a clear sign of a failed design. Once a visitor "gets" the idea behind the store, he wants to see it reflected in every detail and experience it in as many different ways as possible. If that doesn't happen, he rejects the store as illogical, because his positive first impression is no longer supported. The best case scenario is that the potential customer gets bored and starts looking around for the sale racks. Another possibility is that his annoyance leaves a lasting impression, causing him to cross the brand off his personal top ten list for a long time. In the end, the only thing that matters is that the customer is impressed by the brand's values before he leaves the store: this is star designer Peter Marino's simple maxim. ▶

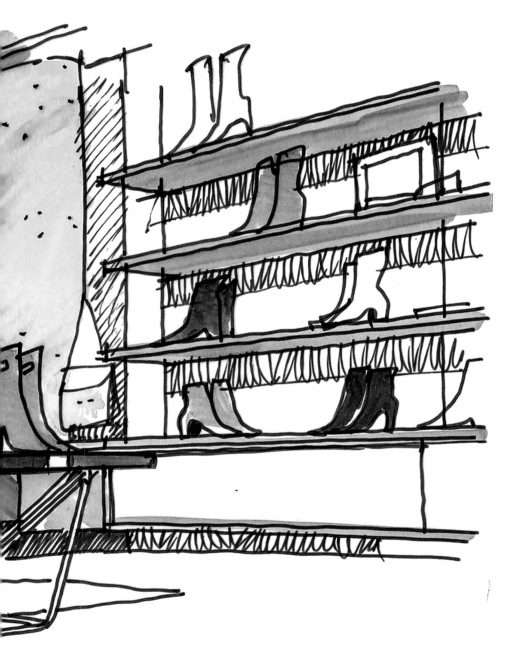

Find the right rhythm

Store design anchors the brand's message in the customer's needs. The deeper that message can go, the more desirable the brand becomes, and the more the customer wants to be part of that world. It's not about following rules or breaking them. It's about finding a rhythm. An interior design that is constantly screaming "Here!" lacks a rhythmic feel, which prevents people from engaging with it. A design that has hit its groove is very alluring. It conveys a coherent personality—that of the brand—with conviction. And above all, it knows when to take a breath and pause, to leave space for the customer to react. Pauses are the high art of design that allow it to unleash its intensity. Whether that's a deliberately empty space in the room or a moment of imperfection will depend on the statement a particular brand needs to make. Of course, the uniformity of blue jeans stacked on shelves stretching to the ceiling seems boring to us today. But the monochromatic stacks of pants in those early jeans stores were actually declaring something outrageous: rebellion. ■

DAMIT DESIGN FUNKTIONIERT

ODER WIE EIN LADEN ZUM SEHNSUCHTSORT WIRD

Aus staubigen Nylonvorhängen vor den Kabinen wurden frei schwingende Saloontüren und verkündeten verheißungsvoll mit jedem Flügelschlag, dass das Leben in einer engen Jeanshose deutlich aufregender sein würde. Die Jeansläden der späten 60er haben sich im kollektiven Bewusstsein ganzer Generationen verankert. Regale und Tische in rustikaler Holzoptik, Kassentresen, die an Bartheken aus dem TV-Klassiker *Rauchende Colts* erinnerten. Vollgestopft bis unter die Decke mit Jeanshosen. Eine Warendichte, die keiner findigen Marketingstrategie entsprungen war, sondern schlicht der Notwendigkeit, die vielen Größen, Fits und Fabrics des blauen Golds einigermaßen geordnet

zu präsentieren. Diese Läden wurden zum Synonym für Freiheit, waren die subversive Gegenveranstaltung zu den biederen Modehäusern ihrer Zeit. Bekamen später durch die heraufziehende Hippie-Bewegung geradezu anarchistischen Charakter. Und legten für die kommenden Jahrzehnte die visuelle Erkennungsmelodie für das Storedesign der Denim-Brands fest. Geradezu archetypisch standen sie für einen neuen gesellschaftlichen Sound, dessen Beat Freiheit und Autonomie war. Bis heute finden sich hartnäckig rustikale Zitate im Ladenbau der Jeanshersteller. Das Storedesign wurde zur Blaupause für eine Geschichte, die einer inneren Logik folgte und darum nicht an Authentizität verliert. Denn die Sehnsucht nach Freiheit hört niemals auf. ▸

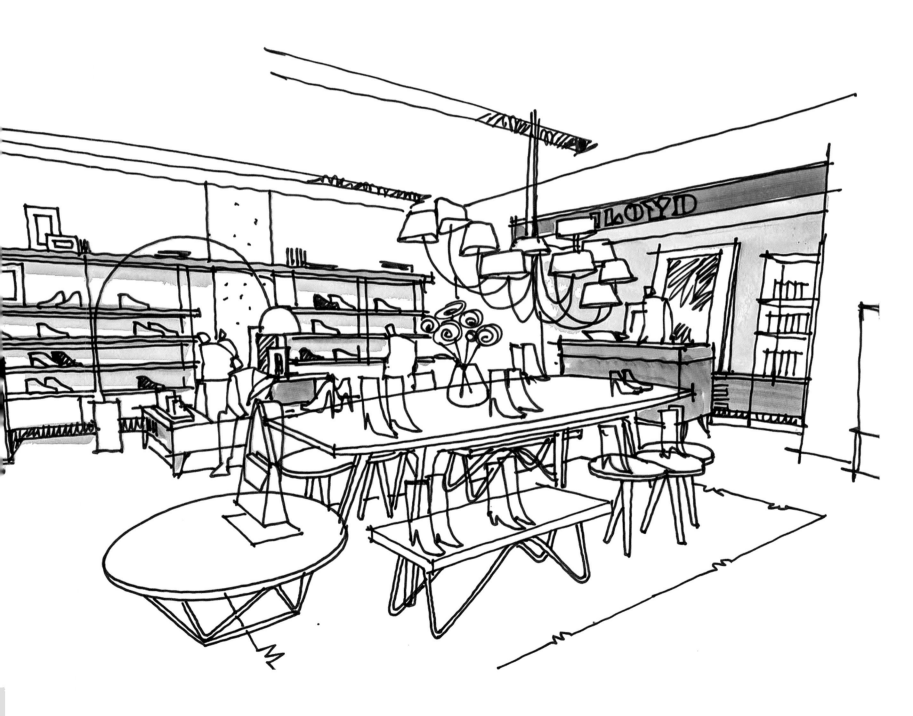

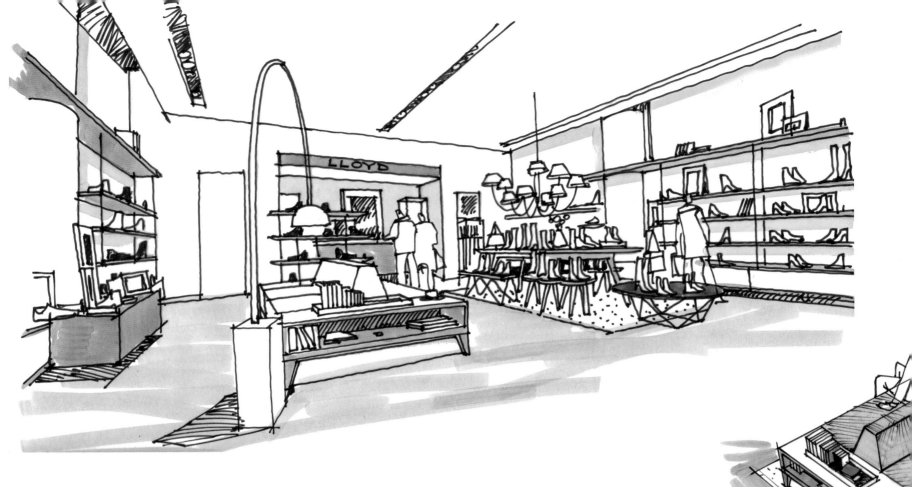

Exzentrik macht bedeutungslos

Gutes Storedesign schafft Urtypen und vermeidet Stereotype. Macht Neugierige zu Käufern, Kunden zu Fans und aus einem eben noch ahnungslosen ein interessiertes Publikum. Gelungenes Design spitzt zu, überzeugt im Detail und schafft eine emotionale Verbindung zwischen Produkt und Kunde. Gestaltung fordert einen schöpferischen Akt – keinen reproduktiven Prozess. Storedesign hat originell und substantiell zu sein. Effekthascherei und Exzentrik lassen es bedeutungslos werden. Sein Auftrag ist es, die Biografie einer Marke in ein dreidimensionales Erlebnis zu übersetzen. Fakten, die visuell zu einer guten Geschichte verarbeitet werden wollen. Die DNA der Marke gibt vor, ob die Story Roadmovie, Drama, Satire oder Daily Soap ist. Wer es schafft, auch dem Trivialen eine gekonnte – und keinesfalls überhöhte – Story zu entlocken, hat gewonnen. Ein Kreativprozess fängt mit dem Weglassen an. Denn erst in der Reduktion werden die Nervenbahnen der Marke freigelegt. Kann nachgespürt werden, was ihre Essenz ist, wie ihre Botschaft lautet. Häufig wird dieser Schritt unterlassen, und viele bunte Gestaltungsentwürfe verhindern eine Markendiskussion, die sich zunächst unspektakulär leise vollziehen sollte. Dann wird schnell bereits Gesehenes kopiert, um Leere auszufüllen. Substanz verkommt zur dekorativen Geste. Interieurdesign hat keinen Selbstzweck, kann ohne ein Verständnis für Kunde und Marke nicht funktionieren. Je dichter und detaillierter die Story erzählt wird, umso vollständiger wird sie wahrgenommen. Jedes Mehr an Gestaltungselementen, architektonischer Raffinesse und aufwendigen Materialien muss sorgfältig auf seine Relevanz hinterfragt werden. Trägt das alles zum gewünschten Markenerlebnis bei? Die Gefahr der Überforderung lauert hinter jedem Detail. Das irritiert und macht aus neugierigen Kunden schnell genervte Verweigerer. In einer dicht komponierten Markenwelt kann hohe Faszination schon im nächsten Augenblick in die Orientierungslosigkeit kippen. Dann hat das Design seine Aufgabe klar verfehlt. Hat der Betrachter die Idee des Stores erfasst, so will er sie in jedem Detail wiederfinden und möglichst vielfältig erleben. Passiert das nicht, lehnt er den Store als unlogisch ab. Weil die zunächst positiv erlebte Resonanz ausbleibt. Der potentielle Kunde ist bestenfalls gelangweilt und fängt an, sich nach Sonderangeboten umzusehen. Oder er ist nachhaltig irritiert, sodass die Marke für lange Zeit von seiner persönlichen Top-Ten-Liste verschwindet. Am Ende ist nur wichtig, dass der Kunde beim Verlassen des Geschäfts von den Markenwerten beeindruckt ist, lautet die einfache Maxime von Stardesigner Peter Marino.

Den richtigen Rhythmus finden

Storedesign verankert die Markenbotschaft in den Bedürfnissen der Kunden. Je tiefer sie erlebbar ist, umso größer wird die Markenbegehrlichkeit und mit ihr der Wunsch, Teil dieser Welt zu werden. Es geht nicht darum, Regeln zu befolgen oder zu brechen. Wichtig ist es, einen Rhythmus zu finden. Einem Interieurdesign, das dauernd laut „hier" schreit, fehlt es an rhythmischem Klang. Es verhindert, dass man sich darauf einlässt. Hat die Designsprache ihren Groove gefunden, wird sie verführerisch. Kommuniziert souverän eine Haltung – die der Marke. Und kann vor allem eines: Pausen einlegen. Raum geben, damit der Kunde in Reaktion treten kann. Pausen sind die hohe Kunst der Gestaltung. Erst durch sie entfaltet Design seine Intensität. Ob das eine bewusst gestaltete Leere im Raum ist oder ein Moment des Unperfekten, hängt letztlich von der Markenaussage ab. Klar, die Gleichförmigkeit der in deckenhohen Regalen gestapelten blauen Hosen mutet heute langweilig an. Tatsächlich verkündeten die monochromen Hosenstapel der ersten Jeansläden aber etwas Unerhörtes: Rebellion. ■

POUR QUE LE DESIGN FONCTIONNE

OU QU'IL DEVIENNE UN LIEU D'ENVIE AU MÊME TITRE QU'UNE BOUTIQUE

Les rideaux en nylon poussiéreux ont fait place à des portes battantes de saloon, annonçant à chaque prometteur battement que la vie est bien plus palpitante en jeans. Les magasins de jeans de la fin des années 60 sont restés ancrés dans la mémoire collective de toute une génération. Des étagères et des tables à l'aspect rustique, des caisses de magasin rappelant le comptoir du bar de la série *Gunsmoke*. Des jeans jusqu'au plafond. Une quantité de marchandise qui n'est pas née d'une stratégie marketing ingénieuse, mais tout simplement de la nécessité de présenter de manière ordonnée les nombreuses tailles, coupes et matériaux de l' « or bleu ». Ces boutiques devinrent synonymes de liberté ; elles représentaient les contre-manifestations subversives de leur époque face aux magasins de vêtements vieillots. Puis, lors de l'apparition du mouvement hippie, elles acquièrent un caractère anarchique et définirent pour les décennies à venir la mélodie visuelle permettant de reconnaître le design typique des boutiques de jeans. Elles étaient tout bonnement l'archétype d'une nouvelle tonalité sociale rythmée par la liberté et l'autonomie. Aujourd'hui encore, l'agencement des boutiques des marques de jeans est inspiré du design de l'époque. Le design de ces boutiques devint le vecteur d'une histoire qui suivait une logique interne sans tout autant perdre de son authenticité. Car le besoin de liberté ne disparaît jamais. ▶

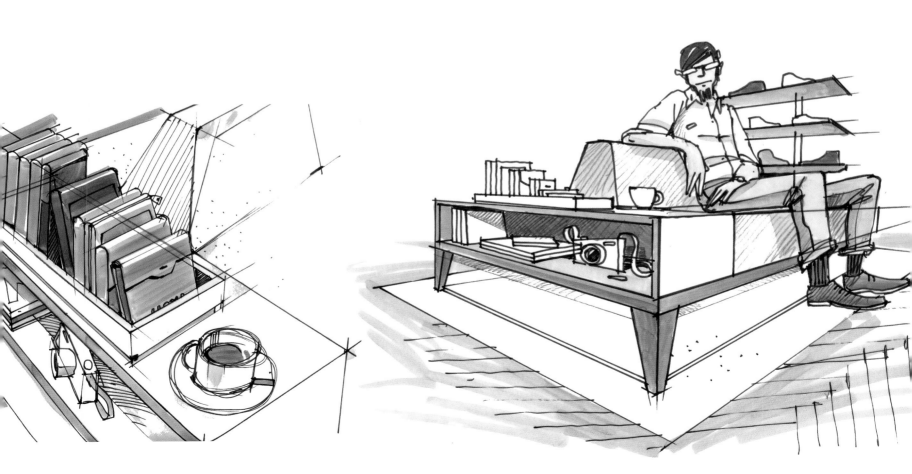

L'excentricité fait perdre tout son sens

Un design de boutique réussi génère des archétypes et permet d'éviter les stéréotypes. Il fait des curieux, des acheteurs, des clients, des fans et d'un public non soupçonneux une clientèle intéressée. Le design abouti s'accentue, séduit par le détail et crée un lien émotionnel entre le produit et le client. La conception nécessite un acte créatif, et non un processus de reproduction. Le design de boutiques se doit d'être à la fois original et substantiel. Le sensationnalisme et l'excentricité le rendent insignifiant. Le design a pour mission de transposer la biographie d'une marque en une expérience tridimensionnelle. Des faits qui veulent être transformés en une bonne histoire visuelle. L'ADN de la marque indique si son histoire est un road-movie, un drame, une satire ou un feuilleton quotidien. Celui qui parvient à faire d'une histoire triviale une légende habilement formulée, et aucunement exagérée, a gagné. Tout processus créatif commence par un abandon. Car ce n'est que dans la réduction que peuvent apparaître les nervures de la marque. Qu'il est possible de ressentir son essence, de percevoir son message. Cette étape est souvent négligée, et des ébauches, nombreuses et hautes en couleurs, empêchent une discussion de fond sur la marque, qui devrait dans un premier temps être discrète et silencieuse. Puis l'on se dépêche de copier quelque chose que l'on a vu ailleurs, afin de combler un vide. La substance cède la place au geste décoratif. Le design d'intérieur n'est pas une fin en soi, et ne peut pas fonctionner sans une compréhension de la marque par le client. Plus l'histoire est racontée de manière dense et détaillée, plus elle est perçue dans son ensemble. Chaque ajout, chaque complément apporté aux éléments d'agencement, au raffinement architectural et aux matériaux doit être remis en question afin de s'assurer de sa pertinence. Cela contribue-t-il à l'expérience de marque que nous souhaitons transmettre ? Le risque d'excès est présent dans chaque détail. Cela a un effet perturbateur et transforme vite des clients curieux en opposants énervés. Dans un monde très densément peuplé de marques, la fascination peut rapidement basculer dans de la désorientation. Le design a alors clairement échoué dans sa mission. Si l'observateur a saisi l'idée de la boutique, il cherche alors à la retrouver dans chaque détail, et à la vivre de la manière la plus diversifiée possible. Si ce n'est pas le cas, il rejette alors la boutique comme étant illogique. Car la résonance, vécue dans un premier temps comme quelque chose de positif, se fait toujours attendre. Le client potentiel, lui aussi, s'ennuie et commence à chercher les offres spéciales. Ou alors il est durablement déconcerté et la marque disparaît pour longtemps de sa liste de marques préférées. Au final, ce qui compte, c'est que lorsqu'il quitte la boutique, le client soit impressionné par les valeurs de la marque. Telle est la maxime du célèbre designer Peter Marino.

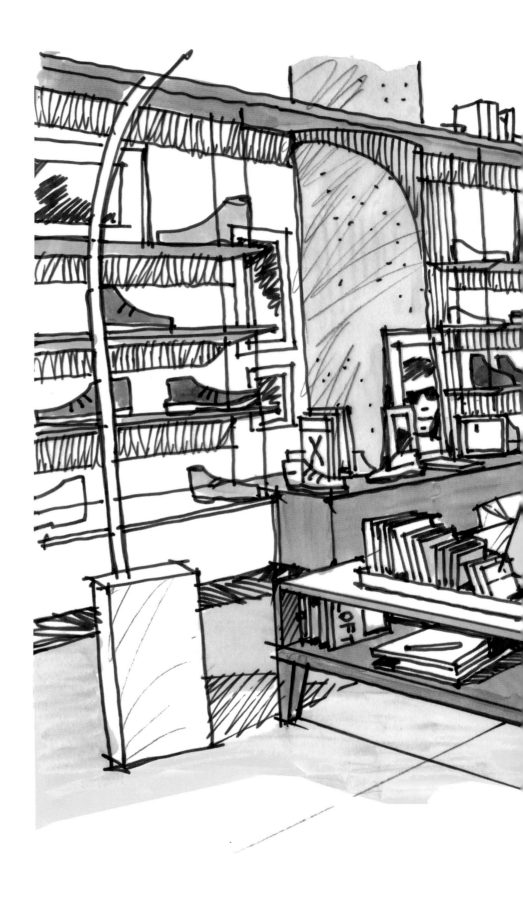

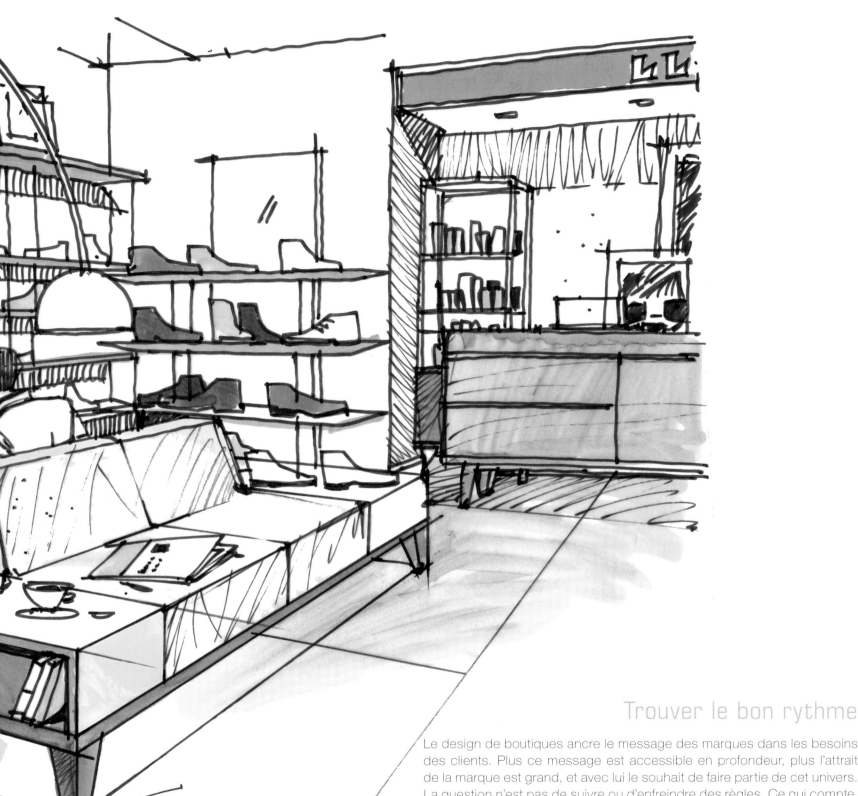

Trouver le bon rythme

Le design de boutiques ancre le message des marques dans les besoins des clients. Plus ce message est accessible en profondeur, plus l'attrait de la marque est grand, et avec lui le souhait de faire partie de cet univers. La question n'est pas de suivre ou d'enfreindre des règles. Ce qui compte, c'est de trouver un rythme. Un design d'intérieur criant toujours au « ici » manque de saveur et de rythme. Il empêche que l'on s'y laisse emporter. Si le langage du design a trouvé son rythme, elle en devient séduisante. Elle communique une attitude : celle de la marque. Et est capable surtout d'une chose : intégrer des pauses. Laisser de la place pour que le client puisse réagir. Les pauses constituent le grand art de l'agencement. C'est grâce à celles-ci que le design peut déployer toute son intensité. Le choix, à cette fin, d'un espace vide ou d'un moment d'imperfection prévu intentionnellement dépend du message que la marque souhaite délivrer. Une chose est claire : l'uniformité des pantalons bleus empilés sur des étagères hautes jusqu'au plafond est aujourd'hui plutôt ennuyeuse. En effet, les piles de jeans monochromes des premières boutiques de jeans annonçaient quelque chose d'outrageux : la rébellion. ∎

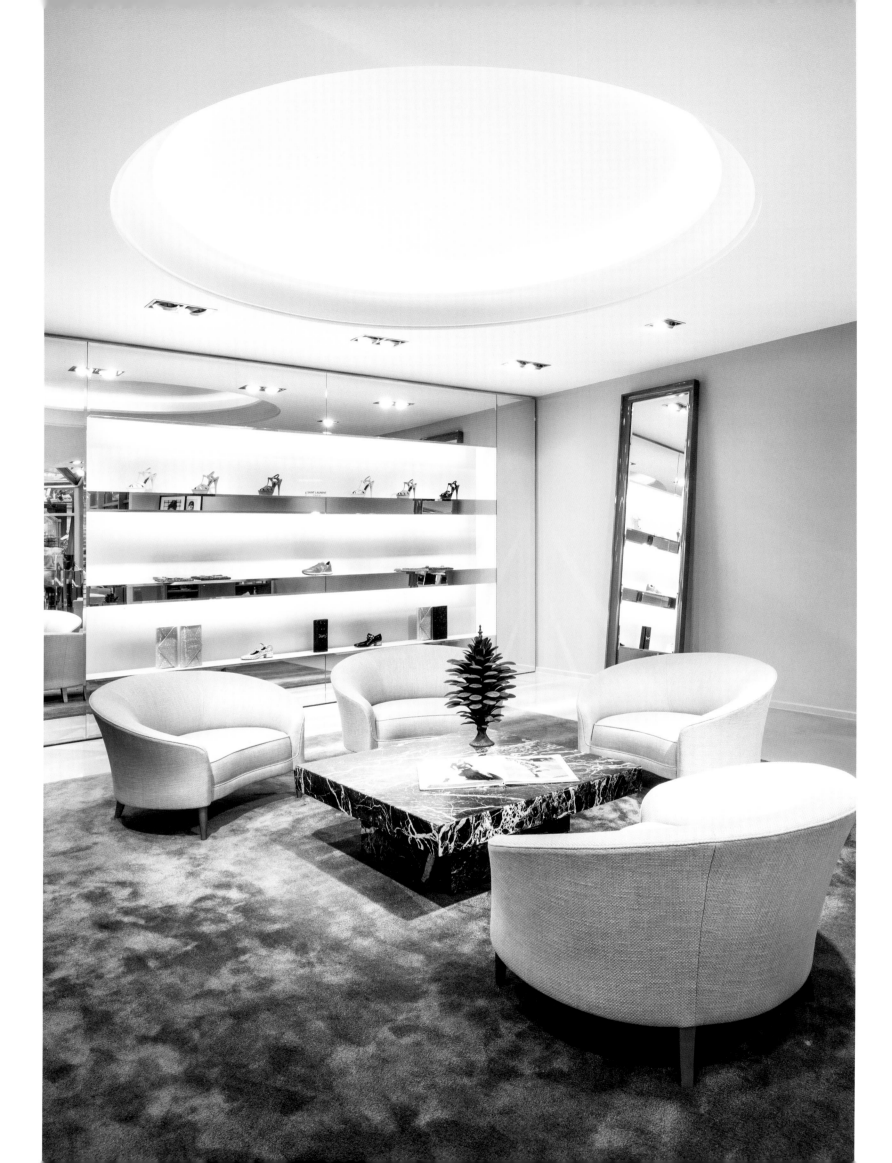

APROPOS

"Luxury means exclusivity. It's about experiencing something unique and feeling that way too. Especially with our office products, it is particularly important to us that we present the luxury we want to sell in an appropriate setting. We focus on handmade materials and one-of-a-kind pieces."

Klaus Ritzenhöfer,
APROPOS The Concept Store

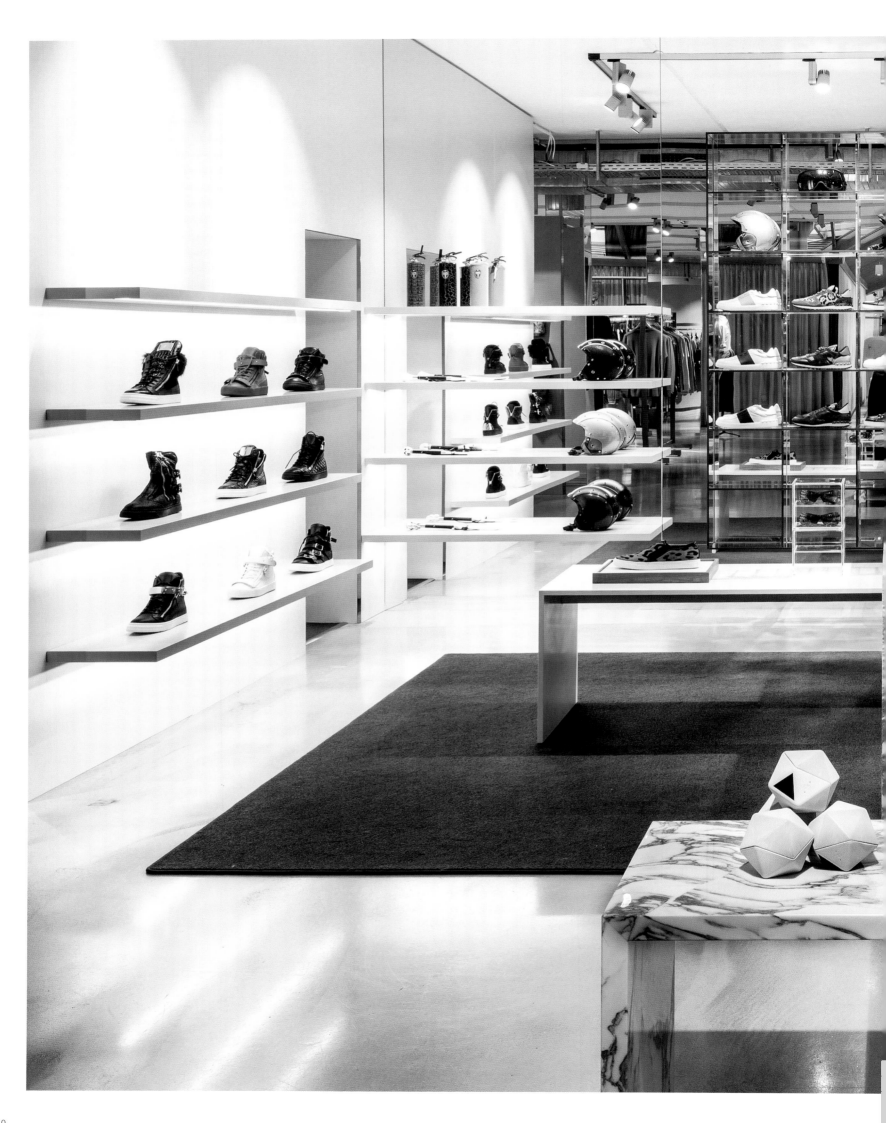

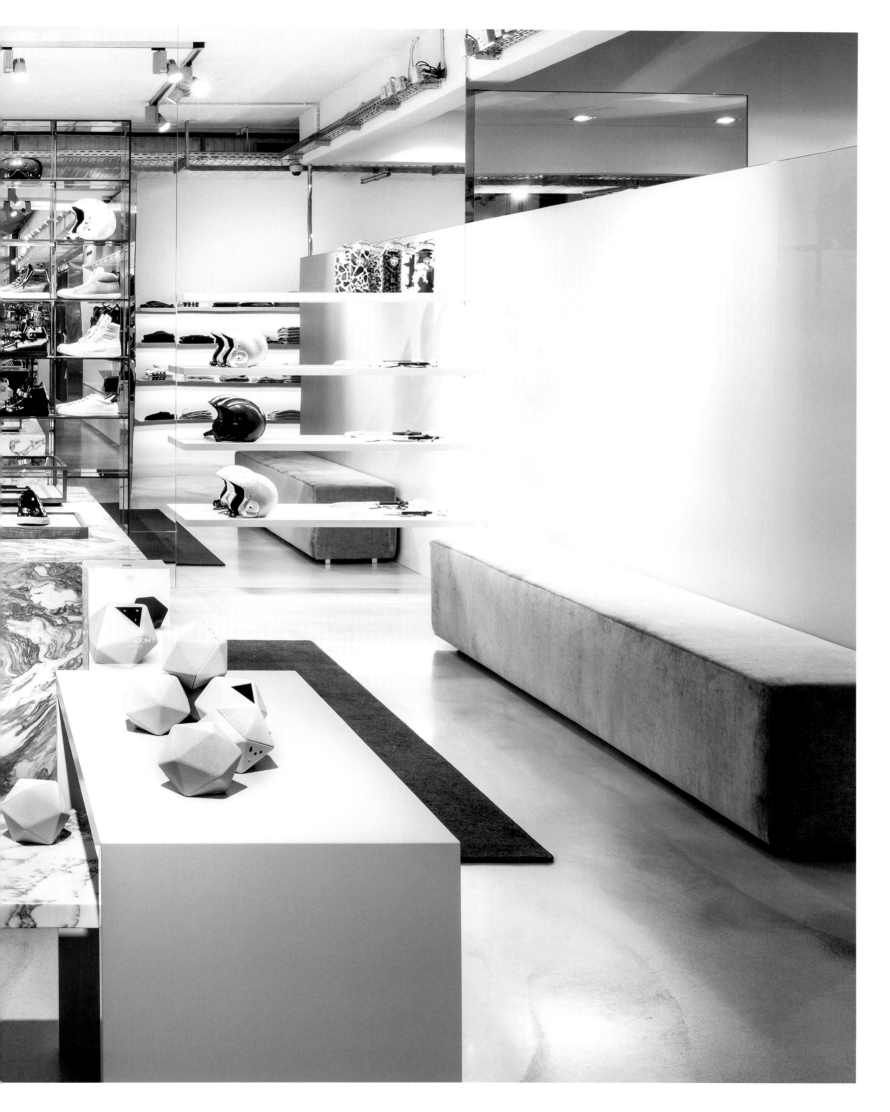

Christian Dior
DÜSSELDORF

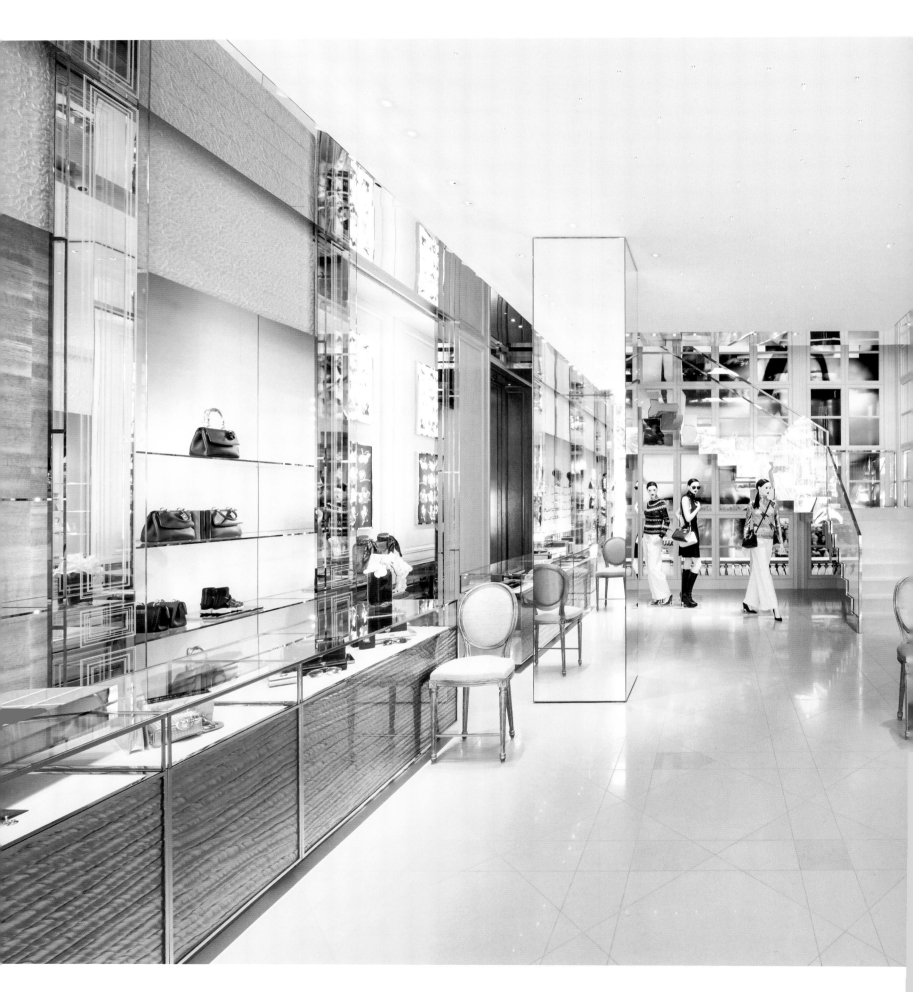

"*Your dresses have such a new look.*"

This compliment from the American editor-in-chief of *Harper's Bazaar* became the foundation of Christian Dior's signature style. Just one year after he opened his atelier in 1946 on Paris' elegant Avenue Montaigne, he was celebrated for his collection and established the "New Look." But defining fashion merely as a look was never sufficient for the legendary designer. It was always about personality and style as well. So it's no surprise that Dior, who had actually trained to join the diplomatic service, published *The Little Dictionary of Fashion* in the '50s. The new Christian Dior flagship store brings aristocratic flair to Düsseldorf's Königsallee: in the style of a 1st arrondissement Paris apartment, designer furniture like the Laurent Chauvat metal shelving and the Roland Mellan "Table qui marche" is added to contemporary art to create an elegant atmosphere.

„Ihre Kleider kreieren einen richtigen New Look."

Dieses Kompliment der amerikanischen Chefredakteurin von *Harper's Bazaar* wurde zum stilbildenden Begriff für die Handschrift Christian Diors. Kaum, dass er 1946 sein Atelier in der eleganten Avenue Montaigne in Paris eröffnet hatte, wurde er bereits ein Jahr später für seine Kollektion gefeiert und begründete den „New Look". Mode nur als Look zu definieren war dem Couturier allerdings stets zu wenig. Es ging immer auch um Persönlichkeit und Stil. Darum wundert es nicht, dass der eigentlich für den diplomatischen Dienst ausgebildete Dior in den 50er-Jahren *Das kleine Buch der Mode* verfasste. Geradezu aristokratisches Flair bringt der neue Flagship Store von Christian Dior auf die Düsseldorfer Königsallee: Im Stile eines Pariser Appartements aus dem 1. Arrondissement wurden Designmöbel wie das Metallregal von Laurent Chauvat und der „Table qui marche" von Roland Mellan sowie zeitgenössische Kunst zu einer eleganten Atmosphäre verdichtet.

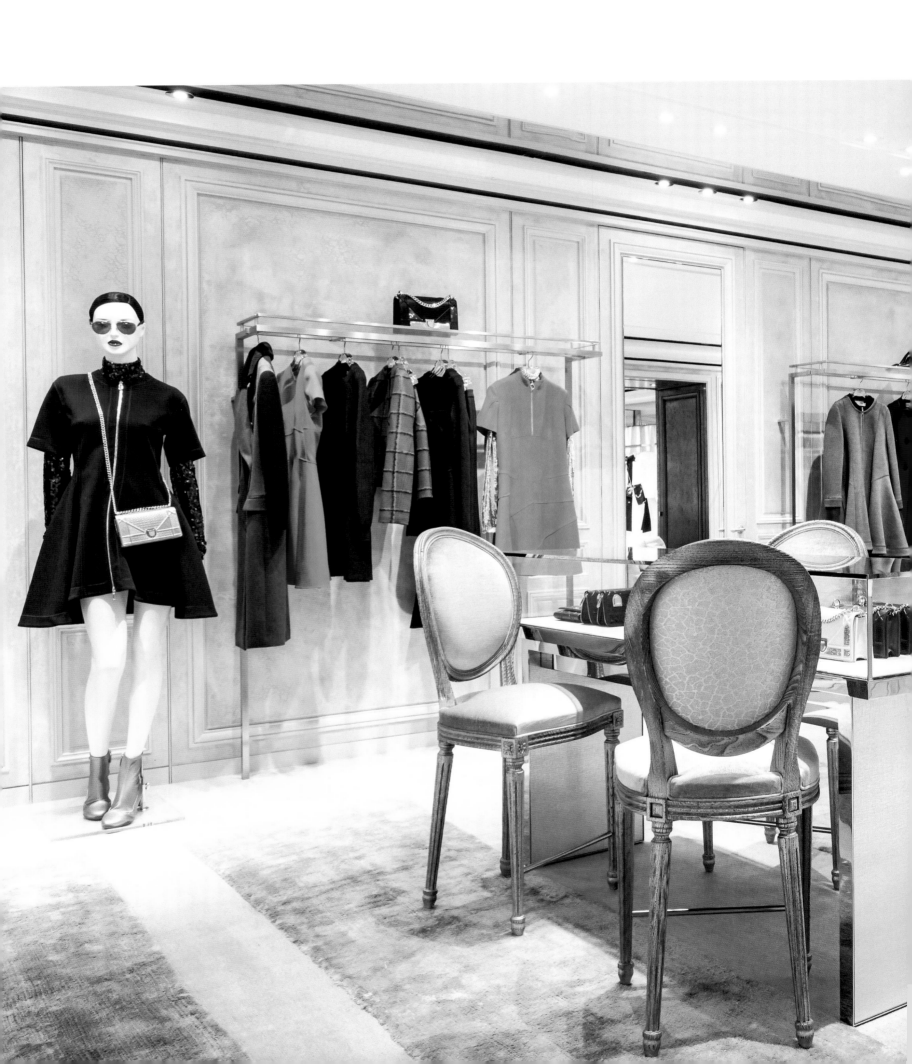

« Vos tenues ont un look tellement nouveau. »

Ce compliment, fait par la rédactrice en chef américaine de *Harper's Bazaar* est devenu le précepte à la base du style et de la griffe Christian Dior. À peine avait-il, en 1946, ouvert son atelier sur l'élégante Avenue Montaigne, qu'il était déjà célébré un an plus tard pour sa collection, créant le « New Look ». Toutefois, limiter la définition de la mode à la seule notion de « look » n'a jamais suffi à ce grand couturier. Depuis toujours, les notions de personnalité et de style sont primordiales. Il n'est donc pas surprenant que Dior, qui avait fait des études qui devaient le mener à un poste diplomatique, rédigeât dans les années 1950 *Le petit Dictionnaire de la Mode*. La nouvelle boutique vedette de Christian Dior, installée sur la Königsallee de Düsseldorf, dégage un charme tout à fait aristocratique. C'est dans le style d'un appartement parisien du 1er arrondissement que les meubles de designer, tels que l'étagère métallique de Laurent Chauvat et la « table qui marche » de Roland Mellan, ainsi que de l'art contemporain, ont été réunis afin de créer une atmosphère toute en élégance.

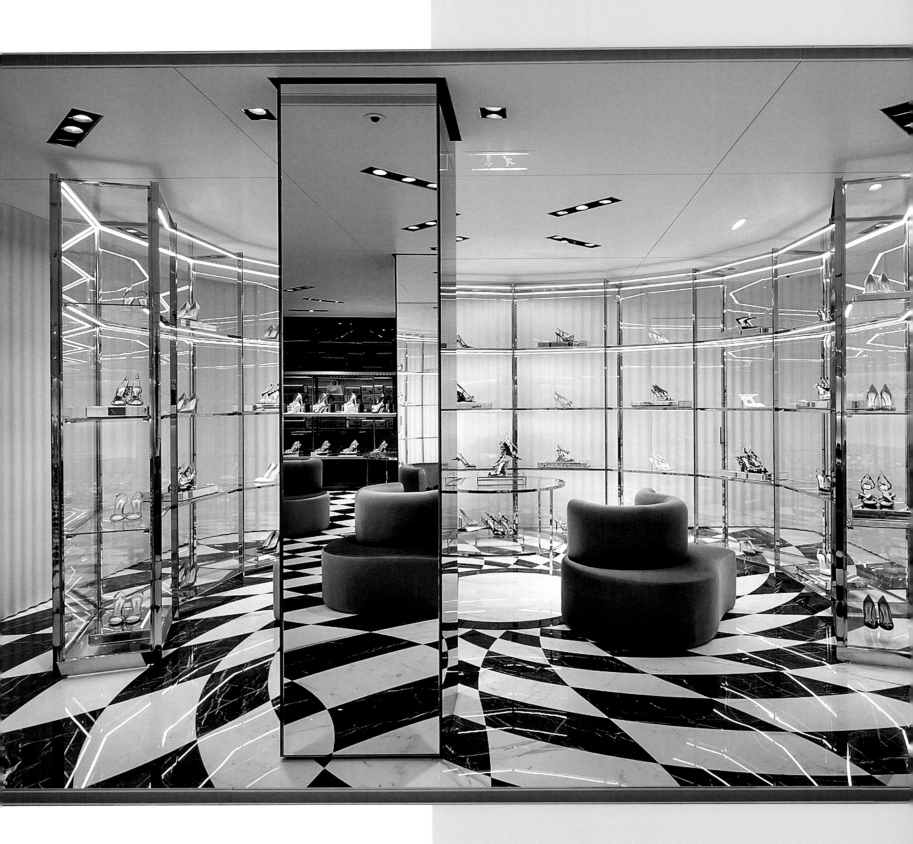

PRADA WOMEN
Paris

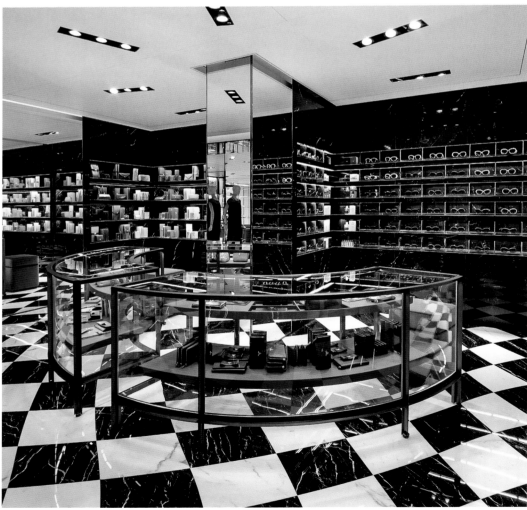

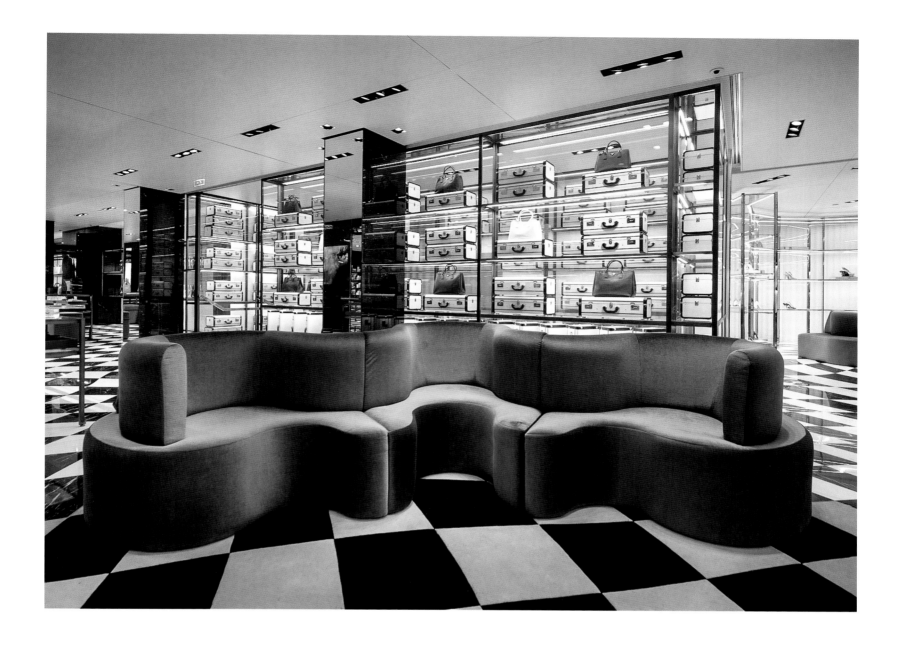

Prada in Paris is an homage to the very first store opened in Milan, Italy in 1913. Milan-based architect Roberto Baciocchi, inspired by the brand's origins, installed black-and-white marble tile on the ground floor of the 19th-century villa on Rue du Faubourg Saint-Honoré. Floor-to-ceiling mirrors and glass elements add transparency. The walls are painted in Prada green, which is also incorporated into Verner Panton's classic Cloverleaf sofa. The sofa provides an organic, playful contrast to the black marble and cool glass displays.

Prada in Paris ist eine Hommage an den ersten, 1913 in Mailand eröffneten Store. Der Mailänder Architekt Roberto Baciocchi hat sich von den Ursprüngen der Marke inspirieren lassen und das Erdgeschoss des Stadtpalais aus dem 19. Jahrhundert in der Rue du Faubourg Saint-Honoré mit schwarz-weißen Marmorfliesen ausgestattet. Deckenhohe Spiegel- und Glaselemente verleihen Transparenz. Das Grün der Wände ist die CI-Farbe und wird auch im Designklassiker von Verner Panton aufgegriffen: Das Sofa Cloverleaf bildet einen organisch-verspielten Kontrast zu schwarzem Marmor und kühlen Glasdisplays.

La boutique Prada de Paris est un hommage à la première boutique Prada, ouverte à Milan en 1913. Le bureau d'architectes milanais Roberto Baciocchi s'est laissé inspirer par les origines de la marque, et a aménagé le rez-de-chaussée du palais de ville, datant du 19ème siècle et situé Rue du Faubourg Saint-Honoré, avec des carreaux de marbre noirs et blancs. Des miroirs et des éléments en verre, s'élevant jusqu'au plafond, lui confèrent une grande transparence. Le vert des murs, couleur de la Corporate Identity, il est également employé dans les classiques de design de Verner Panton : Le canapé Cloverleaf représente un contraste vivant enjoué par rapport au marbre noir et aux parties en verre, froides.

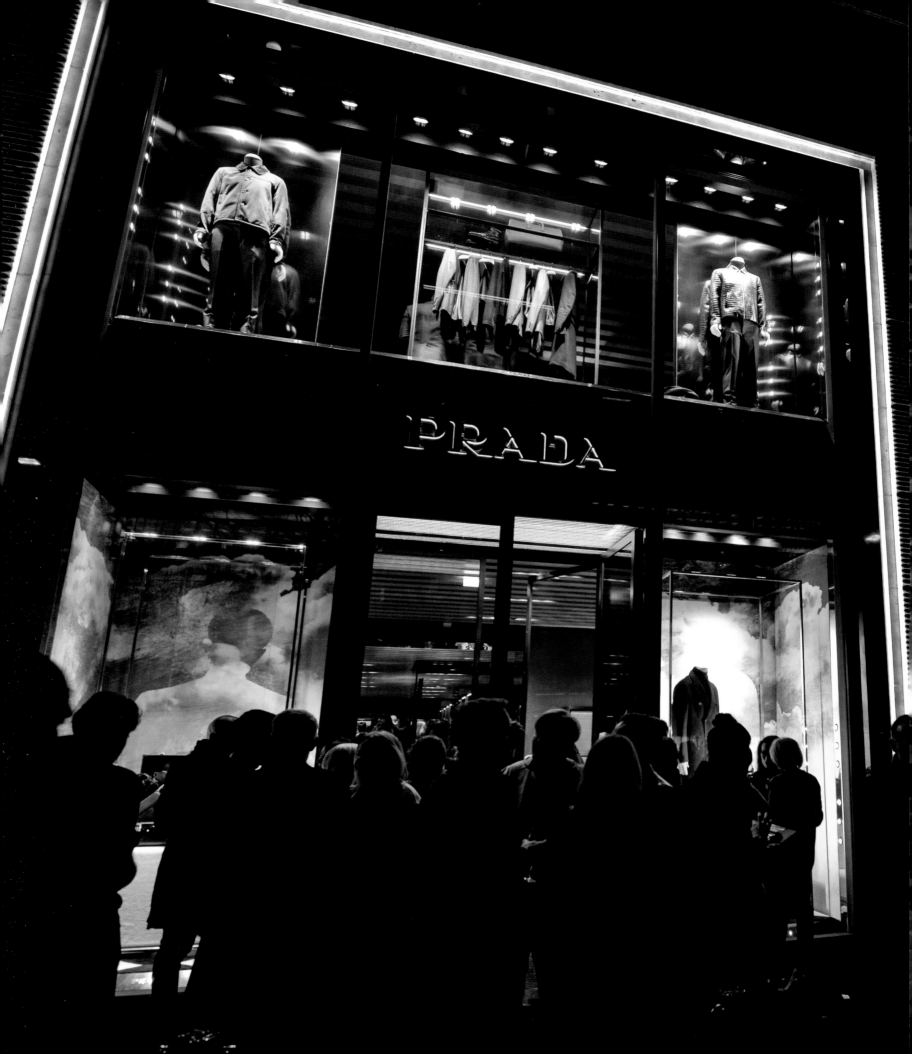

PRADA MEN
Frankfurt

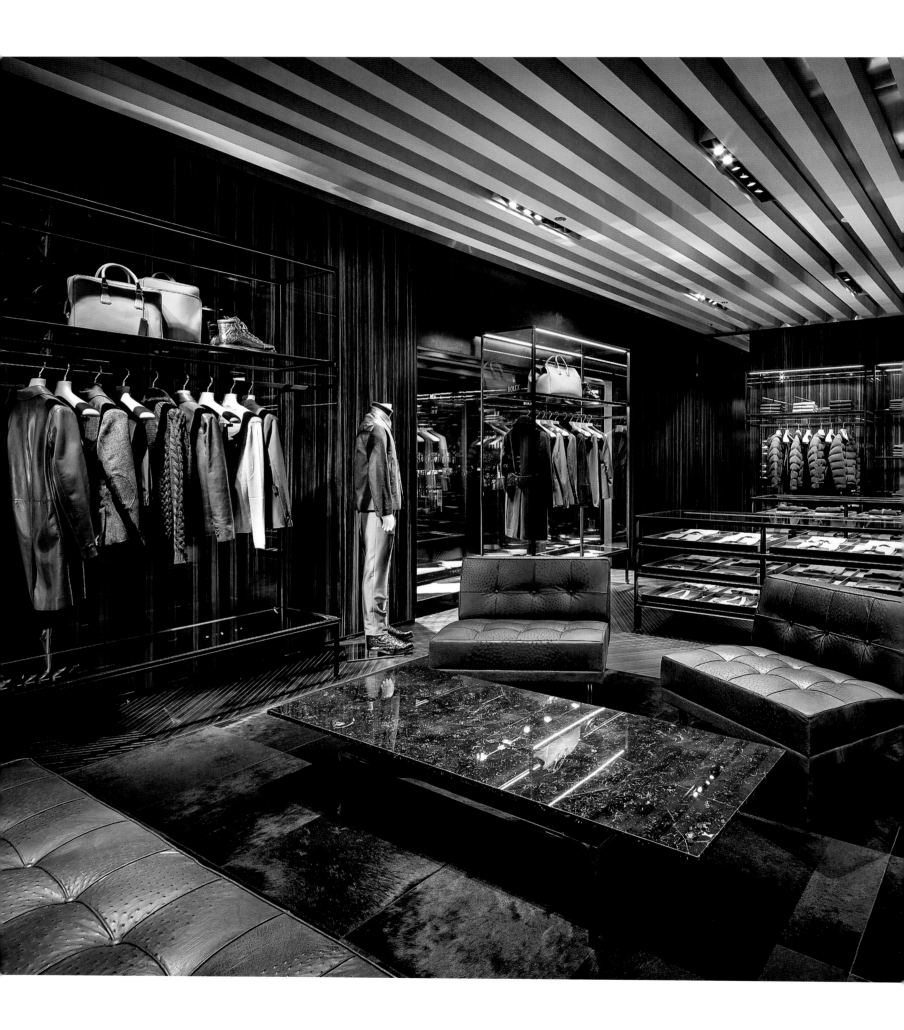

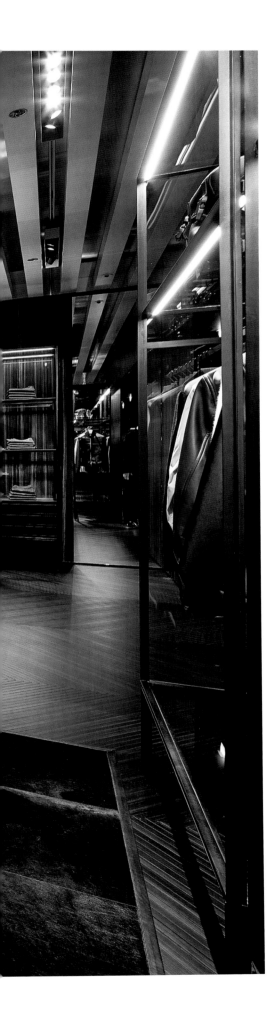

Masculine forms and powerful colors dominate at Prada Men in Frankfurt. The formal business feel of the leather chairs is softened by their intense blue, red, and green color palette. Shelves and presentation tables made of aluminum and glass are backed by elegant walls framed with vertical wood planks. Small marble tiles are laid out in a parquet design to contrast with the orange-red wall color. Marble tables and stairs underscore the formal austereness of the space. The concept by Roberto Baciocchi aims to create an elegant, representative, but still familiar atmosphere.

Maskuline Formensprache und kräftige Farben dominieren bei Prada Men in Frankfurt. Der formale Business-Charakter der Ledersessel wird durch ihre intensiven Blau-, Rot- und Grüntöne aufgebrochen. Regale und Präsentationstische sind aus Aluminium und Glas und stehen vor Wänden, die elegant mit vertikalen Holzriegeln verkleidet sind. Schmale Marmorfliesen wurden wie Parkett verlegt und kontrastieren mit dem Orangerot der Wände. Tische und Treppen aus Marmor unterstreichen die formale Strenge. Das von Roberto Baciocchi entworfene Konzept will eine elegant-repräsentative und dabei vertraute Atmosphäre schaffen.

La boutique Prada Men de Francfort est dominée par un langage visuel masculin et des formes puissantes. Le caractère « business » des fauteuils en cuir est rompu par des tons de bleu, de rouge et de vert intense. Les étagères et les tables de présentation se composent de verre et d'aluminium et sont placées face à des murs habillés d'élégantes barres de bois verticales. D'étroits carreaux en marbre ont été posés comme du parquet, et contrastent avec le rouge-orangé des murs. Les tables et les escaliers en marbre soulignent la sévérité des formes. Ce concept, créé par Roberto Baciocchi, vise à créer une atmosphère élégante, représentative, et familière à la fois.

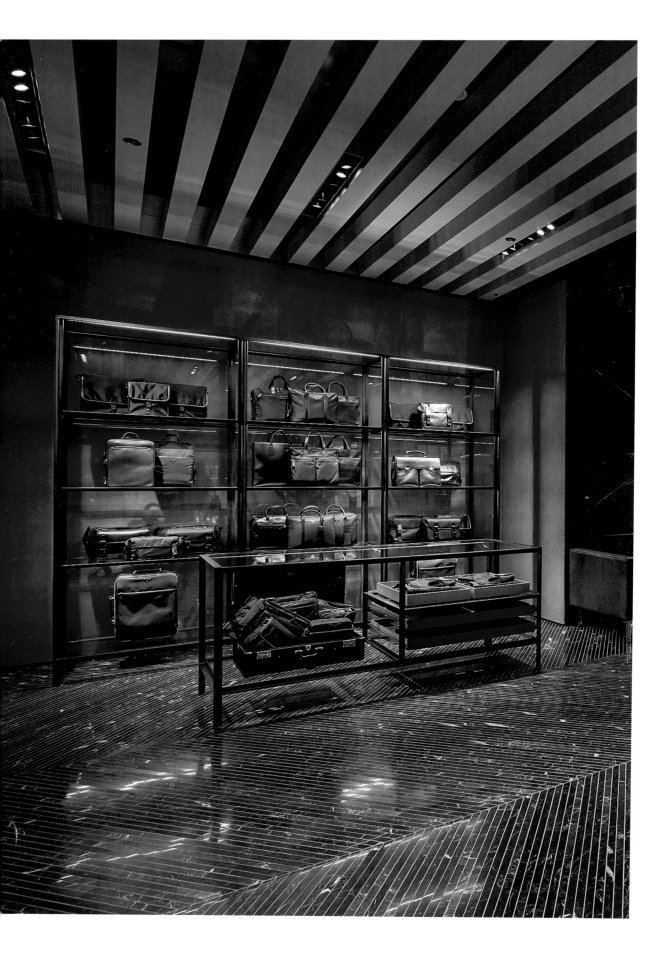

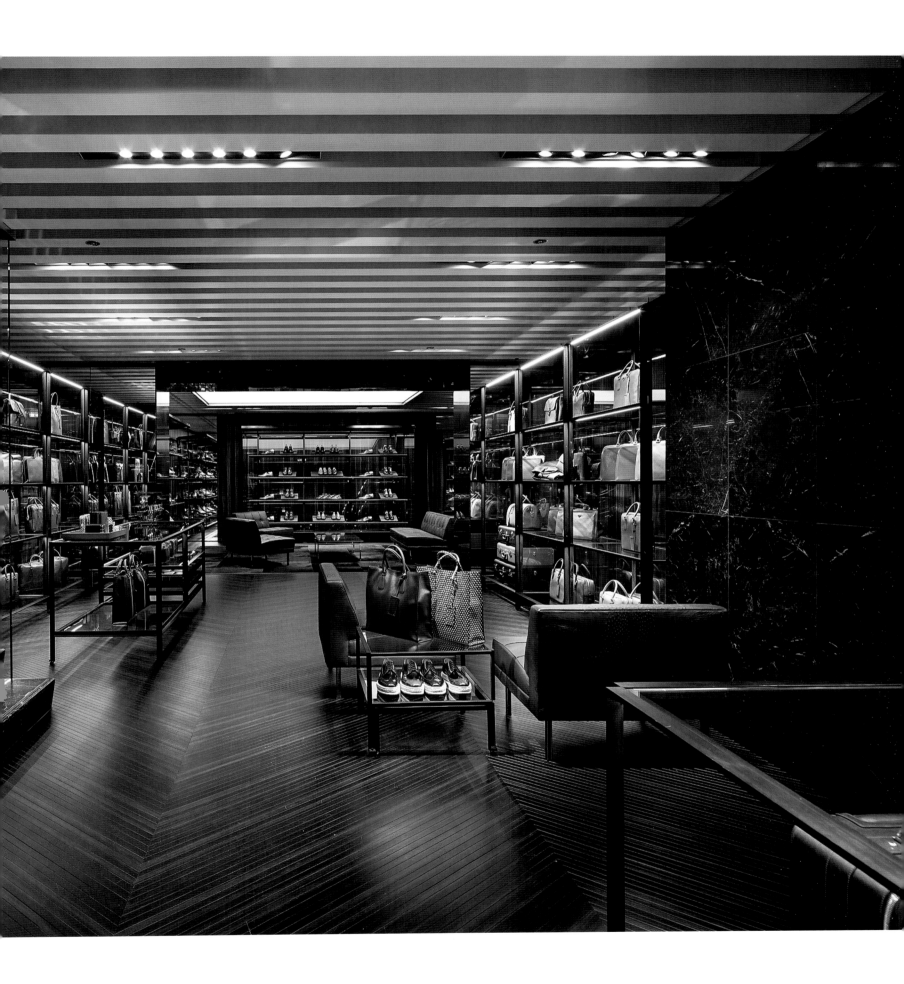

VERSACE

DÜSSELDORF

Always combative, and not afraid to be shrill: Donatella Versace drove the fashion empire of her brother Gianni to the brink of ruin before reviving it like a phoenix rising from the ashes. The brand's new interpretation of luxury builds on its earlier opulence, but still manages to transform the ponderous '80s styles. Versace successfully draws on the signature style of its eccentric but successful founder while giving it a new and modern update. But the clothes that stars and starlets once again proudly wear in public need a suitable stage to make them approachable for everyone. Versace is investing in new stores that want to show one thing above all: identity is generated from one's own history. The store on Düsseldorf's Königsallee combines baroque shapes with high-gloss materials to create tension and excitement: Plexiglas meets Byzantine-inspired mosaic tile floors. Brass-colored track lighting provides decorative structure for the ceiling and incorporates the architectural lines of the wall design. Bright light highlights shapes and accents elaborate details, making the presentation of collections simultaneously dramatic and sensual. Vases look more like monuments, and brass and glass are visually inflated. Donatella's Palazzo: the top creative mind wants retail design to be understood as a dialogue between the past and the future, and she lacks neither dramatic sophistication nor artistic talent. Reminiscent references to the heyday of Italian Baroque splendor—such as the passionate and powerful styling—make the brand DNA a tangible experience. It is not quiet at all, but noticeably more mature. Donatella developed the concept together with British architect Jamie Fobert.

Stets streitbar, gerne schrill: Donatella Versace manövrierte das Modeimperium ihres Bruders Gianni erst an den Rand des Ruins, um dann wie Phönix aus der Asche wieder aufzuerstehen. Der neu interpretierte Luxus knüpft an die frühere Opulenz der Marke an und schafft es doch, den überladenen 80er-Jahre-Stil zu transformieren. Es gelingt, die typische Handschrift des ebenso exzentrischen wie erfolgreichen Gründers zu zitieren und dabei neu und modern zu interpretieren. Was Stars und Sternchen wieder begeistert öffentlich zur Schau tragen, braucht nun auch eine passende Bühne, um nahbar zu werden – für jedermann. Versace investiert in neue Stores, die vor allem eines zeigen wollen: Identität generiert sich aus der eigenen Historie. Spannungsreich verbindet der Store auf der Düsseldorfer Königsallee barocke Formen mit einer hochglänzenden Materialsprache. Plexiglas trifft auf byzantinisch inspirierte Mosaikböden. Messingfarbene Lichtschienen strukturieren dekorativ das Deckenfeld und greifen die architektonische Linienführung der Wandabwicklungen auf. Strahlendes Licht macht Formen stärker sichtbar und akzentuiert aufwendige Details. Die Präsentation der Kollektion wird so dramatisch und sinnlich zugleich. Vitrinen bekommen monumentalen Charakter und werden durch Marmor, Messing und Glas visuell überhöht. Donatellas Palazzo: Die Kreativ-Chefin will das Retaildesign als Dialog zwischen Vergangenheit und Zukunft verstanden wissen und lässt es dabei weder an dramaturgischer Raffinesse noch an künstlerischem Können mangeln. Reminiszenzen an die Blütezeit des italienischen Barock-Prunks – zum Beispiel die leidenschaftliche und kraftvolle Formgebung – machen die Marken-DNA im Store erlebbar. Kein bisschen leise. Aber deutlich gereifter. Entwickelt hat Donatella das Konzept gemeinsam mit dem britischen Architekten Jamie Fobert.

Toujours contestable, volontiers criard : Donatella Versace mena l'empire de son frère Gianni au bord de la ruine, pour ensuite le faire renaître de ses cendres tel un phénix. Cette nouvelle interprétation du luxe s'inspire de l'ancienne opulence de la marque et parvient à transformer le style surchargé des années 1980. Elle réussit à évoquer la typique griffe de son créateur, aussi excentrique que couronné de succès, tout en en livrant une interprétation à la fois nouvelle et moderne. Ce que les célébrités et les starlettes exhibent avec fierté nécessite désormais une scène adaptée, afin de devenir accessible à tous. Versace investit dans de nouvelles boutiques dont l'objectif est de prouver la chose suivante : l'identité est générée par sa propre histoire. La boutique de Düsseldorf, située sur la Königsallee, associe de façon spectaculaire les formes baroques au langage ultrabrillant des matériaux. Le Plexiglas s'allie à des sols en mosaïque inspirés de Byzance. Des rails d'éclairage décoratifs couleur laiton structurent le plafond et reprennent les tracés architecturaux des murs. Une lumière éclatante met les formes en exergue tout en accentuant les détails très élaborés. Ainsi, la présentation de la collection est à la fois dramatique et sensuelle. Les vitrines se voient attribuer un caractère monumental et sont rehaussées de marbre, de laiton et de verre. Le palace de Donatella : la directrice artistique entend le Retail Design comme un dialogue entre le passé et l'avenir, et veille à ce qu'il ne manque ni raffinement dramatique, ni compétences artistiques. Les réminiscences de la grande époque du baroque italien, par exemple les formes passionnées et puissantes, rendent perceptible dans les boutiques l'ADN même de la marque. Certainement pas discret. Mais nettement mûri. Donatella a développé ce concept en collaboration avec l'architecte britannique Jamie Fobert.

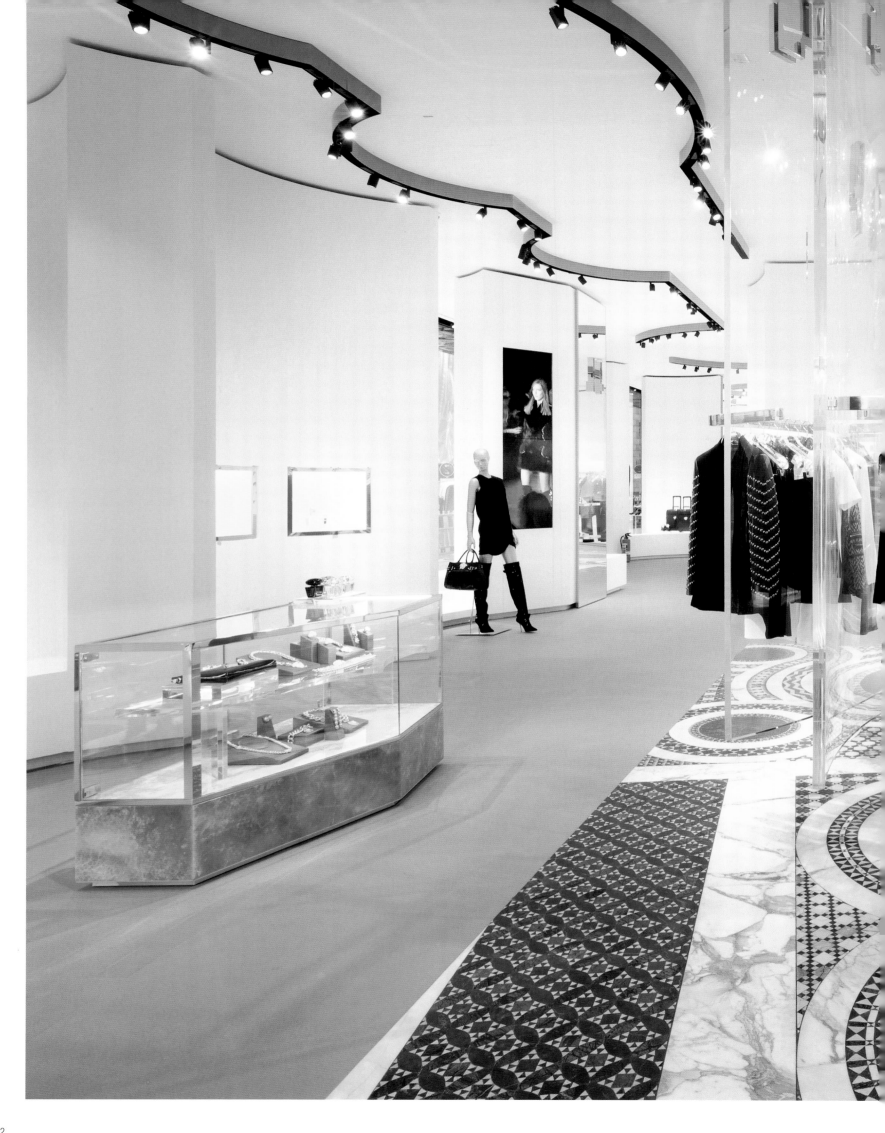

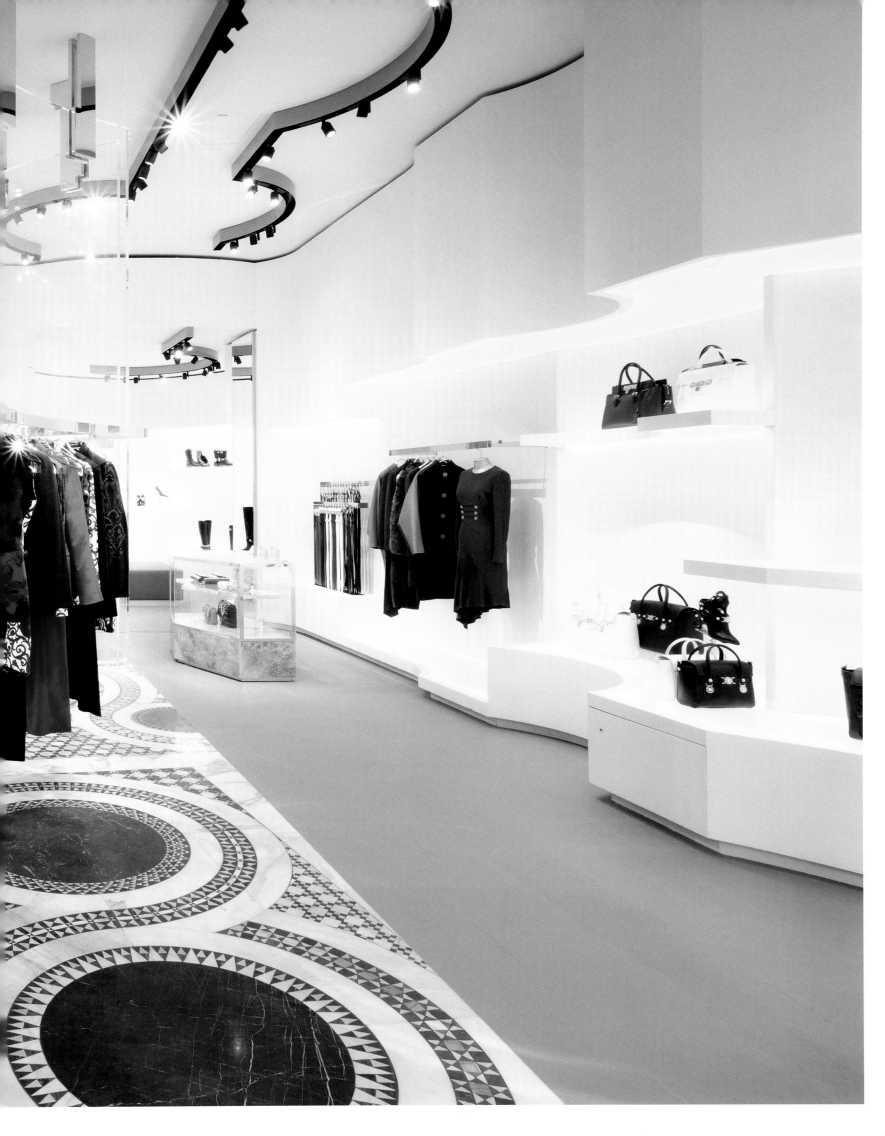

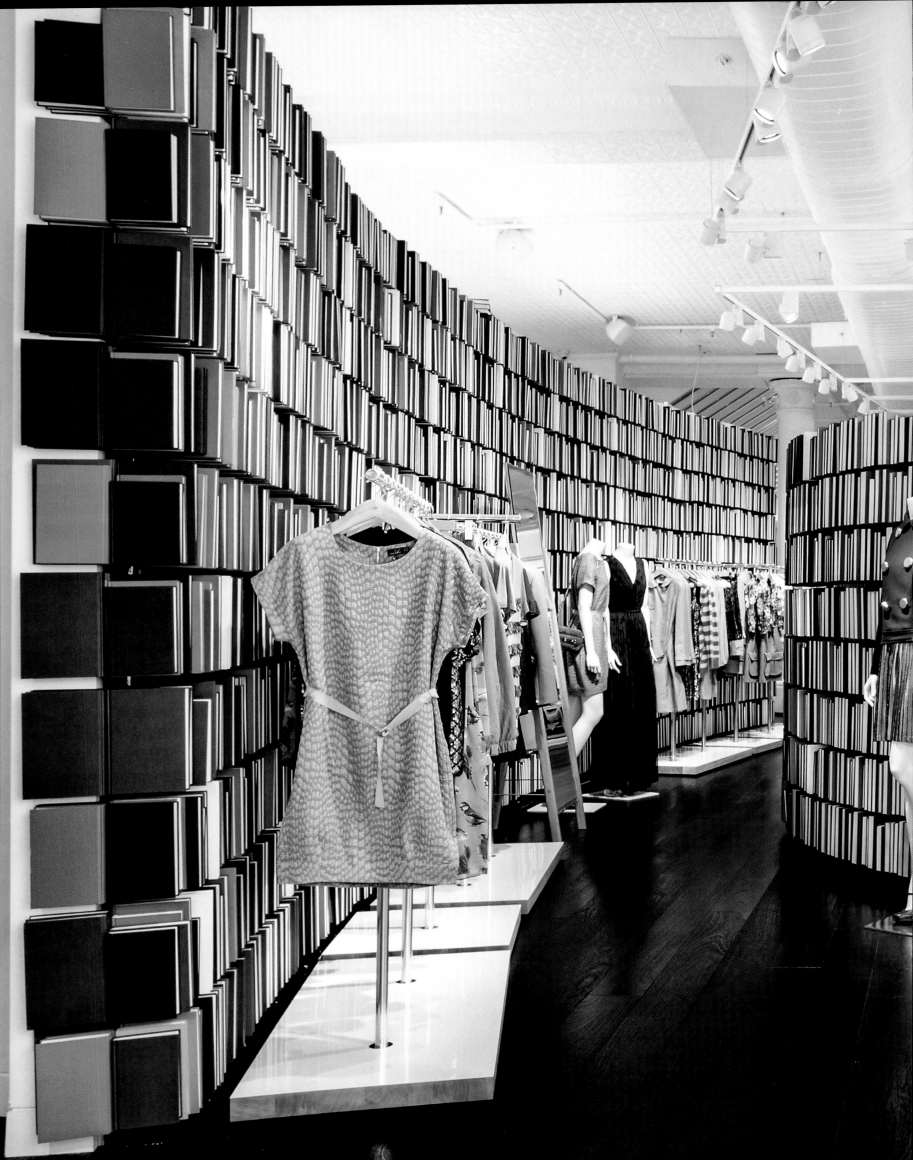

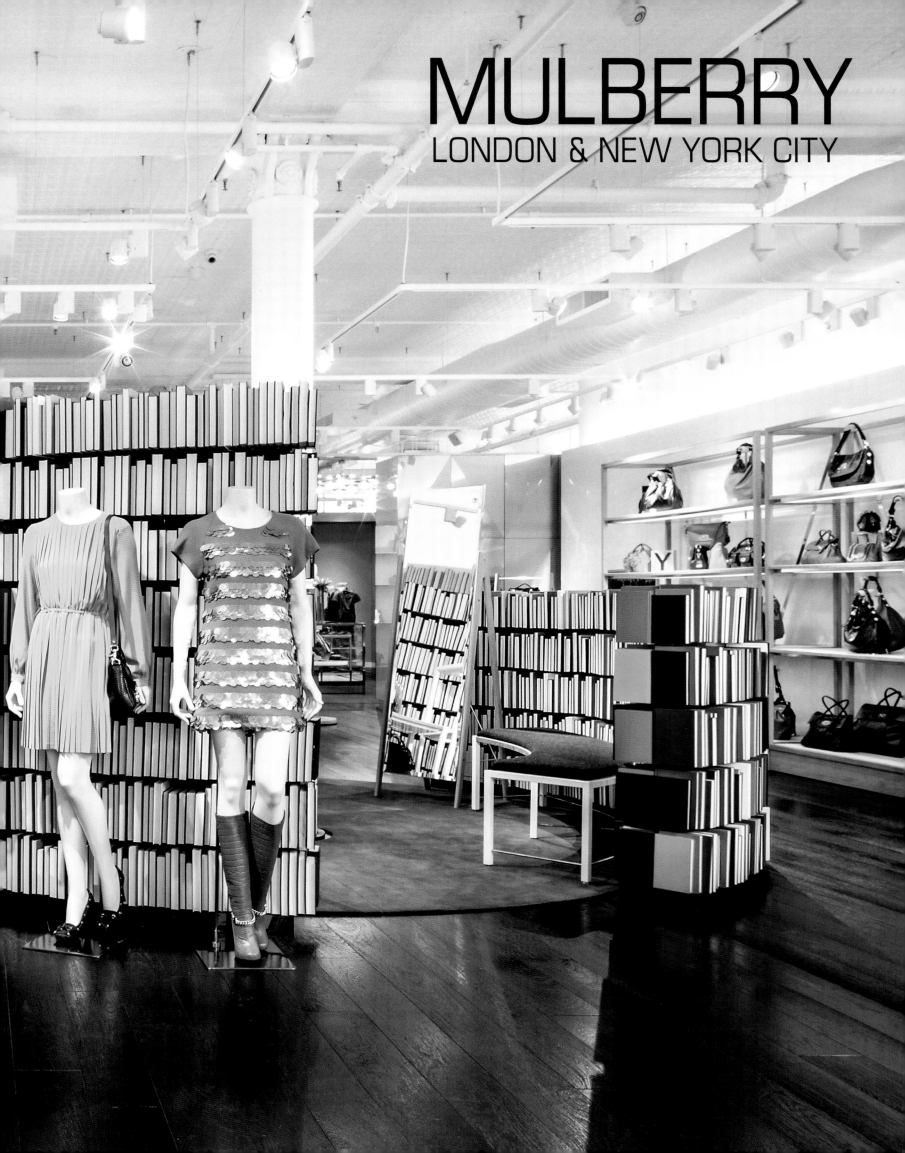

MULBERRY
LONDON & NEW YORK CITY

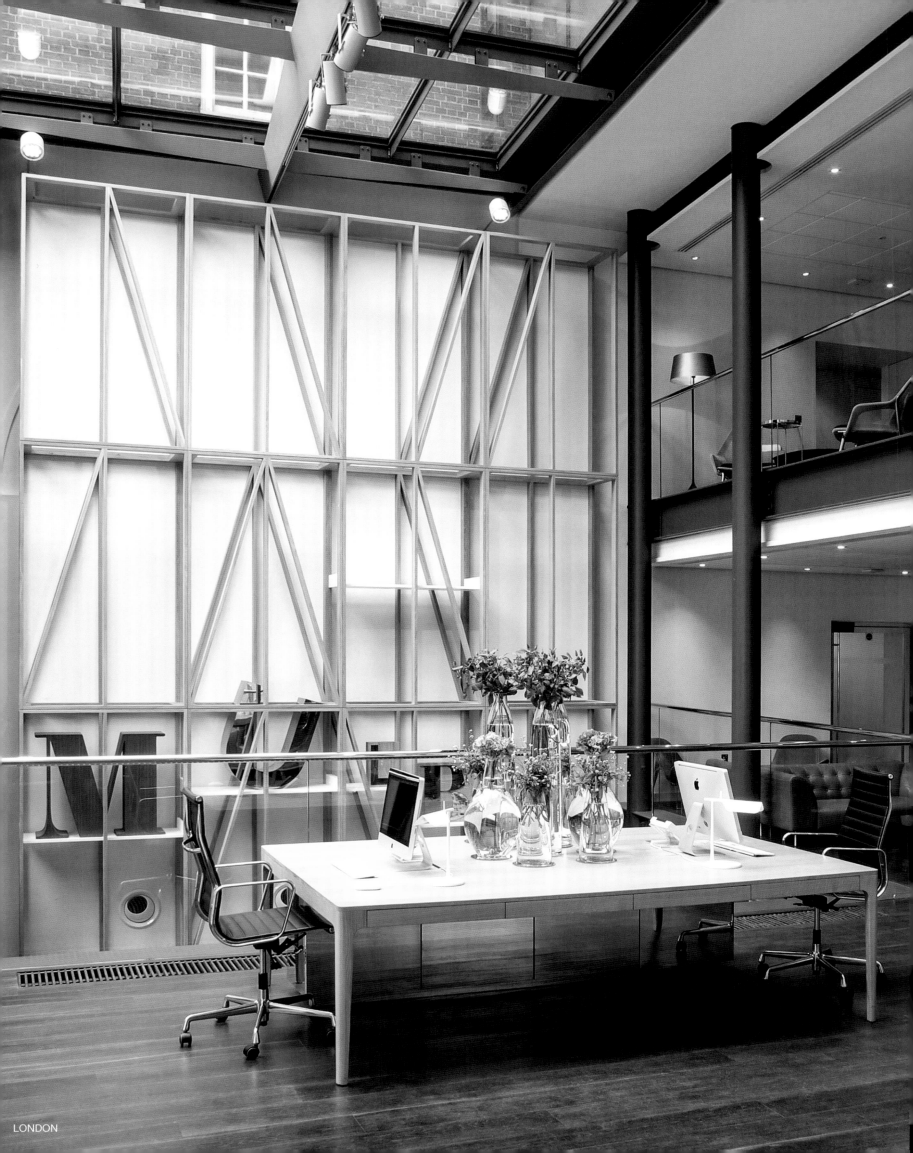

"Mulberry is an English brand with country roots, yet it has a modern and urban customer base. Conveying this dichotomy was just as important to us as the brand's English heritage and its associated emphasis on craftsmanship and tradition. Design allows you to build a culture for a brand and make its values tangible for employees and customers. Good design also makes workplaces more effective, better places to communicate and be productive, and increases well-being. We worked closely with Mulberry to develop a concept that would provide a space not only for the brand culture and Mulberry's home, but also promote cross-collaboration and communication," explains Jason Holley of London's Universal Design Studio. The firm designed the stores and Mulberry's corporate headquarters on London's Kensington Church Street.

„Mulberry ist eine ländlich verwurzelte englische Marke mit einer modernen und urbanen Kundschaft. Diese Dichotomie zu inszenieren war uns ebenso wichtig wie die englische Heritage der Marke und die damit verbundene Handwerkskunst und Tradition zu spiegeln. Durch Design kann man für eine Marke eine Kultur aufbauen, ihre Werte für Mitarbeiter und Kunden greifbar machen. Gutes Design macht auch einen Arbeitsplatz effektiver, kommunikativer und produktiver und erhöht das Wohlbefinden. Wir haben eng mit Mulberry zusammengearbeitet, um ein Konzept zu skizzieren, das nicht nur ein Platz für die Markenkultur und ‚Mullberry's Home' wird, sondern Cross-Kollaborationen und Kommunikation ermöglicht", erklärt Jason Holley vom Architekturbüro Universal Design Studio London. Das Büro konzipierte für das Luxuslabel die Stores und das Headquarter in der Londoner Kensington Church Street.

« Mulberry est une marque anglaise aux racines rurales mais qui a une clientèle moderne et urbaine. Mettre en scène cette dichotomie nous était aussi important que l'héritage anglais de la marque, ainsi que l'artisanat et la tradition qui y sont rattachés. Le design permet de construire une culture pour une marque et de rendre ses valeurs palpables pour ses employés et ses clients. Un bon design rend également les postes de travail plus efficaces, plus communicatifs et plus productifs, et améliore le bien-être. Nous avons travaillé en étroite collaboration avec Mulberry afin de créer un concept permettant non seulement de concevoir un endroit qui puisse accueillir la culture de la marque et ‹ le foyer de Mulberry ›, mais également favoriser les collaborations croisées et la communication », explique Jason Holley du bureau d'architectes Universal Design Studio London. Ce bureau d'architectes a conçu les boutiques et le quartier général de cette marque de luxe, qui sont situés sur la Kensington Church Street de Londres.

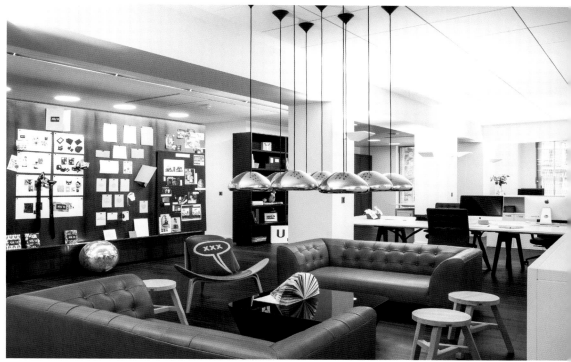

LONDON

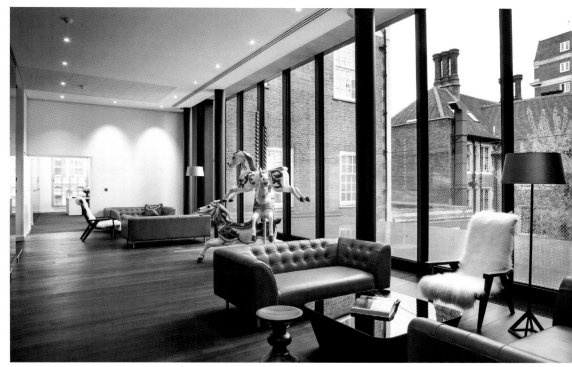

LONDON

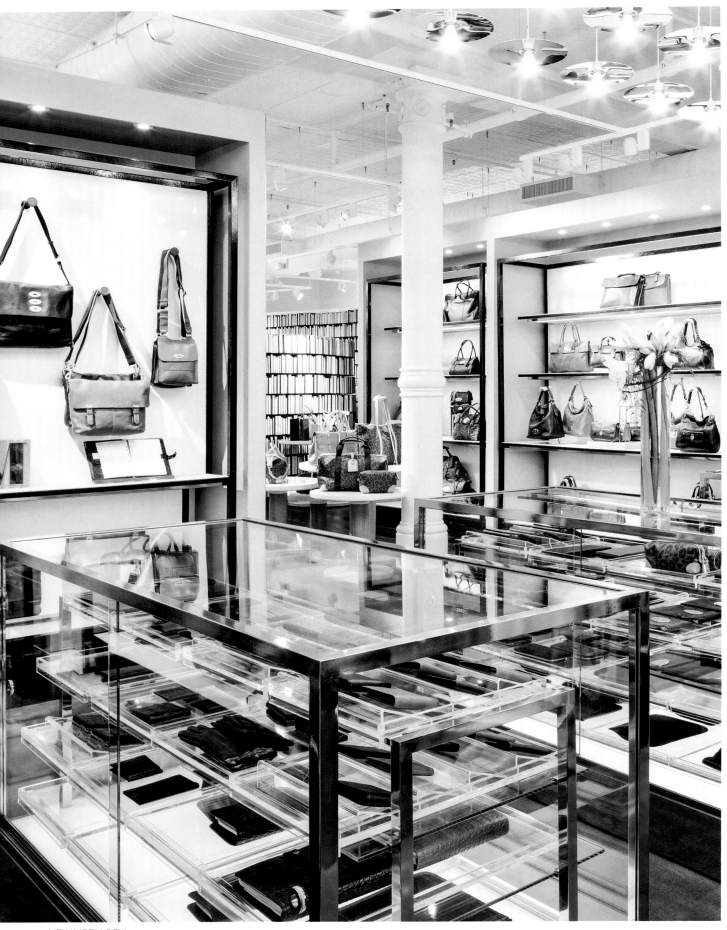

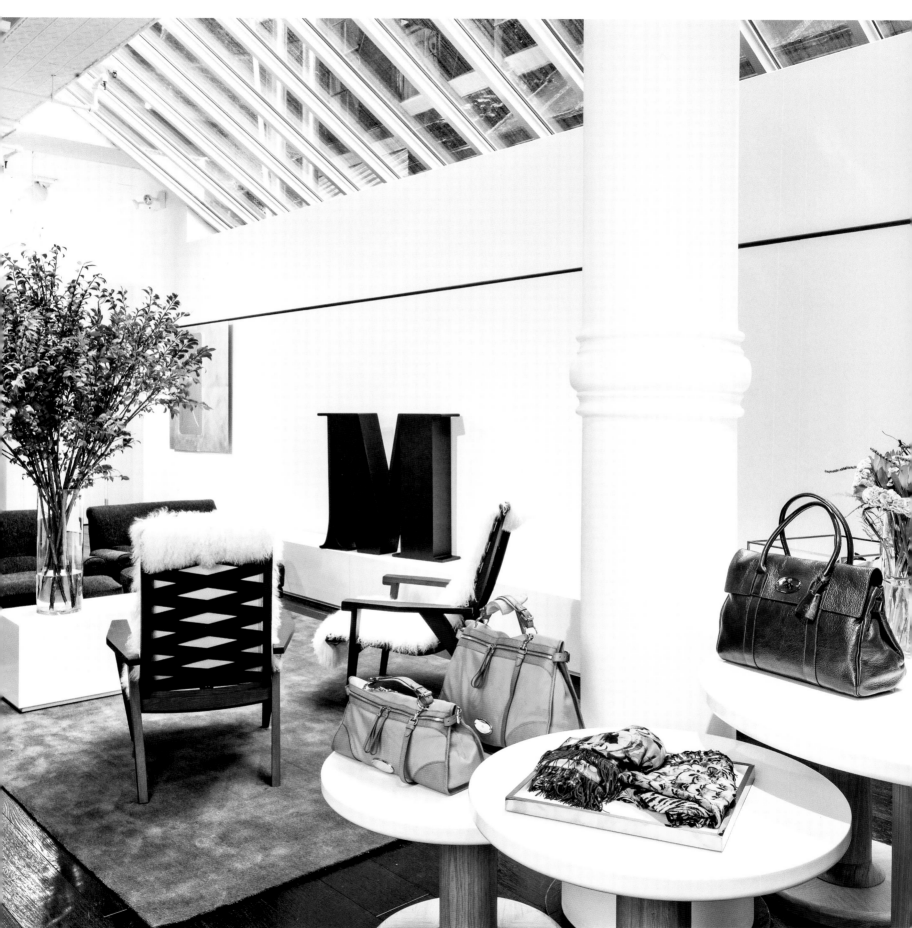

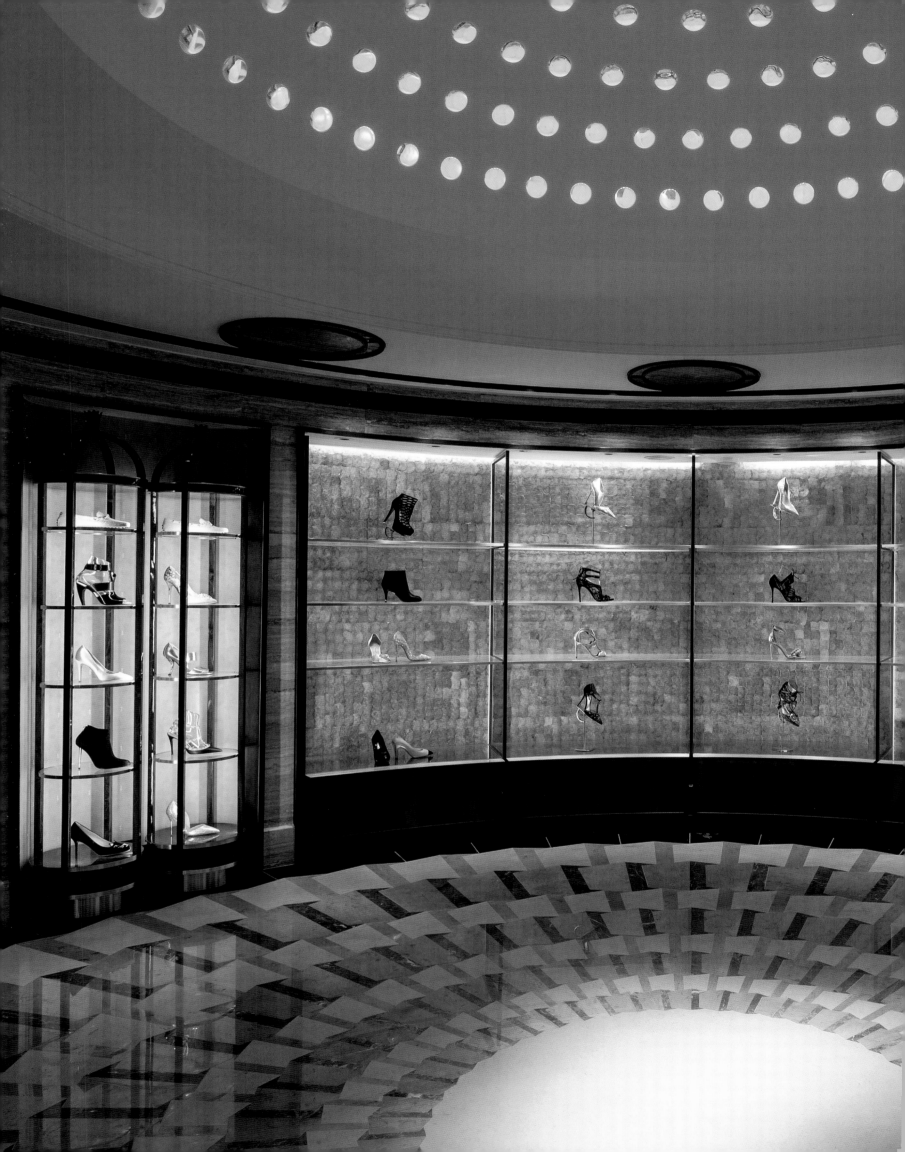

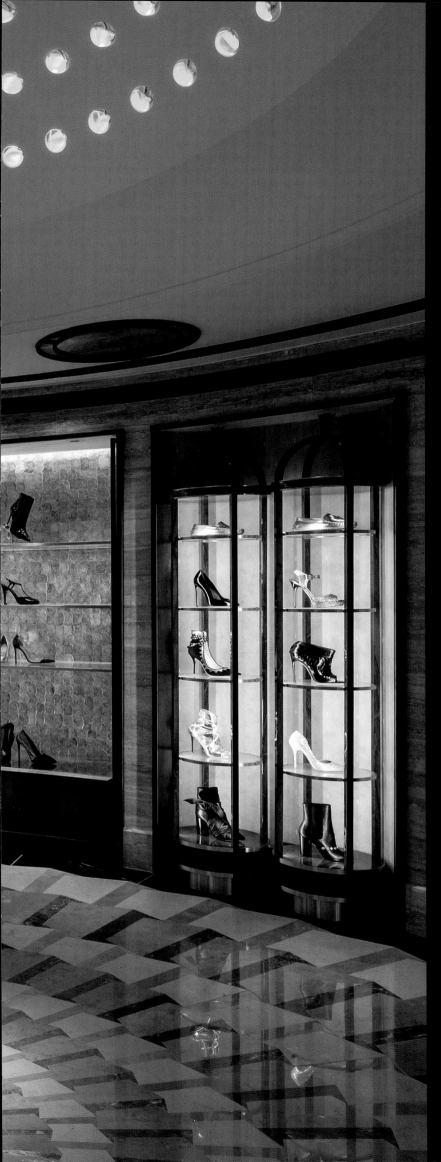

HARRODS

LONDON

"With shoes becoming an ever increasingly important part of the way a woman dresses, and indeed a key part of our business, we are creating a truly fabulous shoe destination in Harrods, to celebrate this."

Helen David,
Fashion Director of Womenswear,
Accessories & Fine Jewellery at Harrods

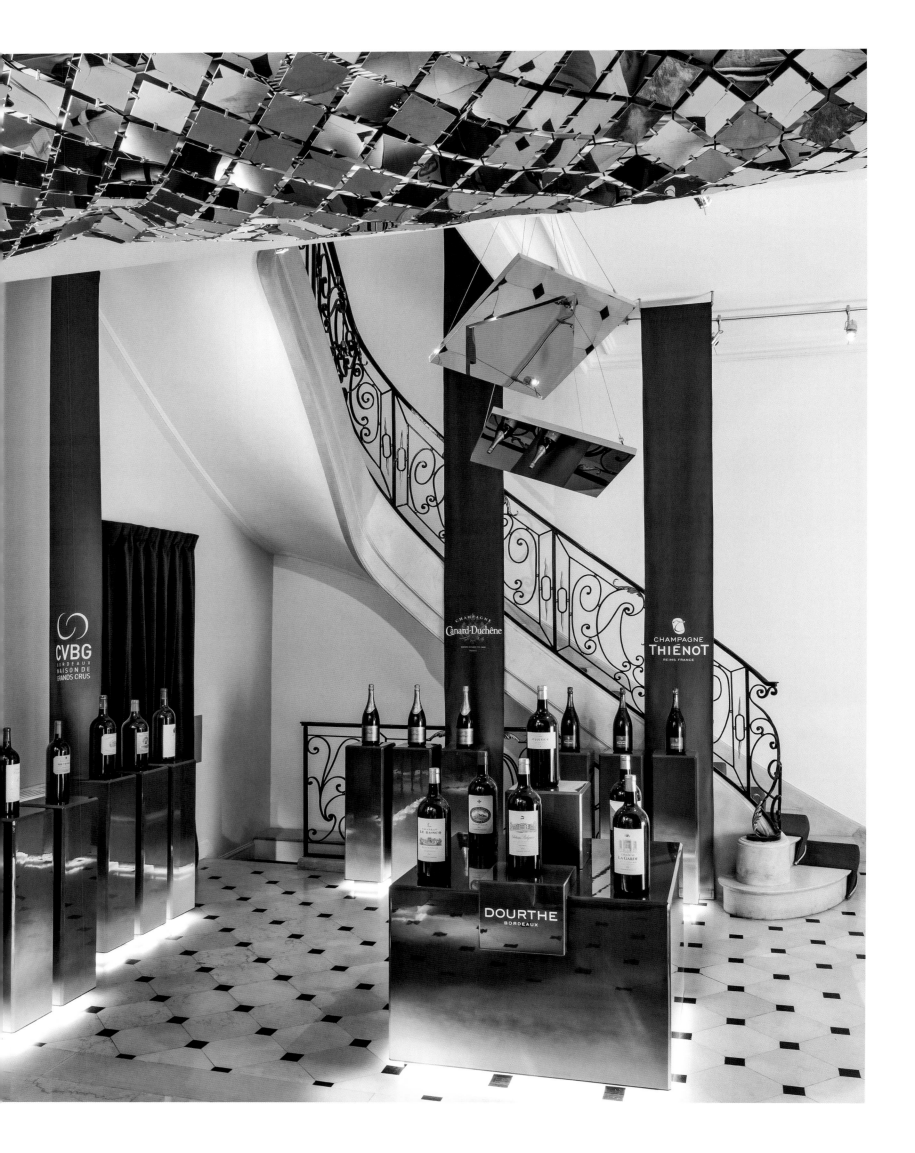

THIÉNOT

"In victory, you deserve champagne.
In defeat, you need it."

Napoleon Bonaparte

The showroom Laure Girodroux and Karolina Lubkowski created for Thiénot Bordeaux-Champagnes in Paris was developed in partnership with French designer Ora-ïto. Like a bubbly wave of champagne, a series of golden squares flows through the historical rooms in the celebrated style of Baron Haussmann.

Der von Laure Girodroux und Karolina Lubkowski kreierte Showroom für Thiénot Bordeaux-Champagnes in Paris entstand in Zusammenarbeit mit dem französischen Designer Ora-ïto. Wie eine perlende Champagnerwelle zieht sich das Band aus goldenen Plättchen durch die historischen Räume im Baustil Baron Haussmanns.

Le showroom du Thiénot Bordeaux-Champagnes créé à Paris par Laure Girodroux et Karolina Lubkowski a vu le jour en collaboration avec le designer français Ora-Ïto. Telle une vague de Champagne aux fines bulles, le ruban de pastilles dorées traverse les salles d'époque de style Baron Haussmann.

" Love it to the max or send it back ! "

"Love it to the max or send it back!" was the battle cry for a completely new era of shopping. In just one move, online retailer Zalando managed to make mouse-click-driven shopping a trendy new sport. Shoeboxes have never been so sexy. Luxury department store Jelmoli of Zurich began mailing out goods in a cardboard box at the end of the 19th century. How unbelievably modern! Most recently, Farfetch, an online portal for luxury fashion, purchased London brick-and-mortar retailer Browns as a kind of test lab on High Street. The hype surrounding e-commerce is giving way to reality. More and more Internet-only players want some traction in the brick-and-mortar world. They want to get to know their customers and understand that in-store experiences are important for building customer loyalty and cannot be completely replaced by online shops. "Omnichannel" is the new watchword. In simple terms, it is about mixing a convincing cocktail for the target demographic that is just right in terms of the brand, product, and service. Of course, tradition-steeped Jelmoli now runs a large online shop as well. But the main thing is that the department store, which was founded in 1833, has remained true to itself and surprises shoppers with high-density product displays, even in its grocery department. Elegant evening robes are displayed next to the cheese counter, and a stack of polo shirts in matching colors helps decorate the olive oil display. Interstore Design developed the concept for the grocery department.

„Schrei vor Glück oder schick's zurück!" war der Schlachtruf einer völlig neuen Shoppingära. Dem Onlinehändler Zalando gelang es mit einem Schlag, die Shoppingtour per Mausklick zum Trendsport zu machen. Noch nie waren Schuhkartons so sexy. Ende des 19. Jahrhunderts begann das Luxuskaufhaus Jelmoli aus Zürich bereits mit dem Versand von Waren in der sogenannten Kartonschachtel. Unerhört modern. Jüngst kaufte das Onlineportal für Luxusmode Farfetch den renommierten Londoner Einzelhändler Browns. Quasi als Testlabor auf der High Street. Der Hype um den Onlinehandel weicht den Realitäten. Pure Internetplayer suchen immer häufiger die Bodenhaftung im stationären Handel. Sie wollen ihre Kunden kennenlernen und haben verstanden, dass In-Store-Erlebnisse zur Markenbindung wichtig sind und nicht völlig durch Onlineshops ersetzt werden können. Omnichannel ist das Zauberwort und es geht schlicht darum, einen überzeugenden Dienstleistungscocktail für die Zielgruppe zu mixen, damit alles passt: Marke, Produkt und Service. Das Traditionshaus Jelmoli unterhält mittlerweile natürlich einen breit aufgestellten Onlineshop. Vor allem aber ist sich das 1833 gegründete Kaufhaus treu geblieben und überrascht vor Ort mit dicht inszenierten Warenbildern, auch in der Lebensmittelabteilung. Da wird die elegante Abendrobe schon mal neben der Käsetheke drapiert und ein Stapel Polo-Hemden farblich passend zum Olivenöl dekoriert. Das Konzept für die Food-Abteilung stammt von Interstore Design.

« Célèbre le bonheur ou alors renvoie-le » était le cri de guerre de cette nouvelle ère de shopping. Le vendeur en ligne Zalando est parvenu à vitesse grand V à faire du shopping par clics de souris un sport tendance. Les cartons de chaussures n'avaient jamais été aussi sexy. Le grand magasin de luxe zurichois Jelmoli commença à expédier ses articles dans des boîtes en carton dès la fin du 19ème siècle. D'une modernité sans précédent. Récemment, le portail de mode de luxe en ligne Farfetch a racheté le fameux commerçant londonien Browns. Pour s'en servir, pour ainsi dire, comme laboratoire d'expériences sur la High Street. Le succès fou du commerce en ligne commence à céder face aux réalités. Les purs vendeurs en ligne cherchent à revenir à plus de « terre à terre » dans des boutiques physiques. Ils souhaitent rencontrer leurs clients et ont compris que les expériences vécues sur le point de vente sont importantes pour la fidélisation à la marque et ne peuvent être totalement remplacées par des boutiques en ligne. « Omnichaînes » : tel est le mot magique. Il s'agit purement et simplement de créer pour le groupe cible un cocktail de services convaincant, afin que tout concorde : Marque, produit et prestation. Aujourd'hui, la maison traditionnelle qu'est Jelmoli exploite bien entendu une boutique en ligne proposant une large gamme de produits. Mais surtout, ce grand magasin créé en 1833 est resté fidèle à lui-même, et surprend sur place avec des tableaux muraux dans une mise en scène intense, et ce, même au rayon alimentation. Une élégante robe de soirée peut orner le rayon fromage, et une pile de polos décore le rayon huile d'olive. Le concept du rayon alimentaire a été élaboré par Interstore Design.

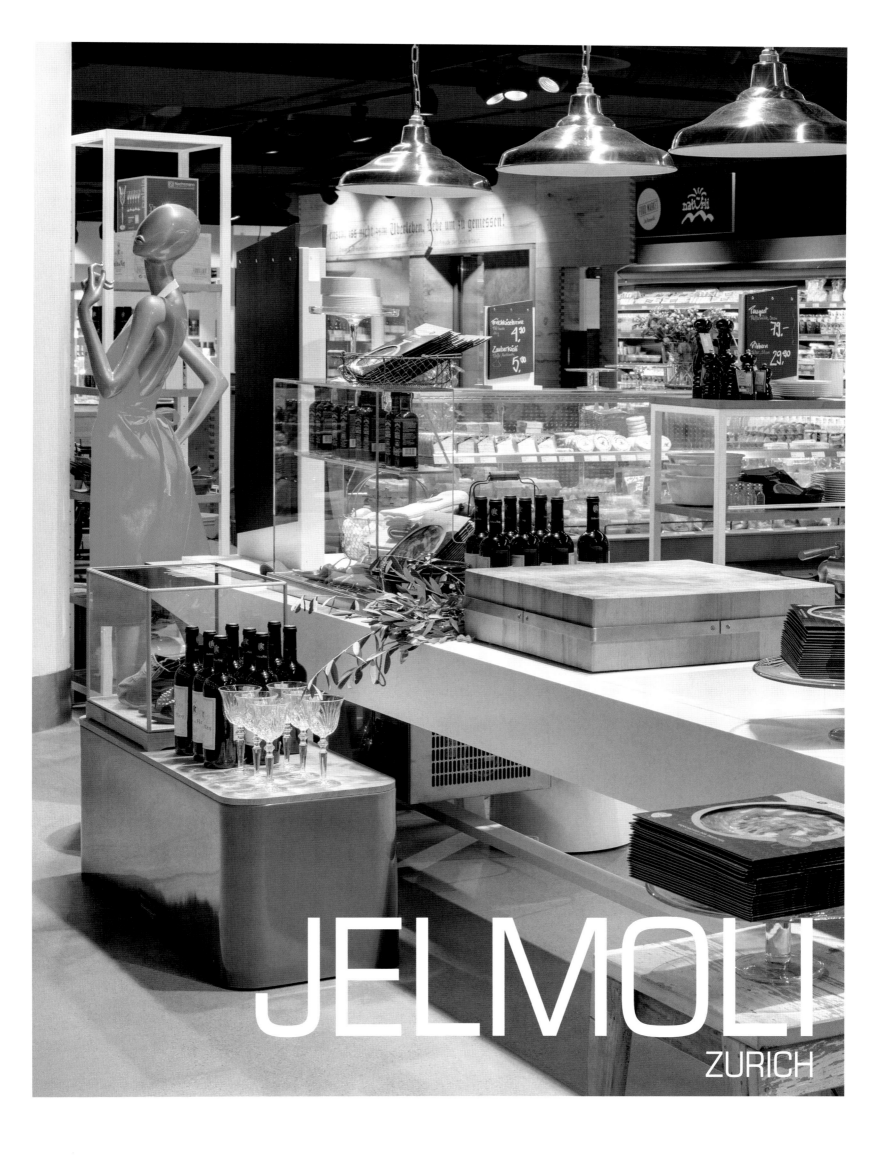

JELMOLI
ZURICH

"Yes,

there they were, a pair of them, luscious, shiny, and simply magnificent. I immediately grabbed them. They were just what I needed: two dazzling, yet soft, golden pillows for my vintage long chair. My home decorator's heart gave a happy hop. Satisfied, I quickly strode to the checkout. But oh, how hip: there was no traditional checkout counter, just an artfully tattooed forty-something sales consultant with a certain lascivious charm. That alone ramped up my emotional-environmental eagerness to buy a few more notches. I had that warm fuzzy feeling you get when you land the right style in the right store at the right time. Fabulous. In a gentle baritone, he asked me how I wished to pay, because usually these things were only handled online nowadays. What a question in a checkout-less hipster store. With my card, of course. Since I did not have the corresponding stick, I eventually had to sign my name with my finger on a tablet—with my finger? Like with finger paints on the windowpane? Mr. Tattoo nodded. To complete the purchase of two extremely stylish pillows for an exorbitant price, I had to scribble around on a wobbly screen with my finger. How incredibly uncool was that? How on earth could you possibly produce the peppy signature you worked so hard to perfect with your gold fountain pen? A signature is always, yes, always, an autograph as well. I mean, really. Twenty minutes later, I had prevailed with a pen, a real printed receipt, and a perfectly normal plastic bag—totally old-school. But worse yet, that hip and trendy feeling was gone. Now I had to dash into the wine department at a high-end department store. Flattering savoir-vivre charm, sparkling crémant—helping hands quickly carried two chilled cases to the checkout. Using my credit card was a snap. Getting the bubbly to the car, not so much. Undaunted, I continued on to the Italian deli around the corner. Alluring ham and huge pieces of Parmesan were nestled seductively together in the yardhigh glass case. As if by magic, the paper-thin slices of ham were rolled up in paper (how crazy!) and passed across the counter. And who the hell decided that we can't have those wonderful big glass cases anymore? Nothing and no one so majestically conveys the heritage of real, healthy food. Just seeing the case, I know that everything that comes out of this treasure chest is of the highest quality, delicious, and produced in an honest and sustainable fashion. By comparison, any home-shopping platform for groceries and those oh-so-snappy "We're loving it" campaigns seem so junky and devoid of nutrition. And of course, Giorgio himself carried the case of Regaleali to my car. I paid with my debit card. Wham, bam, done. Grazie. Maybe the real question isn't how you optimize virtual purchasing processes, but how you emotionalize online shopping."

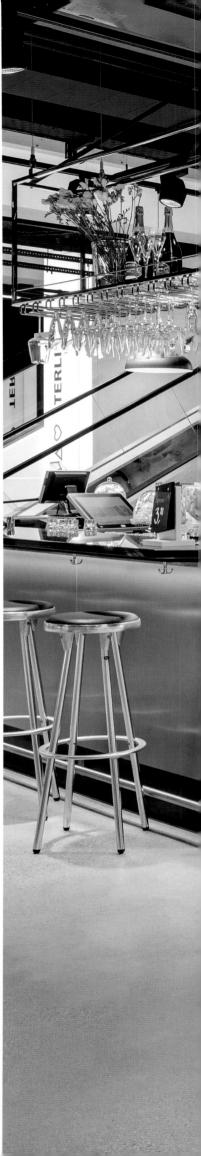

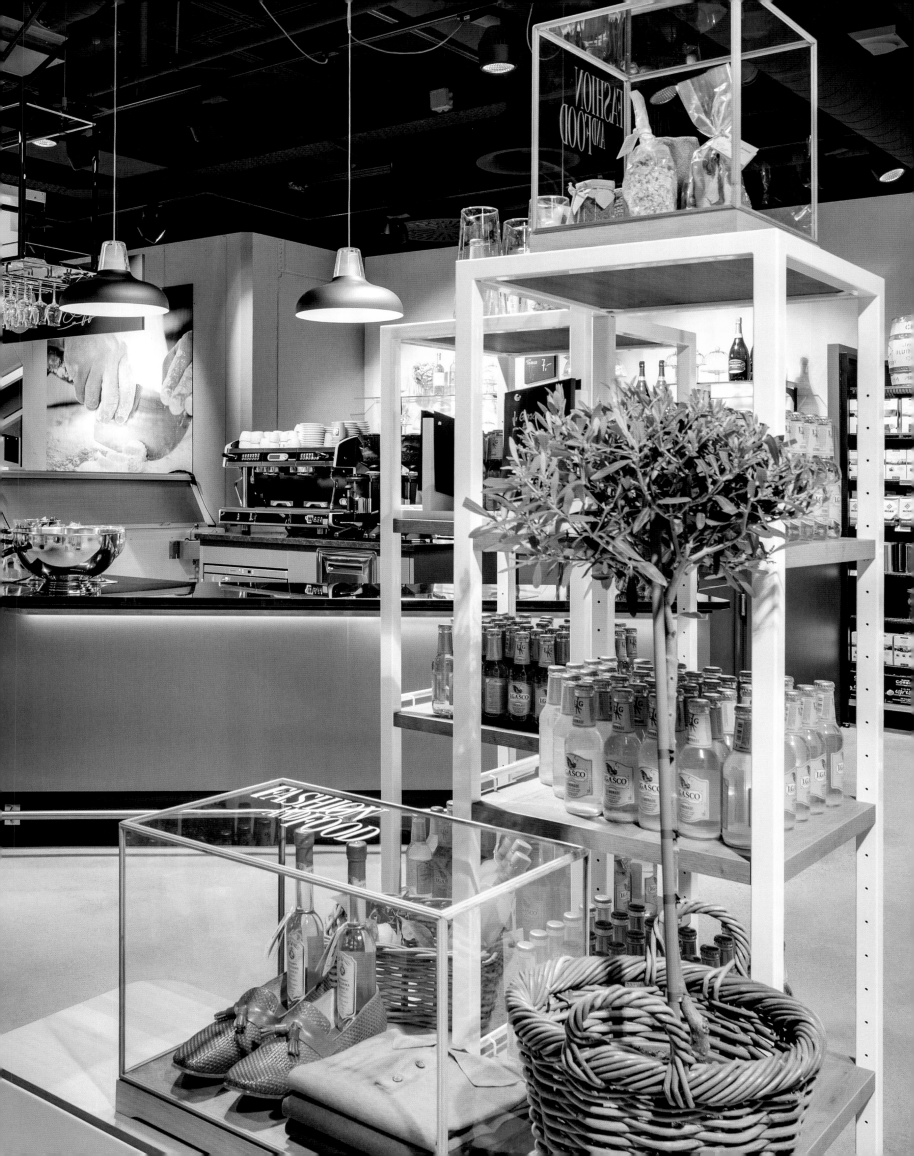

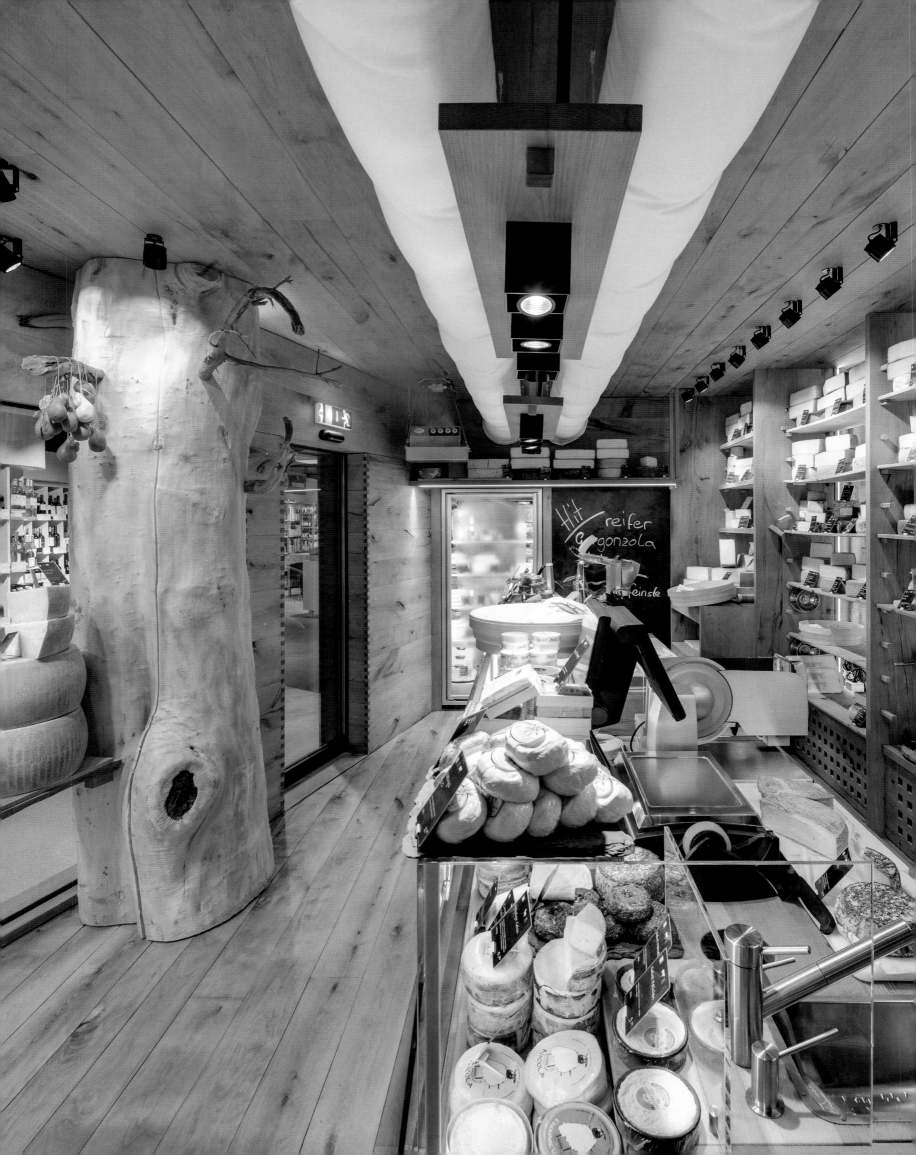

„Ja,

da lagen sie. Zu zweit, knackig, glänzend und einfach prachtvoll. Ich griff sofort zu, genau diese hatten mir noch gefehlt: zwei schillernde und trotzdem weiche goldene Kissen für meinen Vintage Long Chair. Mein Home-Style-Herz hüpfte freudig. Selig und schnellen Schrittes ging es zur Kasse. Oh wie hip: Es gab keine traditionelle Kasse. Stattdessen einen kunstvoll tätowierten Forty-Something-Berater mit laszivem Charme. Das allein wertete meine Kaufentscheidung atmosphärisch-emotional noch mal um einiges auf. Dieses wohlige Gefühl, im richtigen Laden zur richtigen Zeit den richtigen Style gecatcht zu haben. Großartig. Mit sanftem Bariton-Timbre wurde ich gefragt, wie ich zahlen wolle, denn eigentlich werde so was nur noch über den Onlineshop abgewickelt. Was für eine Frage in einem kassenlosen Hipster-Store. Mit der Karte natürlich. In Ermangelung des entsprechenden Sticks sollte ich etwas später mit dem Finger auf einem Tablet unterschreiben. Mit dem Finger…? Also wie Fingerfarben auf dem Kinderzimmerfenster. Mr. Tattoo nickte. Es wurde verlangt, dass ich für zwei extrem stylishe Kissen für einen nicht ganz kleinen Gesamtpreis mit dem Finger auf einem wackeligen Bildschirm herumkrakle. Wie uncool war das denn? Wie sollte man denn da jenen mühsam mit der Goldfeder antrainierten Signature-Schwung hinbekommen? Eine Unterschrift ist immer, tatsächlich immer, auch ein Autogramm. Also wirklich … Zwanzig Minuten später hatte ich einen Stift, eine echte ausgedruckte Quittung und eine ganz norma-

le Plastiktüte durchgesetzt. Total old school. Aber schlimmer noch: Das hippe Trendgefühl war nun leider weg. Jetzt schnell noch in die Weinabteilung eines Luxuskaufhauses. Schmeichelnder Savoir-vivre-Charme, perlender Crémant – helfende Hände trugen mir gleich zwei gekühlte Kisten an die Kasse. Kreditkarte war kein Problem. Zum Auto schleppen schon eher. Unverdrossen ging es weiter zum Italiener um die Ecke. Verlockender Schinken und riesige Parmesanstücke drängelten sich verführerisch in der meterhohen Glastheke. Wie von Zauberhand wurden die in (how crazy!) Papier eingerollten hauchdünnen Schinkenscheiben über die Theke geschoben. Wer, verdammt noch mal, hat eigentlich beschlossen, dass es diese wunderbaren riesigen Glastheken nicht mehr geben darf? Nichts und niemand strahlt die Heritage echter, gesunder Lebensmittel derartig königlich aus. Schon der Anblick dieser Vitrine gibt Sicherheit: Alles, was aus dieser Schatztruhe kommt, ist von bester Qualität, köstlich, ehrlich und nachhaltig produziert. Dagegen wirkt jede Home-Shopping-Plattform für Lebensmittel und die noch so knackig getexteten „Wir-lieben-es"-Kampagnen vitaminlos und nährstoffarm. Und die Kiste Regaleali hat Giorgio natürlich persönlich ins Auto getragen. Bezahlt wurde mit EC. Ging echt schnell. Grazie. Die Frage ist vielleicht nicht, wie man die virtuellen Einkaufsprozesse optimiert, sondern eher, wie man den Onlinehandel emotionalisiert."

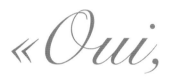

«Oui,

c'était eux. Par deux, tout mignons, brillants, et tout simplement superbes. Je me précipitai dessus. Il me les fallait absolument : deux coussins dorés, à la fois doux et irisés, pour ma chaise longue vintage. Mon cœur très « home style » battait la chamade. Rempli d'une joie béate, je me dépêchai de passer à la caisse. Ô comme c'était hip : Ce n'était pas une caisse traditionnelle. À la place trônait un conseiller magnifiquement tatoué, la quarantaine, au charme envoûtant. Tout cet aspect « ambiance et émotions » valorisa encore ma décision d'achat. Quelle agréable sensation que celle d'avoir trouvé le bon style, dans la bonne boutique et au bon moment ! Magnifique. Le caissier me demanda de sa douce voix de baryton comment je souhaitais régler, car à vrai dire cette procédure ne s'effectuait plus que via la boutique en ligne. Quelle question, dans une boutique hipster sans caisse ! Par carte bleue bien sûr. En l'absence du stylet correspondant, on me fit signer un peu plus tard avec le doigt sur une tablette. Avec le doigt ? Comme la peinture à doigts sur la fenêtre de la salle de jeux des enfants. Monsieur « Tattoo » fit un signe approbatif de la tête. On me demandait, pour deux coussins super stylés vendus à un prix tout sauf modeste, de signer avec un doigt sur un écran pas très stable. C'est certain, ce n'était ni cool ni hip. Comment réaliser ce joli mouvement harmonieux auquel je m'étais patiemment entraîné pour ma signature ? Une signature est toujours, absolument toujours, aussi un autographe. Non mais franchement… Vingt minutes plus tard, j'avais réussi à imposer l'utilisation d'un stylo et

à me faire remettre un ticket de caisse imprimé et un sachet en plastique. Carrément old school. Mais plus grave encore : cette impression de tendance hip avait totalement disparu. Maintenant, il ne me restait plus qu'à me rendre au rayon vin d'un grand magasin de luxe. Le doux charme du savoir-vivre, du Crémant, et des mains volontaires pour porter pour moi deux caisses réfrigérées à la caisse. La carte bleue n'était pas un problème. Les transporter jusqu'à la voiture, en revanche, oui. Vaillamment, je poursuivis mon chemin en me rendant chez l'Italien du coin. Un appétissant jambon et d'énormes morceaux de parmesan se bousculaient, séduisants, dans la haute vitrine. Comme par magie, les tranches de jambon ultra fines emballées dans (how crazy!) du papier passaient sur le comptoir. Bon sang, qui a décidé de supprimer ces magnifiques vitrines en verre ? Rien ni personne ne met mieux en valeur les aliments authentiques et sains proposés à la vente. La seule vue de cette vitrine le confirme : Tout ce qui sort de ce coffre au trésor est de la meilleure qualité qui soit, délicieux, et produit de manière honnête et durable. À l'inverse, toutes les plateformes de shopping pour produits alimentaires, ainsi que leurs campagnes aux slogans « MIAM » et « un délice » sont insipides et n'évoquent ni vitamines, ni éléments nutritifs. Et bien sûr, c'est Giorgio en personne qui a apporté la caisse de Regaleali à ma voiture. Le paiement s'est fait par carte bleue. Sans perte de temps. Grazie. La question n'est peut-être pas de savoir comment optimiser les procédures d'achat virtuelles, mais comment émotionnaliser le commerce en ligne. »

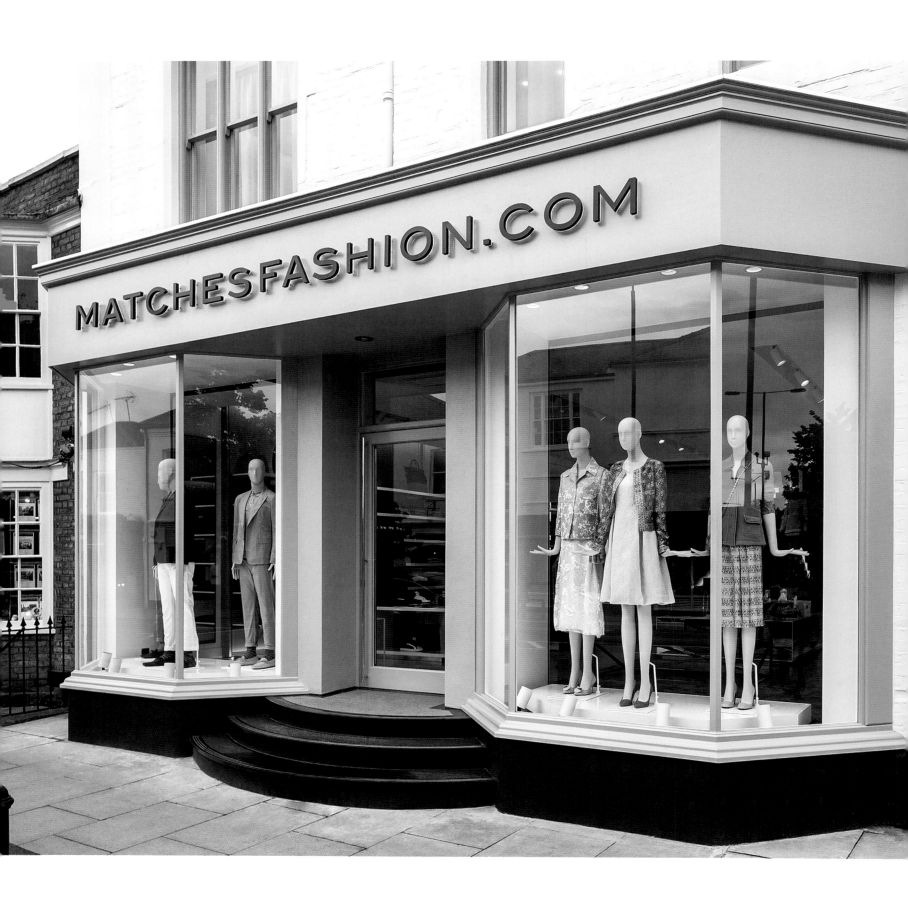

LONDON

MATCHESFASHION.COM

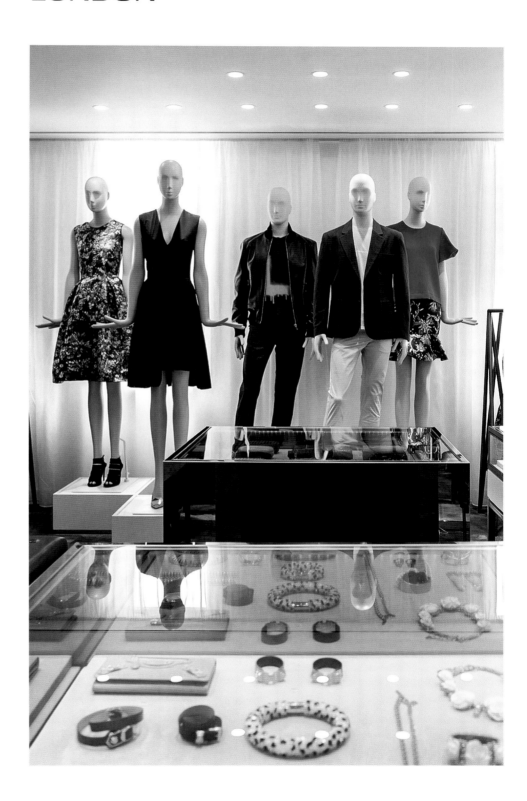

Launched 28 years ago in Wimbledon as a high-fashion boutique, matchesfashion.com founders Ruth and Tom Chapman made the jump to online sales early and found success there. Matchesfashion.com now expertly combines the advantages of social media and online sales with the experience of a brick-and-mortar retailer. After all, "touch and talk" is still the foundation for good customer relationships. London architecture firm MRA recently supplied an elegant store design for an exclusive branded shop in Wimbledon Village. Straight lines and purism are accented with gold. The focal point is the sculptured staircase with toned timber veneer that leads to the ground floor. Tablets allow access to the online world at any point during a shopper's visit.

Vor 28 Jahren in Wimbledon als High-Fashion-Boutique gestartet, gelang den Gründern Ruth und Tom Chapman frühzeitig der erfolgreiche Einstieg in den Onlinehandel. Mittlerweile verknüpft matchesfashion.com souverän die Vorteile von Social Media und Onlinegeschäft mit der Erfahrung eines Retailers. Denn: Touch & Talk ist immer noch die Basis für gute Kundenbeziehungen. In Wimbledon Village inszenierte das Londoner Architekturbüro MRA nun ein elegantes Storedesign für die exklusive Markenauswahl. Geradlinigkeit und Purismus werden mit Gold akzentuiert. Mittelpunkt ist die skulpturale Treppe aus satiniertem Holz, die ins Untergeschoss führt. Via Tablet ist der Zugang zur Online-Welt jederzeit möglich.

Après avoir ouvert leur boutique ultra fashion il y a 28 ans à Wimbledon, les créateurs Ruth et Tom Chapman se sont lancés très rapidement dans le commerce en ligne. Aujourd'hui, matchesfashion.com allie avec prestige les avantages des médias sociaux et du commerce en ligne avec l'expérience d'un commerçant. En effet, la présence physique constitue encore la base d'une bonne relation avec les clients. Le bureau d'architectes MRA a mis en scène, au cœur de Wimbledon Village, une boutique au design élégant, pour une sélection de marques exclusives. La linéarité et le purisme sont accentués avec de l'or. Le point d'orgue est le sculptural escalier en bois satiné qui mène au sous-sol. L'accès à l'univers en ligne est possible à tout moment grâce à une tablette.

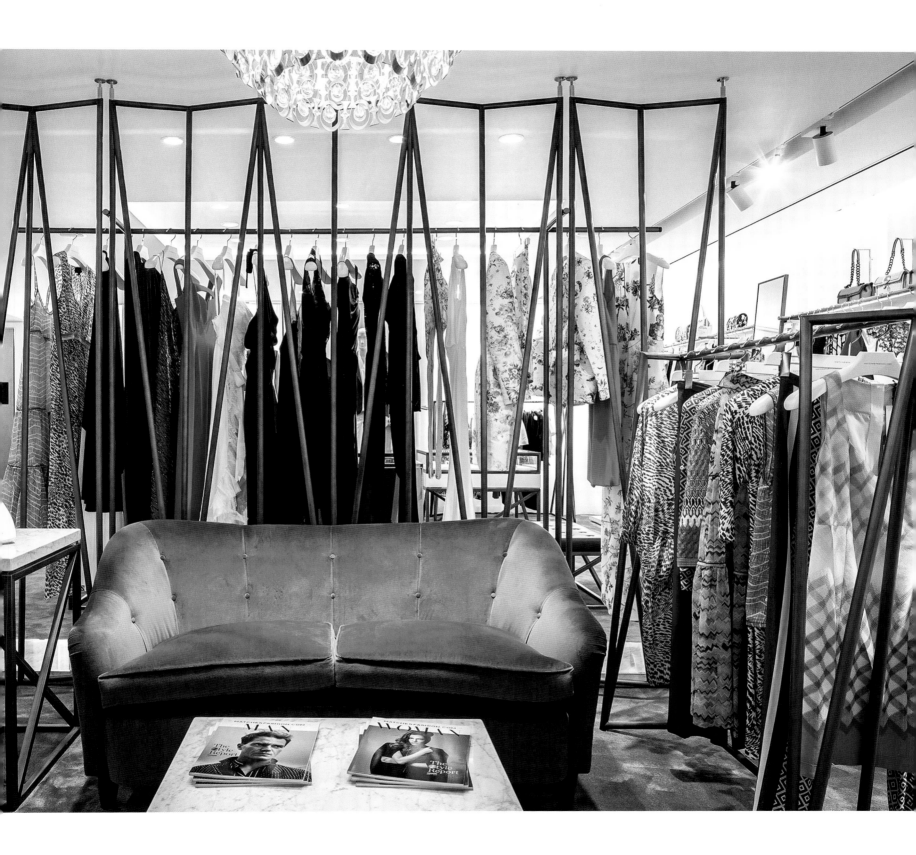

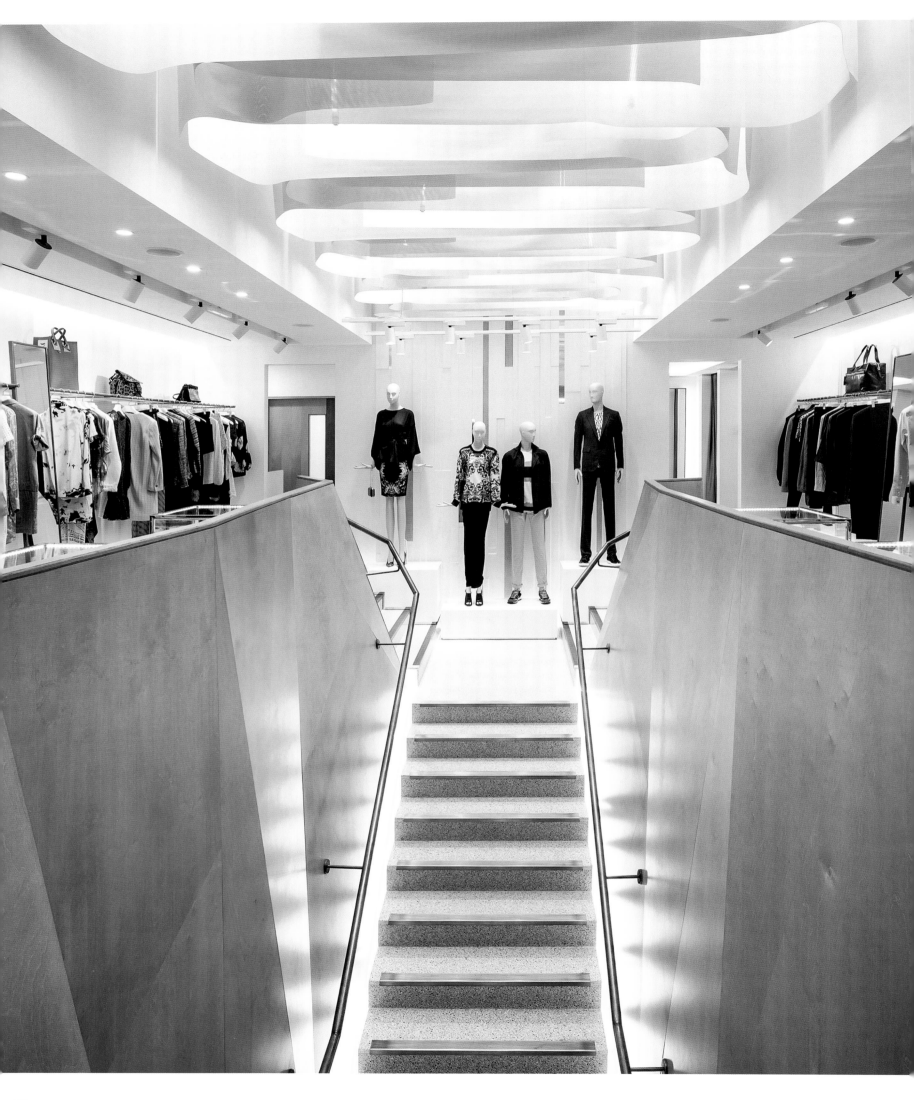

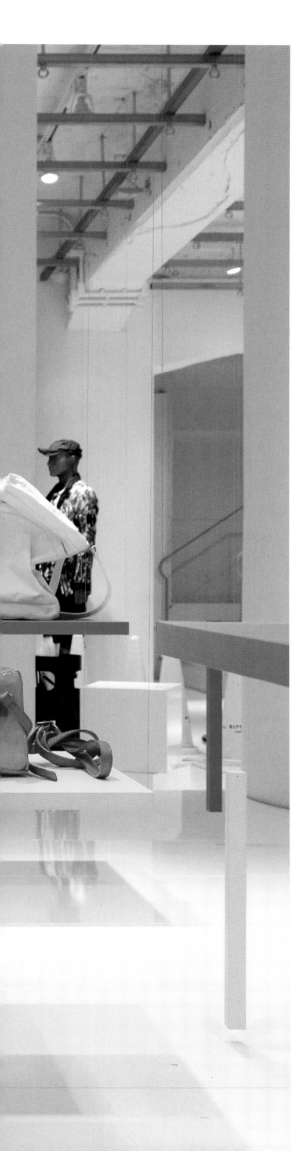

ISSEY MIYAKE

TOKYO

He transformed the ancient Japanese tradition of folding textiles into prêt-à-porter fashion and created a perfume that looks and smells like water; it is still one of the most successful scents ever. Issey Miyake has always had a different perspective on things. He saw the body as a medium for his fashions and never bowed to the model of fashion that changes every season. Japanese design firm Yoichi Yamamoto set up a surprising play on perspectives for Issey Miyake's Tokyo store. Colorful strips of wood float through the space. From a passerby's perspective outside the store, the wood strips create chairs that seem to float in the air, on which products are placed. White is the predominant color, while the open ceiling contrasts with the colorful elements and the gleaming floor.

Er verwandelte die uralte japanische Tradition, Stoffe zu falten, in Prêt-à-porter-Mode, entwickelte einen Duft, der wie Wasser riechen und aussehen sollte und bis heute zu den erfolgreichsten Parfums gehört. Issey Miyake hatte immer schon einen anderen Blick auf die Dinge, sah den Körper als Medium für seine Mode und beugte sich nie dem saisonalen Wandel der Mode. Das japanische Designbüro Yoichi Yamamoto inszenierte für den Store in Tokio nun ein verblüffendes Spiel mit Perspektiven. Farbige Leisten und Holzelemente schweben durch den Raum. Vom Standpunkt außerhalb des Geschäfts vor dem Schaufenster kreieren die Elemente in der Luft schwebende Stühle, die zur Produktinszenierung genutzt werden. Im Raum dominiert Weiß. Die offene Technikdecke kontrastiert mit den bunten Elementen und dem glänzenden Boden.

Il a transformé la tradition japonaise ancestrale du pliage de matériaux en mode de prêt à porter, et créé un parfum ayant la fragrance et l'aspect de l'eau et qui, aujourd'hui encore, est l'un des parfums les plus vendus dans le monde. Issey Miyake porte toujours un regard différent sur les choses, considérant le corps comme un vecteur de sa mode ; il ne s'est jamais plié aux changements de mode saisonniers. Pour la boutique de Tokyo, le bureau de design japonais Yoichi Yamamoto vient de mettre en scène un époustouflant jeu de perspectives. Des baguettes colorées et des éléments en bois sont suspendus à travers l'espace. Depuis l'extérieur de la boutique, face à la vitrine, des chaises flottant dans les airs sont utilisées pour mettre en scène les produits. L'espace est dominé par le blanc. Le plafond technique, ouvert, est en contraste avec les éléments colorés et avec le sol brillant.

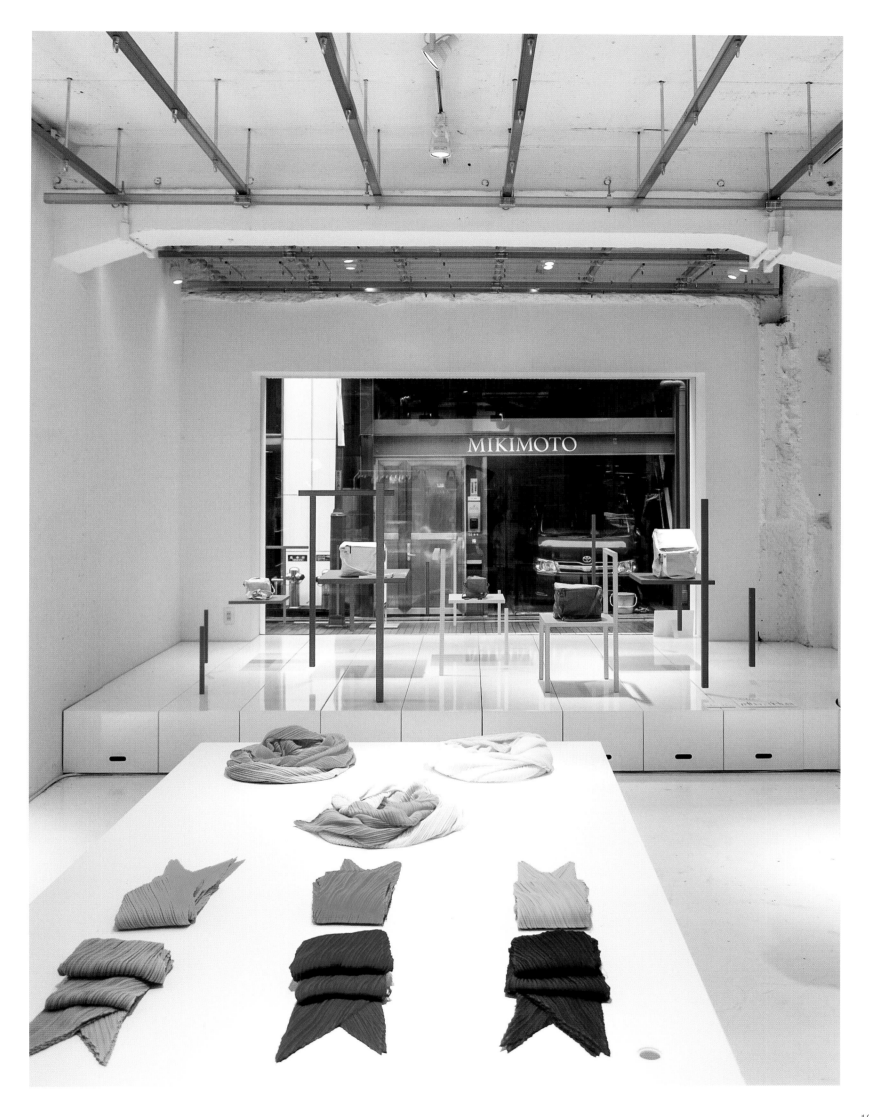

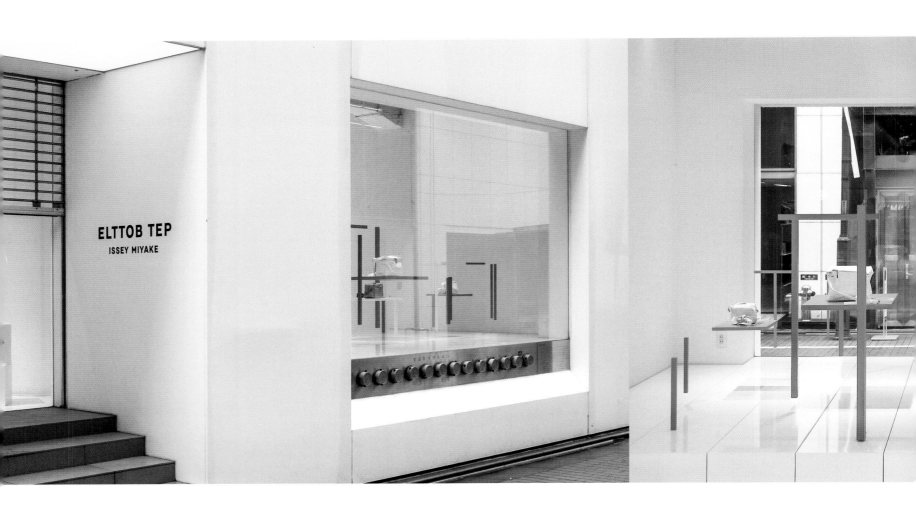

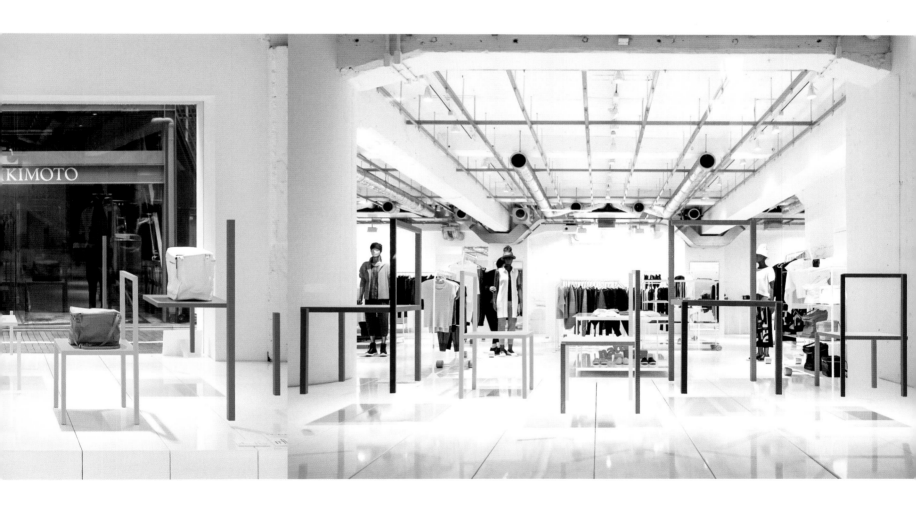

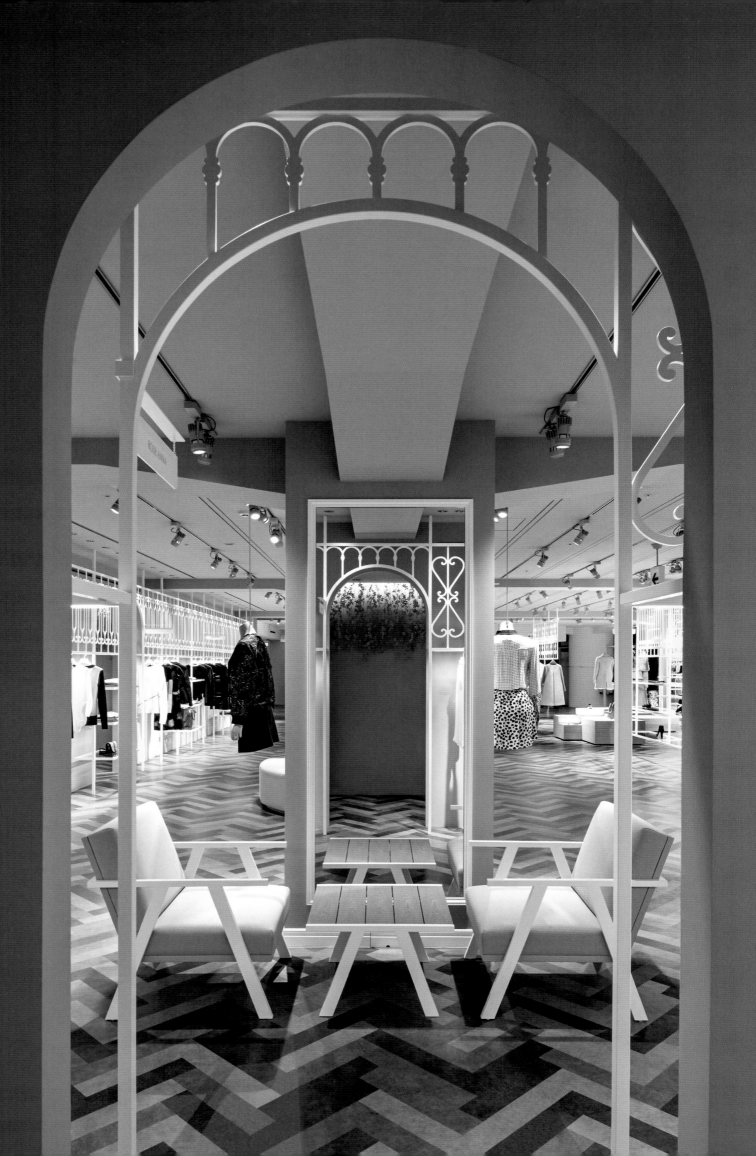

TOKYO
SEIBU

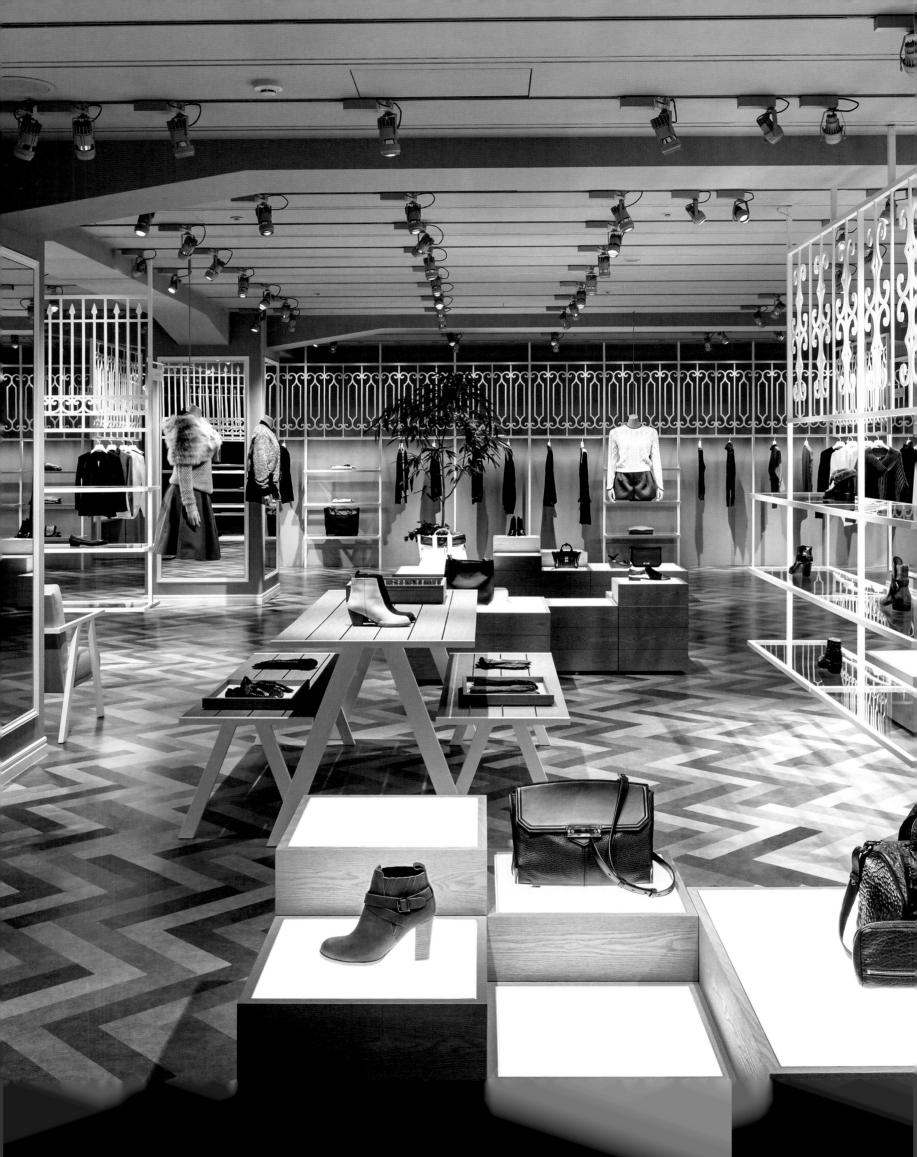

The wrought iron fencing and the geometrically trimmed green of European park spaces provided inspiration to Japanese design firm Nendo. In Tokyo's luxury Seibu department store, white painted fences hang down from the ceiling, holding garlands of flowers leading to gold-colored changing rooms, and providing platforms for geometrical structures. Picnic tables and matching wooden benches complement the look. Shades of white and gray dominate in this retail garden. Unlike their real counterparts, which are carefully laid out in a permanent fashion, the fences, screens, and greenery can be quickly rearranged, and the tables and planters moved around. Above all, the space needs to be flexible to allow each season's new collections to be presented. The plastic French herringbone parquet floor adds a touch of European exotica. Redesigning everyday things that normally register only unconsciously so that they surprise the viewer is the credo of the Japanese designers. They have been known to draw an entire interior design on the walls and floors of a space with chalk. Whether it's lighting for Kartell, mugs for Starbucks, shelving systems for Tod's, or shoes for Camper—it is always about reducing a characteristic form to its essence and giving it a new and unexpected twist.

Die schmiedeeisernen Zäune und das geometrisch getrimmte Grün europäischer Parkanlagen haben das japanische Designbüro Nendo inspiriert. Im Luxuskaufhaus Seibu in Tokio hängen weiß lackierte Zäune von den Decken herab, führen Blumenbögen in goldfarbene Kabinen und sorgen Podeste für geometrische Strukturen. Picknicktische und passende Holzbänke komplementieren den Look. Weiß- und Grauschattierungen dominieren in diesem Retail-Garten. Anders als in den echten und auf Ewigkeit angelegten Vorbildern lassen sich Zäune, Paravents und Begrünung hier schnell umhängen, Tische und Pflanzenkübel verschieben. Denn die Fläche soll vor allem flexibel sein, um immer neue Kollektionen zu präsentieren. Für europäische Exotik sorgt auch das aus Plastikelementen verlegte französische Fischgrätparkett. Alltägliches, das normalerweise nur unbewusst wahrgenommen wird, neu gestalten, um zu überraschen: Das ist das Credo der japanischen Designer, die auch mal eine gesamte Inneneinrichtung silhouettenhaft mit Kreide auf Wände und Fußböden zeichnen. Ob Leuchten für Kartell, Tassen für Starbucks, Regalsysteme für Tod's oder Schuhe für Camper – immer ist es die auf ihr Wesen reduzierte charakteristische Form, die einen neuen, unvorhergesehenen Dreh bekommt.

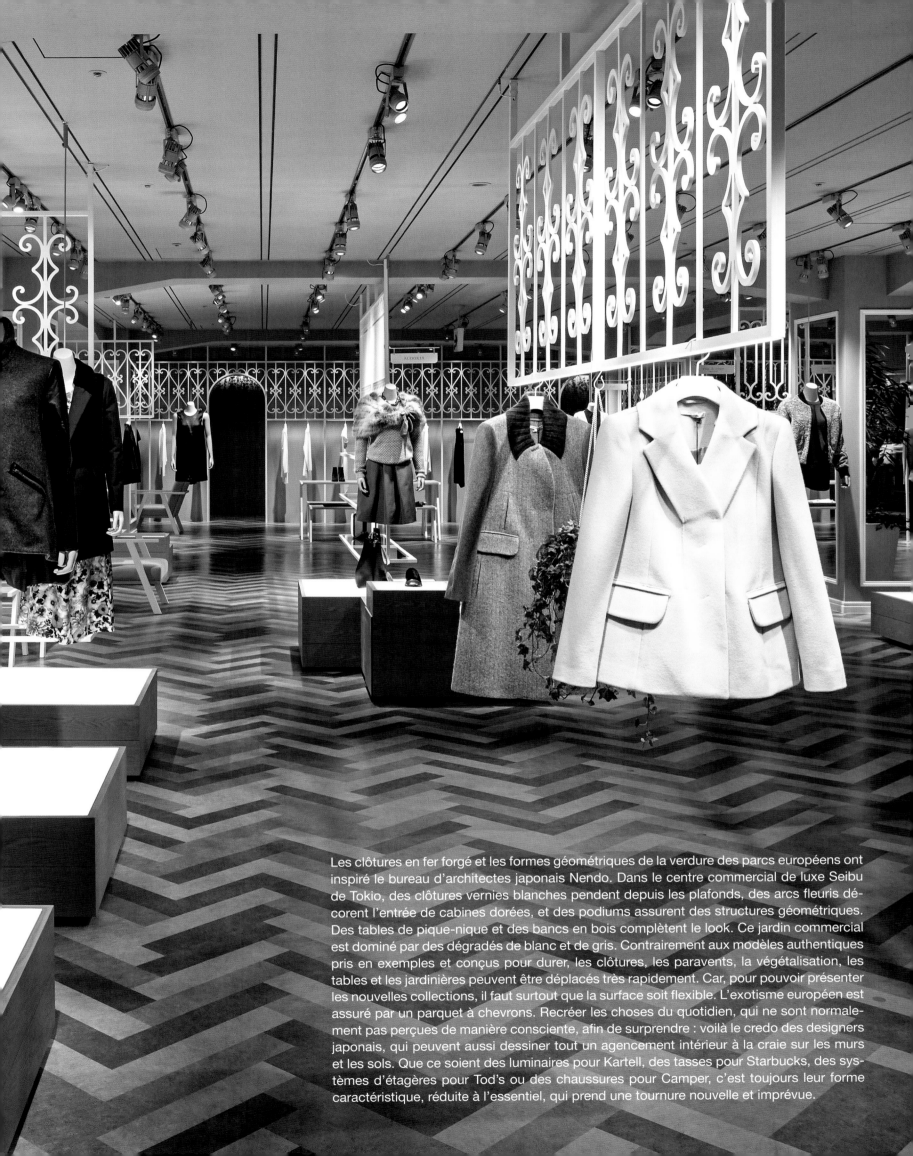

Les clôtures en fer forgé et les formes géométriques de la verdure des parcs européens ont inspiré le bureau d'architectes japonais Nendo. Dans le centre commercial de luxe Seibu de Tokio, des clôtures vernies blanches pendent depuis les plafonds, des arcs fleuris décorent l'entrée de cabines dorées, et des podiums assurent des structures géométriques. Des tables de pique-nique et des bancs en bois complètent le look. Ce jardin commercial est dominé par des dégradés de blanc et de gris. Contrairement aux modèles authentiques pris en exemples et conçus pour durer, les clôtures, les paravents, la végétalisation, les tables et les jardinières peuvent être déplacés très rapidement. Car, pour pouvoir présenter les nouvelles collections, il faut surtout que la surface soit flexible. L'exotisme européen est assuré par un parquet à chevrons. Recréer les choses du quotidien, qui ne sont normalement pas perçues de manière consciente, afin de surprendre : voilà le credo des designers japonais, qui peuvent aussi dessiner tout un agencement intérieur à la craie sur les murs et les sols. Que ce soient des luminaires pour Kartell, des tasses pour Starbucks, des systèmes d'étagères pour Tod's ou des chaussures pour Camper, c'est toujours leur forme caractéristique, réduite à l'essentiel, qui prend une tournure nouvelle et imprévue.

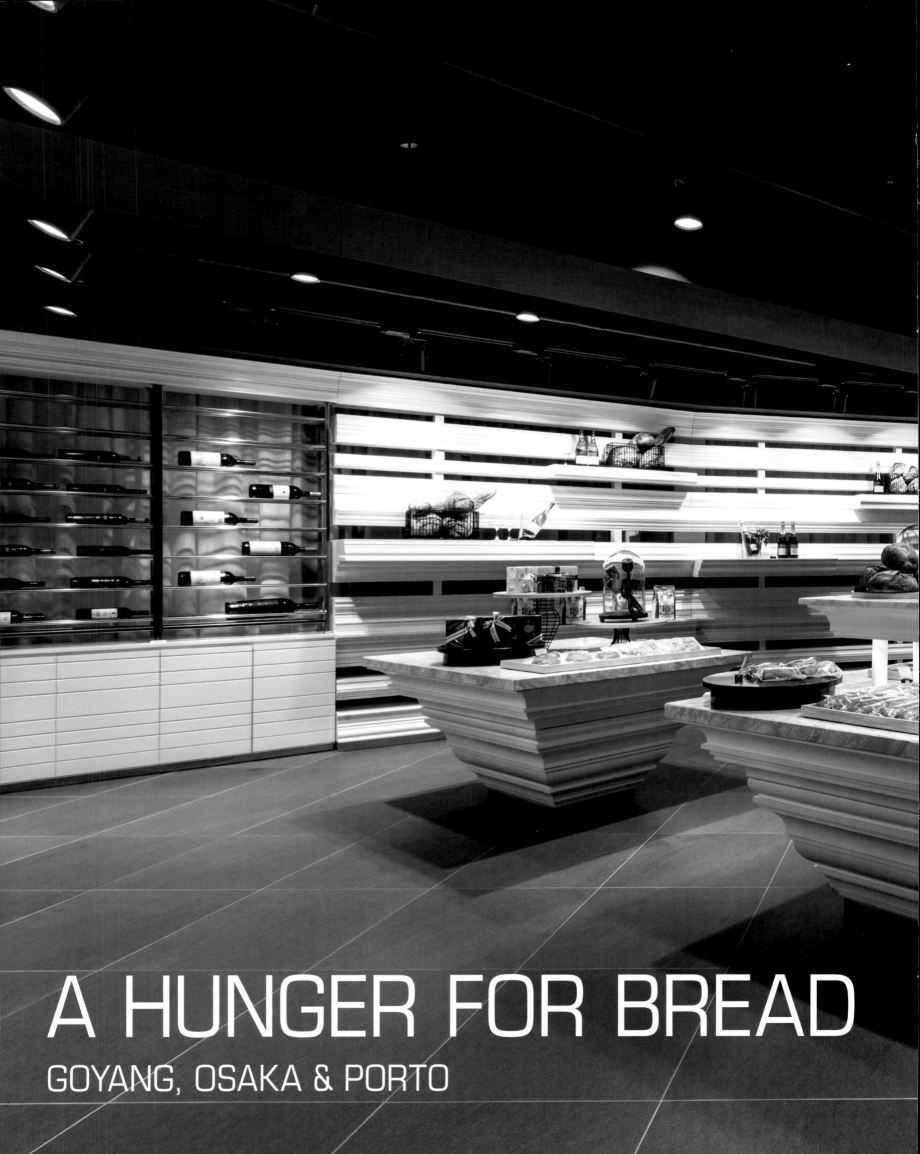

A HUNGER FOR BREAD

GOYANG, OSAKA & PORTO

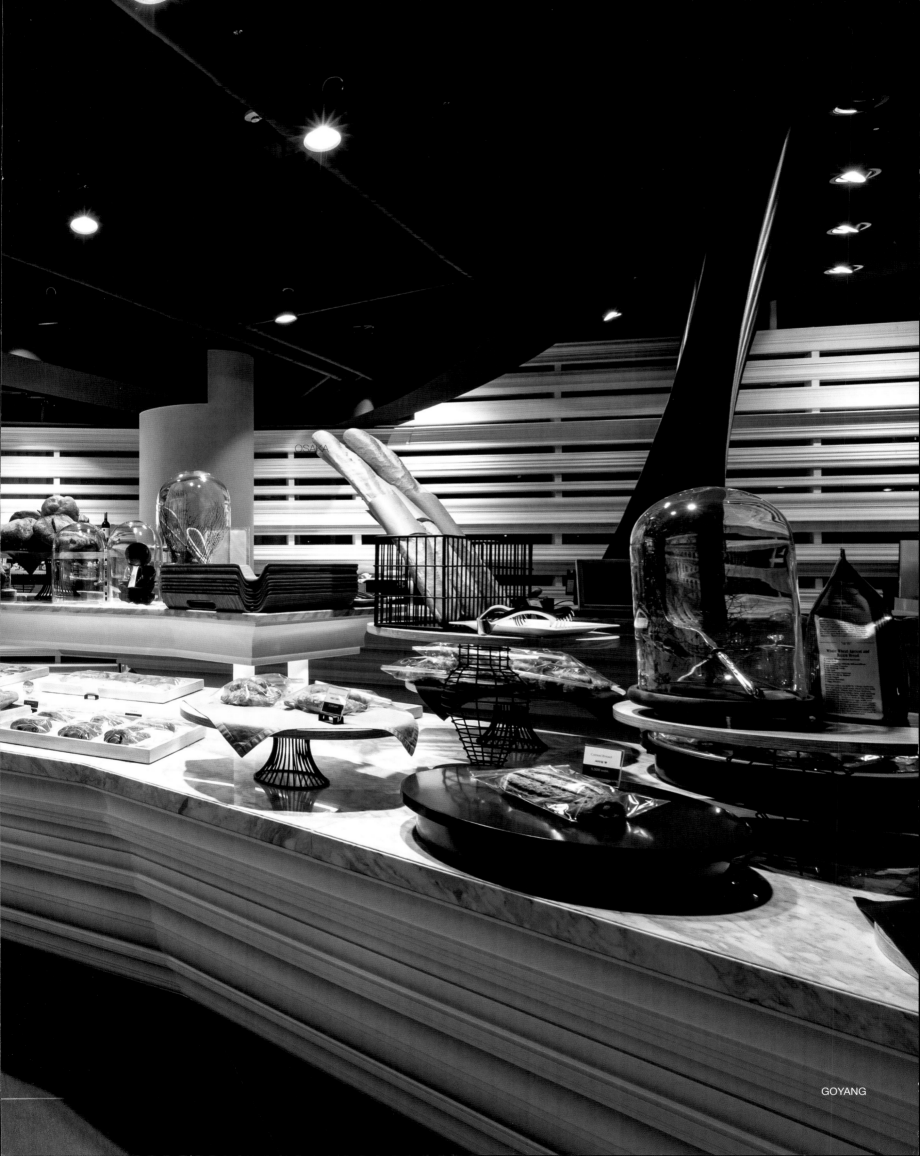

OSAKA

GOYANG

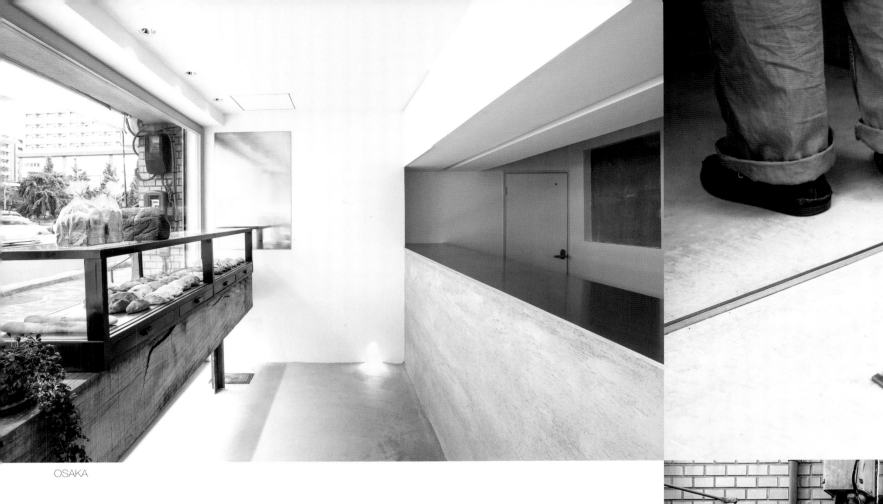

OSAKA

Whether it's fine pastry or good honest bread, it all looks even more delectable in the right environment. For the Confeitaria Pão Quente in Porto, Portugal, architecture firm Paulo Merlini created a space dominated by white wooden slats. They line the ceiling, form walls, and have convex sections that create a sculptural effect. Vanilla-white walls and gleaming white furniture allow the colorful and lavish confections in the long glass cases at the counter to take center stage.

Baroque stucco was the style focus for Il Lago. The bakery and wine store in Goyang, South Korea is a standalone shop in the lobby of the MVL Hotel. The displays, which taper toward the bottom, have futuristic shapes that are completely overlaid with stucco molding. The stacked horizontal slats on the back wall effectively demarcate the space. Cool marble tops on the presentation tables ground the playful confectioner's look, and a black cloth panel hung from above limits the space's vertical reach. Bono Design handled the concept.

Panscape, an Osaka bakery, takes a much more purist approach: an antique countertop element is balanced on an old oak beam. Japanese design firm Ninkipen created the all-aluminum counter, and the name of the bakery is engraved in the concrete steps in front of the entry, modest yet prominent. Untreated wood blocks continue the interior style on the outside.

Ob feines Gebäck oder ehrliches Brot: Noch begehrlicher wird es in passender Umgebung. Für die Confeitaria Pão Quente in Porto hat das Architekturbüro Paulo Merlini eine Rauminszenierung aus weißen Lamellen entworfen. Sie ziehen sich über die Decke, bilden Wände und bekommen durch konvexe Formen skulpturalen Charakter. Vanilleweiße Wände und glänzende weiße Möbel überlassen der farbenprächtigen und üppigen Confiserieware in der langen Theke die Bühne.

Barocke Stuckkunst war die Stilvorlage für Il Lago. Der Brot- und Weinstore in Goyang, Korea, bildet einen Solitär in der Lobby des MVL-Hotels. Die sich nach unten verjüngenden Thekenelemente haben futuristische Formen, die vollständig mit Stuckleisten verkleidet sind. Die Rückwand ist durch die aufeinander gesetzten horizontalen Profilleisten raumbildend. Kühle Marmorplatten auf den Präsentationsmöbeln erden die verspielte Zuckerbäckeroptik, und ein schwarzes abgehängtes Deckensegel begrenzt die Fläche in den Luftraum. Das Konzept stammt von Bono Design.

Deutlich puristischer geht es bei Panscape in Osaka zu: Ein historisches Thekenelement balanciert auf einem alten Eichenbalken. Die Theke hat das japanische Designbüro Ninkipen vollständig aus Aluminium gestaltet. Der Name ist zurückhaltend und dennoch prominent in die Betonstufe vor dem Geschäft eingelassen. Die naturbelassenen Holzblöcke übertragen die Formensprache in den Außenbereich.

OSAKA

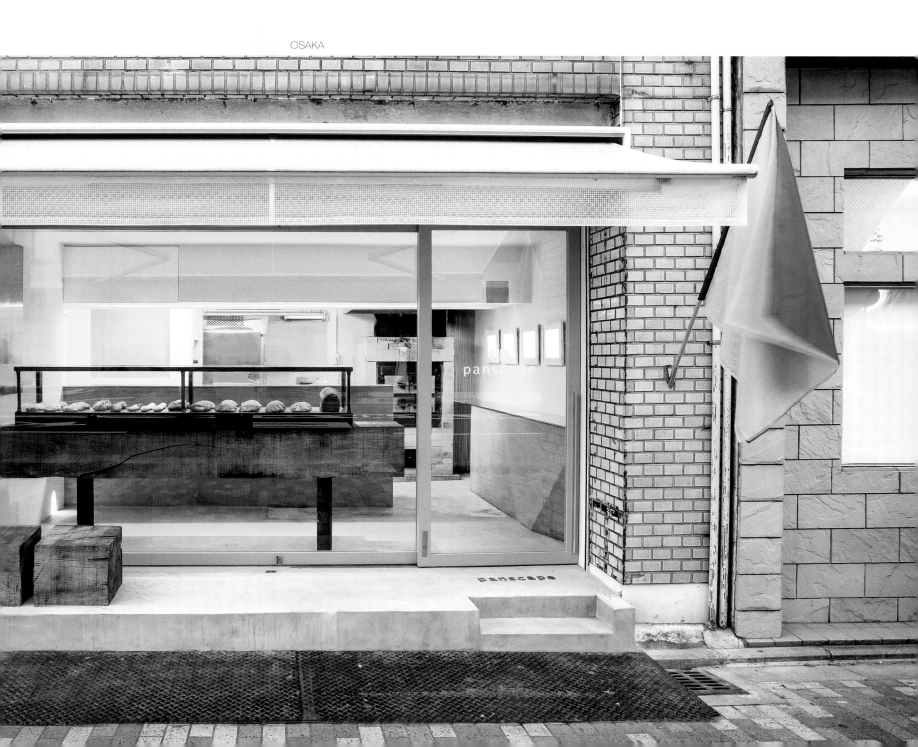

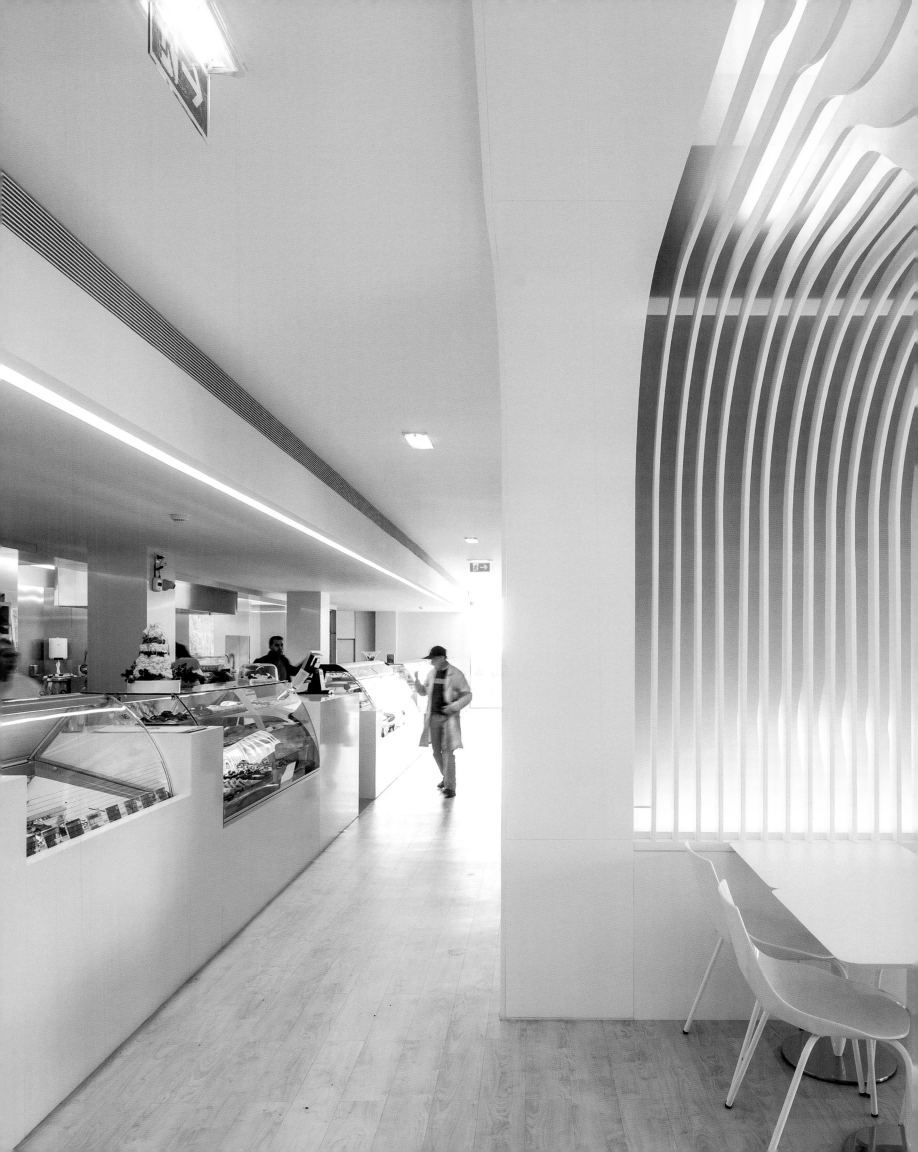

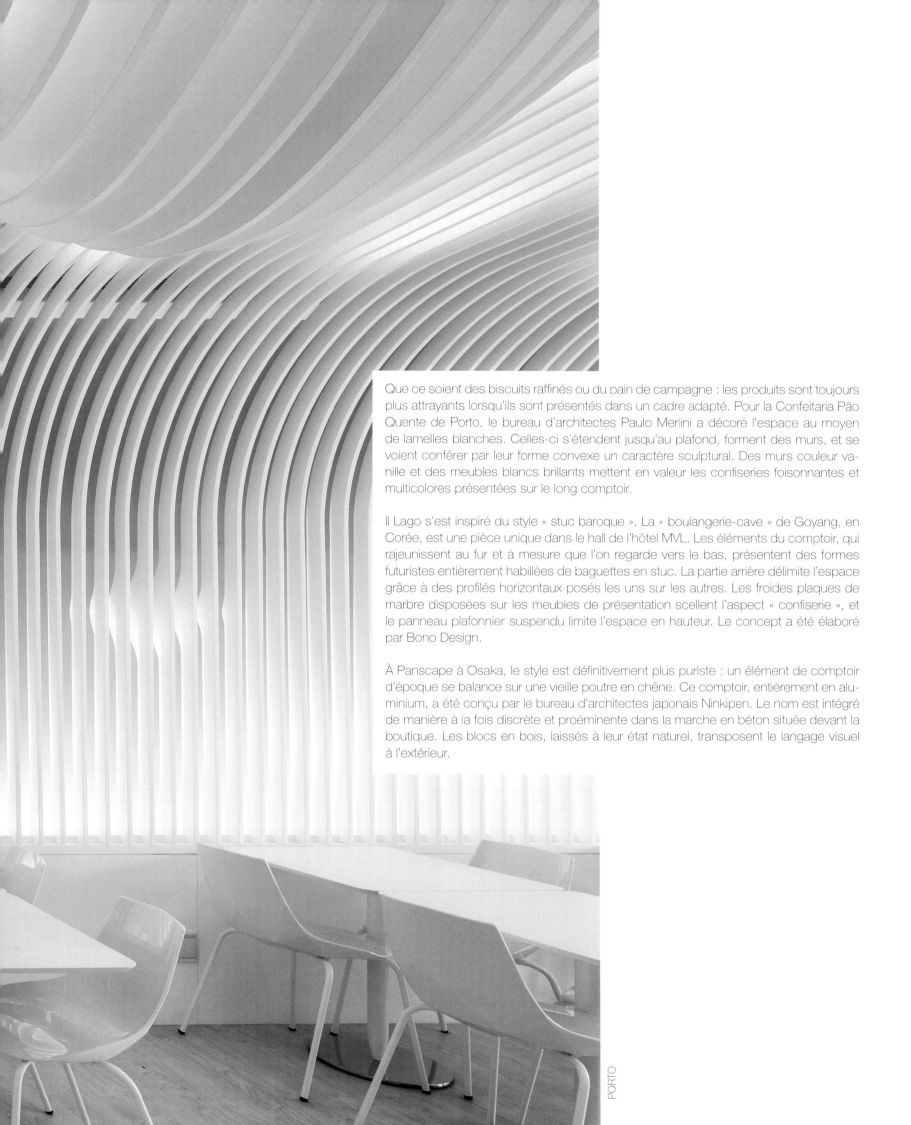

Que ce soient des biscuits raffinés ou du pain de campagne : les produits sont toujours plus attrayants lorsqu'ils sont présentés dans un cadre adapté. Pour la Confeitaria Pão Quente de Porto, le bureau d'architectes Paulo Merlini a décoré l'espace au moyen de lamelles blanches. Celles-ci s'étendent jusqu'au plafond, forment des murs, et se voient conférer par leur forme convexe un caractère sculptural. Des murs couleur vanille et des meubles blancs brillants mettent en valeur les confiseries foisonnantes et multicolores présentées sur le long comptoir.

Il Lago s'est inspiré du style « stuc baroque ». La « boulangerie-cave » de Goyang, en Corée, est une pièce unique dans le hall de l'hôtel MVL. Les éléments du comptoir, qui rajeunissent au fur et à mesure que l'on regarde vers le bas, présentent des formes futuristes entièrement habillées de baguettes en stuc. La partie arrière délimite l'espace grâce à des profilés horizontaux posés les uns sur les autres. Les froides plaques de marbre disposées sur les meubles de présentation scellent l'aspect « confiserie », et le panneau plafonnier suspendu limite l'espace en hauteur. Le concept a été élaboré par Bono Design.

À Panscape à Osaka, le style est définitivement plus puriste : un élément de comptoir d'époque se balance sur une vieille poutre en chêne. Ce comptoir, entièrement en aluminium, a été conçu par le bureau d'architectes japonais Ninkipen. Le nom est intégré de manière à la fois discrète et proéminente dans la marche en béton située devant la boutique. Les blocs en bois, laissés à leur état naturel, transposent le langage visuel à l'extérieur.

PORTO

NATALIE HÄNTZE

Law graduate Natalie Häntze researched Brands at the Point of Sale during her assistanceship with the Chair of Marketing and Retail at the University of Göttingen. After working with different companies in retail, fashion, and interior design, she works as a consultant for various design and architecture firms for the last ten years. As a journalist, markets, brands, and makers first became Häntzes topics for Handelsblatt and later, fashion for Deutsche Fachverlag. Due to her extensive expertise, she has become the leading expert for brand communication and corporate architecture for both company owners and the agency side. Natalie Häntze is editor of the retail and design magazine Design Lodge. She lives and works in Berlin and Düsseldorf.

Die studierte Juristin setzte sich bereits während ihrer wissenschaftlichen Mitarbeit am Lehrstuhl für Marketing und Handel an der Universität Göttingen mit dem Thema Marke am Point of Sale auseinander. Nach Tätigkeiten bei verschiedenen Firmen aus Handel, Mode und Interieur berät sie seit über zehn Jahren Unternehmen sowie Design- und Architekturbüros. Märkte, Marken, Macher wurden parallel dazu auch journalistisch ihre Themen, zunächst für das Handelsblatt und später als Chefredakteurin im Bereich Mode für den Deutschen Fachverlag. Aufgrund ihrer umfassenden Expertise gilt sie sowohl auf Unternehmens- wie auch auf Agenturseite als Expertin für Markenkommunikation und Corporate Architecture. Natalie Häntze ist Herausgeberin des Retail- und Designmagazins *Design Lodge*. Sie lebt und arbeitet in Berlin und Düsseldorf.

Dès sa collaboration scientifique à la chaire de marketing et de commerce de l'université de Göttingen, cette juriste diplômée commença à se pencher sur le thème des « marques sur les points de vente ». Depuis maintenant plus de dix ans, après avoir exercé ses activités auprès de différentes entreprises œuvrant notamment dans les secteurs du commerce, de la mode et des intérieurs, elle prodigue de précieux conseils à des sociétés ainsi qu'à des agences de design et des cabinets d'architecture. Parallèlement à ceci, elle aborde ses thèmes de prédilection que sont « marchés, marques et créateurs » du point de vue journalistique. Elle a d'abord mis ses connaissances au service du quotidien Handelsblatt puis a endossé, plus tard, le rôle de rédactrice en chef de la rubrique mode pour le Deutsche Fachverlag. Forte de son professionnalisme, elle est considérée, autant auprès des sociétés que des agences, comme une excellente experte en communication des marques et en Corporate Architecture. Natalie Häntze est l'éditrice de *Design Lodge*, un magazine dédié au retail et au design. Elle vit et travaille à Berlin et à Düsseldorf.

REFERENCES | QUELLENNACHWEIS | RÉFÉRENCE

Aesop: aesop.com via henri+frank pr | Atelier Oi: atelier-oi.ch | Apropos Concept Store: apropos-store.com | Architecture & Associés J.-C Poggioll P.Beucler: aaarchitectes.com | Architecture Outfit: architectureoutfit.com | Atelier Architecture Gonzalez Haase AAS: gonzalezhaase.com | Blocher Blocher Partners Architecture & Design: blocherblocher.com | Bono Design: designbono.com | Bugatti: bugatti-fashion.com | Buckley Gray Yeoman Architecture: buckleygrayyeoman.com | Ciguë Architecture: cigue.net | Checkland Kindleysides: checklandkindleysides.com | Christian Dior: dior.com via Antje Campe-Thieling PR | Davidoff of Geneva: oettingerdavidoff.com, davidoff.com | Fun Factory: funfactory.de | Fred Perry: fredperry.com via ING Media Ltd | Modehaus Garhammer: garhammer.de | Harrods: Harrods.com | Hunter: hunterboots.com | Interstore Design AG: interstore.ch | Issey Miyake: isseymiyake.com | IWC Schaffhausen: iwc.com via Schoeller & von Rehlingen PR | Jamie Fobert Architects: /jamiefobertarchitects.com | Jelmoli Zürich: jelmoli.ch | KaDeWe Group Berlin: kadewe.com | Karolina Lubkowski: kl-studiodesign.com | Karim Rashid: karimrashid.com | Karl Lagerfeld: karl.com via Schoeller & von Rehlingen PR | Laure Girodroux: lauregirodroux.com | Matchesfashion.com | Matteo Thun: matteothun.com via Renate Janner Communications | MCM: mcmworldwide.com via Häberlein & Mauerer PR | Mercedes-Benz: daimler.com | Mulberry: mulberry.com via Camron PR | MRA Architecture & Interior Design: mra.co.uk | Moysig Retail Design: moysig.de | Nendo: nendo.jp | Ninkipen Architecture: ninkipen.jp | Paulo Merlini Arquitectos: paulomerlini.com | Peter Marino Architect: petermarinoarchitect.com | Plajer & Franz Studio: plajer-franz.de | Prada: prada.com via Loews Public Relations | Pringle of Scotland: pringlescotland.com | Replay: replayjeans.com | Roman & Williams: romanandwilliams.com | Roberto Baciocchi: baciocchiassociati.it | Seibu www.sogo-seibu.jp | Snøhetta Architecture: snohetta.com | Stanley Reich: reichundwamser.de | Stereo Muc: stereo-muc.de; © hansiheckmair.com | Stories: stories-design.com | The Corner Berlin: thecornerberlin.de | The Listener: thelistener.de | The Row: therow.com | Thiénot Champagner: www.thienot.com | Universal Design Studio: universaldesignstudio.com | Versace: versace.com via Loews Public Relations | Viktor & Rolf: viktor-rolf.com | Yoichi Yamamoto Architects: green.dti.ne.jp/yoichi | Weiss-Heiten Design: weiss-heiten.com | Zegna: zegna.com via Schoeller & von Rehlingen PR

Content (clockwise from right to left): funfactory.de; mulberry.com via Camron PR; prada.com via Loews Public Relations; www.tienot.com; Matchesfashion.com

Preface: aesop.com via henri+frank pr; garhammer.de; thecornerberlin.de

Back cover (from top left clockwise to bottom): aesop.com; hunterboots.com; prada.com via Loews Public Relations

IMPRINT

© 2015 teNeues Media GmbH + Co. KG, Kempen

Edited and Texts by Natalie Häntze

Translations by Amanda Ennis,
Shearwater Language Service (English),
Schmellenkamp Communications (French)
Copyediting by Ronit Jariv, derschönste Satz &
Hanna Lemke (German), Marina Madarang (English),
Schmellenkamp Communications (French)
Design by Anika Lethen
Editorial coordination by Inga Wortmann, teNeues Media
Production by Alwine Krebber, teNeues Media
Color separation by Medien Team-Vreden, Germany

Published by teNeues Publishing Group

teNeues Media GmbH + Co. KG
Am Selder 37, 47906 Kempen, Germany
Phone: +49-(0)2152-916-0
Fax: +49-(0)2152-916-111
e-mail: books@teneues.com

Press department: Andrea Rehn
Phone: +49-(0)2152-916-202
e-mail: arehn@teneues.com

teNeues Publishing Company
7 West 18th Street, New York, NY 10011, USA
Phone: +1-212-627-9090
Fax: +1-212-627-9511

teNeues Publishing UK Ltd.
12 Ferndene Road, London SE24 0AQ, UK
Phone: +44-(0)20-3542-8997

teNeues France S.A.R.L.
39, rue des Billets, 18250 Henrichemont, France
Phone: +33-(0)2-4826-9348
Fax: +33-(0)1-7072-3482

www.teneues.com

ISBN 978-3-8327-3284-4

Library of Congress Number: 2015940188

Printed in the Czech Republic

Bibliographic information published by the Deutsche Nationalbibliothek. The Deutsche Nationalbibliothek lists this publication in the Deutsche Nationalbibliografie; detailed bibliographic data are available in the Internet at http://dnb.d-nb.de.

teNeues Publishing Group
Kempen
Berlin
London
Munich
New York
Paris

teNeues